public relations
case studies
from around the world

This book is part of the Peter Lang Media and Communication list.
Every volume is peer reviewed and meets
the highest quality standards for content and production.

PETER LANG
New York • Bern • Frankfurt • Berlin
Brussels • Vienna • Oxford • Warsaw

public relations case studies
from around the world

EDITORS
Judy VanSlyke Turk
Jean Valin
John Paluszek

PETER LANG
New York • Bern • Frankfurt • Berlin
Brussels • Vienna • Oxford • Warsaw

Library of Congress Cataloging-in-Publication Data

Public relations case studies from around the world /
edited by Judy VanSlyke Turk, Jean Valin, John Paluszek.
pages cm
Includes bibliographical references and index.
1. Public relations—Case studies. 2. Organizational behavior—Case studies.
I. Turk, Judy VanSlyke. II. Valin, Jean. III. Paluszek, John.
HD59.P789 659.2—dc23 2014012238
ISBN 978-1-4331-2347-4 (hardcover)
ISBN 978-1-4331-2346-7 (paperback)
ISBN 978-1-4539-1368-0 (e-book)

Bibliographic information published by **Die Deutsche Nationalbibliothek.**
Die Deutsche Nationalbibliothek lists this publication in the "Deutsche
Nationalbibliografie"; detailed bibliographic data are available
on the Internet at http://dnb.d-nb.de/.

© 2014 Peter Lang Publishing, Inc., New York
29 Broadway, 18th floor, New York, NY 10006
www.peterlang.com

Table of Contents

Preface

We experienced a novel sensation when reading the cases in this book. After decades of studying, teaching, and practicing public relations, we tend to scan new works quickly. Here, however, we dug into each case. As a result, we have been influenced deeply by this text.

Why? First, the editors chose precisely the right authors to develop each chapter. These scholars—editors and authors alike—are the best of the best. They are women and men of fierce intelligence and global experience. We consider them some of the world's premier scholars and professionals. As a result, they have enjoyed access to some of the world's most intriguing and influential cases of organizational behavior. These studies will be of tremendous interest to those who teach, study, and practice public relations around the globe.

Second, even a cursory glance at the table of contents shows that the data go well beyond North America to include multinational corporations as well as NGOs and governmental agencies in such countries as Poland, Iran, South Africa, Japan, New Zealand, Costa Rica, Malaysia, the United Arab Emirates, Slovenia, and Finland. This book escapes the western frame in which the literature of our field largely had been confined. It takes a significant step toward overcoming the dearth of published case studies in public relations beyond Canada and the United States.

Third, the cases themselves represent an impressive breadth—from public diplomacy to corporate social responsibility to community relations to tourism to fundraising. One chapter describes the celebration of an energy company's half-century anniversary; another chronicles an innovative campaign for social media; still another explains how one multinational company managed a brand-transformation project for greater stakeholder engagement. Some chapters emphasize measurement whereas others concentrate on communication during times of crises or disaster relief. Along the way, we come to understand the ins and outs of a pachinko parlor in Japan, a kiwi export operation in New Zealand, a "Fan Zone" for football enthusiasts in Poland, and a Dutch engineering and electronics conglomerate. The common denominator of the chapters is that they represent well-developed programs based on research.

As a result of the conceptualization and data collection in these cases, we have solid evidence that public relations at last may be overcoming what some historians of the field have deemed its roots in press agentry. Given that unfortunate beginning, primarily as one-way communication from the organization to its publics, communication professionals long have struggled against the prejudice that comes with equating public relations with spin or flackery. Taken together, the chapters of this global compendium provide readers with glimpses of another world—an excellent public relations practice that is valued by top management and the organization's many stakeholders as well.

One case, that of IBM, uses components of a theory of excellence in public relations that we helped develop three decades ago. Our theory is consistent with IBM's "Smarter Planet" campaign to innovate through technology, largely "Big Data." That is, public relations contributes to organizational effectiveness when it is two-way, concerned with both the interests of the organization and its publics, strategic and managerial. Excellent public relations relies on research both before and after initiatives such as in the "Smarter Planet" case.

These cases all suggest that public relations, when based on formative and evaluative research and practiced ethically, stands to play an ever-bigger role in setting appropriate goals for businesses, governments, and not-for-profit organizations. Given the diversity of cases, though, the book deftly avoids any stench of ideology. Individual cases have value in themselves. No universality is forced on the studies of such diverse operations as Starbucks, the beverage behemoth; a human-rights campaign in Iran; financial interactions between China and Japan; a global fundraising initiative; promotion of tourism in South America; and support of iconic-landmark status for South Africa's Table Mountain.

In fact, because *people* were conducting and evaluating the public relations cases drawn here (and *people*, good scribes all, were writing up the data), we experience

what engineers call "uncontrolled variability." Readers come to understand that there are no universal solutions to the major problems facing even the brightest, most well-meaning practitioners. These problems, we learn from the cases, include lack of credibility or autonomy from senior management, encroachment from marketing enthusiasts, imperfect understanding of metrics as part of ongoing measurement programs, entrenched hostilities between an organization and its stakeholders (and even among those groups), and—as always—limited resources. The frictionless, one-size-fits-all solution remains elusive.

Further, we come to understand that history—including the history of public relations around the world—has no inevitable course. However, we also learn from these cases about encouraging links between responsibility and profitability, between ethics and effectiveness, and between evaluation and evolution toward a practice that is becoming more symmetrical, more diverse, more strategic, and more managerial than in the past.

We acknowledge that serious students—practitioners, professors, or undergraduates—can learn critical lessons even from public relations efforts that went awry, that wasted precious time and money. However, editors Judy VanSlyke Turk, Jean Valin, and John Paluszek have worked with authors in a process of "two-way symmetrical collaboration" to select cases that clearly demonstrate best practices in public relations.

Many of the initiatives analyzed in this book first came to the editors' attention because they had won award competitions sponsored by local, regional, or even international societies in our field. What a resource! Having this text available almost makes us wish we still had a global public relations course to teach.

The cases in this edited book tell the story of how public relations is done in a variety of types of organizations in selected countries. Each chapter gives us an indication of another world. That world, if the scrupulously researched and written cases are to be believed, is characterized by an affirming redistribution of the power formerly concentrated in the boardrooms of large multinational corporations and in the governments of wealthy nation-states. That effective public relations can be shown to be even partly responsible for such a shift is a triumph.

Larissa A. Grunig, Ph.D.
Professor Emerita

James E. Grunig, Ph.D.
Professor Emeritus
University of Maryland Department of Communication
College Park, MD USA

Foreword

I wear two hats when writing the foreword for this innovative book of case studies: first as a practitioner and chair of the Global Alliance for Public Relations and Communication Management, and second as an academic who is constantly searching for new and challenging cases with which to stimulate and draw the best from students.

With my first hat on, I welcome this cogent demonstration that our profession has "grown up." For years we have heard that we are still a young profession, but as we know, youth does not always imply immaturity. Einstein did his most impactful work when he was relatively young and it is the word *impactful* that I am picking up here. These cases show that public relations does make a difference. It makes a difference to organizations by focusing them on what is important and helping them transform their very purpose at times, as the IBM case shows. Public relations also makes a difference to society and can happen even when two people sitting in a bar have an amazing idea and the determination to light an imaginative fire—hence Movember, the worldwide charitable phenomenon originating in Australia.

My vision for the Global Alliance is that it should be an organization that promotes the work of public relations in all parts of our world. For too long Europe and North America have dominated the public relations written landscape. This book draws together cases of many types from all around the world including

Africa, Asia, Australasia, Europe, the Middle East, Scandinavia, North America, Central America, and the Far East. It is certainly the most international of international case collections I have ever seen in one place.

However, I will honestly say—and here is a challenge for us all—that even here there are not enough cases from some of the most densely populated areas of our planet where public relations is an emerging profession making great impact. Africa, Asia, and South America are underrepresented throughout our profession. The editors of this book have purposely attempted to include cases from those continents. The world is the poorer for not having more examples written up to learn from in English for those of us dependent on that language. I know it is the ambition of our editors, and of the Global Alliance, to correct that over the coming years. Holding the next World Public Relations Forum in 2014 in Madrid with presentations in both Spanish and English should bring to our attention new examples of excellent practice, especially in South America.

With my academic hat on, I can say these case studies will be an invaluable resource. Today's world is global and without an appreciation of how the profession is practiced across the world, students are ill served by their tutors. But it is not just an awareness of practice that is important. A respect for different cultures and ways of working is vital. Public relations is in the business of relationships, and not knowing how these are built and preserved in different ways in different places will mean ineffectual practice. I'd go further: Without knowing how *life* is lived in different places, we cannot do our public relations jobs properly. My hope is that these cases will not only be of value in themselves but will also stimulate a hunger to discover the richness of how people live their lives around the world and of how much they have to teach us. By developing those understandings and by making others aware of them, we can begin to fulfill the higher calling of our profession—to be a force for good in the world.

As a practitioner and academic it gladdens my heart to see public relations being taken so seriously around the world. The days of being a messenger or mouthpiece for management are over in our leading organizations, whether they are public, private, or not for profit. These organizations understand not only the potential but also the reality of how powerful public relations can be when it is used strategically and embedded within decision-making. They understand the importance of listening and of engaging with those both inside and outside the organization and of using the intelligence they gather from listening not as a manipulative tool for furthering their own purposes but as a mechanism for finding out how they can add value to the lives of others. Those organizations that still regard public relations as a message delivery service had better sit up and take notice: The world has changed. They can't just deliver messages anymore, either pragmatically

or ethically. They never really could if ethics meant anything to them. They surely will be left behind as organizations have to gain the right to be heard and as they become valued for what they do for others as well as what they do for themselves.

Recent work by the International Integrated Reporting Council on organizational value has proved that reputations and relationships have real value, and the Global Alliance's Melbourne Mandate (http://melbournemandate.globalalliancepr.org/wp-content/uploads/2012/11/Melbourne-Mandate-Text-final.pdf) demonstrates how public relations can be used fully to leverage that value.

When talking to CEOs, it is quite apparent that the best absolutely "get it": Public relations is not just "nice to have," it is essential. They also recognize that skilled practitioners able to advise on the most important decisions are valuable. This book of cases demonstrates why.

Coming back to where I started with the Global Alliance, one of its main aims is to be a worldwide advocate for the profession. These cases show that the profession can speak for itself when given the platform to do so.

I would like to thank Judy VanSlyke Turk, Jean Valin, and John Paluszek for providing that platform through this book. Their work is of huge importance and students, academics, and practitioners will learn an enormous amount from their hard and meticulous work.

Anne Gregory
Professor
University of Huddersfield
a.gregory@hud.ac.uk

Introduction

The mandate of public relations is to build and sustain strong relationships between an organization and its publics, and in doing so, to contribute to the betterment of society.

As public relations has become a global profession, relationships have expanded across every continent, region, and country in the world. The literature of public relations, particularly case studies highlighting best practices from different parts of the world, has lagged behind this globalization of public relations.

The three editors of this collection of case studies, during our travels around the globe, have heard from professors and students of public relations—as well as practitioners—in numerous countries outside North America that there is a lack of "best practices" case studies involving organizations from regions other than North America. We wanted to address that shortcoming and provide examples of best practices from around the world.

All three of us are leaders in the Global Alliance for Public Relations and Communication Management (GA; http://www.globalalliancepr.org), a confederation of more than 70 professional societies and associations in public relations and communication management that has initiated several global initiatives including the Melbourne Mandate, now a global professional beacon for public relations practice. Throughout our global involvement, we have learned of award-winning

cases in various countries, many of them unique and transformative cases with the power to shape society and improve lives.

For this book, we sought either unique cases or award-winning public relations cases from around the world. Based on our collective experience we selected 17 unique cases, some global in scope while others were implemented in a given country. The reader will note that a majority of cases followed a set presentation format suggested by the editors while a few exceptional cases were best presented in somewhat adjusted formats and sequences. Most cases won national or international awards in 2012 or 2013; some have "policy roots" dating further back. All are still very current even in today's fast-paced society. Furthermore, we wanted to reflect the full breadth of activity in managing public relations and were mindful of finding strong cases from different parts of the globe and making them available to scholars, practitioners, and students.

What makes this book unique is its global emphasis and choice of cases that are representative of practices in different countries and various cultural, economic, and even political systems. They deserve to be singled out as examples for practitioners and for educating graduate and undergraduate students whether they are studying public relations in Asia, Africa, Oceania, South America, Europe, or North America. The authors of these case studies are among the world's most respected and recognized scholars and practitioners, another distinguishing characteristic of this book. Moreover, many cases illustrate how the practice of public relations has evolved globally, is being increasingly practiced with two-way symmetrical characteristics, and no longer imposes a universal one-size-fits-all approach to global public relations practice.

In the following pages, the reader will find case studies about global brands such as IBM, Starbucks, and Philips and cases involving governmental, community, and industry initiatives; crisis communications; special events; human rights; corporate communication; sustainability; social media; minority relations; measuring the effectiveness of public relations; fundraising; and country-to-country initiatives in public diplomacy.

The following is a brief snapshot of the cases covered in the book:

- Using elements of the theoretically developed "excellence model" of public relations to reinvent and integrate communication functions at IBM to facilitate adaptation to rapidly changing technology
- How two guys quaffing beers in Melbourne gave birth to the premier global men's health fundraising campaign Movember
- An exemplary case study in special event management for a multinational company: celebrating 50 years at Enel

- Transforming an iconic brand, Starbucks, for a weakening economic and competitive environment
- Implementing a corporate social responsibility and sustainability program at the Danish Co-op to build trade with Africa and support development of indigenous African businesses with a new Savannah brand
- Securing the release of an innocent health caregiver from an Iranian prison through an emotionally moving humanitarian campaign
- Defusing ethnic tensions in Malaysia with a grassroots minority relations program, a partnership of government and nongovernmental organizations, to aid stateless Indian residents
- Developing a plan to brand a country, Finland, to the world
- Taking public the first company in an Asian industry and substantially increasing foreign investment in the company
- Leveraging an international sporting event into strengthening the identity for a city, Poznań, and its country, Poland
- Implementing an ecotourism program in Costa Rica to conserve the country's tropical paradise while simultaneously enabling native residents to benefit economically from tourism
- Developing sound ways for Philips to measure earned media efforts, making it a world measurement leader
- Augmenting the customer listening capacity of the Middle East telecommunications company Etisalat by measuring the impact of its foray into social media
- Managing a crisis in New Zealand where a devastating bacterial disease on a major export, kiwifruit, threatened a company and, indeed, the national economy
- Turning a crisis management situation for a Japanese courier service, Yamato, into an opportunity to provide earthquake aid even though the aid substantially reduced shareholder earnings
- Tackling the issue of illegal dumping in the Slovenian countryside
- Mobilizing an entire country to bring world-class tourism recognition to Table Mountain in South Africa

Case studies can be powerful teaching tools of public relations principles in action for both students and practitioners. They can bring to life theoretical frameworks. They can illustrate the role of public relations practitioners in achieving objectives. And they make the vital link between applied theory taught in classrooms to projects and campaigns such as those selected for this book.

Not all of the case studies in this book demonstrate situations in which everything was done "right." Some of the campaigns did not set measurable objectives. Others used only descriptive data to measure and evaluate results. But all were strategic, focused on meeting organization/client needs. That, we editors think, is clear evidence of the growing sophistication and professionalism of public relations all over the globe.

We are immensely grateful to the contributing authors and to the organizational representatives who provided information for these case studies. We also are grateful for the support and encouragement of the Global Alliance for Public Relations and Communication Management for supporting our effort and for helping disseminate information about the book to the global public relations community.

We also wish to express our gratitude to Louise Pagé-Valin for her editing expertise, technical prowess, and moral support. With her help, our endeavor became much easier to undertake and complete.

Judy VanSlyke Turk, Ph.D., APR, Fellow PRSA
Professor Emerita, Virginia Commonwealth University

Jean Valin, APR, Fellow CPRS
Principal, Valin Strategic Communications

John Paluszek, APR, Fellow PRSA
Senior Counsel, Ketchum
Founder/Producer, Business in Society

Acknowledgments

The editors would like to credit the following organizations for the use of illustrations and slides:

- Movember — logotype
- Enel Italy — project planning charts and photograph
- Starbucks — logo progression designs
- Co-op Denmark — Savannah product line advertisement
- Malaysia *My Daftar* — stock exchange photo
- Fan Zone Poznań — concert photograph
- Philips — management presentation slides
- Etisalat/Social Eyez agency — info graphic slide
- Zespri International Limited — press materials photo
- Yamato Holdings — photograph
- Pristop agency, Slovenia — promotional campaign advertisement
- Cape Town Tourism — promotion photograph

Part I:
Case Studies in Global Campaigns

IBM's Smarter Planet Initiative: Building a More Intelligent World

DON STACKS
University of Miami

DONALD K. WRIGHT
Boston University

SHANNON A. BOWEN
University of South Carolina

EDITORS' NOTE

This case study is the first-known application of excellence theory—what makes public relations excellent—to evaluate a public relations program, and it is even more significant because the public relations program was conducted by IBM, one of the world's largest and most respected companies. IBM rethought its communications from an inside-out standpoint, providing more integration of internal communication functions and demonstrating to external audiences how the company and its people were using technology to adapt to a changing world.

Many case studies claim to analyze excellent public relations and communication programs. Most of these cases take what Stacks (2010) has called the historical case method consisting of a "linear" model moving through the stages of research, objectives, communication, and evaluation known as ROPE (Hendrix, 1998). The

limitation of this model is its failure to include feedback, which led Center and Jackson (1995) to propose a process case method that examined how assessment of a public relations program figured in its final evaluation. Both models provide understanding of *what* was done but offer little to understand the *process* by which excellent public relations programming is conducted. Previously, Grunig (1976) worked on a model of "synchronic communication," later called "symmetrical communication," that incorporated a dialogue or give-and-take communication process. His research culminated in what has come to be known as an "excellence theory" because it identifies factors that make public relations the best it can be through contributing to the overall effectiveness of the organization.

IBM's Smarter Planet initiative reported in this case study was based on the company's goal of building a more intelligent world. The concept attempted to bring together forward-thinking leaders from business, government, and other communities to address how technology and data, especially "Big Data," can create a better world.

This case analyzes one of the best or most excellent public relations programs from a perspective of excellence theory (Grunig, 2001). The case uses a theoretical model of excellence proposed by Michaelson, Wright, and Stacks (2012) while following as closely as possible the format of the other cases in this collection: background, situation analysis, opportunity, goals, objectives, key publics, key messages, strategies, tactics, timetable, budget, and evaluation as divided into the excellence model's three levels.

BACKGROUND

The IBM Smarter Planet initiative that began in 2008 demonstrated excellent communication in a move toward a market-mix model by integrating communication, marketing, corporate, and citizen functions into one function. Historically, IBM has had to reinvent itself as its business market changed from a typewriter to a computer to a service integration company. Although it still produces large-scale computers, for example, "Watson," the company focused its attention on the potential of building a "smarter planet."

IBM's communication focus before 2008 was on external communications and its strength was primarily journalistic in function. Marketing was seen as a separate but equal function with communication that led to tension between the shorter timeline of internal and external communication and marketing's longer-term approach to problems. The opportunity to mesh the two functions, with both now focusing on the relationship of short- to long-term programming,

was presented to Jon Iwata, a trained public relations communicator with experience in internal communications. The campaign goal was to turn a traditional one-way communication model into a relational model focusing on two-way communication that engaged employees in the process and focused on technology's impact on business, lifestyle, and communication. The threat was that functional tensions ("turf battles") would further reinforce the short- and long-term strategies of the past.

METHODOLOGY

This case study was researched and written using two qualitative research methodologies. First, research was conducted through a literature search of other cases written about IBM and its change from a company that was built on computers and software to a service-oriented company. Second, an in-depth interview with Mr. Jon Iwata, senior vice president of marketing, communications, and citizenship at IBM, was conducted.

THE OPPORTUNITY

With the change in functional leadership came an opportunity to rethink communications from an inside-out approach. By naming Iwata its senior vice president of marketing, communications, and citizenship, IBM had in place someone to integrate the messaging strategy in a more holistic way. The result was the "Smarter Planet" strategy. Smarter Planet goals were both internal (organize around a principle and move toward tighter integration of communication functions) and external (to demonstrate how IBM and its people are working with technology to help companies adapt to a changing world).

IBM challenged its internal audience to become a part of the larger company by being its spokespeople. It challenged its client audience to be seen as innovators across all IBM businesses. The differences between the "old" and the "new" IBM dealt with technology and data and how the two could change the world together. This was a shift in focus from production to services, producing an identity and brand that was "unclear and in flux" (Iwata, personal communication, June 27, 2013). (All comments from Iwata in this chapter are from this personal communication.)

The strategic intent was not to make IBM more visible but to make it more relevant to people. As Iwata noted, "By 'relevant,' we sought to demonstrate in a visceral way how the work of IBM and IBMers affected, for the better,

what individuals care about. In this regard we eschewed the traditional notion of B-to-B and B-to-C companies. We set out to connect with individuals." This shift in strategic focus from production to relevance to stakeholders was monumental for IBM.

Since his arrival at IBM in the mid-1980s, Iwata had worked on the communications team, and he took over the communications unit in 2002. In 2008, IBM integrated its communications, marketing, corporate, and citizen teams under Iwata's leadership, integrating communication across all three units to produce a truly integrated communications unit responsible for all internal and external communications. Iwata was named senior vice president for corporate communications and marketing in July 2008.

THE STRATEGY

IBM faced two problems. First, the company's brand and identity had changed. Second, its focus had changed from the iconic producer of equipment—typewriters and computers—to providing services (and data) that were aimed at "making the world better in our day . . . [leading] to the development of a Smarter Planet—our view of how the next era of computing would improve business and society." Thus, a central assumption of the campaign was to make the intelligent use of *data* its central theme. As Mike Fay, IBM vice president of corporate marketing and communications, noted, "Whether it's because people are walking around with smart-phones, or whether it's because processors are now imbedded in all sorts of things like shipping containers, products, or automobiles, you're getting a lot more data now. The average person is leaving a huge trail of data behind them every day. The physical systems of the world are leaving more data" (Wright, 2013).

The strategy led to a vision of a Smarter Planet "driven by three I's—instrumentation, interconnectedness, and intelligence. . . . By using analytics technology to capture and infuse insights into the systems powering industries, governments and even entire cities, IBM was delivering smarter power grids, smarter food systems, and smarter traffic systems." This was to be accomplished by positioning IBM as a leader in data gathering and analysis that would lead it to the forefront in a "compelling strategy for business and government and a leadership agenda for the world." IBM's communication strategy, said Iwata, was to integrate marketing, communications, and citizenship through "igniting compelling conversations, associate[ing] the IBM brand with solving clients' toughest problems, and

position[ing] IBM as a thought leader in industries as diverse as transportation, utilities, and health care."

RESEARCH

Research is the foundation of any excellent campaign. The Smarter Planet Initiative was built on a solid research base. Iwata explained that the research "had its roots in InnovationJam, a massive, online brainstorm IBM staged for employees, clients and partners in 2006. More than 150,000 participants from 104 countries exchanged ideas over the course of three days. The most successful ones—including a system for real-time analysis of traffic flow; intelligent utility grids; smart healthcare payment systems; and solutions to benefit the environment—became part of IBM's Smarter Planet agenda." Iwata also noted some unexpected findings when 20 of its major "marquee client" project requirements were analyzed.

- In all 20 cases, the client's primary motivator was a business need, not a technical one.
- Sixteen of the 20 involved IBM Research, a global network of deep thinkers working on "first of a kind" breakthroughs.
- Fully half of the identified projects required the convening of a new kind of influencer, such as government policymakers or standards bodies.
- Most importantly, all of the 20 client examples involved a convergence of digital and physical infrastructures. IBM was putting computational power into things most people would not consider computers. They were using information technology (IT) in surprising new ways—beyond the traditional data center—by "instrumenting" physical infrastructures such as roads, buildings, wind turbines, and myriad personal devices, and applying sophisticated new analytics software to drive new kinds of intelligence.

Additional findings from the data IBM collected reinforced these findings. The analyses revealed that with data acquisition becoming increasingly instrumented, forecasts saw the amount of available data for new insights was likely to increase worldwide by a factor of 10. For example, from a project with the White House, 900,000 new jobs could be created in Smart Grid, Healthcare IT, and Broadband over the next five years. Governmental stimulus funding of infrastructure improvements also emerged as a global opportunity in the trillions of dollars. Iwata also noted: "Results from search modeling and social media analysis were used to fine-tune the program. For example, 'global economy' was eliminated as a

core messaging pillar, and a strategy was developed to address the fact that 'global warming' far outranked 'climate change' in search behavior."

CAMPAIGN OVERVIEW

The Smarter Planet campaign produced a number of different outcomes over time, often driven by technological and analytical advances. The Smarter Planet campaign was launched in the fall of 2008 with public policy activities intended to focus on "change." Iwata notes that in the fall of 2008, amid a global economic crisis, President Barack Obama was elected on a mandate for change. IBM worked with Obama's transition team to focus on job creation as a function of using "smart" technology, which Iwata noted created the launch platform through a speech by IBM CEO Sam Palmisano on November 6, 2008. Palmisano, speaking to the Council on Foreign Relations, told his audience, "Our political leaders aren't the only ones who've been handed a mandate for change."

Integrating traditional media with issues management, IBM ran op-eds in the *Wall Street Journal* and *Huffington Post*. This initiative resulted in a 28-week series of issue advocacy advertisements integrated with media relations efforts timed to specific press announcements, such as Smart Grid with Malta or traffic congestion in Sweden.

The initial campaign spanned more than 170 countries, and local country communications teams were responsible for local media and governmental relations. As Iwata notes, "Through these tactics, IBM brought the Smarter Planet story to an expanded set of audiences worldwide via print, TV, and social media—including its first corporate-driven blog—driving substantial coverage worldwide."

The success of the Smarter Planet initiative quickly became an overarching framework for IBM's growth strategy and yielded double-digit growth from more than 6,000 client engagements. And by 2010, the campaign had generated $3 billion in revenue. This success led to an extension in 2009 to a "Smarter Cities" campaign that employed a "a multifaceted communications program that demonstrated how cities could be run more efficiently, save money and resources, and improve the quality of life for citizens."

Several developments added to campaign success. In 2009, IBM held Smarter Cities Forum events around the globe demonstrating how public sector leaders could transform city life through interconnected information. In 2010, IBM took its corporate social responsibility programs into the Smarter Planet initiative though a Smarter Cities "Challenge." According to Iwata this was

a three year, pro-bono consulting program to help 100 cities around the globe address some of their most critical challenges, such as economic development, transportation, public safety, and citizen services. IBM contributed the time and expertise of its top Smarter Planet experts from different business units and geographies, putting them on the ground for three weeks to work closely with municipal leaders on recommendations for using data in new ways to make cities smarter and more effective.

In 2011, IBM's "Watson," a learning super-computer, competed on the quiz-based television show *Jeopardy!* Watson defeated two all-time champions and was used in the Smarter Planet initiative through a "Smarter Healthcare" campaign focusing on "cognitive computers." Watson was positioned as the forerunner of today's "Big Data" to illustrate how companies could obtain insights from massive amounts of data and use cognitive computing to transform and improve society.

SOCIAL MEDIA COMMUNICATION TACTICS

In establishing an integrated communications campaign focusing on interaction with audiences, IBM employed a paid, owned, and earned media strategy, using social media channels such as Facebook, Twitter, and LinkedIn to engage constituents in passionate conversations, rather than simply launching one-sided communications to present IBM's brand messages as found in typical marketing campaigns with a media relations focus. According to Iwata, "This was particularly important given the need to establish IBM's brand credentials with a broader audience—even to individual citizens, who were not used to hearing from a business-to-business firm such as IBM—beyond IT decision makers."

INTERNAL AUDIENCE TACTICS

The culture of IBM finds its base in innovation and reinvention across a vast expanse of capabilities and expertise as varied as industry sector expertise, global reach, business consulting, systems, software, and services. Iwata notes that "Bringing together IBM's broad capabilities has historically been a challenge for the company. . . . But like other large global corporations, the tendency to work in silos persisted, though to a lesser degree. This made it challenging for IBM to convey consistent, integrated messages to its clients [and employees]."

A second challenge was the company's thousands of technical leaders who would be skeptical of marketing campaigns—they would have to be won over. As Iwata states, "These realities made IBMers a critical audience for Smarter Planet,

since the initiative could only succeed if the employees rallied behind the effort." The initial internal relations strategy was to change employee thinking from marketing to an actual business strategy and to convince them that it was in their interest to make it succeed.

As noted earlier, IBM's strategic communication objective was to engage audiences in *conversation*. Part of this strategy focused on the IBM employees as conversational partners through using social media and participating in IBM activities. According to Iwata, "Many of the IBMers participating in the program have described their experiences as life-changing, spreading inspiring comments and images with colleagues, friends, and family on blogs and social networks like Facebook." As part of this strategy, in 2011 IBM commemorated its 100th birthday with a major focus on a "Celebration of Service," in which more than 300,000 IBMers performed almost 3 million service hours in 120 countries through 5,000 large activities that served more than 10 million people. Iwata notes, "[t]hese efforts reinforced the power of IBMers to make a difference for society, a key tenet of Smarter Planet."

The buy-in by the IBMers, more than 400,000 employees, helped integrate the Smarter Planet initiative across business units, partnerships, and financial reporting. Iwata noted that IBMers took to social media and engaged in conversations in more than 170 countries, "engaging IBM's 400,000+ employees . . . to ignite conversations on social networks, including 50,000+ employees on Facebook and almost 200,000 on LinkedIn—the world's largest community of employees active in social networking." In addition, Iwata notes that IBMers have shared blog posts, infographics, case studies, and papers. The initiative received media, analyst, and client coverage on social networks. Finally, IBM internal blogs and social networks were leveraged in communicating Smarter Planet messages.

CAMPAIGN OUTCOME: EVALUATION AND MEASUREMENT

How Well Did the Strategic Planet Initiative Campaign Do?

Based on analyses at the end of 2012, the initiative did very well on all aspects. As a business strategy, it yielded trillions of dollars in profits. As a sales strategy, it changed the focus from selling instruments to also selling intelligence and the corporate culture that went with it. It also engaged its employees; by engaging them, they in turn engaged each other and friends, strangers, and clients. Its impact was global not only in the technology sector but also on the practice of global corporate communication itself. It empowered a senior vice president with a communications background who understood the power of messages; it broke silos and empowered employees; and it introduced "smarter" as a way of doing business.

Finally, it argued for what the Arthur W. Page Society (2007, 2013) calls an "Authentic Enterprise" in which corporate character is defined through a shared belief system that is acted on by decision-makers with confidence and advocated at scale through relationships built on localized publics and the needs of companies who have worldwide locations (Wright, 2013).

What Was Learned?

According to Iwata, three key lessons emerged from the Smarter Planet Initiative. First, Smarter Planet showed that corporate communications must be authentically experienced to be effective. Corporate character must be intertwined with the corporate culture. It must be authentic and led from the front to empower employees to actively engage in conversations with others. Authenticity must be the core of strategic decision-making so that words match deeds and ethics is a constant consideration (Bowen, 2010; Bowen, Rawlins, & Martin, 2010). Only in this way does the campaign come across as a movement instead of a corporate marketing campaign.

Second, Smarter Planet demonstrated that corporate communications efforts must be scaled, employing traditional and new technology communications in many directions to truly take hold. Direct engagement enhances traditional public relations tactics such as media relations tied to journalists and other influencers. The focus on social media engagement through various assets such as video, infographics, photos, blog posts, and tweets communicated by IBMers created authentic advocacy and motivated millions of people to pass along messages in their own networks.

Third, Smarter Planet proved that a major global corporation could credibly pursue an aspirational message of hope and progress, even in a cynical world. In communicating its messages, IBM paid attention to using plain language, breaking down complex issues, and avoiding jargon. It provided the grist for employees to carry on conversations with others. The conversations were at all levels of society and government and were branded as true conversations—not monologues from a faceless large corporation but real conversations between interested parties who had similar needs and issues. Iwata noted that "IBM's message of progress was a strategic imperative. Given the need to establish its brand credentials with a broader audience, Smarter Planet offered people a reason to see the company in a new light."

IMPLICATIONS OF THE CAMPAIGN

That the Smarter Planet Initiative was a success is demonstrable. However, just how well was it done? Was it a campaign that should be held up as excellent,

one that offered results beyond expectations? This next section takes the Smarter Planet Initiative case one step further and analyzes its impact on the practice of corporate communication from a model of campaign excellence.

OBJECTIVES-DRIVEN EVALUATION

Smarter Planet programming was set around three communication objectives: informational (get the narrative out), motivational (get the company around the Smarter Planet strategy), and behavioral (drive the narrative to stakeholders, with an emphasis on "smarter solutions"). Key publics were employees and corporate customers. Key messages focused on insight, effectiveness, efficiency, agility, connections, risk management, and innovation.

The Michaelson, Wright, and Stacks's (2012) excellence model has three levels: basic, intermediate, and advanced. The *basic level* evaluates programming objectives, research and strategy, outputs, outtakes, and outcomes; at this level tactics, timetables, budget, and programming evaluation are established. The basic level is *proponent*—all elements must be successfully completed or the campaign fails, much in line with Maslow's (1970) hierarchy of needs in which movement to higher levels is dependent on the ability to survive at the lowest level. The advantage of this model is the evaluation at the intermediate and advanced levels. The *intermediate* level evaluates programming creativity, leadership, and connections to stakeholders. The *advanced* level evaluates whether the program sets industry standards (see Figure 1.1).

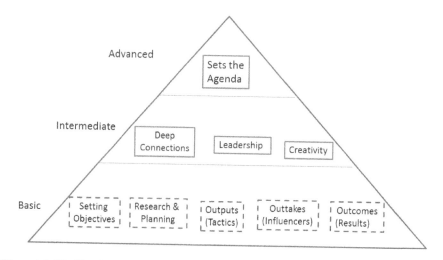

Figure 1.1. The Excellence Pyramid.

Basic Level Evaluation

According to Michaelson et al. (2012), any successful campaign has to move through five basic planning components. Although there are no directional inputs, it is assumed that the first leads to the second, the second to the third, and so forth. Campaign success is being able to evaluate each component as to whether it successfully met the criteria for success, often simply a "yes" or "no," but also on more quantitatively based criteria.

Goals and Objectives

Prior to setting objectives, it is implicit that there are both corporate and communication goals. In the Smarter Planet campaign the corporate goal was three-fold. First, the initiative needed to clarify the identity and brand of IBM to customers, employees, investors, communities, and other stakeholders. The second was to re-create an IBM of technicians to strategists with internal publics: to make all IBM employees into IBMers. Third, IBM had to make the company more relevant to others through demonstrating, as Iwata states, "in a visceral way how the work of IBM and IBMers affected, for the better, what individuals care about."

The strategic intent of this campaign focused on three objectives. The first objective was *informative* (Stacks, 2010): get employees to understand the changing nature of the company. From an IBM that predominately made products to an IBM that made possible analyses of available data from all sorts of instrumentation (including that which IBM continued to produce, i.e., Watson), the focus needed to be on evaluation for innovative and breakthrough thinking in a converging, networked world. Thus, it was important that employees, at all levels and specialties, understand where IBM was heading in its new worldview. Hence, the informational objective was to first make IBMers aware of new ideas and relationships within and outside the company. A second informational objective then was to share the re-strategized IBM with a new audience base. Instead of a B-to-B or B-to-C base, the new audience was perceived as a relational audience that carried on conversations about IBM, its services, and its products with others.

The second objective focused on *motivating* IBMers to become communication agents instead of just employees. This objective required a change of employee attitude about the company from its values to its culture to its "products." The motivational objective then focused on building IBM as an authentic company, one that the IBMers would believe in, act toward, have confidence in, and advocate. This objective was critical in getting the campaign off the ground and creating a new audience/customer base.

The third objective was aimed at *behavior change*. Through meeting the first two objectives, IBMers would take the forefront in communications policy, merging civic engagement with marketing and traditional communications into an overarching messaging strategy. That is, the IBMers would communicate with friends and others without having to be asked: The objective was to have IBMers believe in IBM's new corporate character.

Research and Planning

The second component of a successful campaign is research and planning. As noted earlier, large amounts of data were collected from both within IBM and in conjunction with clients ranging from the White House transition team to initial conversations with employees, clients, and partners—more than 150,000 participants—who brainstormed in an "InnovationJam" that yielded new ideas and directions and began to set up message strategies for the "new" IBM. This included a major case study research project, the annual IBM forecast of technology needs, research on how infrastructure investments would affect job creation, statistical modeling of extant data, and a social media analysis that produced a key core messaging pillar.

Outputs

As noted earlier, the strategy was not to design a traditional marketing or communications-only campaign but to focus on the relationships that the company and IBMers had with a new audience base: friends, customers, strangers, and whatever or whomever might be interested in hearing what IBM was or would be doing in the future. Outputs, then, were focused on conversation and distributed through social media networks internal and external to IBM: Blogs, tweets, Facebook pages, and other social media platforms were employed across the company and employees were empowered to communicate their vision of the "new" IBM as they understood it. This is not to suggest that marketing and traditional communication strategy was eliminated; it took a backseat and provided a means to get the company's message out to those who might be interested in establishing a relationship with IBM. Thus, Smarter Planet integrated all communications into a comprehensive messaging strategy that was inclusive rather than exclusive.

Outtakes

The fourth basic component deals with outtakes. Outtakes research evaluates message awareness, understanding, message tone, share of voice, social network

volume, and so forth (Michaelson et al., 2013). The traditional outtake emphasizes two distinctly different targets: third-party endorsers or influencers, and within-campaign measurement of each of the three basic objectives. In the case of Smarter Planet, Iwata emphasized that traditional third-party endorsers—news reporters, important bloggers, editors—were not the primary focus of the campaign, as would be the case in most corporate communications campaigns. The strategy was for the IBMer to become an authentic influencer in his or her personal and professional communication networks. As Iwata went on to note:

> Many of the IBMers participating in the program have described their experiences as life-changing, spreading inspiring comments and images with colleagues, friends, and family on blogs and social networks like Facebook. The Smarter Cities Challenge has also engendered good will for IBM among public sector clients around the world. This is particularly important in emerging markets such as Africa, China, and Latin America, setting up potential opportunities for paid IBM engagements in the future.

IBM continually monitored the company's social networks and traditional media to ensure that the key messages being communicated were meeting expected benchmarks. Thus, IBM looked at both traditional and nontraditional outtake analyses in extending the campaign over time and increasingly developed and launched innovative sub-campaigns such as those associated with Smarter Grids and the Smarter Cities Challenge.

Outcomes Evaluation

An outcome is a campaign result based on campaign objectives (Stacks & Bowen, 2013). The Smarter Planet Initiative met and exceeded campaign expectations, objectives, and goals. The campaign yielded an "army" of IBMers who truly believed that IBM's corporate character was reflected at a personal level. They internalized IBM's new vision, mission, and values, becoming authentic advocates for the company. As Iwata noted, in 2010, just two years after it launched, the Smarter Planet Initiative generated US$3 billion in revenue and double-digit growth from more than 6,000 client engagements. In 2011, IBM celebrated its centennial. A major focus of commemorating IBM's founding was the "Celebration of Service," in which IBMers around the world spent an entire day volunteering in their local communities. More than 300,000 IBMers performed 2.8 million service hours in 120 countries, via 5,000 large-scale activities, that served more than 10 million people. These efforts reinforced the power of IBMers to make a difference for society, a key tenet of Smarter Planet.

One of the campaign's goals was to reinvent the IBM culture. Iwata explained that five years before the launch of Smarter Planet, IBM embarked on an effort to reexamine its core values as a way to prepare itself for shifts playing out in technology and in the global economy. In 2003, well before social media took hold, the company held "ValuesJam," an online, three-day event that allowed any IBMer in the world to weigh in on what IBM should stand for and how IBMers should operate. After analyzing scores of online dialogues and comments, the company distilled the content into a set of IBMer-generated corporate values:

- Dedication to every client's success
- Innovation that matters—for our company and for the world
- Trust and responsibility in all relationships

The new IBM values were integrated into company policies, processes, and daily operations.

There can be no conclusion except that IBM's Smarter Planet Initiative was successful at the basic level. It met the first test and its results surpassed even what was expected.

Intermediate Level Analysis

The excellence model's second (intermediate) level consists of three components: deep connections, leadership, and creativity. The three components came into play during the campaign's developmental stage and, unlike the basic level, are less quantitative and more subjective in evaluation. One could evaluate the components on a yes/no or met/did not meet metric, but that would not illustrate how the campaign was led, its creativity, and how deeply the company supported it.

Deep Connections

Deep connections are the result of connecting to target audiences in an authentic and sincere way. The adjective *deep* implies that the connection between the company and its audiences comes from a mutual understanding (and respect) for the company's vision, mission, and ethical values—its corporate character. Clearly, IBM made deep connections with its internal and external audiences. As advocates for the company, employees served as influencers based on their personal beliefs in IBM, what it was attempting to do, and their confidence that the company would not just "talk the talk," but "walk the walk" with them in their conversations with others. The integrating of communications and marketing provided the talking

points for conversations to begin and to continue on- and off-line without any party feeling that the relationship was marketing driven, an important point for its acceptance by skeptical and highly educated employees. Social media connections proved to be highly innovative in the integrated campaign, allowing both internal and external discussions/threads to continue as the campaign evolved into sub-campaigns over time.

Leadership

Internal leadership support and alignment by senior management across a company, product, or brand is necessary to achieve an intermediate level of campaign excellence. As Grunig and Grunig (2006) and Grunig, Grunig, and Dozier (2006) argue, there must be internal support, and that support includes the corporate communication function sitting at the "management table." IBM's decision to integrate communications, marketing, and civic engagement into one function and to bring in Iwata to lead that function demonstrates senior management's endorsement of the role of corporate communication across the company. According to Michaelson et al. (2012), "Exceptional campaigns have communications taking a pivotal and central role in integrated communications planning. Who else has the message strategy and mastery?" (p. 19).

As Iwata notes:

> The Smarter Planet campaign is a cross-company effort executed under my leadership as IBM's senior vice president of marketing and communications, who reports to the IBM CEO, Sam Palmisano. IBM's Smarter Planet communications campaign [was] executed by hundreds of IBM communications professionals and agency partners around the globe, who took direction from me, but almost all of whom report to local country marketing communications departments or IBM product, sales, research, and consulting/services units. Edward Barbini, IBM vice president of external relations who reported to me until recently, provided day-to-day management of the external communications facets of the Smarter Planet communications program, in concert with the communications VPs of IBM's product, sales, research, and consulting/services units [who also reported to Iwata until recently]. Barbini and the communications VPs now report to Ben Edwards, IBM's VP of global communications and digital marketing, who reports to me.

Senior management's commitment could best be evaluated through CEO Palmisano's (2008) crediting IBM's values as key to the success of Smarter Planet:

> I truly believe that none of our work since [the 2006 InnovationJam]—remaking IBM's portfolio of products and services, . . . globally integrating our company, . . .

even launching our Smarter Planet agenda in the depths of the global recession—would have been as effective or sustainable if we had not first gone back to basics, back to our roots, back to the foundation of our culture.

Creativity

Creativity is measured by the original, inventive, and efficient execution of the campaign's messages. The pioneering use of a social media strategy, the idea exchange event, and providing a mix of marketing and relational messaging content clearly provide indicators of the creativity employed by the Smarter Planet campaign. As noted, the campaign's creativity was and is being noted both internally and externally to the company.

Advanced Level Analysis

At the highest level of excellence is the advanced campaign. This campaign sets the agenda for target audiences, the industry, and corporate communications in general. That Smarter Planet has lasted to this writing and morphed into sub-campaigns is testament to its enduring qualities. How well has the campaign been received by its peers? Iwata says:

> Smarter Planet helped IBM captured the most prominent annual marketing and communications industry awards in a single year. For Smarter Planet, IBM garnered the Gold Effie for the most effective global marketing campaign, and the Silver Anvil in reputation and brand management communications. IBM won three Sabre awards: for corporate branding, media relations and for the best corporate branding campaign [the Platinum Award] of any company. In addition, the Smarter Planet campaign won *PR Week*'s "Corporate Branding Campaign of the Year" award.

In 2012, four years after launching Smarter Planet, Interbrand ranked IBM #3 in its annual ranking of the 100 Best Global Brands. Interbrand wrote, "Smarter Planet, IBM's ground-breaking business strategy, continues to drive new product and service development, employee engagement, and corporate citizenship. It remains a textbook example of how to create, build, and deliver a world-leading business-to-business brand."

The Smarter Planet Initiative not only meets the criteria for excellence in corporate communication but also has set new benchmarks that are now the standards against which other campaigns will be measured.

SUMMARY

The Smarter Planet initiative was launched in 2008 and provided IBM with an opportunity to rethink communications from an inside-out approach. The initiative's goals were both internal and external. They were internal because they provided opportunities to move toward tighter integration of communications functions and a focus on internal audiences. They also were externally focused to demonstrate how the company and its people were using technology to adapt to a changing world. The strategic intent was to make IBM more relevant to changes both inside and outside the company.

Based on extensive research that included an idea exchange involving more than 150,000 people from 104 different countries, the Smarter Planet campaign produced a number of disparate outcomes, most driven by technological and analytical advances. The campaign spanned more than 170 countries and quickly became an overarching framework for IBM's growth strategy, yielding double-digit growth from more than 6,000 client engagements and generating trillions of dollars of revenue profits. The campaign played a major role in showing how the communications and marketing functions of a company can work together successfully and support one another's integrated and strategic goals as well as the company's overall business goals.

Iwata explains that three key lessons were learned through the initiative. First, Smarter Planet showed that corporate communications must be experienced authentically to be effective. Second, Smarter Planet demonstrated that corporate communications efforts must scale in many directions to truly take hold. And third, Smarter Planet proved that a major global corporation could credibly pursue an authentic, positive message of hope and progress even in a cynical world.

REFERENCES

Arthur W. Page Society. (2007). *The authentic enterprise*. New York: Arthur W. Page Society. Retrieved from http://www.awpagesociety.com/insights/authentic-enterprise-report/

Arthur W. Page Society. (2013). *Building belief: A new model for activating corporate character and authentic advocacy*. Retrieved from http://www.awpagesociety.com/insights/building-belief/#sthash.mI2WoADt.dpuf

Bowen, S. A. (2010). The nature of good in public relations: What should be its normative ethic? In R. L. Heath (Ed.), *The Sage handbook of public relations* (pp. 569–583). Thousand Oaks, CA: Sage.

Bowen, S. A., Rawlins, B., & Martin, T. (2010). *An overview of the public relations function*. New York: Business Expert Press.

Center. A. H., & Jackson, P. (1995). *Public relations practices: Managerial case studies and problems.* Upper Saddle River, NJ: Prentice Hall.

Grunig, J. E. (1976). Organizations and public relations: Testing a communication theory. *Journalism Monographs, 46.*

Grunig, J. E. (2001). Two-way symmetrical public relations: Past, present, and future. In R. L. Heath (Ed.), *Handbook of public relations* (pp. 11–30). Thousand Oaks, CA: Sage.

Grunig, J. E., & Grunig, L. A. (2006). Characteristics of excellent communication. In T. A. Gillis (Ed.), *The IABC handbook of organizational communication* (pp. 3–18). San Francisco: Jossey-Bass.

Grunig, J. E., Grunig, L. A., & Dozier, D. M. (2006). The excellence theory. In C. H. Botan & V. Hazelton (Eds.), *Public relations theory II* (pp. 21–55). Mahwah, NJ: Erlbaum.

Hendrix, J. A. (1998). *Public relations cases* (4th ed.). Belmont, CA: Wadsworth.

Maslow, A. H. (1970). *Motivation and personality* (3rd ed.). New York: Addison-Wesley.

Michaelson, D., Wright, D. K., & Stacks, D. W. (2012). Evaluating efficacy in public relations/corporate communication programming: Towards establishing standards of campaign performance. *Public Relations Journal, 6.*

Palmisano, S. (2008, November 6). Speech.

Stacks, D. W. (2010). *Primer of public relations research* (2nd ed.). New York: Guilford.

Stacks, D. W., & Bowen, S. A. (Eds.). (2013). *Dictionary of public relations measurement and research* (3rd ed.). Gainesville, FL: Institute for Public Relations. Retrieved from http://www.instituteforpr.org/topics/dictionary-of-public-relations-measurement-and-research/

Wright, D. K. (2013). The organization of the corporate communication function. In R. Gambetti & S. Quigley, *Managing corporate communication: A cross-cultural approach.* London: Palgrave.

AUTHORS' NOTE

We would like to thank Jon Iwata for finding the time to respond to the authors' questions about the role of public relations and corporate communications in the Smarter Planet Initiative. Additionally, we would like to acknowledge the work of Rebecca Wilson-Flewelling, a student in the Master of Science in Public Relations degree program at Boston University, for her assistance with this case study.

Movember: Growing Moustaches for a Global Focus on Men's Health

BILL PROUD
Queensland University of Technology Business School

ROBINA XAVIER
Queensland University of Technology Business School

EDITORS' NOTE

The rapid growth of this innovative global fundraising campaign can be traced to a simple yet compelling story promoted by an elaborate public awareness and public relations campaign earning valuable earned media. Indeed, Movember makes full use of core public relations approaches by building relationships with stakeholders and convincing men to change their behaviors by talking about men's health.

Moustaches: Some people love them, some loathe them. But when the humble moustache can bring together more than three million people worldwide and raise, on a cumulative basis, more than $447 million (AUD) globally for men's health, its power as a catalyst for change gets lots of people talking.

This case study outlines the runaway success of the worldwide Movember movement following its 10th anniversary and shows how "people power" has been fostered through a strategic public relations campaign to draw attention to important issues in men's health.

In November each year, Mo Bros and Mo Sistas, the monikers created for participants in this campaign, from more than 20 countries raise awareness of, and funds for, men's health issues. Through the Mos' efforts, Movember has become the largest nongovernment funder of prostate cancer research in the world as well as supporting many other programs such as those addressing men's mental health initiatives. All this has come from two mates sharing a beer 10 years ago in 2003 in Melbourne, Australia, daring each other to grow a moustache for the duration of November. As people asked questions about what they were doing and joined the Mo Bros and Mo Sistas, the power of the Mo was realized.

This case study explores the goals and objectives of the campaign as well as its global target publics. Its clear messaging strategy is outlined as well as its people-led tactics, which have successfully drawn record numbers of people into the Movember movement. Evaluation of its success against its goals is discussed and its plans for the campaign past its 10th anniversary will be outlined.

BACKGROUND

During November each year, a worldwide campaign raises vital funds and awareness for men's health. The campaign, Movember, has men growing moustaches from Australia to Ireland and Russia to India, raising more than $135 million (AUD) each year for important causes, specifically prostate cancer and men's mental health.

The stars of the campaign, the Mo Bros (those who grow moustaches), start the month of November by registering at www.movember.com with clean-shaven faces. Then for the entire month of November, the men grow moustaches and raise funds by seeking sponsorship for their efforts. They are supported throughout the month by Mo Sistas, women who wish to get involved in raising awareness of men's health issues. At the end of the month, all involved celebrate their Movember journey, often by throwing a party or attending one of the "Gala Parties" held in different cities around the world.

Since its beginnings in Melbourne, Australia, in 2003, Movember has become a global movement engaging with more than three million Mo Bros and Mo Sistas who participate in countries such as Australia, New Zealand, the United States of America, Canada, the United Kingdom (UK), South Africa, Ireland, Finland, the

Netherlands, Spain, Denmark, Norway, Belgium, the Czech Republic, Austria, France, Germany, Sweden, Switzerland, Hong Kong, and Singapore.

Movember was the brainchild of two friends, Travis Garone and Luke Slattery, who over a beer in a suburban Melbourne bar wondered where the Mo, or moustache, had gone. For some fun, the friends decided to talk their mates into growing a moustache. Recognizing that they could kill two birds with one stone (revive a fashion legend and do some good), they decided to develop a campaign about men's health and prostate cancer. This campaign became Movember and the men agreed to collect $10 from anyone who agreed to grow a Mo. Travis Garone designed the first Movember logo, and they sent an email to their friends titled "Are you man enough to be my man?" Thirty men took up their challenge and became the first Mo Bros.

The first year went well and the friends decided to formalize their idea and get participants focused on a cause. The two originators were joined by Adam Garone, Travis Garone's brother, who helped expand Movember by registering a company and creating a website. Justin Coghlan then joined the movement to run the campaign in a second Australian state, Queensland.

Wanting to focus on men's health issues, the team agreed to formally support prostate cancer as their cause. In 2005, the team launched a new creative campaign with the concept, "Give Prostate Cancer a Kick in the Arse." The campaign saw more than 9,000 Mo Bros join in and raised more than $1 million (AUS) for the Prostate Cancer Foundation of Australia, Movember's first official men's health partner.

The campaign needed full-time support to continue to grow and in 2006, the four cofounders established an official Australian charity, The Movember Foundation, with full-time employees. Cofounder Slattery developed Movember's official tagline, "Changing the face of men's health."

While prostate cancer had been the original focus, the group realized that depression was also a significant issue for men's health in Australia and *beyondblue,* the Australian national depression and anxiety initiative, was taken on as Movember's second men's health partner.

The Movember campaign was launched in New Zealand in 2006 in partnership with the Prostate Cancer Foundation of New Zealand. Word spread and Mo Bros in Spain and the United Kingdom (UK) joined the campaign. By the end of 2006, more than 56,000 Mo Bros and Mo Sistas had raised more than $9 million (AUS).

In 2007, the four cofounders decided to mount a significant international campaign. Adam Garone launched the USA and Canadian campaigns in partnership with Queensland University of Technology, the Prostrate Cancer Foundation, and Prostate Cancer Canada. Coghlan launched the UK campaign with the Prostate Cancer Charity, and Slattery ran the Australian and New Zealand campaigns.

A campaign also started in Spain through a partnership between Queensland University of Technology and Fundación Contra el Cancer (FEFOC). The international campaign saw more than 134,000 participants raise more than $21 million with significant attention focused on men's health issues during the month of November.

Today, Movember (www.movember.com) operates within a set of core values:
Fun

- We create fun.

Accountable

- We are accountable and transparent. We strive to exceed best practice cost-to-funding ratios.

Caring

- We are passionate, dedicated, caring people that [sic] are here to serve the Movember Community.

Collaborative

- We are one team working together and sharing knowledge to accelerate the realization of our shared goals. This is fundamental to how we operate at Movember, with our partners, relevant researchers and practitioners.

Humble

- We have a humble attitude and approach to everything we do.

Innovative

- Born from an entrepreneurial spirit, we apply innovation across the organization to improve efficiency and the Mo Bro and Mo Sista experience.

Change Agent

- We stand for constructive change. We challenge the norm in all our activities and as a result we drive significant outcomes from the conversations we create and funds we raise.
- We will drive significant outcomes for men's health from the funds we raise.

While the moustache-growing campaign gains the public's attention every year, Movember has developed a Global Action Plan (GAP) outlining a number of ongoing programs to support the organization's goals. Launched in 2011, GAP was set up to address critical challenges in prostate cancer research through global collaboration. As a result of working with prostate cancer partners around the world, Movember identified an opportunity to accelerate research outcomes by providing

researchers the opportunity to work together on specific projects. More than 100 of the world's top prostate cancer researchers have joined Movember's GAP, all of them committed to working together on research and sharing their knowledge in the area (Movember, 2012).

Equally important to the movement is the issue of survivorship, a funding area that is less well known. While diagnosis is the first step in a man's prostate cancer journey, survivorship is the next. Survivorship programs can have a dramatic impact on the quality of life of men who have been diagnosed with prostate cancer. To help address survivorship issues in Australia, Movember established A Survivorship Action Partnership (ASAP) with support from its men's health partners, *beyondblue* and the Prostate Cancer Foundation of Australia. The initiative has facilitated the creation of a collaborative network of organizations across Australia focused on improving the lives of men living with prostate cancer and their partners, families, and caregivers. In 2012, Movember committed $5 million over three years to ASAP, representing its most significant investment in survivorship programs to date.

The Movember campaign continues to grow each year, bringing in new participants and their donors. In 2012, more than 1,125,000 registrations were recorded. By putting a fun twist on a serious issue, Movember focuses on changing the actions and attitudes of men when it comes to their health. The moustache is Movember's catalyst for change, giving men the opportunity and confidence to talk about their health with others.

METHODOLOGY

This case was researched and written using normal qualitative research techniques, among them a review of databases relevant to the fundraising sector, an analysis of a major industry report on the sector by IBIS World, a detailed analysis of information provided by the Movember organization over its history, and a detailed study of its comprehensive website.

The secondary research was supplemented by in-depth phone interviews undertaken with senior Movember staff to understand the complex implementation of the program.

SITUATION ANALYSIS

Medical practitioners around the world know that men rarely talk about their health—with each other, their families, or their doctors. Conditions go undiagnosed

and untreated until they are critical, leading to ongoing suffering and even loss of life. On average, considering all causes of mortality, men die five to six years younger than women. With the growing incidence of mental illness, thousands of men suffer in silence before taking their own lives with devastating effects on families and loved ones. The suicide rate is four times higher for men than women, and more than five men die prematurely each hour from potentially preventable illnesses.

This is why Movember works to change men's habits and attitudes about their health and educate men about the health risks they face. Going further, Movember encourages men to act on that knowledge, thereby increasing the chances of early detection, diagnosis, and effective treatment.

Movember is a charity and therefore has to operate within the guidelines of not-for-profit organizations. It operates in a highly competitive market, competing with thousands of other worthwhile projects for money, participants, and attention against thousands of worthy causes. Charities and not-for-profit organizations perform important roles in society with overall population growth and aging in many countries proving to be strong organic growth drivers.

In Australia, the original home of Movember, the not-for-profit sector employs approximately one million workers on a paid basis and drew revenue in excess of $112 billion (AUS) in 2012–2013 (IBIS, 2013).

Over the past five years, sector revenue has increased by an average of 3.3% per year, and only fell briefly during 2008–2009 when private and business donors cut back amid uncertain economic conditions. There are more than 600,000 not-for-profit organizations currently operating in Australia, including about 40,000 large-scale organizations that contribute significant funds to specific causes (IBIS World, 2013).

Accordingly, sector concentration levels are very low, with the four largest players accounting for well under 10% of sector revenue among them.

Many organizations are community focused and operate only in their local areas. The sector is highly diverse, ranging from operating hospitals, arts organizations, schools, and churches to grassroots fundraising and community causes. Government grants and funding are a crucial form of income for the sector, with not-for-profit organizations routinely partnering with government departments to provide services to the community. The sector also relies heavily on volunteers. Another important factor is the large range of products and services offered by organizations in the sector.

Many different issues affect the not-for-profit sector, particularly the discretionary income of households. As household spending tightens with the growing costs of everyday living, households become more hesitant to contribute to discretionary areas such as charitable giving.

While organizations such as Movember do not seek to make a profit, they need to remain financially viable at the end of each period to ensure they are sustainable in difficult future periods. Recent economic turbulence has underlined the need for organizations in the sector to possess sufficient funding reserves to be able to adequately respond to needs during times of hardship in the community, often in an environment of falling levels of income. What constitutes an adequate level of reserves varies greatly, depending on the line of work in which a charity or not-for-profit organization is engaged, its cost structure, its size, and the variability of its income streams. Many organizations are drawing heavily on best business practices from the for-profit sector to become more efficient in protecting their ongoing positions.

Growing competition has also required organizations to be clear about their purpose and their accountability to attract donor dollars from individuals, business, and the government. Failing to display these characteristics is now likely to cast an organization in a negative light and arouse suspicion. However, much is still needed, with a recent report suggesting that 75% of donors do not believe that charities communicate well about how donations are used (IBIS, 2013).

Technological changes have led to innovations in fundraising methods. Mobile applications are now easily accessible and can provide awareness of various causes and further the aims of various sector organizations, particularly health-focused not-for-profit organizations. Donations via applications and texting, already occurring in the United States, are being examined in Australia and in other countries where Movember campaigns are implemented.

IBIS World 2013 identifies 250 "Key Success Factors" for a business. The most important for the sector in which Movember operates are the following:

- Ability to attract local support/patronage: A large number of organizations are community-based and rely heavily on the community's support.
- Optimum capacity utilization: Charities and not-for-profit organizations often operate on tight budgets and use volunteer labor. Using both financial and human resources efficiently is very important in such a situation.
- Ability to raise revenue from additional sources: In addition to traditional forms of fundraising and revenue from service delivery, many organizations derive considerable funding from government grants, estates of deceased donors, and corporate giving programs.
- Ability to effectively manage risk: Revenue streams for many charities can be volatile, dependent on economic conditions or one-off events. Many larger charities and not-for-profit organizations set aside cash reserves or other investments to reduce short-term funding risks.

CORE OPPORTUNITY

Movember is focused on changing the face of men's health globally and thus has an interest in all issues relating to men's health. Its primary focus is on raising awareness and funds for prostate cancer and men's mental health.

While there are many reasons for the poor state of men's health, there is considerable evidence that men live shorter lives than women and have higher health risks including smoking, alcohol abuse, and obesity.

Movember's research shows that men access health services less frequently than women and when they do visit the doctor, they typically present in a late stage of illness, thereby denying themselves the chance of early detection and effective treatment of common diseases. Movember believes that many men don't have regular health checks because they fear it will lead to a hospital visit, are embarrassed, or can't or aren't willing to make the time.

GOALS AND OBJECTIVES

The annual campaign focuses on the "Movember Effect," using the Mo (moustache) to spark conversation and spread awareness of men's health each year. It seeks to raise funds to support key men's health issues, in particular prostate and testicular cancer and men's mental health.

The campaign goals each year are to raise funds for men's health programs by generating conversations about men's health that lead to the following:

- Greater awareness and understanding of the health risks men face
- Convincing men to take action to remain well
- Educating men so when they are sick, they know what to do and take action

Each country's team sets specific objectives around key areas such as the number of registrations, the funds to be raised, the ability to re-sign former participants, the average funds to be raised per Mo, and the number of desired media hits.

KEY PUBLICS

Mo Bros

Mo Bros are the key participants in each annual campaign, signing up to grow a moustache. They effectively become "walking, talking billboards" during November

and raise awareness by prompting private and public conversation around the issue of men's health.

Mo Sistas

A Mo Sista is a woman who loves the Mo. She supports the Mo Bros in her life through their moustache-growing journey. These women also are committed to raising awareness of men's health issues and support the fundraising effort along the way.

Donors

Donors support those participating directly in the campaign. They can be individuals or groups, one-off or repeat donors.

Men's Health Partners

Movember partners with key groups to achieve its desired outcomes particular to its men's health programs. It selects the most suitable organization in each country and then invests significant effort in building solid working relationships. Partners must adhere to a strict set of criteria that include corporate governance, leadership, outcomes achieved, financial management, and alignment with the Movember vision.

Media

Movember targets global media outlets to help spread the word of the campaign as well as the importance of men's health. Media can be targeted for local markets as well as globally.

KEY MESSAGES

Through its global campaigns, Movember works to educate and inform men on core health messages and wants men to understand the importance of the following:

- Responsibility: the quality of your health is up to you
- Prevention: diet and lifestyle choices dramatically influence the quality of life today and in the future

- Detection: early detection of an illness provides the best chance of effective treatment while minimizing complications and side effects (Movember, 2012)

Movember uses the tag line "Changing the face of men's health" to focus its campaigns. By growing a moustache for 30 days, men change the appearance of their face. In doing so, they may also change their understanding and attitudes toward their health and the health of their male friends, colleagues, and family members.

The Mo is the key visual message for the campaign. It acts like the colored ribbon in many global campaigns (think pink ribbons for breast cancer awareness, white ribbons to stop violence against women, etc.) and is the catalyst for change within this campaign.

Figure 2.1. Movember logo.

STRATEGIES

Movember is primarily a word-of-mouth campaign. The in-person communication is reinforced through digital media with story-telling central to the success. Each Mo Bro and Mo Sista shares his or her personal participation stories in his or her preferred way. The narrative is a powerful tool, easy to share and highly

personal, which grows and deepens participation. The organization's research suggests that 67% of people first heard about Movember as a result of word-of-mouth communication (http://www.movember.com).

The annual month-long campaign is designed to be innovative, fun, and engaging, using growth of a moustache on a usually clean-shaven man to prompt questions and engagement. Men are constantly asked, "Why the Mo?" Justification and an explanation follow, resulting in a highly effective and authentic word-of-mouth campaign.

Discussion is critical to the overall awareness and education campaign that is central to Movember's goals. Generating discussion helps to break down the barriers that prevent men from taking responsibility for their health.

TACTICS

Movember's awareness and education program is delivered through a number of different activities, including an ambassador program, media relations, events, community outreach, educational materials, the Movember website, and creative campaign collateral materials. Each campaign needs its own "edge" to keep people engaged and encourage them to continue their support for the initiative.

Creative Campaign

Each year a new creative concept is developed. This is then operationalized through all communication channels, including the website, printed materials, and media. The Movember campaign must keep attracting former participants back to the program; the campaign is refreshed each year to generate renewed interest, while also designed to attract new recruits.

Website (http://www.movember.com)

The website is critical to Movember's success, particularly as the campaign has spread globally. Mo Bros and Mo Sistas register through the website and in doing so create an engaged and active global online community. The online platform acts as an information site as well a portal for the online community to share its experiences throughout the month of November. It has many features including the Mo Space, which is where a personal donation can be made, and a campaign page where Mo Bros and Mo Sistas can post photos and messages. It also features a

newsroom, which covers the latest updates on Mo news. As there are many official events linked to Movember, the website acts as the official event noticeboard providing information to participants around the world. It also features competitions to further engage participants and draw on their competitive streak. And, most importantly, it operates as a point of access to men's health information, supporting the underlying purpose of Movember.

A recent study of traffic to the movember.com site showed the following:

Table 2.1. Sources of Traffic to movember.com in 2012 (Movember, 2012).

Source	Percent
Direct	34.9%
Facebook	28.5%
Google	18.4%
Other	14.7%
Twitter	2.5%
Other search engines	1%

Demonstrating its centrality to the global campaign, the website attracted close to 11 million unique visitors during the 2012 campaign and more than 122 million page views with an average of 4 minutes per visit.

Media Relations

The campaign continually seeks media opportunities on local and global levels to spread its messages and encourage participation. Each country's team works with local media to share the Movember stories, drawing from the best of the personal narratives of local participants.

Social Media Campaigns

Social media platforms have enhanced the ability of campaign participants to share their stories and raise awareness of men's health issues. Social media are used to encourage others to join and drive action on behalf of Movember. Various platforms focus on sharing photos, videos, thoughts, and experiences. The Movember Facebook page has a global audience as outlined below.

Table 2.2. Countries' Share of Movember Facebook Fans/Likes (Movember, 2012).

Country	Total	Percent
Europe	57,282	26%
United Kingdom	43,181	20%
USA	34,934	16%
Canada	28,167	13%
Australia	21,355	10%
South Africa	16,680	7%
Ireland	10,917	5%
New Zealand	6,072	3%

Twitter users support the campaign with hashtag #Movember as a global trending topic in November, each year generating close to one million tweets as was the case during the 2011 campaign.

Social media allow the campaign to benefit from celebrity support around the world with posts such as the following by leading entertainers and global media personalities such as Stephen Fry (English comedian, actor, and television presenter) and Ricky Gervais (English comedian and actor):

- "So, final day of Movember. Starting to wonder if I shan't keep the little chap for a while longer. It's nice to stroke." (Stephen Fry)
- "Morning Twerps. Halfway through shaving I paused for Movember. First and last time you will see me like this." (Ricky Gervais)

Corporate Team Building

Movember encourages corporations around the world to use the moustache-growing exercise as a team-building activity and to encourage discussion around men's health. Staff in different departments and sites within companies can participate by growing moustaches, supporting those who do, spreading the message through their own networks, celebrating at company events, and raising money. The contribution and level of involvement can be tailored for individual companies with limited additional effort and coordination.

Communicating News from Men's Health Partners

The Movember team in each country has a close working relationship with its men's health partners, meeting regularly and proactively seeking out information on projects funded by Movember. Keeping the Movember community informed of how its funds are making a difference is a key objective for the Movember team, especially between campaign periods. Movember uses its ongoing media channels to communicate this information to key publics.

Leveraging Promotional Opportunities Through Campaign Partners

Movember uses a partnership strategy to further its impact. It collaborates with like-minded and innovative partners to leverage the brand association and takes advantage of joint promotion opportunities to expand audience reach.

Partners are chosen for their fit and relevance to the Movember brand, their passion for the cause, and how they appeal to Movember target audiences. The major partners play a huge part in growing the campaign each year. Each creates a fully integrated awareness campaign to support its involvement in Movember and creates powerful contributions to the overall awareness campaign.

Typically, partner activities include the following:

- Providing goods and/or services that facilitate the growth and development of the Movember campaign
- Enhancing Movember's profile through their advertising, public relations, and promotional programs
- Engaging internal participation through customer and industry networks
- Committing to monetary contributions, which assists in underwriting the Movember campaign
- Providing "money can't buy" experiences for prizes
- Spreading Movember's health messages throughout their own businesses, and to their business partners, customers, and friends

CALENDAR/TIMETABLE

The campaign preparation begins each year with planning for new initiatives already underway since the previous year's campaign. Promotion of the campaign intensifies as November approaches with key activities during the surrounding months and follow-up activities in the weeks after the moustache-growing period.

However, the work around building and supporting relationships with key partners and communicating the work of Movember and its supporting partners is ongoing year-round.

BUDGET

Movember's annual reports outline how the funds raised are applied in support of the organization's goals. As per Movember's charter, the vast majority of funds raised need to be directed to the programs it supports. Administration costs need to be kept to a minimum, but some level of retained funds also is important to ensure the sustainability of activities. The following table is the breakdown for 2012; percentages are rounded to the nearest whole number so the total adds to more than 100 (Movember, 2013):

Table 2.3

Expenses	Percent
Men's Health Programs	89%
Fundraising Costs	7%
Administration Costs	2%
Retained Funds	3%
Total	101%

Included in the 2 percent assigned for administrative costs are all public relations, promotion, and outreach activities. For reference purposes, the 2003 Movember annual report listed outreach and promotional activities as approximately 13% of total administration costs.

EVALUATION

Movember's goals are related to raising awareness, fundraising, and providing support and funding for men's health research.

In 2003 there were 30 registered participants. Almost 10 years later in 2012, more than 1.1 million Mo Bros and Mo Sistas around the world participated in the Movember campaign. The global campaign collected in excess of $447 million (CAD) representing an increase of some $12 million from the previous year's campaign. There were more than 3.2 million individual donations, demonstrating

the importance of the networks around those participating directly in the campaign. There is major growth in key countries, including Canada and the United Kingdom.

While complete data for 2012 are still to be finalized, the table below shows the participants and funds raised globally in the 2011 campaign. Amounts are expressed in local currencies (http://www.movember.com):

Table 2.4

Country	Registered Participants	Number of Individual Donations	Total Funds Raised	Average Funds Raised per Registered Participant
Australia	142,084	680,155	$29.6 million	$193
Canada	246,427	948,827	$42.2 million	$172
Ireland	15,454	63,402	$1.7 million	$112
New Zealand	13,134	45,580	$1.4 million	$109
South Africa	17,941	17,978	634,337 RAND	R258
United Kingdom	253,193	1,129,890	$22 million	$87
United States	144,499	356,331	$15.2 million	$106

Men's health groups around the world have benefited from the funds raised through the campaign. For example, in Australia, the Prostate Cancer Foundation of Australia and *beyondblue* received significant donations from Movember.

The New Zealand men's health partners were the Cancer Society and Mental Health Foundation of New Zealand. In the United Kingdom the men's health partners were Prostate Cancer UK and The Institute of Cancer Research (ICR). In Ireland the men's health partners were the Irish Cancer Society/Action Prostate Cancer, and in the United States the men's health partners are the Prostate Cancer Foundation and Livestrong. In Canada, the men's health partner is Prostate Cancer Canada, and in South Africa, the men's health partner is CAN/SA (Cancer Awareness South Africa).

Globally, up to 2012, there were more than 30,000 media articles during the campaign periods including coverage in leading publications from around the world, from the *Wall Street Journal* in the United States to the *Sunday Times* and the *Guardian* in the United Kingdom. In terms of awareness through media

and the campaign website, the Table 2.5 results were achieved (http://www.movember.com):

Table 2.5

Country	Media Articles	Visits to Website	Total Page Views of Website
Australia	5,728	5.73 million	19.46 million
Canada	7,000	9.3 million	36.5 million
Ireland	787	2.8 million	2.17 million
New Zealand	298	2.77 million	1.8 million
South Africa	300	2.61 million	0.87 million
United Kingdom	3,028	10.55 million	37.8 million
United States	14,443	6.65 million	17.16 million

A recent study of Australian participants (www.movember.com) showed that 90% of participants spent time thinking about improving their general health and 80% of participants visited a doctor in the last 12 months. Just over 70% of participants discussed men's health with their family, friends, or colleagues during the Movember campaign. Nearly half the participants undertook personal research on men's health issues during the campaign.

REFERENCES

IBIS World Industry Report. (2013, April). Charities and not-for-profit organizations in Australia.

Movember Annual Report. (2011–2012). Retrieved from http://www.movember.com

Movember Annual Report. (2012–2013). Retrieved from http://www.movember.com

Enel's 50 Years of Energy, Millions of Moments

VALENTINA MARTINO
Sapienza Università di Roma

ALESSANDRO LOVARI
Università degli Studi di Sassari

EDITORS' NOTE

We chose this case in part because we are familiar with the Enel communication organization, having performed, on behalf of the Global Alliance for Public Relations and Communication Management, an extensive benchmarking exercise in 2012 (see *Who Has Seen the Future?* at http://www.globalalliancepr.org/website/page/excellence-corporate-public-relations).

In addition, this 50th anniversary project won an award from the Italian Association of Public Relations Agencies (ASSOREL) in 2012. As you will see, the strength of this special event lies in the establishment of many partnerships with stakeholder groups in addition to a robust internal communications component. The case was also supported by an excellent project management infrastructure and top design elements, which made this 50th anniversary truly special. Its main strategy of enjoying 50 years of memories while imagining 50 years into the future permeated the execution of the project. It is a model of special event planning.

An integrated corporate communication campaign carried out through 2012 sealed the celebrations for the 50th anniversary of Enel Group, a global leader in the energy sector.

In the context of increasing Italian and international interest in the relational value of the company's history and heritage, Enel's "Moments" campaign offers a good example of an original, nonconventional, and nonrhetorical celebration of an important corporate anniversary. The project integrates a wide range of public relations activities involving all strategic publics: not only the company's internal community but also shareholders, institutions, local communities, media, and customers in both domestic and international markets.

BACKGROUND

Enel was founded December 6, 1962, as the Italian National Corporation for Electric Energy, with the aim of operating in the production, transportation, distribution, and sale of electricity following the nationalization of the energy sector.

The company began its activities in 1963 in the years of the Italian economic boom, gradually absorbing more than 1,200 existing electricity companies. Since then, the history of Enel has intertwined with the modernization of Italy. The transition from a public monopoly to a multinational corporation was completed in 1992 when Enel became a joint-stock company. This change from a public agency enabled it to found and participate in companies both in Italy and internationally. Enel made its debut on the stock market in 1999.

As of 2012, Enel had approximately 60 million customers and 74,000 employees. It currently has more shareholders than any Italian company, the largest of which is the Italian Ministry of Economy and Finance, which owns about a third (31.24%) of the capital. Following the liberalization of the electricity market in the late 1990s, Enel rapidly expanded the international scope of its business, establishing itself as a multinational corporation in 40 countries and on four continents and becoming one of the leading integrated players in the power and gas sectors in Europe and—through the subsidiaries of Endesa, the Spanish power company taken over by Enel Group—in Latin America.

The profound changes that occurred over the last 50 years transformed Enel into a successful player in the global market. Its development is a testimony to the company's extraordinary ability to anticipate and adapt to strategic, organizational, and cultural changes, while enhancing its traditional corporate identity. Over the years, the Enel Group also has strongly committed to sustainability, becoming a world leader in the development of renewable sources and adopting

an articulated environmental policy. The company also complies with international standards of transparency and governance, and it invests large resources in innovation with 600 million euros allocated to research and development in its 2012–2016 business plan.

Since the transformations that occurred in the 1990s, Enel has increasingly focused on the significance and value of its institutional heritage. As a consequence, the company's communication activities, coordinated by the External Relations Department since 2007, are constantly engaged in highlighting Enel's valuable contributions to the social, cultural, and entertainment sectors, resulting in Enel receiving many awards and a deserved reputation as an early adopter of "best practices" in the Italian public relations community.[1]

Enel's social commitment emerges, in particular, from the charity activities carried out by "Enel Cuore," a nonprofit organization the company created in 2003, and from the promotion of an innovative use of electricity in the various fields of social life. Enel's corporate social responsibility has inspired a number of initiatives such as the adoption of an Ethical Code in 2002, which is binding on all employees of the group, and the annual publication of a Sustainability Report, produced in conjunction with the consolidated financial statements of the group since 2003. Additionally, at the beginning of 2012, Enel formally adopted the United Nations' guiding principles on business and human rights (2011), approving a policy on this issue that enhances and expands the commitments already stated in its Ethical Code and other company documents.

In 1990 Enel launched the cultural project "Light for Art," promoted in collaboration with important cultural institutions all over the country with the aim of creating artistic lighting for the greatest Italian monuments such as the Basilica of San Marco in Venice (1990), Basilica of San Francesco in Assisi (1991), Cathedral of Spoleto (1992), the excavations of Pompeii (2000), and, in Rome, the Imperial Fora (1993), Vatican Art Gallery (1993), Pantheon (1996), Altar of the Nation (1997), Palazzo Altemps (1997), and the Quirinale Gardens (2003).[2] Enel also established numerous partnerships with many of the most prestigious Italian cultural institutions such as the Venice Biennale, La Scala and Piccolo Theatre in Milan, and many others in Rome such as the Borghese Gallery and Vittoriano Museum, the Academy of Santa Cecilia, and the Auditorium Parco della Musica, of which Enel has been the main sponsor since 2006. Since 2007, Enel also has supported the event "Enel Contemporanea" (http://Enelcontemporanea.Enel.com) with the aim of sustaining public art on the theme of energy. The event, promoted in collaboration with MACRO (Museum of Contemporary Art of Rome), annually presents never-before-exhibited works by internationally renowned artists selected since 2010 through the Enel Contemporanea Award.

The company's internal communication is strongly supported by corporate media such as its monthly house organ *Enel Insieme* and the Intranet *Global In-Enel*. With the creation of the closed circuit Enel TV in 2000, Enel became the first large Italian company to have a business television channel, later transformed into Enel.tv on the Web. Most recently, the creation of Enel.radio on the Web in June 2011 has further contributed to the establishment of a powerful integrated network supporting Enel's internal communication activities.

METHODOLOGY

This case study has been researched thanks to the generous collaboration of Enel's External Relations Department, which granted the authors access to the company's communication strategies, activities, and scheduling.

Research methodologies included in-depth interviews and informal meetings with communication leaders within the company (i.e., executive vice president of external relations, head of external relations, etc.), direct observations, and analysis of several informative sources, among them internal corporate documents, reports, and other publishing and communication materials related to the project.[3] The study includes also a review of the literature on public relations, corporate communication, and reputation (Argenti, 2007; Fombrun & van Riel, 2004; Goodman & Hirsch, 2010; Grunig, Grunig, & Dozier, 2002; van Riel, 1995; Yang & Grunig, 2005) and of sector publications and studies within which Enel's excellence in communication is unanimously recognized and analyzed.

SITUATION ANALYSIS

Over the years, Enel, the former public company whose history is tightly intertwined with Italy's own, has manifested an unrelenting penchant for innovation, allowing it to become an internationally competitive multi-utility. This corporate ethos probably has contributed to a recent awareness of the value of the company's tradition for both scientific and communication progress. Indeed, only in recent years it has committed itself to a systematic conservation and divulging of its corporate heritage, providing access to a vast documentary memory that represents a cross-section of the economic history of Italy as well as of other countries in which Enel does business.

One of the most significant initiatives in this sense was the creation in 2008 of a historical corporate archive. Still open today in Naples and free to the public, it absorbed eight local archives already open to the public since 1997 following the

reorganization started in 1985 in collaboration with the Centre for the Historical and Economic Documentation on Enterprise. Enel's historical archive houses a vast collection of documents and artifacts related to the history of the Italian electricity industry from the nineteenth century to the present. Recognized in 1992 as "of remarkable historical interest" by the Italian government agency responsible for regional archives, the archive is currently affiliated with Museimpresa, the Italian Association of Company Archives and Museums.

In the same spirit, since 2002 Enel has occasionally opened its power stations to the public and created historical museums with the aim of acquainting local communities with the development of electricity in Italy. The most noteworthy examples are the Geothermal Museum at the power station of Larderello (Pisa) and the information center at the power station of Torrevaldaliga Nord in Civitavecchia (Rome).

Enel also has made its documentary and iconographic heritage accessible online at the *Enelikon* project website (http://Enelikon.Enel.it), an interactive documentary platform providing access to a selection of historical materials taken from Enel's historical photographic and audio-visual archives, which are available in digital format to both professionals and the public. Another interesting project is *Fragments of History*, an audio-visual magazine accessible through a dedicated section of the company's website; it aims to chronicle the history of the company since its founding using historical audio-visual materials Enel made available for the first time on the Web.

Table 3.1. The Campaign for Enel's 50th Anniversary: Enel SWOT Analysis.

Strengths	Weaknesses
✓ Institutional origins ✓ Roots in the *made-in-Italy* tradition ✓ Innovation and internationalization ✓ Performance acknowledged by the market ✓ Ethics ✓ Conservation of the institutional heritage ✓ High brand awareness and reputation	✓ Fragmented identity as a group at the international level ✓ Weak synergies between corporate and commercial communication ✓ Innovation oriented culture at the expense of tradition ✓ Fifty years as neither a centennial celebration nor a "minor" anniversary
Opportunities	**Threats**
✓ Social rediscovery of corporate heritage ✓ Cross-media narration ✓ Targeted involvement of stakeholders ✓ High-quality visibility ✓ Empathy and listening	✓ Growing competition in the energy sector ✓ Crisis and austerity climate ✓ Citizens' discontent and distrust of institutions ✓ Celebration rhetoric

CORE OPPORTUNITY

The attention dedicated to Enel's corporate heritage led to the launch of an important corporate campaign in 2011, organized to commemorate the 150th anniversary of Italian unification. In its campaign, Enel paid homage with the theme "Enel for the 150 years of the Italian people." The project was developed in the context of a "mind opening insight"—"For one day let's not talk badly about Italy"—trying to offset the bad habit Italians have of being negative. The numerous celebratory initiatives were based primarily on the materials of the historical archive, which were for the first time fully used to chronicle the origins and milestones of Enel's history, seen through the lens of Italian history and presented as an example of Italian virtuosity.

Drawing on an increasing awareness and availability of documentary resources, these initiatives paved the way in 2012 for an original and impressive celebration of Enel's first 50 years of activity, an important corporate anniversary underlined by an integrated campaign that evolved from the context described in Table 3.1.

GOAL

On December 6, 2012, Enel "turned 50" and, for this occasion, launched a communication and public relations campaign aimed at creating targeted opportunities to engage stakeholders. This initiative was consistent with the general tendency of enterprises and other organizations to invest in the promotion and communication of their history and heritage as cultural values to be shared with economic and social stakeholders (Martino, 2013; Misiura, 2006; Montemaggi & Severino, 2007; Urde, Greyser, & Balmer, 2007). This contemporary trend toward the rediscovery of the traditions of enterprises, brands, and products manifests itself in a variety of forms made available to the public: the celebration of corporate anniversaries and "birthdays" (Deal & Key, 1998), often organized in the form of communication events with media appeal; the promotion of historical collections related to the country's industrial culture; and the creation of historical archives and museums dedicated to the conservation of the corporate heritage of single or associated companies (Martino, 2013).

In this context, this case history offers an example of excellence: a project that steers away from clichés and stereotypes and successfully promotes the "young" history of the company. The rich program of events for Enel's 50th anniversary actually reveals the strength of a vision able to focus on the historical memory of a private organization not in a self-referential but rather in a deeply relational

way. Enel envisioned its corporate anniversary as the occasion for a number of initiatives aimed at involving both the corporate community and all strategic target audiences under the aegis of a common set of shared values.

Grounded in a contemporary communitarian vision, the history of a company such as Enel became a vehicle for revisiting the histories of Italy and, in conjunction, the people who work for the Enel Group. Enel's Mission Statement for its celebration stated:

> This is a journey into our history—50 years of challenges and profound changes that have brought Enel to be among the greatest electric utility companies in the world. Since its initial spark, this journey has decisively contributed to the energetic needs of Italy and its industrial development, bringing innovation and progress.... It intends to be a journey in time where every step represents a turning point in the history of Italy, in our customs, lifestyles, and energy consumption. It also pays homage to all those people who have worked and still work in the company and have contributed to making Enel what it is today. (Enel Celebration Mission Statement)

OBJECTIVES

The celebration was animated by a unconventional and highly social view of the corporate history. The intention was to escape from self-celebratory tones and the traditional rhetorical discourses typical of heritage branding such as the hackneyed dialectics past/future, tradition/innovation, and to focus instead on the value of the reassuring continuity of Enel's presence in contemporary society.

To distinguish it from similar initiatives, the project's goal and objectives successfully conveyed and creatively expressed the social orientation that the company has developed over the years. Thus, an important corporate event became an occasion to invest in the company's corporate heritage as a new platform for interacting with stakeholders.

In particular, for a company strongly oriented towards innovation, the 50th anniversary represented an important occasion to

> take a breath, reconstruct, take stock of past achievements and plan for the future by making the most of a turning point—mark a point of discontinuity. It was an opportunity for a rebirth, an occasion to make a point. What we tried to achieve was a total identification with, and sharing of, all initiatives.... This allowed us to put order in our storytelling and make it "flow." (DiNardo, personal communication, 2013)

The objective of Enel's anniversary campaign was to strengthen its corporate positioning and reputation, both in Italy and internationally, through the involvement of opinion leaders and the establishment of quality relationships with a variety of business partners. In this spirit, the project focused on the enhancement of corporate culture and the use of storytelling promoting both the involvement of external stakeholders and the multicultural cohesion of Enel's community as one company across the world.

Internal Relations Objectives

The project was characterized by a strong focus on Enel's corporate community that inspired the 2012 internal communication plan. The internal relations objectives were to enhance a shared company culture among former and current employees and the personnel of companies Enel owned and/or managed in other countries by positioning Enel's values as elements of cohesion and unification for the entire multinational Enel Group. In particular, main objectives were the following:

1. Reinforcing pride in belonging to the company as well as a community dimension by retracing the milestones of the company's history and its connections with Italy's history
2. Highlighting the value of people in Enel's history and promoting the active involvement of former and current employees in the celebration program
3. Supporting the change management strategy of the Enel Group through initiatives sensitive to the personnel of the member companies outside Italy, highlighting the connections between the origins and development of Enel as a group, when the company incorporated more than 1,000 firms operating in Italy before the energy industry's nationalization

Institutional and Marketing Relations Objective

The campaign was characterized by a strong corporate orientation and an unprecedented willingness to make the most of possible synergies between Enel's internal corporate and integrated marketing communication, exploiting the potential impact of a significant corporate history and reputation as a vehicle for an indirect commercial promotion.

By referring to the company's history, the advertising campaign and other targeted communication initiatives promoted engagement with strategic target audiences and reinforced the emotional connection between the brand and its

current and potential customers. Particular attention was paid to the involvement of a young target audience, thanks to the participatory Web (i.e., social media and social network sites) and contacts at live events.

Concurrently, the celebration focused on sharing an Italian success story: Italian entrepreneurship exporting technological and innovative skills. The objective was to engage and influence public opinion activated by communication and media attention that accompanied and amplified the celebration program. And by promoting the numerous public affairs activities, Enel sought to highlight the company as a great protagonist of Italy's economic history, contributing to and reinforcing its institutional presence and generating quality relationships with political and institutional players at national and international levels. Enel also wanted to highlight its quality relationships with key audiences whose goodwill always had been decisive for the creation of infrastructure projects involving local communities.

Economic-Financial Relations Objective

Another objective of Enel's campaign was to consolidate the company's relationships and reputation in the economic-financial field, conveying a message of solidity to commercial partners, shareholders, and private financial backers.

None of the objectives was stated in quantitative terms, making it difficult to measure and substantiate the success of the campaign.

KEY PUBLICS

The 2012 celebration was the occasion for implementing a number of initiatives aimed at involving the company's strategic target audiences, both in Italy and internationally. The key target audiences included the following:

- The Enel Group's members: employees and management as well as former employees and employees' families
- The partners of the group: companies acquired by Enel and their employees and management in the global market
- Local communities interested in and affected by the Enel Group's economic activity
- Institutions and political players influencing Enel Group's business worldwide
- Media, both traditional and online

- Public opinion and citizens in the countries where Enel Group conducts its business
- Shareholders and financial backers who provide current and potential economic resources
- Current and potential customers, with special attention to younger audiences (18–24 years old)

KEY MESSAGES

The campaign was implemented in a general climate of austerity and crisis; therefore, it employed sober, rather than triumphant, tones. The program of events emphasized stakeholders' identification with the corporate history and was presented in terms of the lives of individuals. In this spirit, the anniversary above all intended to celebrate the everyday dimension of energy and its role in the attainment of the most important individual achievements: The 18,250 days Enel spent on "50 years of life" were emotionally represented in the campaign as a shared path of values, rather than the static picture of a story.

This key message was based on the results of a focus group conducted with the company's professional partners and agencies involved in the project for supporting communication, advertising, event, publishing, and media activities. The focus group took into account socioeconomic and public opinion climate indicators provided by the Institute for Studies on Public Opinion (ISPO), which highlighted the emergence of a general sentiment related to everyday needs and family values. Based on this assumption, key messages focused on the following:

- Everyday life rather than past/future
- Rediscovery of the value of personal achievements
- Involvement and aggregation
- Promotion of Italian virtuosity

The objective of the underlying narrative strategy was to bring the full corporate history into a more accessible dimension of current moments with which stakeholders might identify themselves. Luca DiNardo, Enel's head of external communication, gave these reasons for choosing this message:

The project comes from the intention to share this important event with all Enel's audiences, which have different relationships with the company. Our idea was to break down the 50 years into infinitesimal units—moments—thus allowing each

interlocutor to appropriate them and associate the company and its history with a moment of personal happiness and success.... The first risk we tried to avoid was to convey an idea of the moment as something ephemeral, rather than an investment in the future. This was essential: we certainly wanted to celebrate, but in a perspective of restart. It seemed far too didactic to celebrate the past by looking at the future, so we found this original formulation: breaking down the temporal axis and looking at both the past and future. In this way we avoided the risk of trivialization and triumphalism, which are out of place in this historical moment. (DiNardo, personal communication, 2013)

STRATEGIES

Based on these premises and messages, the campaign strategy was to create an impressive narration of the corporate history in which Enel's achievements were relayed through employees' achievements and chronicled through individuals' emotional experiences. This strategy fit with the broader framework of Enel's corporate strategies. As Gianluca Comin, Enel's executive vice president of external relations, explained, the Enel Group's priority was the enhancement of the company's institutional positioning:

Grasping free market opportunities without losing the company's institutional value because the institutional value allows a range of customer relationships that the mere commercial approach would disperse. The 50th anniversary represented a great occasion to highlight the value of Enel's institutional role for the country, its role of community service, and the technical competence that has characterized its history. The commercial aspect is, after all, fleeting, whereas the institutional one is permanent: from this perspective, one of the most important factors is certainly memory. (Comin, personal communication, 2013)

It was this spirit that informed Enel's strategic planning starting in mid-2011: a clear awareness of how the 50 years of corporate history might represent a unique opportunity for a corporate campaign to capitalize, both medium and long term, on the perception of Enel's presence in people's everyday life, and its closeness to people. As Enel's head of external communication DiNardo suggested:

We did not take on the paternalistic or detached attitude of a 50-year-old company, but we put ourselves on the line and placed ourselves among the people. It was the first Enel campaign in which we got inside people's lives, representing energy as something belonging to them. We placed ourselves in a listening attitude. (DiNardo, personal communication, 2013)

The base strategy was the promotion of a dynamic Enel representation able to involve a young target audience, one of the main foci of Enel's campaign and commercial strategies.

TACTICS

By availing itself of the consulting expertise of a number of professional agencies and research institutes, Enel translated the strategic objectives of its campaign into an articulated program of communication and public relations activities.

The integrated public relations campaign included both the development of new projects and the implementation of existing initiatives in different fields: visual identity, advertising, media relations, internal communication, events, publishing, public affairs, partnerships, and promotional activities, as reported in Table 3.2.

Table 3.2. Communications and Public Relations Activities and Tactics for 50th Anniversary.

Identity	Internal Communication
• Celebration brand • Coordinated graphics • Branding and signage • Gifts and gadgets	• Online contest in partnership with ANSE • Enel Family Birthday • Institutional Exhibition • Travelling Exhibition • Internal media • Happy Birthday Enel
Publishing	Events
• Celebration brochure • Historical monographs • "Oxygen" monograph • Sixties-style prints	• Celebration Day at Bocconi University • Concerts at Santa Cecilia and La Scala • Enel 5.0 Tour • Local events • Events outside Italy

Continued.

Media	Historical Archive
• Advertising campaign • Institutional video of the celebration • Celebration website • Digitalization of the historical video archive	• Historical exhibition • Extraordinary openings
Partnerships and Special Initiatives	**Promotional Activities**
• Enel Foundation • "Energies for Research" competition • "Enel Lab" incubator • Media partnerships • Celebration stamp	• Enel's Brothers • "50 e vinci" contest • Enel's special points of sale and flagship store
Implementation of Pre-existing Projects	
• "Enel Contemporanea" permanent installation • Nature and territory • PlayEnergy • Historical archive	

Advertising Tactics

At the core of the celebration program was a multi-subject advertising campaign targeted to a wide audience, including the youngest and the new customers, diffused through television, press, and billboards, with the intention of celebrating the goals of inspiring people's lives and their orientation toward the future. The original claim "50 years of energy, millions of moments shared between us"[4] indeed expressed an original narrative analogy between the company's history and the most meaningful achievement of people's lifetimes, which exemplified the participatory strategy of the entire celebration.

The television campaign on the primary local and satellite domestic channels consisted of three 30-second commercials focusing, respectively, on the personal achievements of a young athlete,[5] a graduate's old father, and a new mom by retracing the steps that led the protagonists to accomplish their most cherished goals. The advertising campaign, created by Saatchi & Saatchi Rome, was translated for the press into content such as photo shoots that also were used to advertise special celebration events.

In addition to such traditional channels, the campaign also included outdoor advertising on billboards at the main Italian and Spanish airports and intense Web-based advertising communication carried out through Enel's anniversary website (http://50.Enel.com) and a strategic use of social media, in particular Facebook and Twitter.[6]

Visual Identity Tactics

The celebration brand "ENEL 50" (Figure 3.1), created for the occasion, integrated references to the corporate anniversary. The layout resembled a Polaroid photo: an icon of energy consumption of the past able to evoke memories and pictures related to everyday life in a non-nostalgic way.

Fig 3.1. Celebration Brand for Enel's 50th Anniversary.

The celebration brand and related coordinated graphics appeared in various communication materials and in all languages of the countries where Enel operates.

Event Tactics

The program included a variety of official events and, in particular, two concerts of the Orchestra of Santa Cecilia Academy (of which Enel is a founding member) held in Rome and Brussels.

The history of electricity and its role in the social, cultural, and economic development of Italy and the world were narrated in a playful and spectacular way by

"Enel 5.0" (Figure 3.2), a high-tech travelling road show organized in eight Italian cities (Naples, Bologna, Rimini, Florence, Genoa, Catania, Rome, and Milan) between May and December 2012.

Fig 3.2. "Enel 5.0" Tour.

In these community events, dedicated to local families and children, the history of electricity was narrated in a contemporary and futuristic way through interactive displays and a timeline articulated into five macro-scenarios: "Italy with a national grid," "The energy miracle," "A time for reflection," "Energy without borders," and "A new electric age."[7]

A number of local and international events also were held at Enel power stations with the participation of the authorities of the countries in which the Enel Group did business.[8] Celebration Day (December 6, 2012) was the culmination of the commemoration and ended the celebration year. An official closing event was held at the Luigi Bocconi School of Economics in Milan with the company's management board and important Italian political personalities, such as the minister of economy and finance, in attendance.

Internal Communication Tactics

Accompanying the year's anniversary events were many internal communication projects such as Enel Family Birthday, held in the national company's sites (Rome, Milan, Turin, Mestre, Florence, Arezzo, Pisa, Naples, Catanzaro, Brindisi, Palermo, and Cagliari). Dedicated to employees and their families and centered on children, a party on June 16, 2012, brought together simultaneously, for the first time in the company's history, 10,000 employees and their families from more than 30 Enel locations in Italy. For this occasion, the electric control rooms hosted by the company's headquarters in Rome, normally only accessible to Enel staff, were open to the public.

On the same day, Enel's auditorium in Rome opened a permanent anniversary exhibition dedicated to employees ("The future, for the past 50 years").[9] A second travelling exhibition was organized at eight other locations in Italy: Brindisi, Palermo, Reggio Calabria, Pisa, Florence, Turin, La Spezia, and, in 2013, Montalto di Castro (Viterbo). Both exhibitions showcased photographs and historical materials taken from Enel's historical archive in Naples. The archive was accessible to the public for extraordinary openings and guided tours November 19–25, 2012, on the occasion of the exhibition, entitled "1,271 companies in one reality," aimed at retracing the origins and history of the company.

There was a constant flow of information through intense internal media activities as well as special reports dedicated to Enel's history. At the beginning of 2012, Enel's internal media were entrusted with the task of opening the celebrations, launching the first special issues of the monthly publication *Enel Insieme*, special programs on Enel TV, and, soon afterwards, on Enel's Web radio. The editorial program "Enel 50" started in May 2012 with the first radio-TV live broadcast and the creation of an ad-hoc space on the Intranet, with the aim of socializing employees to the company's history and the initiatives for the anniversary. Other initiatives included a second special cover on Enel's in-house publication *Enel Insieme*, which followed the celebration year with nine issues, and the creation of special menus and celebration cakes for the company's canteens on the anniversary day. Finally, a number of initiatives were promoted in collaboration with the association of Enel's current and former employees (ANSE), such as the creative contest "Enel—18,250 days of emotions and memories" held online. In the second part of the year and into 2013, this contest collected memories of Enel's history through the perceptions of its protagonists, who were invited to recall moments of their professional lives in a variety of narrative formats (short stories, poems, photographs, videos, etc.).[10]

Publishing Tactics

An intense use of publishing tactics accompanied the campaign with the most noteworthy including the following:

- An institutional celebration brochure
- A monograph issue of Enel's corporate magazine *Oxygen* (Enel, 2012)
- A new graphics style for both commercial printing and a new illustrated corporate publication featuring a comic-strip history of energy[11]
- Three historical monographs by important Italian publishers—Bergami, Celli, and Soda (2011), Castronovo (2012), and Castronovo and Paoloni (2013) that retraced the history of Enel and Italian electrification

A rich audio-visual narration was developed for the corporate TV channel that also was accessible externally on the Web (http://www.eneltv.it). Furthermore, a corporate video was produced by 40 young filmmakers Enel selected from around the world to express their creativity on a crowdsourcing online platform dedicated to the celebration, sharing Enel's message virtually on the Internet.

Partnerships and Special Initiative Tactics

Enel also celebrated its anniversary with a special postage stamp, presented at an official meeting held in Rome in the presence of the undersecretary of the Italian prime minister. Involved in this event were numerous television (including Sky) and print media (i.e., *Il Sole24Ore*, *La Repubblica*, and *Corriere della Sera*).

The company's active engagement in supporting research, education, and entrepreneurship in the energy sector led to the creation of the Enel Study Centre Foundation, a nonprofit organization promoting research on the socioeconomic impact of energy, sustainable development, and innovation. The initiative encompassed two projects, presented in a cycle of meetings at various Italian universities with the aim of exploring new opportunities for future research, such as the competition "Energies for Research," promoted in collaboration with the Conference of Italian University Rectors Foundation (CRUI) that awarded 20 scholarships to graduates and Ph.D. holders in the fields of renewable energies, the economic impact of energy production, and corporate social responsibility. On the occasion of its 50th anniversary, Enel also focused on investing in youth entrepreneurship with the first edition of the contest "Enel Lab," a sustainable start-up incubator promoted in partnership with the Spanish electricity company Endesa (now part of the Enel Group), with the aim of supporting the most innovative Italian and

Spanish start-ups in the field of clean energy technologies through an incubation program offered to a selected number of supervised projects (http://lab.Enel.com).

Promotional Activity Tactics

The campaign also included a number of promotional initiatives at Enel's points of sale, with one of the most significant being "Enel's Brothers," dedicated to customers born on the same date as Enel. Another initiative was the competition "50 and win" at Enel's points of sale and its flagship Milan store, with prizes awarded every month from July to September 2012 to the 50th new customer.

Tactics That Implemented Pre-existing Institutional Projects

The 50th anniversary also was celebrated with a special "Enel Contemporanea," organized for the sixth year in 2012. The courtyard of the MACRO (Museum of Contemporary Art of Rome) in Rome's Testaccio quarter hosted a permanent installation of green netting and bamboo dedicated to light and donated by Enel to the city of Rome. After signing a release agreement, visitors walk through the "Big Bambù" sculptural structure, created by American brothers Doug and Mike Starn, to experience a new perspective on the city.

In addition to "Enel Contemporanea," two other pre-existing projects were re-interpreted for the occasion: "Nature and Territory," an awareness-raising program on environmental issues and safeguarding the areas bordering Enel plants, and "Play-Energy," an educational project developed in partnership with schools to promote the diffusion of information on electric energy and a responsible energy culture.

CALENDAR/TIMETABLE

The celebration program was launched at the beginning of 2012 with the first internal communication activities and continued throughout the year, intensifying in the second half of 2012 (especially from the end of May onward) as the official Celebration Day drew near.

Some initiatives continued into 2013, such as the institutional exhibition at the company's headquarters in Rome and the last venue for the travelling exhibition in Montalto di Castro (Viterbo); recognition of the employees who won the online creative contest; selection of innovative start-ups participating in "Enel Lab"; and the permanent installation of "Enel Contemporanea" at MACRO Testaccio in Rome.

The campaign planning is shown in Table 3.3, which reports all the different communication and public relations activities and their implementation during 2012.

Table 3.3. Communication and Public Relations Planning (Main Activities).

Activities	January	February	March	April	May	June	July	August	September	October	November	December
Identity												
Celebration brand												
Coordinated graphics												
Branding offices and plants												
Gifts and gadgets												
Internal communication												
Online contest with ANSE					24							
Enel Family Birthday						16						
Travelling Exhibition						16						
Celebration open day						16						
Internal media					Intranet							
Media												

Continued.

Activities	January	February	March	April	May	June	July	August	September	October	November	December
Advertising campaign												
Institutional video												
Historical video												
Celebration website												
Media relations												
Daily press					30 / 31	14		19				3
Periodical press												
Main events												
Celebration Day												
Concerts at Santa Cecilia and La Scala				27 Moscow					6 Moscow		6 Milan 20 Rome 24 Bruxelles	6 Milan 20 Rome
Enel 5.0 Tour					31/5 – 3/6 Naples	14–17 Bologna		19–25 Rimini	27–30 Florence	25/10 – 4/11 Genoa	15–18 Catania	5–9 Rome 20 – 23 Milan
"Play Energy" award ceremony						7 Rome						

Continued.

Activities	January	February	March	April	May	June	July	August	September	October	November	December
Historical Archive (openings and other activities)												
Publishing												
Celebration brochure												
"The Game of Roles" (monograph)									26 Rome			6 Milan (Cele-bration Day)
Oxygen 50 years												
Sixties-style prints												
Archive monographs												
Partnerships and special initiatives												
Enel Foundation (launch)						13 Rome						
"Energies for research" competition						13 Rome						

Continued.

Activities	January	February	March	April	May	June	July	August	September	October	November	December
Enel LAB incubator (launch and local activities)						13 Rome						
Media partnerships												
Celebration stamp (presentation)											19 Rome	
Promotional activities												
Enel's Brother												6
Enel Point and Flagship												
Implementation of pre-existing projects												
"Enel Contemporanea"												10
"Play Energy" (ad hoc)												
"Nature and Territory"												
Other activities												

BUDGET

The entire project was realized within Enel's annual communication budget. There was not an allocation ad hoc, but synergies were created with existing programs, and activities were optimized to maximize the results.

EVALUATION AND MEASUREMENT

Enel's 50 years campaign was monitored and evaluated with different tools responding to different objectives and time frames (short and long period). In particular, it included counts of outputs (i.e., number of visits, number of readers, page views, etc.), media coverage measurement, and a systematic evaluation of reputation and brand equity outcomes, promoted by Enel in the middle term and today still in progress.

The campaign received vast coverage in Italian and international media, with Enel decidedly gratified by the results in terms of contacts and participation in various initiatives by both the corporate community and wider public. Additionally, in 2012 the company capitalized on the positive impact of the corporate campaign and was able to affirm positive effects on the company's climate, commercial opportunities, and, above all, institutional perception of Enel.

Thanks to the continuing collaboration with various research institutes, a meticulous in-progress and ex-post monitoring of the efficacy of the communication and public relations initiatives was carried out. These studies also have verified a widespread penetration of the campaign into the main internal and external target audiences, as identified in the following strategic planning table (Table 3.4).

Table 3.4. Diffusion and Contacts of the Campaign (Main Initiatives).

Initiative	Diffusion/contacts
Media communication	
Celebration website (http://50. Enel.com)	- 733,920 visits (June 1/December 31, 2012) - 673,709 unique visitors - 980,524 page views
Special events and initiatives	
"Enel 5.0" Tour	150,000 visitors in eight cities
Big Bambù	43,000 visitors (December 2012/October 2013)
"Enel Lab" Incubator	215 start-up projects

Continued.

Initiative	Diffusion/contacts
Institutional video contest	40 participants More than 1,200 views on YouTube (as of June 2013)
	Publishing
Oxygen magazine (monographic issue on the 50th anniversary)	Print run of 20,000 copies, of which 9,300 distributed on trains
Enel—From National Monopolist to Global Leader (monograph)	Print run of 2,000 copies
The Game of Roles (monograph)	Print run: - 2,000 copies not distributed on the market - Available to bookshops by order only
The 50 Years of Enel (monograph)	Print run: - 2,000 copies - Available to bookshops by order only
	Internal communication
"Enel Family Birthday"	- 30 locations throughout Italy - More than 10,000 visitors across all seats - 350 visitors in the control rooms of Enel's headquarters - 22,000 visits to the website dedicated to the initiative
Institutional exhibition	20,000 visitors
Travelling exhibition	7,510 visitors in eight cities
Creative contest in partnership with ANSE	- 55,076 unique visitors - 462,354 page views - 83,897 visits - 611 projects - 30,095 voters
Intranet—"Enel 50" section	40,211 page views 17,591 visits
Enel.radio and Enel.tv	50,000 contacts (2012 broadcast scheduling)
Enel Insieme magazine	283,500 distributed copies (of which 30,000 related to the 50th anniversary special issue)
Happy Birthday Enel	35,000 employees and 52 canteens involved throughout Italy

Media Coverage Measurement

Between April 2012 and January 2013, Enel's campaign was the object of widespread domestic and international media coverage, with 555 stories including newspaper articles (531, of which 120 were Italian and 14 international) and broadcast reports (24, of which 13 were Italian radio and television broadcasts). Domestic and international media coverage skyrocketed in the first week of December 2012, driven by the approaching Enel Celebration Day; in the days following December 6, the press dedicated special attention to the cultural project "Enel Contemporanea," which kept the anniversary in the spotlight until the beginning of 2013.

A study titled "Monimedia," regarding media coverage quality, was conducted by the Eikon Strategic Consultant agency, through a secondary analysis of corporate media coverage using both quantitative and qualitative methods. The research results show that in 2012 Italian and international media dedicated significant special attention to Enel for its 50th anniversary and to corporate programs promoting clean energy and youth entrepreneurship (Enel Direction of External Relations, 2013).

Brand Equity Measurement

The celebration year also was characterized by the strengthening of the corporate brand equity, as shown by the annual study conducted by the GfK Eurisko research institute in the framework of a multi-client Advertising Tracking Study. Its Brand Equity Index is an indicator of brand awareness and perception in Italy and shows a constant positive trend in the 2010–2013 three-year period.

Enel's already-high brand awareness remained stable, with a top-of-mind brand recall equal to 85% in the energy sector where it maintains its position as the top brand despite growing competition from and increasing popularity of its greatest competitors. And the quality of Enel's corporate image increased further in 2012; this result appears much more significant given the company's critical socioeconomic context that could have had a negative impact on the perception of a company such as Enel.

Enel highlighted its institutional origins and role, which also is its most distinguishing feature, strengthened in 2012. The company also seems to have benefited from the numerous corporate communication activities celebrating the anniversary: an impressive campaign, with major impact, able to re-launch the image of a company aware of its history and, at the same time, project it into the future (GfK Eurisko, 2012).

Enel is continuing to measure and evaluate its brand awareness and equity in the annual EuriskoTracking Study conducted in 2013 and 2014.

ACKNOWLEDGMENTS

Enel's major acknowledgments and awards have spoken to the campaign's quality.

Enel won the Friendly Imagines Award, promoted by UDI (Italian Women Union), for a quality and non-stereotypical use of female images in communication in one of its advertising scripts for television. Additionally, at the annual Award for Public Relations, organized by ASSOREL (Italian Association of Public Relations Agencies), the campaign was honored with a special award for the category "Grow Italy" as the best initiative aimed at the improvement of the company's reputation for providing goods and services for domestic and international markets.

Furthermore, the "Enel Lab" incubator, promoted for the corporate anniversary, won the European Excellence Awards 2013 for the energy sector in partnership with the European Association of Communication Directors (AACD) to honor the best communication campaigns in Europe.

CONCLUSION

The campaign for the 50th anniversary of Enel provides a detailed observation of the contemporary uses of heritage branding in light of the exemplary forward-looking integrated communication activity. It represented a significant step in a medium- and long-term investment in the still-young corporate tradition that Enel celebrated by highlighting its social potential and avoiding rhetorical discourse.

The public relation campaign also brought out the symbolic and regenerating role played by an important corporate anniversary, which allowed the company to take stock of its past experience and start a new cycle based on an increasing investment in its heritage. This was particularly urgent at a time when every company is called on to face constant changes, and to prove ability to adapt and transform itself. The example of a company as large as Enel shows how the discovery of tradition may support a winning approach to change and internationalization, based on the promotion of commonly held values and, in particular, on the recognizability of the culture of origin: the Made-in-Italy tradition, expressed by Enel in the technology business sector.

Finally, the celebration program was particularly noteworthy for the successful depiction and rendition of the company's history and its product (energy) as well as for its intrinsic cultural quality. The initiative offers, in fact, an exemplary experience of an investment on conservation and safeguarding (and not only communication/storytelling) of corporate history. It is no accident that the campaign, under the coordination of Enel's Direction of External Relations, has recovered and made use of materials from the Enel historical archive and other internal structures. Conceived in this way, the project was animated by a socially inclusive model of organizational memory, which appears as a multifaceted prism embracing the interactions with a plurality of strategic publics, both inside and outside the borders of the company.

NOTES

1. On the history of Enel's communication, see the special issue *Communicare con energia. Enel 1962-2012* (AA.VV., 2012).
2. The project later evolved into initiatives such as "Light for Dance," "Light for Poetry," and "Light for Music."
3. The case study follows the 12-level model of analysis described in the updated version of the "RACE" scheme: this model of analysis, used for public relations and communication campaigns, was developed in Wilson and Ogden, 2010.
4. These words appear on the panel located in the auditorium of Enel's headquarters in Rome, introducing the permanent historical exhibition dedicated to its employees.
5. This original subject was specifically thought to reach a young target audience.
6. The company's presence on various social networks has converged into the "Enel Sharing" platform (http://Enelsharing.Enel.com) and the activities of a specific communication unit dedicated to new and digital media.
7. The initiative was open 24 hours a day, with guided group tours (see the website www.enelinquepuntozero.it). The format of the event followed and innovated the one created for *Incredible Enel*, a travelling village dedicated to energy, which in 2009 toured many Italian cities and in 2011 also landed in Spain.
8. In particular Enel also celebrated its 50 years in Romania, with a photographic exhibition (Bucharest, May 17–June 10, 2012), and Russia, with the historical interactive exhibition *Enel: energia@mondo* (Moscow, September 12–28, 2012).
9. The exhibition includes a section dedicated to the history of safety at Enel, with photographs and other historical materials.
10. The online vote involved employees and a qualified jury of experts. The creative contributions proposed by current and former employees have been at the center of a monographic issue of ANSE's news bulletin (ANSE, 2013).
11. The innovations introduced by electric power in everyday life are told through the story of the Raggianti ("Radiant") family, in a sort of 1960s-style family album.

REFERENCES

AA.VV. (2012). *Comunicare con energia. Enel 1962–2012*. Supplement to "Prima comunicazione," 434.

ANSE (2013). *I cinquant'anni di Enel nei ricordi dei Soci ANSE*, 1.

Argenti, P. A. (2007). *Corporate communication*. Boston. McGraw-Hill.

Bergami, M., Celli, P., & Soda, G. (2011). *Enel. Da monopolista nazionale a leader globale*. Egea: Milan.

Castronovo, V. (2012). *Il gioco delle parti. La nazionalizzazione dell'energia elettrica in Italia*. Rizzoli: Milan.

Castronovo, V., & Paoloni, V. (2013). *I cinquant'anni di Enel*. Laterza: Bari.

Comin, G. (2008). Il modello di comunicazione integrata Enel. In U. Collesei & V. Ravà (Eds.), *La comunicazione d'azienda. Strutture e strumenti per la gestione* (pp. 321–331). Isedi: Novara.

Deal, T., & Key, M. K. (1998). *Corporate celebration: Play, purpose, and profit at work*. San Francisco: Berrett-Koehler.

Enel. (2012). The future, for the past 50 years. *Oxygen, 16*.

Enel Direction of External Relations (Eds.). (2013). *Sustainability report 2012*. Retrieved from www.enel.it

Fombrun, C. J., & van Riel, C. B. M. (2004). *Fame and fortune: How successful companies build winning reputations*. Upper Saddle River, NJ: Prentice Hall.

GfK Eurisko. (2012). *La brand equity dinamica di Enel*. Indagine Multiclient Sinottica Tracking Pubblicità.

Goodman, M. B., & Hirsch, P. B. (2010). *Corporate communication: Strategic adaptation for global practice*. New York: Peter Lang.

Grunig, L. A., Grunig, J. E., & Dozier, D. M. (2002). *Excellence in public relations and communication management: A study of communication management in three countries*. Mahwah, NJ: Erlbaum.

Martino, V. (2013). *Dalle storie alla storia d'impresa. Memoria, comunicazione, heritage*. Bonanno: Acireale-Rome.

Misiura, S. (2006). *Heritage marketing*. Oxford: Butterworth-Heinemann.

Montemaggi, M., & Severino, F. (2007). *Heritage marketing. La storia dell'impresa italiana come vantaggio competitivo*. Milan: Franco Angeli.

Urde, M., Greyser, S. A., & Balmer, J. M. T. (2007). Corporate brands with a heritage. *Journal of Brand Management, 1*, 4–19.

van Riel, C. B. M. (1995). *Principles of corporate communication*. London: Prentice Hall.

Wilson, L. J., & Ogden, J. (2010). *Strategic communications planning for effective public relations and market*. Dubuque, IA: Kendall Hunt.

Yang, S. U., & Grunig, J. E. (2005). Decomposing organizational reputation: The effects of organization–public relationship outcomes on cognitive representations of organizations and evaluations of organizational performance. *Journal of Communication Management, 9*(4), 305–325.

AUTHORS' NOTE

Special thanks go to Enel's External Relations Department staff members Gianluca Comin, executive vice president of external relations, and Luca DiNardo, head of external communication, for the information and materials they provided. Enel represents exemplary transparency in communications, expressed in particular through the numerous contributions and public speeches by Comin, a former president of the Italian Federation of Public Relations (FERPI).

The conceptualization and writing of the case study are the result of the common work of the authors. The attribution of each paragraph is the following: Valentina Martino wrote paragraphs from "Background" to "Event Tactics" (included); Alessandro Lovari wrote paragraphs from "Internal Communication" to "Acknowledgments" (included). The introduction and the conclusion of the case study were co-written.

Starbucks' Global Month of Service

CHUN-JU FLORA HUNG-BAESECKE
Hong Kong Baptist University

EDITORS' NOTE

Starbucks is an iconic brand, but even iconic brands were affected by the global financial crisis that began in 2008. Starbucks faced its first operational crisis in its 40-year history: customers cut back on their visits to Starbucks, and at the same time, Dunkin' Donuts and McDonald's emerged as competitors in the coffee business. Starbucks used the economic crisis it faced to transform the company by reviewing corporate values and missions, and by reconnecting with its important stakeholders. This case study is a "classic" in that Starbucks' crisis response rekindled growth and transformed the brand into one that an increased number of consumers considered "for someone like me."

Corporations nowadays function in a diverse, complex environment with dynamic stakeholders. Steyn (2003) pointed out that the role of business in society in the 1990s has evolved to today's "corporate community" approach: stakeholders are considered partners of an organization in its socioeconomic business environment, and stakeholders are co-creating an organization's values. As a result, organizations

need to integrate socio-political-economic resources and views in their business operations to enhance their competitive advantage.

In dealing with such an ever-changing and complex business environment, the role of corporate communication has changed from its previous task of just fixing negative media coverage, or creating "noise" for organizations (Schultz & Kitchen, 2004). Various studies (e.g., Brønn, 2007; Grunig, Grunig, & Dozier, 2002; Yang & Grunig, 2005) have shown that public relations helps build mutually beneficial relationships with stakeholders, improve return on investment, and enhance corporate reputation. The functions of corporate communication should be interactive, integrated, and global. Corporate communication should bring value to customers (who are important stakeholders), help build alliances, lead with communication, and establish the corporate brand (Schultz & Kitchen, 2004).

According to Waddock (2001), there are primary stakeholders that shape a business (e.g., employees, customers, and suppliers) and critical secondary stakeholders that corporations rely on for infrastructure, such as the government and communities. Gao and Zhang (2006) contended that corporations should develop policies and activities that are an integral part of their stakeholder relationship networks. In addition, stakeholders should find these networks easy to understand and meaningful. As a result, understanding, identifying, and balancing different stakeholders' interests become significant for corporations.

The Institute of Social and Ethical Accountability (ISEA, 1999) defined stakeholder engagement as "the process of seeking stakeholder views on their relationship with an organization in a way that may realistically be expected to elicit them" (p. 9). Beckett and Jonker (2002) contended stakeholder engagement is a balanced concept that helps develop a sustainable corporation: Corporations should be able to balance the pursuit of corporate profits and maintain stakeholders' interests. As this is the corporate community era, corporations should build their brand with values that are widely accepted by stakeholders. The "negotiated brand" (Gregory, 2007) that the corporation seeks to achieve with stakeholders by responding to their input will bring competitiveness for the corporation.

The Edelman goodpurpose Fourth Annual Global Consumer Study 2011 (Edelman goodpurpose study, 2011) found that consumers indicated they favor social purpose brands, expect brand involvement in good causes, and have more trust in brands they view as ethically and socially responsible. The corporate communication function of a company, therefore, is important in building the negotiated brand by responding to the expectations from different important stakeholders.

BACKGROUND

Starbucks (NASDAQ: SBUX) was founded March 30, 1971, by Jerry Baldwin, Zev Siegl, and Gordon Bowker as a single store at Pike Place Market in Seattle. At that time, Starbucks was only a whole bean, ground coffee and tea roaster and retailer. In 1987, the owners sold the company to a former employee, Howard Schultz, who quickly expanded Starbucks outside the Seattle area.

Over the years, Starbucks' mission in the way it operates business has been "one person, one cup and one neighborhood at a time." In June 1992 Starbucks had its initial public offering and went into the stock market. In 1996, the first Starbucks store outside the United States and Canada was opened in Tokyo, Japan. As of April 2011, the time of the campaign discussed in this case study, there were 17,000 Starbucks stores in 55 countries. These stores, as per the corporate ideology at Starbucks, are positioned as friendly and cozy places to meet family and friends or for individuals to spend time by themselves quietly. In most of the stores, besides hot and cold beverages, various coffee products (whole-bean coffee, instant coffee, etc.) are offered to customers. To go with the coffee, there are pastries and sandwiches, along with books, music, and mugs. Starbucks has diversified its product range and extended its business model into areas not directly associated with coffee.

As Starbucks has been positioning itself as strongly connected with people and communities, in 2008 it launched a community website, My Starbucks Idea (http://mystarbucksidea.force.com/), to collect suggestions, ideas, and comments from customers. By the end of November 2013, it had generated 120,667 product ideas (including coffee and espresso drinks, Frappuccino beverages, tea and other drinks, food, merchandise, music, Starbucks cards, new technology, and other product ideas); 39,212 experience ideas (such as ordering, payment and pick-up, atmosphere, and locations); and 23,484 involvement ideas (including building community and social responsibility both within and outside the United States). This website has successfully connected the company with its customers and the communities in which it does business. Starbucks implemented the involvement ideas most frequently mentioned and commented on by visitors to the website, demonstrating that the company listens to its stakeholders.

Another unique aspect of corporate culture at Starbucks is how strongly it has connected with its audiences, particularly with respect to its "partners," a term Starbucks uses to refer to its employees because, according to Schultz and Gordon (2011), working for Starbucks is "not just a job, it's our passion. Together, we embrace diversity to create a place where each of us can be ourselves. We always treat each other with respect and dignity. And we hold each other

to that standard" (p. 113). Therefore, Starbucks' employees will be referred to as partners in this case study.

METHODOLOGY

This case study used secondary research into materials provided by Starbucks and Edelman to the Public Relations Society of America (PRSA) in support of their winning entry in PRSA's Silver Anvil Awards competition. The author also analyzed documents from online news, trade magazines, and newspaper reports for this case. In addition, she interviewed the Edelman senior vice president of the Greater Seattle area, Tamra Strentz, who has been working on the Starbucks account since 2007 and was deeply involved in its 40th anniversary celebration campaign.

SITUATION ANALYSIS

Schultz, who had left the company in 2000, returned in 2008 and helped Starbucks clarify its vision:

> To become an enduring, great company with one of the most recognized and respected brands in the world, known for inspiring and nurturing the human spirit. (Schultz & Gordon, 2011, p. 106)

Based on this vision, seven corporate goals were set:

- Be the undisputed coffee authority.
- Engage and inspire our partners.
- Ignite the emotional attachment with our customers.
- Expand our global presence while making each store the heart of the local neighborhood.
- Be a leader in ethical sourcing and environmental impact.
- Create innovative growth platforms worthy of our coffee.
- Deliver a sustainable economic model. (Schultz & Gordon, pp. 106–108)

However, despite its compelling, socially conscientious vision, and the goals compatible with its vision, Starbucks faced the first operational crisis in its 40-year history. A global economic downturn started with the largest bankruptcy case in U.S. history in 2008. However, even before that, Starbucks already was in a precarious

situation. On July 7, 2008, the stock price for Starbucks had fallen to $14.95 a share, the lowest in the last 52 weeks (Schultz & Gordon, 2011). By July 29, 2008, the company had eliminated 1,000 positions. Worse yet, after the Lehman Brothers collapse on September 15, 2008, the stock price declined further to $7.17 a share, its all-time low, on November 20, 2008 (Historical Price Lookup, n.d.).

The global financial crisis had a huge impact on Starbucks as customers were forced to cut short their trips to Starbucks in more ways than one. According to Schultz and Gordon (2011), the global depression and experts' opinions portraying Starbucks as "a poster child for excess" (p. 185), began to have a psychological impact on customers who thought that "by carrying around a cup of Starbucks coffee, they were not appearing frugal enough" (p. 185). At the same time, Starbucks was faced with the simultaneous emergence of two major competitors. Both McDonald's and Dunkin' Donuts saw profitability in the coffee business and began to offer coffee at comparatively affordable prices (Ignatius, 2011). On top of that, McDonald's opted to center its coffee promotion around the statement that paying four dollars for coffee wasn't a smart thing to do, a message aimed directly at Starbucks.

In dealing with this economic crisis, besides laying-off partners and correcting numerous business problems, Starbucks strived to transform the company by re-reviewing corporate values and its mission and by reconnecting with its important stakeholders. Exactly one year after Starbucks' stock price fell to its historical low of $7.17, it had gone up to $21.41 on November 20, 2009 (Historical Price Lookup, n.d.).

Instead of crediting such an achievement to the CEO himself, Schultz maintained that this comeback showed how Starbucks and its partners all collaborated to resolve the business problems and crisis (Schultz & Gordon, 2011).

Yet, according to Strentz (personal communication, July 19, 2013), by the fall of 2010, Starbucks had shown the slowest growth over two consecutive years in its 40 years of history. This depressing situation worried some of the major stakeholders, notably shareholders and the board, that Starbucks was no longer in a dominant position in the market. The company realized that to achieve its goal of sustainable global expansion, it had to rebuild trust first.

RESEARCH

Research showed that stakeholders in different parts of the world no longer felt they were engaged with the brand ("Starbucks: Transforming the Brand," n.d.). Schultz and Gordon (2011) attributed this to the company being too focused on store expansions, having all but forgotten its core values and mission. In

realizing the problem, Starbucks had to create momentum to reinforce connections with different stakeholders. In addition, after surviving the worst of the economic turmoil, Starbucks needed to demonstrate its return to its core corporate and market values. So, instead of continuing with its original strategic plan, Starbucks decided to use the occasion of its 40th anniversary to launch a comprehensive global campaign to reengage stakeholders and illustrate its plans for moving forward.

In the third quarter of 2011, Starbucks' efforts began to show results: many financial analysts upgraded their stock recommendations of Starbucks and the company posted record revenue and earnings per share ("Starbucks Brand Transformation," n.d.).

Research, particularly Edelman Public Relations' annual goodpurpose study (Edelman goodpurpose study, 2011), guided the formation of campaign goals and objectives, identification of key publics and messages, strategies and tactics, and measurement of results ("Starbucks Global Month," 2012).

To have a successful campaign that returned to the core values of the company and reengaged the stakeholders, the following research findings served as the guiding principles of the campaign planning ("Starbucks Global Month," 2012):

Edelman's Fourth Annual goodpurpose Study

Since 2008, Edelman Public Relations has conducted an annual global goodpurpose study that explores how consumers perceive societal issues and their expectations on how corporations and brands should contribute to society. As Starbucks prepared for a stakeholder engagement campaign, the findings of the fourth goodpurpose study provided the direction and foundation for campaign planning. Highlights of the study findings included the following:

- Seventy-one percent of global consumers believed that companies and consumers could achieve more to support good causes by working together.
- Eighty-six percent of global consumers believed that business had to place at least equal weight on society's interests as on its business interests.
- Forty-two percent of global consumers, when selecting from the values of social purpose, design and innovation, and brand loyalty, nominated social purpose to be the key purchase motivator in choosing between brands of equal quality and price.
- Sixty-three percent of global consumers wished companies would make it easier for them to make a positive difference.

- Sixty-four percent of global consumers considered it was no longer enough for corporations to only donate money; instead, they expected corporations to integrate good causes in their daily business operations.
- Sixty-one percent of global consumers would have a more favorable opinion of corporations that integrated good causes into their business operations, regardless of why they did so.

Edelman's 2011 Trust Barometer Study

Since 2000, Edelman Public Relations has conducted an annual Trust Barometer study that surveyed attitudes and perceptions among global opinion leaders (between 25 to 64 years of age, college educated, among the top 25% of the income groups per age group with reported significant media consumption and engagement in business and policy news) toward their trust in different organizations such as corporations, nongovernmental organizations (NGOs), government, and media. The 2011 Trust Barometer findings indicated the following:

- People had more trust in NGOs than corporations to do what is right for society.
- People in developed markets were more distrustful toward the media than people in still-developing markets.
- Sixty-six percent of people trusted the food and beverage industry more than other industries.
- Among opinion leaders, what mattered for positive corporate reputations were high-quality products or services, transparent and honest business practices, a company they could trust and that treated employees well.
- For all the surveyed countries, opinion leaders had high expectations that corporations invest in society.

In addition to these findings, research also showed that people were much less likely to believe media reports than information from NGOs, business, and governments. Consequently, getting a message across required simultaneous use of several channels.

Internal Starbucks Survey

Starbucks conducted its own survey to define audiences and identify approaches for the campaign. The key conclusion was that most (80%) Starbucks customers were interested in participating in volunteer activities in their communities.

SWOT Analysis

Based on interview results and relevant reports, a SWOT (strengths, weaknesses, opportunities, and threats) analysis of Starbucks as a company and brand revealed the following:

Strengths

- Customers all over the world, many of whom used to be greatly engaged in the brand
- Quality of the coffee
- Extensive store locations in more than 50 countries
- A unique corporate culture that emphasized being a responsible company and part of its communities

Weaknesses

- Continuous store expansion had made the company ignore its own values and mission in the market
- A price drop in the stock market

Opportunities

- Brand refresh represents Starbucks' new freedom and flexibility to explore new products, experiences, and regional growth strategies
- New ways to connect with current and future customers and stakeholders to support growth
- Increasing awareness among consumers globally of corporations' incorporating good causes in their business operations

Threats

- The brand community did not think Starbucks was a strong brand.
- Big new brands entering the market in 2008 and 2009: McDonald's introduced McCafé and Dunkin' Donuts also was positioning itself in the market as a place for coffee. These big brands were going after Starbucks.

Campaign Goal

The goal of the campaign Edelman developed for Starbucks was to fully transform the brand and return the company to a position of operational strength ("Starbucks: Transforming the Brand," n.d.).

Objectives

Edelman Public Relations outlined the following objectives for Starbucks' brand transforming campaign: growth, transformation, and connection ("Starbucks: Transforming the Brand," n.d.).

Growth

For the company to move forward, it was important that stakeholders' values and visions be aligned with the company's. An internal survey showed great interest among partners in their involvement in community service works. Starbucks has always positioned itself as closely linked with its communities. Therefore, for the company to move forward successfully, community service views from stakeholders needed to be incorporated into the company's planning.

A more specific objective also was developed: the campaign intended to achieve more than 75% message penetration in media coverage so as to effectively communicate Starbucks' future goals ("Starbucks: Transforming the Brand," n.d.).

Transformation

There were two stages to this objective: first, to enhance brand quality by showing Starbucks' conformance to core vision, mission, and values in action; and second, by enhancing its brand quality to increase the brand favorability among the major internal (employee) and external (customers) stakeholders.

Connection

Starbucks needed to deepen its relationships with customers and partners globally to reconnect and to strengthen their loyalty to the brand. In addition, the company promoted *Onward*, a book written by Starbucks CEO Schultz, as a must-read business book so stakeholders and shareholders could understand how Starbucks regained its market status.

TARGETED STAKEHOLDERS

Research had identified the following key publics/stakeholders:

- Partners: As employees have always been an important part of the company, in the reconnecting and rebranding process, the company hoped to recognize the effort and support from the partners in its return to success, and the passion for the company's future.
- Shareholders, financial analysts and business enthusiasts: To fully understand how Starbucks returned to success and the company's recommitment to its own values.
- Customers: The campaign also was meant to deepen the connection Starbucks had with customers based on the company's history, reinforce Starbucks serving the highest quality coffee, and elevate the relationship with partners.

Strategies

Three major strategies were developed to align with the objectives for this campaign ("Starbucks: Transforming the Brand," n.d.):

- A global growth strategy that illustrated retail, consumer packaged products, and digital platforms to highlight Starbucks' future growth
- Expressing Starbucks' transformation by revealing a new brand evolution logo. Starbucks' internal studio designed a transformed corporate logo that illustrated the brand redevelopment. In addition, Starbucks intended to reinforce the impression that all its beverages and products are cleverly handcrafted.
- Creating personal connection (or reconnection) opportunities with stakeholders such as customers, partners, local communities, and business influentials. This would require more interpersonal communication opportunities. To accomplish that, Starbucks planned to create occasions to show appreciation to partners and customers; to give back to communities; to openly discuss its business environment with investors, business influencers, and enthusiasts; and to apply direct engagement and social media platforms to reconnect stakeholders to Starbucks' values.
- Using owned (for example, the company website), traditional (television, newspapers, and magazines), and social media (such as Twitter and Facebook) to create awareness among targeted stakeholders around the world to

encourage their participation in global marquee events and local partner-driven service events such as a Starbucks global month of service planned for 2011.

- Employing a "rolling thunder"[1] approach for sharing main messages to targeted audiences. This would be accomplished by:
 - Using preexisting media activities to enhance the awareness and excitement about the Global Month of Service
 - Using Starbucks' words to tell stories for establishing the tones and directions of future discussions
 - Attracting local media interest in service events
 - Amplifying the influence of messages targeted at stakeholders by using third-party advocates
 - Creating marquee (high-profile) event experiences to encourage participation of targeted stakeholders

Tactics

Communicating Its Blueprint for Growth

Beginning in December 2010, Starbucks met with investors, shareholders, and business enthusiasts to discuss the company's brand development campaign (Strentz, personal communication, July 19, 2013). Investors and shareholders were comprehensively informed about Starbucks' "Blueprint for Growth." At several events, such as an investor conference and its annual shareholders' meeting, Starbucks management outlined its business model that integrated retailing with customer packaged products and digital platforms to lead the company to growth.

At its 20th annual shareholders' meeting in spring 2011, the company focused on how it was redeveloping itself to be a truly global corporation "by harnessing a powerful portfolio of brands with a unique business model, combining a global retail footprint with a significant Consumer Products business, and leveraging direct customer engagement that drives growth across all channels globally" ("Starbucks Outlines Blueprint," 2011). The plan included extending the brand beyond retail stores, developing the company's international development into emerging markets, and—despite Starbucks' two consecutive years of slow business growth by the fall season of 2010—strengthening financial results "by the return of top line growth and continued operational efficiencies that resulted in dramatic margin and earnings acceleration throughout the year" ("Starbucks Outlines Blueprint," 2011). The healthy financial situation of the company also provided more opportunities and directions for Starbucks' profit growth.

Brand Evolution

With its in-house design team and Lippincott, a global brand strategy and design consultancy, Starbucks reviewed other companies' brand refresh initiatives, specifically those run by Caribou, Pepsi, Walmart, Apple, and Nike (Strentz, personal communication, July 19, 2013; "Starbucks Logo Evolution," 2011).

In addition to coffee, Starbucks also managed Tazo tea, Ethos water, and Seattle's Best Coffee brands. As a result, as part of its 40th anniversary celebration, Starbucks launched the evolution of its brand on March 8, 2011, to indicate the company's continuous growth and its unique business model. The new logo showed "the brand's famous seafaring logo shift from being green and black to solely green" ("Starbucks Drops 'Coffee,'" 2011). Moreover, the original outer circle of the logo with "Starbucks Coffee" was removed, which brought more prominence to the siren figure ("Starbucks Drops 'Coffee,'" 2011).

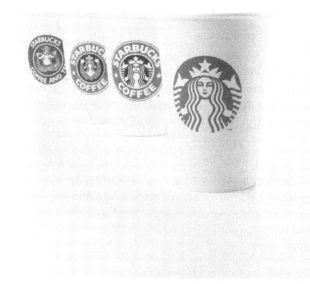

Figure 4.1. The Progression of the Starbucks Logo.

The new logo also reflected the new Starbucks strategies. First, it highlighted Starbucks' new business model: a commitment to diversifying the products the company provided to customers. Starbucks no longer only provided coffee for customers. More premium handcrafted espresso and food offerings were the new

items, such as Cocoa Cappuccino, Starbucks Tribute Blend, VIA Tribute Blend, and Starbucks Petites.

Second, the decision to keep only the green color in its logo deliberately shows Starbucks' commitment to be a sustainable green corporation.

After the new logo was designed, it was tested with loyal consumers and the feedback was positive ("Starbucks Drops 'coffee,'" 2011). This left the company confident that the new logo would be accepted by its stakeholders.

Four stores across the globe—Solana in Beijing, Avenue de l'Opera in Paris, Brompton Road in London, and Times Square in New York City—unveiled the new logo on March 8, 2011. In addition, outside the company's headquarters in Seattle, the new Siren design was unveiled during a lunchtime partner celebration ("Starbucks Celebrates 40 Years," 2011). CEO Schultz commented on the new logo, noting that as Starbucks continued to connect with more customers around the world in innovative ways, the brand also was evolving to address the changing global market. The new logo, which customers saw in all stores later in 2011, reflects this evolution by honoring Starbucks' deep coffee heritage while allowing the company to grow in exciting new ways ("Starbucks Celebrates 40 Years," 2011).

The 16-Market Book Tour (March–May 2011)

In promoting Schultz's book *Onward* as a business must-read among different stakeholders globally, the *Onward* Book Tour and Partner World Tour was organized. CEO Schultz shared with business influencers, customers, and partners the stories of how Starbucks transformed the brand and the company's vision and values. Town hall meetings also were organized to engage with partners in major markets. Book tours and town hall meetings were held in the following markets:

- In the United States: Seattle, Los Angeles, San Francisco, Denver, Chicago, New York City, Boston, and Washington, D.C.
- In Canada: Toronto and Vancouver
- In Europe: London, Berlin, Paris, and Madrid
- In Asia: Shanghai and Seoul

Global Month of Service

Starbucks announced that April 2011 was to be its Global Month of Service. In the past, Starbucks' community works were determined primarily by partners' health care programs and the company's philanthropic giving. For this special Global Month of Service, Starbucks wished to deepen its community relation-

ships and engagements globally, not only for April 2011 but also for years to come ("Starbucks Global Month of Service," 2012). Starbucks collaborated with national and local nongovernmental organizations (NGOs) around the world to develop community service activities. Because the company's community service priorities focused on youth and the environment, Starbucks arranged the following activity highlights around these areas (Strentz, personal communication, July 19, 2013).

- In London on April 5, 2011, Starbucks partnered with UK Youth, an NGO that helps young people learn the skills and capabilities they need in life, to provide three years of service in the areas of Westminster, Waterloo, and Pimlico. The activities included, for instance, refreshing and replanting gardens at the Churchill Gardens Estate for senior residents. In all, more than 300 Starbucks partners and more than 150 young people from local youth groups participated in these initiatives.
- In the United States, the global month of service activities were arranged in three major cities: Los Angeles (on April 9), New York City (on April 23), and Seattle (on April 30). Starbucks worked with HandsOn Network, with partners' participation, to paint murals and in general beautify schools, and on landscaping/maintenance of parks and public spaces. In all, nearly 2,000 Starbucks partners participated in the U.S. community service work.
- In Toronto, Canada, on April 16, Starbucks collaborated with Volunteer Canada, a national NGO that encourages everyone to involve themselves in community service work and works with different organizations on various community service activities. Projects here, as in the United States, included painting murals, school beautification work, and landscaping and maintenance of parks and public spaces. In all, more than 750 Starbucks partners and community volunteers participated in Canadian service activities.
- In Shanghai on April 25, Starbucks collaborated with CharyoU, an NGO that explores innovative models to solve social problems and enhance social improvements, to renovate the Guomei district into a greener neighborhood. More than 750 Starbucks partners and community volunteers participated in this project.

Reconnecting with Partners and Customers

A series of events reconnected Starbucks with important stakeholders, partners, and customers (Strentz, personal communication, July 19, 2013).

- In kicking off the company's 40th anniversary celebration, CEO Schultz, accompanied by hometown Seattle partners, attended the NASDAQ Opening Bell ceremony at the original Pike Place Market store at 6:30 a.m. Pacific Standard Time on March 8, 2011.
- Starbucks introduced Tribute Blend coffee, a special blend introduced for Starbucks' 40th anniversary. Tribute Blend put together four all-time favorite Starbucks coffees: Ethiopian, Aged Sumatra, Papua New Guinea, and Colombian coffee. All four flavors have their own unique characteristics widely welcomed by customers. This special blend captured the history of Starbucks and was created to honor the company's customers, partners, local communities, and coffee roasters and producers.
- As part of its anniversary celebrations, Starbucks acknowledged the importance of its customers. From March 10 to March 12 in 2011, at the local time of 2:00–5:00 p.m., all customers could enjoy, with the purchase of a beverage, a complimentary Starbucks Petite at participating stores in the United States and Canada.
- On Schultz's 16-city world tour, the company offered partners an opportunity to meet CEO Schultz face-to-face to hear his views. Starbucks also took this opportunity to recognize achievements of employees in different local markets.
- Starbucks delivered a free copy of Schultz's book *Onward* to all partners.

Media and Marquee Events

Five media and marquee tactics were employed so Starbucks could share a compelling message and connect directly with stakeholders worldwide ("Starbucks Global Month of Service," 2012).

- Using already planned media activities to enhance awareness and excitement about the Global Month of Service. For example, in March 2011, when Starbucks kicked off the 40th anniversary celebration and announced it was refreshing its brand, Starbucks unveiled information on its upcoming Global Month of Service marquee events to top-tier global media. On Earth Day in April 2011, the Starbucks team attracted the media's attention to local service activities by positioning these service activities as a good opportunity to celebrate Earth Day.
- Using Starbucks' own words in telling stories to establish the tones and directions of future discussions. Starbucks placed well-developed advertorial articles discussing Starbucks' commitment to community in United Airlines' in-flight magazine, *Hemispheres*, that reached more than 12 million

people around the globe. On April 5, 2011, Starbucks President Cliff Burrows and the CEO of the NGO Points of Light, Michelle Nunn, co-wrote a post on Huffington Post sharing their reasons for participating in Starbucks Global Month of Service. This helped to frame present and future conversations with targeted stakeholders and the media.

- Attracting local media interests in marquee and other service events. Starbucks developed targeted media pitches with information of local relevance to ensure coverage and to increase reader awareness of local service events. In addition, through calendar listings and local media buzz, Starbucks was able to drive media and public attention to the marquee events.
- Amplifying the influence of messages to targeted stakeholders through third-party advocates. Starbucks partnered with HandsOn Network, an NGO that intends to inspire and motivate people to change the world, to share information on Global Month of Services posts through HandsOn Network's and Starbucks' digital channels. Moreover, during the London marquee event, Starbucks also commenced a three-year partnership with Starbucks UK, Starbucks Ireland, and UK Youth, an organization that intends to help young people learn skills and competencies required for successful lives.

Timeline

December 2010:	Analysts conference
January 2011:	Launch of the new logo
March 2011:	40th anniversary celebration kick-off
March–May 2011:	Book tours for Schultz and his book *Onward* in 16 markets
April 2011:	Global Month of Service

Evaluation

Once Starbucks began its yearlong 40th anniversary celebration, 58,000 customers and partners were engaged through more than 1,400 events in 27 countries on four continents. Community service projects amounted to an accumulated financial value to communities of approximately US$ 3.3 million ("Starbucks Global Month of Service," July 2012). Based on the objectives of growth, transformation, and connection that Starbucks developed for this campaign, Starbucks and Edelman conducted the following evaluations ("Starbucks: Transforming the Brand," n.d.).

Growth

- During the five-month campaign period, Starbucks media coverage exceeded that of its competitors by 18%. In addition, there was an increase of 15% of share of voice compared to the year before.
- As for awareness of the location of Starbucks' stores, there was an increase of 11% compared with the previous year, and the awareness rate was higher than that of competitors.

Transformation

- Brand relevance: There was a 14% increase in consumers who considered the brand to be "for someone like me."
- Brand favorability: Consumers, after they learned about and experienced the brand evolution, showed a 40% increase in brand favorability. After CEO Schultz's 16-city worldwide tour there was an 87% increase in brand favorability among partners.
- Brand quality: Starbucks achieved a 15% lead in brand quality over its nearest competitor.

Connection

- Almost one in four persons considered Starbucks a valuable part of their communities.
- The book by CEO Schultz, *Onward*, was number one on 2011 bestseller lists compiled by Barnes & Noble, the *Wall Street Journal*, and the *New York Times*.

Media Publicity

- Media saturation: In all 24 countries where Starbucks implemented this campaign, there was extensive media coverage on more than 70 days. Some of the media coverage was through influential media outlets, for example, the *New York Times*, the *Wall Street Journal*, the *Financial Times*, *Asahi BE*

(Japan), and radio and television programs on CBS, National Public Radio (NPR), CNN, and CNBC.

- Message resonation: In terms of tones of the media coverage, 94% of coverage was neutral to positive and there was 84% message penetration. For example, Business Wire in New York reported in a neutral tone on a series of Global Month of Service activities in Starbucks' 10th anniversary celebration.

The positive recognition of Starbucks' effort and its contributions in communities where Starbucks does business also was mentioned in a story in *Food and Beverage—Close Up*:

> The value of this one month of service equals approximately US$4.2 million to these nonprofits across the globe, and is equivalent to almost 100 people engaged in service full time—40 hours a week—for an entire year. To give examples of the impact that can be achieved in 200,000 hours, volunteers could remove four million pounds of debris from 200,000 small parks or improve schools for 4,000 students ("Starbucks Celebrates Global Month of Service in April," 2011)

CONCLUSION

The phased approach for announcing each brand milestone allowed Starbucks to share a cohesive, multifaceted brand transformation story worldwide. Starbucks communication teams across 24 markets provided local insights and expertise to ensure the story resonated and helped establish meaningful connections with key influencers and stakeholders.

Ultimately, the brand transformation aligned stakeholders with the strategic vision for the company's growth; provided new ways to engage with customers, partners, and stakeholders; and demonstrated Starbucks' recommitment to core mission and values. Starbucks continues to be a leader in its market centered on coffee, food, and beverages. Since its brand transformation, it has expanded its brand portfolio through strategic acquisitions including Evolution Fresh, La Boulange, and Teavana. The company also continues to engage with stakeholders, and the corporate vision highlights Starbucks' commitment to its partners, customers, communities, and suppliers, and to the environment. To underline that these activities were not just one-offs, Starbucks has continued these service endeavors.

As an example, rather than donating to parties or politicians, CEO Schultz thought business leaders should take part in improving life and providing job opportunities to low-income groups. Starbucks therefore donated its profits from

stores in Harlem and Manhattan in New York City and in the Crenshaw neighborhood in Los Angeles to two community organizations working to improve education and job training for low-income young adults. Likewise, teenagers in high schools received barista training at Starbucks shops (Jargon, 2011).

Stakeholder engagement requires corporations to go beyond making profits and attaining stakeholders' interests. Welford (1995) contended that businesses should develop a corporate culture that is consistent with sustainable development. To achieve that goal, he said, corporations should shift from:

- Objects to relationships
- Parts to the whole
- Domination to partnership
- Structures to processes
- Individualism to integration
- Growth to sustainability (p. 117)

Starbucks' rapid expansion before 2008 had resulted in the company losing its focus on its original corporate values. The recognition of this loss led to Starbucks' resolve to reconnect the company with its stakeholders. Through months of talking, listening to, and engaging stakeholders in various activities, Starbucks once again proved itself a successful brand. The measures taken toward that end included a joint effort to work with partners and NGOs on community service activities. Starbucks also demonstrated social responsibility by delivering quality products, recognizing partners' contributions, showing appreciation to customers' support, and incorporating different views and comments from its diverse global stakeholders in the decision-making process. The sum of these measures turned out to be a promising recipe for success.

NOTE

1. "Rolling Thunder" is a term used internally by Starbucks' public relations firm, Edelman Public Relations.

REFERENCES

Beckett, R., & Jonker, J. (2002). Accountability 1000: A new social standard for building sustainability. *Managerial Auditing Journal, 17*, 36–42.

Brønn, P. S. (2007). Relationship outcomes as determinants of reputation. *Corporate Communications: An International Journal, 12*(4), 376–393.

Edelman goodpurpose study (2011). Retrieved from http://purpose.edelman.com/

Gao, S. S., & Zhang, J. J. (2006). Stakeholder engagement, social auditing and corporate sustainability. *Business Process Management Journal, 12*(6), 722–740.

Gregory, A. (2007). Involving stakeholders in developing corporate brands: The communication dimension. *Journal of Marketing Management, 23*, 59–73.

Grunig, L., Grunig, J., & Dozier, D. (2002). *Excellent organizations and effective organizations: A study of communication management in three countries.* Mahwah, NJ: Erlbaum.

Historical Price Lookup. (n.d.). Starbucks investor relations. Retrieved from http://investor.starbucks.com/phoenix.zhtml?c=99518&p=irol-stocklookup

Ignatius, A. (2011, July). The HBR interview: "We had to own the mistakes." Retrieved from http://hbr.org/2010/07/the-hbr-interview-we-had-to-own-the-mistakes/ar/1

ISEA. (1999). *Accountability, 1000 (AA1000): Standard, guidelines, and professional qualification.* London: Institute of Social and Ethical Accountability.

Jargon, J. (2011, October 5). Starbucks pushes to create jobs. *Wall Street Journal* (Online). Retrieved from http://search.proquest.com/docview/896137133?accountid=11440

Schultz, D. E., & Kitchen, P. S. (2004). Managing the changes in corporate branding and communication: Closing and re-opening the corporate umbrella. *Corporate Reputation Review, 6*(4), 347–366.

Schultz, J., & Gordon, J. (2011). *Onward: How Starbucks fought for its life without losing its soul.* New York: Rodale.

Starbucks brand transformation. (n.d.). *PR Week.* Retrieved from http://awards.prweekus.com/starbucks-brand-transformation

Starbucks celebrates 40 years of great coffee with new look, new global products, and a tribute to customers, partners and community. (2011, March 8). *Business Wire.* Retrieved from http://search.proquest.com/docview/855723819?accountid=11440

Starbucks celebrates global month of service in April. (2011). *Food and Beverage Close-Up.* Retrieved from http://search.proquest.com/docview/859074566?accountid=11440

Starbucks drops "coffee" from logo as it eyes brand extensions. (2011, January 6). *Campaign Asia-Pacific.* Retrieved from http://www.campaignasia.com/Article/243374,Starbucks+drops+coffee+from+logo+as+it+eyes+brand+extensions.aspx

Starbucks global month of service. (2012, July 11). *Holmes Report.* Retrieved from http://www.holmesreport.com/casestudy-info/12123/Starbucks-Global-Month-Of-Service.aspx

Starbucks logo evolution. (2011, January 6). Logo Design Love. Retrieved from http://www.logodesignlove.com/starbucks-logo-evolution

Starbucks outlines blueprint for profitable growth at annual shareholders meeting. (2011, March 23). Reuters. Retrieved from http://www.reuters.com/article/2011/03/23/idUS217401+23-Mar-2011+BW20110323

Starbucks: Transforming the brand with a global public affairs campaign. (n.d.). Edelman Case Studies. Retrieved from http://www.edelman.com/work/starbucks-40th-anniversary-transforming-the-brand-with-a-global-public-affairs-campaign/

Steyn, B. (2003). From strategy to corporate communication strategy: A conceptualization. *Journal of Communication Management, 8*(2), 168–183.

Trust Barometer 2011. (2011, January 25). Edelman Editions. Retrieved from http://edelmaneditions.com/2011/01/trust-barometer-2011/

Waddock, S. (2001). Integrity and mindfulness: Foundations of corporate citizenship. In J. Andriof & M. McIntosh (Eds.), *Perspectives on corporate citizenship* (pp. 25–38). Sheffield: Greenleaf.

Welford, R. J. (1995) *Environmental strategy and sustainable development: The corporate challenge of the 21st century.* London: Routledge.

Yang, S. U., & Grunig, J. E. (2005). Decomposing organizational reputation: The effects of organization–public relationship outcomes on cognitive representations of organizations and evaluations of organizational performance. *Journal of Communication Management, 9*(4), 305–325.

AUTHOR'S NOTE

The author would like to thank Alan VanderMolen, vice chair of Daniel J. Edelman Holding Company, for his kind assistance with this project. Special appreciation also goes to Tamra Strentz from Edelman Public Relations, who kindly agreed to be interviewed and provided additional information for this case study, and to the public relations staff at Starbucks for clarifying some points in early drafts of this case study.

Part II:
Case Studies in Social Responsibility

Coop Denmark and Africa: Development Through Trade

FINN FRANDSEN
Aarhus University

WINNI JOHANSEN
Aarhus University

EDITORS' NOTE

This case study provides a model for corporate social responsibility and sustainability. A Danish cooperative organization introduced and branded a series of products under the name Savannah that were produced in African countries south of the Sahara desert that suffered from an unfavorable reputation in the western world. Substituting development through trade for development aid proved transformational for African products and those involved in producing them, and also proved profitable for Coop Denmark.

This is how the introduction to the Savannah product series begins on Coop Denmark's corporate website:

> Savannah is a series of tasteful and exotic high quality products from Africa. The Savannah series represents a broad assortment of products. You can buy organic yoghurt from Uganda, dark chocolate from Ghana, and cold pressed avocado oil from Kenya. In Coop, we believe in development through trade. Each time you buy Savannah products, you contribute to the development in Africa.

Savannah is a product series established with the purpose of creating "development through trade" in African countries south of the Sahara desert. Coop Denmark is a large membership organization (hence the Coop in the company's name) owned by its members. Since its creation, Coop Denmark has worked hard to promote itself as a company that takes the word *responsibility* seriously.

The aim of this case study is to present the background of Coop Denmark's Africa initiative and how it has developed since its inception in 2010 to what constitutes Coop's Africa initiative today. We will describe the goals and objectives as well as the challenges of this ambitious project. We also will identify the key publics and examine the communication strategies and tactics applied by Coop Denmark in its campaign where marketing communication (branding of the Savannah products) goes hand in hand with public relations and corporate social responsibility (CSR and corporate branding).

BACKGROUND

Coop Denmark was originally named *Fællesforeningen for Danmarks Brugsforeninger* (Danish Consumers' Cooperative Society), abbreviated as FDB. It was founded in 1896 on the initiative of Severin Jørgensen (1842–1926), an industrious and idealistic cooperative manager from Jutland, the peninsula forming the mainland part of Denmark. The new national association was created as a procurement company for the growing number of local cooperatives, which had started spreading in the 1860s. The purpose of these cooperatives was to provide the poorest part of the population with better and less expensive consumer goods by establishing cooperatives, where each individual member owned a part of the corporation.

The Danish cooperative movement was strong from the end of the nineteenth century until the 1960s, forming a series of producer- or consumer-controlled companies all over the country (dairies, slaughterhouses, agricultural purchasing and sales associations, saving banks, etc.). The people behind these cooperative organizations were medium-sized farmers with a political affiliation to the Danish liberal political party Venstre. They were inspired by the Danish priest, poet, and philosopher N. F. S. Grundtvig (1783–1872) and were in opposition to the old power elite in Denmark: the big landowners and the conservative political party Højre. The ideology behind the cooperative movement, including Coop Denmark's strong focus on being a member-driven

organization, was influenced by ideas about autonomy, democracy, and self-organization.

FDB became Coop Denmark in 2002 when Coop Norden, a pan-Scandinavian retail chain owned by three national cooperatives (Sweden's KF, Denmark's FDB, and Norway's Coop NKL), was established due to the growing internationalization of the market for consumer goods. As a result of this transformation, the association FDB was separated from the business Coop Denmark. FDB still held a 38% stake in the new company. However, the poor performances of Coop Norden caused the parent companies to re-divide Coop Norden's operations by 2008, replacing Coop Norden with Coop Trading, an inter-Nordic procurement company for co-ops in Denmark, Norway, Sweden, and Finland.

Today, 1.3 million Danes out of a population of only 5.5 million people are members of Coop Denmark. This makes Coop the country's leading retailer and supermarket conglomerate with about 1,200 supermarkets (SuperBrugsen, Dagli'Brugsen, and Irma), hypermarkets (Kvickly), and discount stores (Fakta). In 2011, Coop Denmark had more than 36,000 employees and revenue of 39.6 billion DKK (USD $7.2 billion). Its most important competitors are Danish Supermarket Ltd. (including Føtex, Netto, and Bilka), the Norwegian discount supermarket chains Rema 1000 and Kiwi, and the German supermarket chains Aldi and Lidl. Coop Denmark has a market share of 42% while Danish Supermarket Ltd. has a market share of 34%.

Coop Denmark's vision is to be the most responsible retail company in the Danish market. For years, Coop Denmark, selling one-third of all the food products consumed by Danes, has worked hard to fulfill this vision. It started these efforts in the 1980s with the marketing of ecological products. Today, Coop Denmark focuses on responsible retailing within four key areas: (1) health, an area where Coop has established labeling schemes such as the Keyhole label to assure that healthy products are easy to find in the supermarket; (2) the environment and ecology, where Coop is working on expanding the market for eco-products, protecting the environment, and avoiding unnecessary waste of food; (3) the climate, with Coop working on providing information about climate-friendly purchasing habits; and (4) ethical trade, which is the area to which Coop Denmark's Africa initiative contributes. Consequently, these four key areas set the frame for Coop's focus on propelling a positive social impact and consumer involvement, and also one involving suppliers in innovative value chain solutions to social, environmental, and economic challenges in upstream activities in specific value chains.

METHODOLOGY

This case study was conducted applying various qualitative research methods. There was one semi-structured in-depth interview (lasting two hours), followed by a series of short verbal exchanges by telephone and email, with senior advisor Brian Sønderby Sundstrup and CSR project manager Layanna Martin, responsible for Coop Denmark's Africa initiative. Coop Denmark also provided access to relevant documents including *Coop Denmark Responsibility Report 2011*, *Behind Coop's Africa* initiative (a 90-page booklet distributed among Coop Denmark's employees in November 2013), and *Coop Inside*, Coop Denmark's employee magazine. In addition, the case study incorporated information retrieved from the corporate website (first, the *Trade with Africa* portal), articles from *Samvirke* (Coop Denmark's member magazine), as well as the media coverage of Coop's Africa initiative in Danish national newspapers in 2012 and 2013 (delivered by Infomedia A/S, a Danish provider of media intelligence).

SITUATION AND SWOT ANALYSIS

Denmark is located in Northern Europe, one of the richest parts of the world based on gross domestic product (GDP) and a region that acknowledges individual and human rights. The situation is different on the African continent where individual and human rights are not ratified to the same extent as in the western part of the world. Also, African countries suffer from a stereotypical reputation in the western world. Some of the root causes of this reputation are the following:

- Africa is often described, erroneously, as a single entity ridden with conflict, famine, war, corruption, and disease.
- Media coverage of Africa is often one-sided and positions the continent and its populations as helpless and dependent.
- As aid beneficiaries, many African countries perpetuate the image of Africa as a helpless and dependent continent.
- Africa is known as a continent with child labor and workers' rights issues.
- The rhetoric concerning Africa revolves around the concept of *reducing poverty*, and not around the concept of creating *wealth and growth*.

However, "Africa is the largest recipient of Danish development aid."

The stereotypical reputation of Africa in the western world including Denmark raises important issues that Coop Denmark had to address in its African initiative (especially in relationship to the Savannah product series):

- How can unfavorable country-of-origin perceptions be overcome when branding African products to consumers in the Danish market?
- Which communication challenges exist for a first-mover (i.e., the first company to enter a new market) in the Danish market in terms of branding African products to Danish consumers?
- How should stakeholder expectations be managed concerning those consumers with high involvement who demand responsibly sourced products and thus expect African products to be fair trade or organic when this is not the case with the Savannah brand?

CORE OPPORTUNITY OR PROBLEM

The problem was as follows: On one hand, many African countries receive large amounts of development aid from Denmark; on the other, Denmark does not trade very much with African countries. Africa is the second largest continent in the world, where approximately one billion (or around 15%) of the world's population lives. However, Africa's share of the world's trade represents only 3%. Aid tends to delay the development of modern business in Africa. Coop Denmark is contributing to a solution to this problem with its African initiative focusing on development through trade. Danish media have coined this new trend "development business."

SWOT ANALYSIS

Given this problem, what are the strengths and weaknesses (internal conditions), and what are the opportunities and threats (external conditions), that Coop Denmark had to consider concerning its Africa initiative? Table 5.1 presents some of the most important challenges that Coop Denmark had to face.

Table 5.1. SWOT Analysis.

Internal Conditions	
Strengths	Weaknesses
• A strong company (history, size, revenue, number of employees and members, etc.) • Long experience with CSR programs • Experience with operations in a foreign country (e.g., Honduras) • Experience with partners (e.g., the Danish environmental organization Nepenthes, which changed its name to Forests of the World in 2011, http:/www.verdensskove.org). • The risk is spread among several African countries and several different products	• Lack of internal commitment to the Africa initiative (from top management, but also from lower-level employees) • Lack of internal collaboration between departments • Lack of resources geared toward development initiatives • Disconnect between needs of local African communities and Coop's needs • Lack of knowledge about how to organize suppliers around a private label/sub-brand
External Conditions	
Opportunities	Threats
• Africa needs more global trade and commercial investments as a supplement to traditional development aid. • Growing interest among Danish consumers for new and interesting products • Limited trade focus on African products by competitors in the Danish retail market	• The stereotypical and unfavorable reputation of Africa • Coop needs to develop a new "way" of doing business with African suppliers (suppliers don't come to Coop, Coop has to go to them) • Lack of product volume • Negative reactions to "development business" (development through trade) among Danish consumers • Consumer expectations that the Savannah brand applies to the Fair Trade label

GOALS

Ethical trade is one of the key areas in which Coop Denmark promotes itself as a responsible company. Coop Denmark created a list of ethical guidelines and obligations applicable to the company itself and to its suppliers, as well as a policy for ethical trade. The ethical obligations are reflected in activities such as the Danish Ethical Trading Initiative, a multi-stakeholder initiative founded in 2008 that brings together trade unions, business associations, NGOs, and companies; its membership in the United Nations Global Compact, which promotes 10 ethical social responsibility principles; and its membership in the Business Social Compliance Initiative (BSCI). The policy for ethical trade is contained in a set of principles specified in Coop's Policy for Ethical Trade (see Appendix 5.1).

Since late 2010, Coop Denmark's Africa initiative has been a key component of the company's ethical trade activities. The philosophy behind this initiative is simple: Increased trade with African countries will lead to a positive development whereby the production capacity and the competitiveness of these countries will be strengthened. Thomas Bagge Olesen, CEO of FDB, said in October 2010: "The development strategy of the government involves the business world, and now we will also strengthen Africa as part of our core business, the supermarkets. By demanding and selling more products, we will make Africa richer through trading" (http://www.coop.dk,2010).

Thus, in 2010, Coop Denmark's Africa initiative conformed to the development aid policy launched by the then liberal Danish government ("Freedom from Poverty—Freedom to Change"). However, in 2013, under a new government led by a prime minister from the Social Democratic Party, both the minister of commerce and the minister of development highlighted the need to rethink the concept of development aid: "Aid to a sustainable development is a cornerstone in Danish development policy. At the same time we have a group of Danish companies that can deliver many of these solutions. It can create a synergy involving the strengths of Danish businesses even more for the benefit of the development in Africa" (*Information*, 2013). In line with this, Coop Denmark has received funding from Danida (Danish International Development Agency, Ministry of Foreign Affairs of Denmark, http://um.dk) for its development project in Kenya.

Coop Denmark's Africa initiative is comprised of parts created at two different points in time, but existing side by side. In late 2010, Coop Denmark developed a bipartite strategy for its Africa initiative. On the one hand, Coop chose to develop the market of high-quality African products and market these products on the Danish market. On the other hand, Coop's objective was to contribute to the sustainable development of African smallholders by integrating farmers, who

would not otherwise have access to a commercial market, in existing value chains. Consequently, Coop's mission was to propel social, economic, and environmental development among African smallholders through trade by way of Coop's private label, Savannah. This was to be accomplished through different development projects in sub-Saharan Africa, funded by Coop's own Africa pool.

Give Africa a Hand

In 2010, prior to Coop's introduction of its development initiatives and the Savannah brand, Coop introduced a pilot project, the "Give Africa a Hand" campaign. The objective and focus of the "Give Africa a Hand" campaign involved Danish consumers and private investors in the sustainable development of African farmers. Aside from purchasing African products, consumers were also able to invest in the farms from which these products originated by lending them money. To assure the highest degree of transparency concerning these loans, Coop Denmark collaborated with MYC4, an "Internet marketplace" where investors from around the world could lend money directly to entrepreneurs doing business in Africa ("What Is MYC4?," www.myc4.com). The clients themselves determined the interest rate of these micro loans, starting at the amount of 35 DKK (USD $6). The loans had to be paid back over a period of 6 to 12 months. In this way, consumers contributed to commercially sustainable production of African products for sale in the Danish market. Coop's collaboration with MYC4 was suspended in 2011 when Coop initiated its first development project in Kenya in collaboration with CARE Denmark and the Kenyan vegetable producer Sunripe.

A Focus on Partnership and Trade with Africa

Contrary to the "Give Africa a Hand" campaign that involved consumer investments, Coop's Africa pool is managed by Coop itself and does not include consumer investments; Coop's main focus is trade with Africa and not traditional aid as a means of creating sustainable development. Here is a story, published on Coop Denmark's Trade-with-Africa Web portal, that illustrates the goal and the way the Africa pool operated:

Cocoa production and child labor

Ghana is the second largest producer of cocoa beans in the world, having more than 750,000 small farms. The country is poor, and instead of going to school the children must often help their parents in the fields, especially during harvests. Experience

shows that as soon the farmers gain a profit, they send their children to school. By offering agricultural training to the farmers it is estimated that they will be able to increase their production by almost 40 percent. The quality of the cocoa beans also will be improved, which then again will give the farmers a higher price for their products. This economic stability tends to assure that the children will attend school. Together with two of its partners, Coop Denmark supports 4,800 Ghanaian cocoa farms through sustainable product methods including agricultural training.

An integral part of Coop's Africa initiative involved the Savannah brand, which included products from African countries south of the Sahara desert that would contribute to African economic profitability and stability. In line with Coop's focus on trade, the Savannah brand had to exist on a par with other Coop brands and therefore had to be commercially sustainable and of interest to consumers. The new product series was launched in February 2012 consisting of the following products:

- Lime marmalade produced by Eswatini Kitchen in Manzini, the largest city in Swaziland. Eswatini is a cooperative with 50 employees, all women and many of them single mothers. The profit from the sale of the lime marmalade goes to Manzini Youth Care, an organization that provides food and accommodation for young adults and children living in the streets.
- Vanilla pods from Uganda
- Whole wheat and chocolate cookies from Tanzania and Uganda
- Coffee from Kenya
- Orange and pineapple juice from Ghana and Kenya
- Beef from Namibia
- Victoria Bars from Tanzania

In its present form, the Africa initiative collaborated with selected suppliers and interest organizations. In Kenya, Coop Denmark collaborated with CARE Denmark, an autonomous foundation established in 1987. CARE Denmark focuses on "strengthening the capacities of poor people living in rural areas with the purpose of improving their livelihoods, as well as the recognition of and respect for their rights" (http://www.care.dk). CARE Denmark operates in 10 African and Asian countries including Ghana, Kenya, Tanzania, and Uganda. In all of these countries the organization collaborates closely with citizens.

In Tanzania, Coop Denmark collaborates with the World Wildlife Foundation (WWF). In Namibia, Coop Denmark collaborates with Meatco Foundation, founded in 2009, a foundation and not-for-profit organization that "aims to work to alleviate poverty and improve conditions among the rural subsistence farming communities" in the north of Namibia (www.natures-reserve.co.uk).

Other partners included IBIS, an independent, member-based education and development organization in Denmark (the name is a symbolic reference to the ibis bird flying from North to South and feeling at home in both hemispheres); Source Trust, a not-for-profit organization set up by Armajaro Trading Ltd. to help farmers improve their livelihoods through sustainable farming practices; and Toms, the largest chocolate and confectionary manufacturer in Denmark.

From the start, Coop Denmark emphasized that its Africa initiative was not philanthropic in nature. As a result, it had to be commercially sustainable for Coop, its suppliers, and the primary producers of the Savannah products.

Over time, a few critical voices were heard in media coverage. In the same week the Savannah product series was launched, Coop Denmark was criticized for sending out mixed signals. On one hand, the company was praised for acting in accordance with a change in consumer patterns with groceries, and moving from a focus on ecology to a focus on social sustainability, including a wish to improve working conditions in less-developed countries. On the other hand, Coop Denmark was criticized for including in the Savannah series African products that were neither Fair Trade nor Organic "Green." An expert from the Copenhagen Business School explained:

> It may send mixed signals when you on one hand sell goods produced in Africa, but they are not necessarily eco-products or Fair Trade products. The problem may be that the people identified as the target group that could pull off the sale simply don't want to, because they do not see the product as good enough. (Winther, 2012)

Coop Denmark responded to this criticism by saying that products with a label are often more expensive than ordinary products, and that adding labels to African products would be a barrier to substantial sales in the Danish market because the added cost would deter many consumers from buying these products.

OBJECTIVES

Coop Denmark defined three objectives for its Africa initiative for the period 2012–2015:

- Concerning the Africa pool: Before the end of 2015, Coop Denmark will spend at least 10 million DKK (USD $1.8 million) on the development of small farms and suppliers. In 2012, Coop donated $2.4 million DKK (USD $435,000) to the pool. The entire amount goes to the development projects.

- Concerning the Savannah product series: Before the end of 2015, Coop Denmark will create a turnover of more than 100 million DKK (USD $18.1 million). Simultaneously, from 2012 to 2015, Coop will expand the assortment of the series from the original 16 products to at least 60 products.
- Finally, Coop Denmark will substantially increase the press coverage of African products and trade with Africa through promotional activities and goal-oriented communication.

KEY PUBLICS

The Coop Denmark Responsibility Report 2011 contained a stakeholder map produced by the company that reveals a great deal about the worldview of Coop. As Table 5.2 demonstrates, the map is both a list of key stakeholders and an account of communication activities (including research) vis-à-vis the individual stakeholder groups to which is added some self-appraisal, such as looking at Coop Denmark's relations with the media.

Table 5.2. Coop Denmark's Generic Stakeholder Map.

Stakeholder Group	Communication Activities
Danish consumers	Annual survey among the clients of SuperBrugsen and Kvickly including questions concerning their behavior and attitudes toward health, environment and ecology, climate, and ethical trade
Members of FDB and Coop Plus	Members who have joined Coop Plus receive information about Coop via direct emails and http://www.coop.dk
FDB	FDB and its 1.3 million members own Coop as one of its subsidiaries. FDB and Coop collaborate on specific projects.
Suppliers	Coop Denmark has a policy and a code of conduct for suppliers (see Appendix 5.1).
Employees	Coop reaches its employees through the employee magazine *My Coop—Inside*. In addition, employees receive news emails and participate in town hall meetings at Coop Denmark headquarters in Copenhagen. Surveys are conducted among the employees concerning their knowledge about, and attitudes toward, the social responsibility work of Coop.

Continued.

Stakeholder Group	Communication Activities
NGOs	Coop has partnerships with Save the Children Denmark and World Wildlife Fund Denmark. In 2011, Coop invited the NGOs to a dialogue meeting encouraging them to comment on Coop's new CSR strategy.
Public authorities	Coop participates in dialogue meetings and hearings concerning legal proposals and acts organized by the public authorities. Coop is represented on various forums such as the Danish Council for Corporate Responsibility.
Media	Coop is the third-most-covered company by the media in Denmark, and has the most positive media coverage of its CSR efforts.

Source: Coop Denmark Responsibility Report, 2011.

Having a full overview of the key publics involved in Coop Denmark's Africa initiative requires specifying and adding other stakeholder groups: African farmers and suppliers, partners, and aid agencies operating in African countries south of the Sahara desert.

The consumers thought to be most interested in the Savannah product series and the Trade-with-Africa concept had one or more of the following characteristics: they already know about African products; they are ideologically oriented, that is, they only buy ecological products; and/or they are economically oriented, that is, a good price is better than a good conscience.

STRATEGIES

Coop Denmark applied a diversified communications strategy to its Africa initiative. The strategy consists of (1) a special portal entitled Trade with Africa, which included a blog; (2) product branding of the Savannah products mixing corporate level campaigns with local campaigns and events organized by individual member stores or chains; and (3) the Savannah Storytellers, a group of volunteers who tell stories about Coop Denmark's African initiative.

The Trade with Africa Portal

On the corporate website of Coop Denmark, there is a short description of the Africa initiative under the link "Ethical Trade" (under "Corporate Social

Responsibility"). In addition, Coop Denmark created a special Trade with Africa portal (www.handelmedafrika.dk) that contained the following elements: (1) presentation of the Savannah products; (2) stories about the African initiative; (3) background of the project; and (4) a blog. The portal is especially suited for the visual presentation of the products, but it also is well suited as a medium for telling stories through imagery and sound about Africa and African products.

The blog included in the portal is titled "Why Buy African?" The purpose of this blog is to present "a different and more balanced picture of the African reality and how Danish consumers can have an impact on this reality" (http://blog.handelmedafrika.dk). Danes were invited to participate in an "open and honest dialogue about the growing development in Africa." Four bloggers, all young women between 28 and 34 years old, chronicled their experiences with the Savannah products.

PRODUCT BRANDING

The products of the Savannah series were, and continue to be, subject to product branding in the same way as all products sold by Coop Denmark in its numerous supermarkets. The Savannah brand and the product branding strategies were carefully designed and were adjusted to take into account the perceptions and imagery about Africa.

When the Africa initiative was launched, Coop Denmark was aware of the importance of presenting to its customers and stakeholders a different picture of Africa, and in particular of African products. Perceptions and non-product imagery have a large impact on consumers' perception of a new brand. If the consumers have a negative, unfavorable perception of Africa or African products, they may refrain from buying the products just because of the country of origin and the imagery associated with that country. The task at hand centered on developing a new and contemporary imagery together with stories that did not associate African products with hygiene problems or food risks, but instead brought high-quality, delicious products to the mind of consumers. However, the stereotypical imagery of a poor and hungry Africa is still prevalent, more so than the signs of sustainable social, economic, and environmental growth (interview with senior advisor Brian Sønderby Sundstrup and CSR project manager Layanna Martin, Coop Denmark, September 11, 2013).

According to Sundstrup and Martin (personal communication, September 11, 2013), consumer surveys conducted by Coop Denmark showed that Danish consumers supported the idea of helping Africa through the development of trade. Thus, Coop wanted to present a picture of high-quality products but at the same

time support the positive dream, alive among many Danish consumers, about Africa. For this reason, its product campaigns tried to appeal to something in between. The series was renamed Savannah, and its key strategy was to stress the tastefulness, deliciousness, and high quality of the products rather than focusing on Africa as such. The packaging's black color in combination with gold was chosen to signal exclusive products, and the acacia tree was used as a symbol of the dream of Africa.

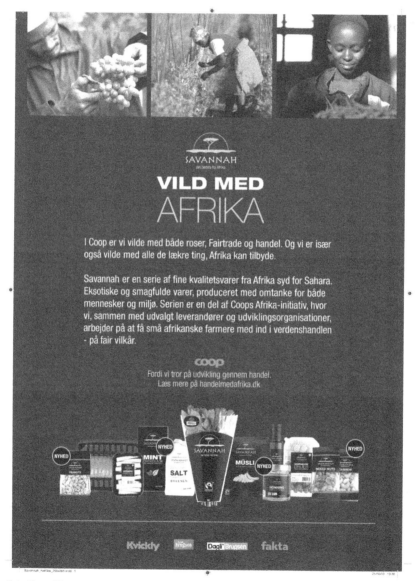

Fig 5.1. Coop Denmark's "Wild with Africa" campaign, November 2013.

The Savannah Product Series

The key messages were transformed into pay-offs such as "development through trade," "the best from Africa," and "new delicious and exotic products" and included sentences about how tasteful African products can add something to the Danish cuisine, whether they are ecological yogurt from Uganda, dark chocolate from Ghana, or cold-pressed avocado oil from Kenya.

At the corporate or group level, Coop developed three annual campaigns. The media-mix mainly consisted of three types of media: (1) ads and journalistic news articles within the Coop's member's magazine *Samvirke*; (2) Facebook; and (3) advertisements in specific lifestyle magazines to project focus on the exclusive and exotic quality. However, at the local level, member stores also developed their own individual campaign activities. Individual stores promoted the whole Savannah series through specific events, in-store material, original flyers, and sales material distributed weekly with a focus on price or product news.

Events in Member Stores

One of the characteristics of many Coop stores is that they see themselves as being a member store with a democratic aim. The consumers who are members all have a membership card, and they usually are democratically oriented, especially when it comes to development projects. This means that they take ownership of a project such as the Africa initiative. In these member stores, people are proud of standing with a product that has an "attitude." They care for the Savannah products and the Africa initiative, and they launched a series of local activities from specific flyers to Saturday events with Africa as a main theme.

In fact, the stores took over ownership to such a high degree that Coop at the corporate level had to acknowledge that it needed to take this into account (Sundstrup and Martin, personal communication, September 11, 2013). It was indeed important that the stores and the members created ownership for the series, accepting corporate assistance in doing this, especially in relation to their in-store activities and events. This also was a way to control, at least to some extent, what occurred. Some of the stores were so attracted to the Africa initiative that they invented special and often creative events, offers, and activities. However, and unfortunately, some activities reactivated the old myths about Africa. This was the case, for instance, when a store held a Saturday event with a circus including "animals" from Africa, or when a store collected contributions to give a hand to the hungry people in Africa. These are exactly the kind of stereotypes that the Africa initiative tried to make people abandon.

Savannah Storytellers

These local store activities gave birth to a new idea: the Savannah Storytellers. The Savannah Storytellers are now part of the strategic plan implementation with stories from Africa and about the Africa initiative. In June 2012, Coop Denmark advertised for volunteers among Coop members, or member electives, who would commit themselves to tell stories about Coop's Africa initiative, the Savannah product series, and Coop's focus on development through trade, and an engaged, vivid, and authentic way in lectures to other FDB members, or to people with a special interest in the topic. The voluntary work as a Savannah Storyteller included a trip to Africa. The deadline for application was August 12, 2012.

From a total of 89 applicants, Coop chose eight persons as Savannah Storytellers. Three men and five women, all average consumers, were chosen from different parts of Denmark to engage in dialogue and face-to-face communication with Danish consumers about trade with Africa. It was important that the Savannah Storytellers were able to relate to their audience in a down-to-earth manner. Although they acted as representatives of Coop, their task was to relay a personal and authentic account of their own impressions and experiences of Coop's Africa initiative and sustainable development in sub-Saharan Africa. Therefore, these eight Storytellers went through a series of workshops and were subsequently sent on an educational trip to Kenya and Uganda where they experienced some of the development projects and visited some of the smallholders producing beans and sugar peas for Coop's Savannah brand. Back in Denmark, they told their stories at venues including the annual meeting or the general assembly of the 3,500 Coop member stores around the country. In this way, they served as personal ambassadors for the Africa initiative.

The Savannah Storytellers were a success. In return for the trip to Africa, the eight storytellers each had to give an average of 10 lectures about their experiences in Africa. In total, 80 storytelling events took place, and more than 6,000 people heard the stories. In addition, the stories were told in articles and videos that can be found at the Trade with Africa portal (http://www.handelmedafrika.dk).

The individual stores also could ask for a Savannah Storyteller to be present at a Saturday afternoon event of some kind. This resulted in many different lectures and stories. According to senior advisor Brian Sønderby Sundstrup, Coop Denmark, it was important to have "the courage to let go of the control, and to work with the idea of co-creation and the storytellers as individual ambassadors for the product series and the initiative" (personal communication, 2013). In November 2013, Coop started recruiting a new team of Savannah Storytellers.

At the Trade with Africa portal, the following story told by one of the Savannah Storytellers is posted. She tells about her visit to a farmer in Kenya named Bon Fis:

> Bon Fis holds a sugar pea in front of me telling me that he gets a better and more stable price for his vegetables now when he sells them to Sunripe, which sells them to Coop before he had to accept the price offered by the local dealers. And both price and volume varied a lot. Today, he knows that the trucks from Sunripe will arrive twice a week. He can make plans for the harvest asking more of his neighbors to help him with picking in the field in order to finish the harvest in time. However, the collaboration is not without problems. "You want to have perfect beans," he says. "No brown spots, no pesticides, and clean water. If this is not the case, Sunripe will not buy my beans." I tell him about how his sugar peas are located together with other vegetables in my coop, and how I as a consumer always try to find the best package when I purchase vegetables. Although my SuperBrugsen is far away from the fields in Kenya, it makes sense.

Internal Branding

The internal communication of Coop Denmark turned out to be one of the biggest challenges for the Africa initiative. According to Sundstrup and Martin (personal communication, September 11, 2013), they had underestimated the importance of the internal dimension. The Savannah product series belonged to the business division of Coop and was managed by the sales and marketing department. The CSR division is separate. It was important that internal stakeholders acknowledge the relevance of the initiative. Perhaps people at the corporate level of Coop Denmark did not communicate enough about the relevance of the initiative: Why have we taken this initiative? And why do we have to be proud of it? To trade with Africa also means to think in terms of volume and the constant supply of new products: "If there are not enough products and/or new products to expand the assortment, and constant marketing efforts are not being made, the initiative will die. In order to avoid such a situation, it needs to be highly prioritized by the marketing department" (Sundstrup & Martin, personal communication, September 11, 2013).

Retailers often focus on the operational level of their businesses. Therefore, they were looking for the point in time where the Africa program went from being an initiative to develop trade with Africa to being a profitable part of daily operations. Another challenge was the strong sales culture of retailers. Usually, the suppliers knocked on the door when they had new products to offer. Only rarely do purchasers leave their offices. However, it is even more rare that somebody can travel to Denmark from Africa to knock on the door of Danish retailers. This

demands new ways of thinking. At this point, in late 2013, the goal of Coop Denmark for production in Africa is to reach five times the current production. Thus, the business part is important, but it is also about creating a link to a responsibility strategy at the corporate level as well as to the chains and stores. To rebuild the lack of internal communication about the initiative, a new 90-page booklet titled *Behind Coop's Africa Initiative* was distributed among Coop Denmark's employees in November 2013. By telling employees about the development of the initiative, presenting facts about African production and the contributions it has made to African farmers, plus the challenges and the reactions to them, Coop Denmark hoped to create a better understanding of the importance and relevance of such initiatives, and to make people believe in the African initiative at a business level by comparing it to the launching of eco-products.

TIMETABLE AND BUDGET

The implementation of Coop Denmark's Africa initiative doesn't follow the tight schedule of a campaign in the proper sense of the word. It was spread over a period of two years. Table 5.3 indicates some of the milestones along the road.

Table 5.3. Initiative Timetable.

2008	Coop Denmark is the co-founder of the Danish Ethical Trading Initiative.
Fall 2010	The Africa Pool is established.
October 25, 2010	The "Give Africa a Hand" campaign is launched to increase sales of African products.
February 2012	The Savannah product series is launched.
June–August 2012	Coop Denmark advertises for Savannah Storytellers.
November 2013	The "Wild with Africa" campaign to promote the Savannah products begins.
2012–2015	Implementation of strategy (more money for development projects; more products in the Savannah series; more promotional activities).

In 2012, the original goal of Coop Denmark was to reach annual revenues of 40 million DKK (USD $7.2 million); it surpassed that goal by reaching 70 million DKK (USD $12.7 million). In 2013, Coop reached the goal of 60 million DKK (USD $10.9 million). It is Coop's goal to reach annual revenues of 100 million

DKK (USD $18.1 million) by the end of 2015. Each year, Coop Denmark spends 3 million DKK (USD $54.54 million) on development projects.

EVALUATION AND MEASUREMENT OF RESULTS

According to an article published in October 2012 by *Samvirke*, Coop Denmark's member magazine, Danish consumers like the Africa initiative. A survey conducted by Coop and presented in this article showed that 45% of all respondents were able to recall the Savannah brand, and that 93% of them expressed a positive attitude toward the Africa initiative. They described the initiative as "relevant," "trustworthy," "sympathetic," "good for Africa," and "good for the clients." According to another article, published in September 2012 by the Danish news agency Ritzaus Bureau, the sales of African products were twice what had been expected. "Our ambition was to sell Savannah products for 40 million DKK in 2012, but already in mid-August we had reached 50 million DKK. So it is a success," declared Lasse Bolander, president of FDB's board of directors (Ritzaus Bureau, 2012).

THE FUTURE OF THE AFRICA INITIATIVE

Other retailers may want to join Coop Denmark in addressing opportunities in Africa. It is important to involve other players to "grow the movement," exactly as was the case when ecology took off in the 1990s. To take similar initiatives on other continents is another potential scenario. Concerning the Savannah product series, it probably will have to face the new climate agenda, and to be challenged by climate issues. Is it, for instance, acceptable to fly vegetables from Africa to Denmark? Another future issue to be addressed is access to water. Responsible initiatives such as Coop Denmark's Africa initiative always are likely to be subject to complex dynamics in a globalizing world.

APPENDIX 5.1. COOP DENMARK'S POLICY FOR ETHICAL TRADE

Coop and its subsidiaries:

- Must respect human rights and employee rights together with other competitive conditions when selecting suppliers

- Must work actively to take effective initiatives ensuring that goods and services are produced in a way that is no threat to employee rights or human rights
- Will demand that Coop's suppliers must be able to document that the production takes place in accordance with the ethical guidelines and the ethical policy—and to develop arrangements to verify this
- Must contribute to take effective initiatives ensuring that the production of goods for the stores complies with the ethical guidelines
- Will work through dialogue for the ongoing improvement of production conditions among suppliers that are complying with the ethical guidelines
- Must work systematically with ethics as an integrated part of purchasing and selling goods
- Will use the fair trade label when/if/where there is a demand
- Will publish an annual status report about the work with ethics, as part of the company's annual report
- Will influence the debate on ethics in the retail trade through a dialogue with owners, consumers, public authorities, organizations, and other stakeholders (http://om.coop.dk)

REFERENCES

Coop.dk. (2010, October 25). FDB og Coop hjælper Afrika i supermarkedet. Retrieved from http://www.coop.dk.

Coop Inside. Coop Denmark's employee magazine. Retrieved from http://coopforum.dk.

Hoovers (2013). Coop Danmark A/S Profile. Retrieved from http://www.hoovers.com.

Martin, L., & Sundstrup, B. S. (Eds.) (2013). Behind Coop's Africa Initiative. Herlev: Coop Denmark.

Olsen Dyhr, P., & Friis Bach, C. (2013, January 13). Afrikas vækst kræver nytænkning af handel og bistand. Information. Retrieved from http://www.information.dk.

Ritzaus Bureau. (2012, September 13). FDB: Kunderne vilde med afrikanske varer. Retrieved from https://www.ritzau.dk.

Samvirke (2012, October 1). Vi vil gerne Afrika (1.10.2012). Retrieved from http://samvirke.dk.

Sundstrup, B. S. (2013, April 18). Udstilling femdoblede omsætning og øgede avancen på Savannah. Coop Inside. Retrieved from http://coopforum.dk.

Werge, M. (Ed.). Coop Denmark Responsibility Report 2011. Retrieved from https://om.coop.dk/ansvarlighedsrapport2011.

Winther, J. (2012, February 2). Coop vil score kassen på druer og oksekød fra Afrika. Berlingske Tidende. Retrieved from http:://www.b.dk.

AUTHORS' NOTE

We would like to thank senior advisor Brian Sønderby Sundstrup and CSR project manager Layanna Martin who are responsible for Coop Denmark's Africa initiative for providing us with invaluable information about the case and for their helpful comments on this case study.

Costa Rica Develops an Ecotourism Paradise

BARBARA DESANTO
Kansas State University

EDITORS' NOTE

Tourism in Costa Rica generates the country's highest annual revenue from a single source. While they welcomed these visitors, the Costa Rican government and tourism officials were concerned about preserving Costa Rica's tropical paradise and about enabling native residents to benefit economically from tourism. What resulted was an indigenous tourism campaign that developed into one of the most recognized and highly regarded sustainable ecotourism programs in the world.

Costa Rica: the rolling R of the country's name as it trips off your tongue conjures images of brilliantly colored exotic birds, pristine waterfalls, lush greenery—a tropical paradise that offers a feast for the eyes and the soul. And for the past several decades, Costa Rica has seen an increasing number of international visitors who want to experience its unique landscape and climate. While the Costa Rican government and its tourism sector have welcomed these visitors, they also developed and implemented one of the world's most recognized and highly regarded

sustainable ecotourism programs in the world. Use Google to search *ecotourism*, and Costa Rica will be at the top of the list almost every time.

Ecotourism is generally understood to be primarily concerned with preserving the natural physical habitat in a sustainable manner, while balancing the sharing of the natural resources with tourists to generate economic wealth for a region or country's people. This type of indigenous tourism has been studied by a number of scholars (e.g., Ashley, Goodwin, McNab, Scott, & Chaves, 2006; Cole, 2006; Fallon, 2002) with the conclusion that such forms of tourism, including ecotourism, can contribute to social and economic development (Butler & Hinch, 2007).

Schellhorn (2010) took a different perspective in his study, looking specifically at the social justice issues of who benefited most from tourism in some of the world's newer exotic locations. His conclusion was, "Native people will only benefit from the development of their resources if this process enables them to realize their own aspirations" (p. 132). Schellhorn further refines this concept, saying, "The prevailing conditions of culture, education, ethnicity, gender, politics, history, location, mobility, socio-economy, tourism skills, and knowledge constitute key barriers" (p. 115) to realizing aspirations.

Nel-Lo (2008) enumerated the characteristics of Costa Rican rural tourism: "Community-based rural tourism in Costa Rica is an advanced stage of ecotourism, under which tourism development is led by families and local communities who assume responsibility for protecting and capitalizing on their natural and cultural heritage" (p. 167).

This case study fits with Schellhorn's (2010) concept of social justice and economic benefits and with Nel-Lo's (2008) refined definition of ecotourism that explicitly includes native human resources as a recognized element of the physical environment of ecotourism. It focuses on a new Costa Rican government public-private partnership to protect and develop a relatively new addition to an important part of Costa Rica's ecotourism—the protection and preservation of the country's *residents* as a natural resource. As described here, it addresses the delicate balance of encouraging and educating small enterprise providers of native tourism to share their cultural as well as natural environments in the context of their daily lives and habitats with an increasing number of visitors who want to experience the "real" Costa Rican lifestyle and culture. The win-win outcome for the native tourism providers is to grow and sustain economic, social, and cultural benefits for themselves while providing a high-quality cultural ecotourism experience for tourists.

BACKGROUND

The Creation of Ecotourism

The 1970s saw the creation of ecotourism, with Costa Rica identified as one of the top global participants; indeed, *New York Times* travel writer Elizabeth Becker (2013) christened Costa Rica as "the birthplace of ecotourism" (p. 245). As ecotourism developed in Costa Rica, however, the Costa Rican government funneled the majority of its resources and development monies to attract larger internationally owned hotels over Costa Rican smaller investment native properties (Honey, 2003).

The foreign-based investment strategies did grow the tourism industry; in 2000 Costa Rica hosted more than one million visitors in a country the size of West Virginia. This rapid growth initiated a groundswell movement of various natural park officials, environmentally concerned scientists, and community activists pointing out that rural and native communities were not benefitting from this tourism investment strategy (Honey, 2003).

One reason for fewer economic and social benefits for natives was that a substantial number of middle- and lower-class Costa Ricans have managed to move into small-scale auxiliary businesses associated with ecotourism, including opening tour agencies or restaurants featuring local dishes, renting riding horses, or building butterfly "farms" or a few "guest cabinas" (Honey, 2003, p. 42). A Cornell University study also reported inconclusive findings regarding ecotourism's effectiveness as a social responsibility and community tourism-development strategy (Stem, 2001).

Similarly, Seales and Stein's 2011 Costa Rican tourism study found that "the longer a business has been in existence, the less involved it was in the local community" (p. 24). That said, there was certainly community involvement, "such as purchasing local supplies, employing local people, and patronizing local accommodations" (p. 26). However, the authors also conceded that the value of local community economic benefits could be underrepresented because most tourism revenue is private data proprietary to the businesses.

Government Public Policy Efforts

Another factor affecting community involvement in developing tourism products that create meaningful benefits for natives is the government policies specifically targeted to create conditions that support local development. LeHoucq (2010) examined the public policy system in Costa Rica and concluded that "Costa Rica managed to combine economic growth with equitable development and to become a social democracy" (p. 56). In Costa Rica, "exports, imports, and tourism-generated

foreign exchange went from 56.9 percent of GDP between 1983 and 1986 to 96.7 percent between 1995 and 1998" (Lizano & Zuniga, 1999, p. 16).

Government participation in tourism began in 1931 with the National Tourism Board, which in August 1955 became the Instituto Costarricense de Tourism (ICT, the Costa Rican Tourism Board), responsible for promoting sustainable Costa Rican tourism. The new government department's function was to create financial incentives in the form of tax breaks for tourism-related businesses providing hotel, food and beverage, travel agency, and transportation services.

To support and enhance the ecotourism efforts, in 1997 the ICT introduced a voluntary green program, the Certification for Sustainable Tourism Program (CST). The initial purpose was to create a higher profile for environmental protection activities in the form of incentives for tourism businesses to create more substantial and impactful environmental practices (Nel-Lo, 2008). Within 10 years, 108 specific requirements were articulated in the CST certification standards (Aguero, 2007).

Although the ecotourism physical environmental standards were championed, development of the benefits for rural communities and residents lagged behind. Most recently, Basurto (2013) focused on the class-based barriers that he concluded hampered rural community development:

> Findings suggested it was not enough to enact legal reforms allowing and encouraging local participation. Successfully involving local participation required attention to the class-based relationships within the protected area bureaucracy that create incentives (or not) to link with the local rural citizenry affected by these areas. In three out of four conservation areas, the dominant social class and urban-rural dynamics combined with a lack of accountability mechanisms have discouraged any real rural involvement and empowerment for decision-making.

Basurto's main recommendation was that local residents must be educated to understand their roles of becoming involved citizens determining their own futures and, in this instance, learning how to protect yet share their culture and environment as tourism products.

The case study of tourism development in La Fortuna, Costa Rica, conducted by Matarrita-Cascante, Brennan, and Luloff (2010), corroborated Basurto's contention that efforts to develop local relationships increased the social justice and the economic earning power as well as protecting the environment.

Center for Latin American Competitiveness and Sustainable Development Commissioned Reports

The Costa Rican government commissioned the Center for Latin American Competitiveness and Sustainable Development (INCAE) to produce periodic reports on the state of its tourism public policies. The 1997 report focused "on the conservation and environmental protection institutional infrastructure in Costa Rica, suggesting that it is in the tourism industry's interest to become more actively involved as an environmental advocate" (Pratt and Olson, 1997, p. 28). Pratt's 1997 report also concluded that regional planning for tourism was a worthwhile endeavor and noted that in some limited areas, private property owners were working together (p. 28). The report made reference to the fact that local people would benefit economically, but did not say specifically how.

The 2002 report, *Competitividad del Turismo en Costa Rica (Competitiveness of Tourism in Costa Rica)*, commissioned by the Costa Rican government to comply with required public distribution and conducted by the INCAE Center for Latin American Competitiveness and Sustainable Development, identified tourism as "the main generator of foreign exchange in the country" (p. 1) and discussed Costa Rica's tourism brand efforts and its international position as an ecotourism leader. It also cautioned Costa Rican tourism enterprises to not lose sight of protecting the country's environment. "It is essential to strike a balance between tourism and the environment surrounding natural and social environments" (Pratt, 2002, p. 5).

The 2013 report noted the continuous increase in the number of tourists and the fast maturation of the tourism industry, along with a real estate boom, but identified Costa Rica as becoming complacent with its success in this sector (Pratt, 2013). "It is the first time that Costa Rica faced challenges in its tourist industry" (Pratt, 2013). Among the challenges were changing world economic conditions, needed in-country infrastructure improvements in transportation services, safety concerns, continued foreign development influences, and a decreased emphasis on competitiveness in different tourism segments. The report's main findings included "that the sector has innovated very little, it has the same product that it had 10 to 15 years ago, but it is now less interesting and easy to copy, and that tourists (today) are, interested in proven experiences" (Pratt, 2013). While most of the preceding years tourism investments were in mass tourism, this report suggested that niche and lifestyle tourism are areas of potential growth. *El Financiero* (the financial) newspaper reported "the sector should go for new customers interested in experiences... [and] should encourage cluster development to encourage the creation and development of small and medium tourism enterprises" (2013, February 20).

ICT Support Program: A Rural Tourism Companies Community

In response to the INCAE Center for Latin American Competitiveness and Sustainable Development's 2013 report's concern about small and medium tourism enterprise developments, the ICT developed a rural community tourism program, Programa de Apoyo: A Empresas de Turismo Rural and Comunitario (A Rural Tourism Companies Community).

METHODOLOGY

This case study was researched and written using several qualitative research methodologies, including analysis of four major tourism reports: Honey's 2003 North American Congress on Latin America (NACLA) report on ecotourism in Central America and three University of Costa Rica five-year studies of Costa Rica's tourism industry commissioned by the Costa Rican Department of Tourism, the Instituto Costarricense de Turismo (ICT). The author also conducted an in-depth interview with ICT's director Ruth Alfaro, who also provided materials and plans from the ICT archives and website. The author also conducted in-depth interviews with University of Costa Rica Professor Harold Hütt Herrera and Professor Carolina Carazo who teach in the University of Costa Rica's public relations program.

SITUATION ANALYSIS

A traditional SWOT analysis summarizes the tourism situation ICT identified from the 2013 INCAE report.

Table 6.1. SWOT Analysis of 2013 Tourism.

Strengths	Weaknesses
• Established international tourism brand • Strong global financial base and appreciation of the native colones currency • Continuous growth in number of tourists • Continued government support of protected land	• Complacency resulting in decreased innovation in tourism offerings • Deteriorating infrastructure • Lack of education for potential new small and medium tourism providers

Continued.

Opportunities	Threats
• Development of diverse tourist segments in the small and medium tourism communities • A relatively untapped small and medium tourism sector offering unique cultural and social experiences	• Easy-to-copy ecotourism offerings • Decreasing tourist demand for mass tourism offerings • Unstable global economic conditions resulting in less leisure travel • Global real estate market collapse

CORE OPPORTUNITY OR PROBLEM

The Department of Tourism's role in national tourism development is well established in Costa Rica, mainly through its strong worldwide reputation for sustainable "green" and adventure tourism and its previous successes in attracting and retaining foreign investment that developed the large enterprise, higher-end types of tourism. This opportunity has become somewhat of a liability, however, as the high-end, mass type of tourism brought in from outside the country has created a rift between the social classes in Costa Rica, especially in the lower and middle classes who provide much of the service labor in the industry, primarily in the cities and along the coasts.

The opportunity, then, is to diversify Costa Rican tourism by providing education and resources to develop the rural tourism sector, the areas of the country that lie between the cities and the coasts. This would address the key concerns of the third ICT tourism review: (1) to not base tourism on one type of tourism, in this case, ecotourism; (2) to extend the economic tourism sector to rural tourism where residents there have opportunities to create and share in tourism dollars on a personal basis; and (3) to preserve as well as showcase Costa Rica's rich rural environment through cultural and social heritage tourism.

GOAL

ICT Director Ruth Alfaro Rojas (personal communication, August 19, 2013) articulated the goal of this program: "Support product development and community rural tourism in a sustainable manner, highlighting the diversity and cultural

richness of the rural communities with the goal of improving the standard of living of its peoples."

The goal was based on the partnership of the government-sponsored ICT department with the efforts of Rural Tourism (RT); Costa Rican companies that buy local products to service the tourism industry with income returned to the business owners providing the services; and Rural Tourism Communities (RTC) registered as associations or cooperatives that provide services to build local tourism products. The income generated is returned to the local families who provide the lodging, tours, and/or restaurant services.

OBJECTIVES

The ICT 2016 rural tourism plan listed these objectives as essential to achieving the rural tourism development goal. None was expressed in quantifiable, measurable terms:

- Rescuing and strengthening the different varieties of local culture
- Increasing local residents' participation in developing their own small and medium tourism enterprises, rather just being service workers for large, mass tourism enterprises
- Creating local community tourism production chains
- Protecting the local areas' resources
- Creating a system to distribute the income from these enterprises to the communities that produced it
- Improving the standard of living while preserving the local culture

STRATEGIES

The underlying strategy supporting these objectives was based on providing resources and education to encourage development in this sector in a "sustainable manner, highlighting the diversity and cultural richness of the rural communities to improve the standard of living of its peoples" (Ruth Alfaro Rojas, personal communication, August 19, 2013). An important element was recognition of the added value the destination provides through authentic experiences in agricultural activities, cultural traditions, and understanding and enjoyment of the natural environment.

ICT calls this the Development Model and sought to build a permanent, sustainable tourism product that offered an experience harmonizing authentic contact with the engaging idiosyncrasies of Costa Rican life; in essence, tourists should be offered to experience the lifestyle, culture, and products only available in Costa Rica through a variety of services adhering to set government standards of quality, safety, comfort, and fair dealing. ICT also would oversee and balance the coexistence of large, modern, and small branches of tourism, all with the goal of sustainability. It also would limit the influence of large, foreign investors who create tourism destinations based on the climate and natural features, such as beaches, with little or no incorporation of Costa Rican natives except in service positions (Ruth Alfaro Rojas, personal communication, August 19, 2013).

ICT was instrumental in defining and securing government regulation for rural tourism to include *posada* rural tourism. Posadas are a type of rural property with at least three rooms equipped with private bathrooms that also provide on-site food services, the equivalent of Costa Rican "bed and breakfast" establishments.

ICT also was instrumental in having the Costa Rican government recognize new "actors" or rural tourism residents and communities, as economic producers, with the goal of having a portion of rural-generated tourism dollars returning to rural communities to help equalize income distribution and fight poverty. ICT's efforts led to acceptance and, ultimately, to the ability to secure resources to develop this tourism sector.

KEY PUBLICS

- Local communities and their residents
- Rural businesses providing different parts of the production chain
- Government and local authorities involved in protecting Costa Rica's natural resources while providing economic and educational/business support for new enterprises
- Tourists looking for unique cultural and social experiences

While the Costa Rican government has been a long-time partner in tourism development, the focus on the new category of tourism providers required different types of support to develop this tourism sector, especially in the rural communities themselves. Native Costa Ricans did not have a well-developed sense of a service culture; they needed to be educated about providing service to international visitors. Similarly, native Costa Ricans had not had the need to be business managers or to learn about marketing and promoting a tourism product; they needed education and

guidance in developing business skills and marketing themselves to different types of tourists, who in this case were tourists seeking cultural experiences.

KEY MESSAGES

ICT's key messages were aimed at the rural residents and communities to help them develop the skills and mindset of tourism business providers. The ICT's list of key messages was designed to assure potential rural tourism providers that it was dedicated to providing them with the resources and skills to be successful. The messages include the following:

- ICT would provide training and advice to local employers to help them develop their tourism products.
- ICT would provide marketing and promotion assistance as well as education to assist local communities to market themselves.
- ICT would provide access to technology (e.g., Web and social media) to help with marketing and promotion.
- ICT would provide access to financial resources to rural communities to develop tourism outlets.
- ICT would provide further education about environmental and cultural responsibility (Ruth Alfaro Rojas, personal communication, August 19, 2013).

ICT called this the development model, which sought to build a permanent, sustainable tourism product that offered an experience harmonizing authentic contact with the idiosyncrasies of Costa Ricans; in essence, tourists could experience the lifestyle, culture, and products only available in Costa Rica through a variety of services that adhered to set government standards of quality, safety, comfort, and fair dealing.

TACTICS

The 2012–2013 ICT program focused on four aspects of the rural tourism business:

- Posada rural tourism: The typical establishment is a private home with a minimum of three bedrooms with private baths in an area that provided food services either in the individual posadas or in the nearby rural area.

- Local agencies: Developing and training travel agencies specializing in rural tourism, located in the rural area and offering a local tourist destination. This engaged the local community in promoting itself.
- Activities: These were based on designated areas that provided tourist services that preserve Costa Rican local cultural heritage, much of which is based on rural agriculture and family-run enterprises.
- Food and beverage service: These efforts would assist rural restaurants, eateries, and local sellers of food and beverages to recognize their native local specialties as cultural experiences. One area of emphasis was on promoting Creole food services in homes.

Tactics also included counseling for individual tourism providers; training in business and regulatory paperwork; merchandising and marketing instruction; service personnel training programs; and promotional assistance and instruction.

CALENDAR/TIMETABLE

The Programa de Apoyo campaign objectives were to be achieved in three years, beginning in 2013 and ending in 2016. During that time, seminars would be offered throughout rural areas to educate and train the rural community residents about the resources available as well as to help them meet the regulatory requirements of the Costa Rican government.

A January 2014 initiative to help rural communities develop their marketing and promotion plans involved a partnership of students from the University of Costa Rica Public Relations Department with public relations students from Kansas State University. Under the direction of ICT, each Costa Rican public relations student was paired with a Kansas State public relations student; the pairs visited and consulted different rural tourism enterprises and developed promotion and media strategies for their chosen rural enterprise. The strategies were reviewed by ICT, which used them to assist rural enterprises.

BUDGET

Most monetary data are proprietary because of the private sector actors. Pratt's 1997 government-mandated report Sector Turistico en Costa Rica states the ICT involvement in environmental issues is "impossible to fully quantify based on available data" (p. 2). However, the ICT tourism-marketing budget for 2013 is US$17 million, an increase from 2012 (http://insidecostarica.com).

EVALUATION AND MEASUREMENT OF RESULTS

The Pratt report, commissioned by the Costa Rican government with NCAE, is heavily relied on as an outside evaluation tool; its next report, most likely in 2014, certainly will be one of the evaluation measures. Of special interest will be indicators of the growth in the rural tourism sector as a new source of revenue, along with the amount of money that was returned to rural communities to improve their standards of living.

A second indication will be the changes in the number of rural residents living in poverty. This tourism program specifically targeted rural areas that traditionally do not have the economic resources available to larger cities and more developed areas. Changes in rural incomes should provide a measure of how well this partnership is working.

Another in-country measurement indicator will be the number of rural residents and communities that participate in the offered education, training, promotion, technological, and financial resources available to develop their tourism enterprises. An especially interesting number could be the growth pattern in this venture: Would rural residents participate on an ongoing basis or would they get discouraged and quit?

A final measure will be the growth of rural Costa Rican tourism's reputation as a cultural destination in the country's international tourism markets, particularly the United States. Tourism data indicate that an increasing number of international travelers are looking past mass tourism to more intimate and personal experiences. This trend should be reflected in this new Costa Rican venture.

CONCLUSION

The lesson to be learned here is that public/private partnerships can benefit all involved stakeholders. Tourism in Costa Rica generates the country's highest tourist annual revenue from a single source as well as providing more untapped opportunities to develop additional sectors, such as rural tourism, to increase revenue. Engaging Costa Rican residents has the potential to create more entrepreneurs, which can help expand the country's business class. The people who today provide services to large, mass-tourism businesses can now become business owners themselves, with the hope of addressing immediate issues of economic equity and a static tourism product, while in the longer term preserving and showcasing a unique culture that only Costa Ricans can provide.

REFERENCES

Aguero, M. (2007-11-07). "ICT espera 2 millones de turistas a finales del 2008." *La Nacion.* http://www.nacion.com/ln_ee/2007/noviembre/07/economia1306648.html. Retrieved 2013-08-31.

Ashley, C., Goodwin, H., McNab, D., Scott, M., & Chaves, L. (2006). *Making tourism count for the local economy in the Caribbean. Guidelines for good practice.* Retrieved from http://www.propoortourism.org.uk/caribbean/index.html

Basurto, X. (2013). Bureaucratic barriers limit local participatory governance in protected areas in Costa Rica. *Conservation and Society, 11*(1), 16–28.

BCCR (The Central Bank of Costa Rica). (2014). Costa Rica: Tourism incomes. Retrieved from http://www.visitcostarica.com/ict/pdf/anuario/Statisical_Yearly_Report_2012.pdf

Becker, E. (2013). *Overbooked: The exploding business of travel and tourism.* New York: Simon & Schuster.

Butler, R., & Hinch, T. (2007). Introduction: Revisiting common ground. In R. Butler & T. Hinch (Eds.), *Tourism and indigenous peoples: Issues and implications* (pp. 1–14). London: Butterworth-Heinemann.

Cole, S. (2006). Cultural tourism, community participation and empowerment. In M. K. Smith & M. Robinson (Eds.), *Cultural tourism in a changing world: Politics, participation and (re) presentation* (pp. 89–103). Clevedon, UK: Channel View Publications.

Fallon, F. (2002). *Tourism interrupted: The challenge of sustainability for Lombok Island, 1987–2001.* Unpublished Ph.D. thesis, University of New England, Armidale, NSW, Australia.

Honey, M. (2003, May/June). Giving a grade to Costa Rica's green tourism. *NACLA Report on the Americas, 36*(6), 39–46.

INCAE reveals weaknesses in the tourism strategy of Costa Rica. *El Financiero* (*The Financial*) [Costa Rica]. 20 February 2013. Retrieved from http://www.elfinanciero.com.mx/

LeHoucq, F. (2010, Winter). Political competition, constitutional arrangements, and the quality of public policies in Costa Rica. *Latin American Politics and Society, 52*(4), 53–77.

Lizano, E., & Zuniga, N. (1999, September). Evolucion de la economia de Costa Rica durante el period 1983–1998: Ni tan bien, ni tan mal, *Documento no. 2.* San Jose: Academia de Centroamerica.

Matarrita-Cascante, D., Brennan, M. A., & Luloff, A. E. (2010). Community agency and sustainable tourism development: The case of La Fortuna, Costa Rica. *Journal of Sustainable Tourism, 18*(6), 735–756.

Nel-Lo, A. (2008). Impacts on developing countries of changing production and consumption patterns in developed countries: The case of ecotourism in Costa Rica. (PDF). INCAE, available at *International Institute for Sustainable Development* website.

Pratt, L. (2002, September). Loros y retos del turismo Costarricense (Achievements and Challenges of Costa RicanTourism). Retrieved from http://www.incae.edu/EN/clacds/publicaciones/pdf/cen608.pdf

Pratt, L. (2013, February). *Competitividad del turismo en Costa Rica* (Competitiveness of Tourism in Costa Rica). PowerPoint slides. H. Hütt Herrera, personal communication, 20 August 2013.

Pratt, L., & Olson, N. (1997, July). Sector Turistico en Costa Rica: Analisis de Sostenbilidad (Costa Rica Tourist Sector: Sustainability Analysis), INCAE Centro Latinamericano de Competitividad y Desarrollo Sostenible (INCAE Latin American Competitiveness and Sustainable Development). Retrieved from http://www.incae.edu/es/clacds/publicaciones/pdf/cen760.pdf

Seales, L., & Stein, T. (2011). Linking commercial success of tour operators and agencies to conservation and community benefits in Costa Rica. *Environmental Conservation, 39*(1), 20–29.

Schellhorn, M. (2010). Development for whom?: Social justice and the business of ecotourism. *Journal of Sustainable Tourism, 18*(1), 115–135.

Stem, C. J. (2001). *The role of local development in protected area management: A comparative case study of eco-tourism in Costa Rica.* Unpublished dissertation, Cornell University.

Tourism Institute to spend $17 million on marketing in 2013. Retrieved from http://insidecostarica.com/2013/01/17/tourism-institute-to-spend-17-million-on-marketing-in-2013/

Part III:
Case Studies in Public Diplomacy

The "Free Silva" Justice Campaign: Convincing Iran Through Advocacy

KATERINA TSETSURA
University of Oklahoma

EDITORS' NOTE

The "Free Silva" campaign is an exceptional example of how creative—one might even say "inventive"—public relations strategies and tactics can achieve humane outcomes despite international tensions, cultural impediments, and historical precedents. Reflecting on "Free Silva," educators, their students, and practitioners as well can take renewed pride in the profession and seek to do likewise whenever such an opportunity arises.

NGOs are an essential part of any civil society; their goal is to allow citizens' participation in conversations about civil and human rights issues around the world. When transnational NGOs engage in communication in a country in which a fully functional civil society is practically nonexistent, their employees might be subject to political prosecution. This case study examines how transnational NGOs can use the power of public relations in the international arena—and why understanding symbolic and accountability politics of persuasion in communication campaigns in countries that restrict civil liberties is crucial. Using a theoretical framework of transnational advocacy networks, first introduced by social constructivist political

scientists Keck and Sikkink (1998), this case study demonstrates how the campaign practitioners were able to use the power of advocacy networks through a successful use of public relations strategies. The case study of the public relations campaign to free Silva Harotonian—a young woman who worked for IREX's Maternal and Child Health Education and Exchange Program in Iran and was arrested and charged with violating Iranian law—illustrates complex communication strategies the transnational NGO used in a challenging environment that rarely allows discussions about civil and human rights issues.

BACKGROUND

On June 26, 2008, Harotonian, an Iranian citizen of Armenian descent, was arrested soon after an afternoon meeting with friends. That evening, Harotonian was sent to Iran's notorious Evin Prison, located in Evin, an area in northwestern Tehran. About a year earlier, Harotonian, a graduate of Tehran's Azad University where she studied Armenian literature, had moved to Yerevan, the capital of Armenia, to work for IREX, the NGO based in the United States that offers international education and professional training opportunities around the world (Barsoumian, 2010). IREX receives support from the United States and other governments to run its programs. Harotonian was a coordinator for IREX's Maternal and Child Health Education and Exchange Program, designed to help Iranian maternal and child health care professionals visit American counterparts to learn from one another.

At the time, as a Yerevan-based administrator of the program launched in 2007, Harotonian was the only IREX staff member who on occasion traveled to Tehran, Iran, to meet participants and to explain travel logistics for an upcoming exchange (PanArmenian.net, 2010). One of her trips turned out to be longer than she had expected: Harotonian was detained and charged with violating Iranian law by spying and plotting a "soft revolution" against the Islamic Republic of Iran (Saberi, 2010, p. 132).

According to IREX representatives, the NGO has had numerous academic programs with Iran over the years, and IREX staff had been invited to Iran by the Iranian government on several occasions to discuss cooperation and to present papers. "For this reason, as well as other promising overtures, IREX had no reason to believe the program Harotonian was working on would have been construed in any negative fashion by the authorities," said Paige Alexander, vice president of IREX (International Campaign for Human Rights in Iran, 2009). According to Alexander, Harotonian also had informed the Iranian authorities of her project

during her January 2008 trip by contacting the Department of Health. Nevertheless, she was imprisoned, awaiting a court ruling. This was the first time an IREX employee had been accused of spying, according to IREX president Robert Pearson (Kingsbury, 2009).

For seven months, Iranian officials advised Harotonian's family and her employer IREX to stay quiet and let the legal proceedings take their normal course. On January 19, 2009, Harotonian was convicted of "attempting to overthrow the Iranian government" and sentenced to three years in Evin Prison. A week later, IREX hired Edelman, a global public relations firm, to create awareness about Harotonian's situation and help free her from the Iranian prison (Edelman, 2011, p. 1).

METHODOLOGY

The "Free Silva" case study is analyzed through a lens of constructivist politics of persuasion. According to Keck and Sikkink (1998), networks can use four types of constructivist politics in persuasion: information, symbolic, leverage, and accountability. The case demonstrates how two particular types of constructivist politics, symbolic and accountability, were used in this campaign to effectively frame the issue and to ultimately achieve the goal of the campaign: to free Silva Harotonian from an Iranian prison. The case also utilized the concept of boomerang effect to demonstrate how non-governmental organizations (NGOs) and other governmental and non-governmental actors can influence nation states through a well-designed public relations campaign. To make the argument, the researcher used publicly available materials and information from Edelman, the global public relations firm that developed the "Free Silva" campaign for its client International Research and Exchanges Board (IREX). The author also analyzed traditional and online media coverage of the case to document how the campaign contributed to Harotonian's parole from prison.

SITUATION ANALYSIS AND SWOT

The campaign "Free Silva" faced numerous challenges, the most significant of which was speaking publicly about civil and human rights violations in Iran. Furthermore, campaign organizers had to recognize the possibility of prosecution and other restrictions to which foreign nonprofits and NGOs operating in the theocratic republic were susceptible. The situation became even more difficult after the Iranian presidential elections, held on June 12, 2009, resulted in protests, civil disobedience, and increased government scrutiny and arrests (Edelman, 2011).

Since many of the involved parties (IREX, Edelman, and several of Harotonian's family members) were based in the United States, the campaign had to research neutral communication channels as well as impartial influentials to successfully implement the program. Practitioners from Edelman researched previous cases of detainments in Iran over recent years to identify parallels to Harotonian's case, to determine best possible strategies, to pinpoint tactics, and to uncover details that would potentially help Edelman contribute to a positive outcome for the campaign. In particular, they carefully studied cases of other prisoners who had recently been released from Evin Prison. As a result, the following SWOT analysis was created.

Strengths

First, a heavy media push by the family and/or home country was essential for the successful outcome. The campaign had strong support from family and IREX to attract attention to Harotonian's situation. In addition, the campaign needed alignment of high-profile advocates and international influencers; practitioners were confident they would be able to secure support from multiple public figures and representatives of major nonprofits and human-rights-watch organizations. Harotonian's case was an example of a person who dedicated her life to helping Iranian health care professionals and who was simply caught in the middle of a series of misunderstandings and unfortunate circumstances.

Weaknesses

Limited information was available about prisoners or situations in such cases. This created special challenges for the campaign. In addition, no official communication channels existed between Iran and the United States, so the campaign had to find alternative channels for communication with Harotonian's lawyers and with activists who could provide help on the ground in Iran. Moreover, the program needed to secure support from other governments who might have some influence with Iran or have strong, or recently improved, relations with Iran.

Opportunities

First, the campaign needed to make it possible for Iran to save face. Previous successful releases of prisoners included public confessions from the incarcerated or personal appeals from high-ranking political officials. Second, many of the previous releases occurred in conjunction with holidays, major events, or significant speeches in Iran. The campaign's practitioners saw many opportunities to attract

global attention to the case with the help of nongovernment health care organizations as well as governments that support humanitarian causes. Because Harotonian was of Armenian descent, the campaign could expect to count on support of a well-connected global Armenian diaspora. Finally, the fact that Harotonian was a Christian, a religious minority in Iran, could have either helped or hurt her case. On one hand, the Iranian government has publicly stated its religious tolerance of Christianity in Iran and has sometimes used the presence of the Christian minority to showcase Iranian diversity and tolerance of Christianity (Aghajanian, 2010). However, Iran, a conservative Islamic republic, has not always demonstrated its claimed tolerance of its Christian minority.

Threats

Protests, civil disobedience, and repression after the Iranian presidential elections, which coincided with Harotonian's arrest, may have contributed to her imprisonment and may have reduced chances for successful negotiations for her parole or pardon. Another potential threat was that Harotonian was a Christian. Finally, Harotonian's case was complicated by the recent arrest of medical doctors Kamiar and Arash Alaei, brothers and U.S. citizens who were famous for their regional HIV/AIDS training programs in the Middle East and Central Asia (Grondahl, 2011). The brothers had been arrested four days prior to Harotonian's arrest and had been convicted for the same alleged conspiracy: to overthrow the Iranian government. They had learned of their conviction on January 10, 2009, one day after Harotonian was informed of the court's decision in her case (Grondahl, 2012).[1] During one of her trips to Iran, Harotonian had been introduced to the Alaei brothers. Alleged affiliation with the Alaei brothers as well as a clear connection between Harotonian's employer IREX and the U.S. government made Harotonian's case harrowing:

> Because the case involves Iran detaining one of its own citizens, U.S. officials have little leverage to act on Harotonian's behalf. Indeed, some of her backers quietly worry that too much support from Washington could backfire in a case where the defendant is trying to prove she wasn't working for the U.S. government. (Kingsbury, 2009)

CORE OPPORTUNITY OR PROBLEM

Civil and human rights issues in Iran, the complications of foreign nonprofit and nongovernmental organizations operating there, and the protests and arrests

surrounding Iran's presidential elections also complicated the case. Despite these challenges, Edelman thought it might well achieve the goal of raising international awareness by building a transnational advocacy network of key influencers through a public relations campaign. The campaign focused on raising global awareness about Harotonian's unjust imprisonment. Influential governments and transnational human rights activist organizations helped find ways to leverage support for Harotonian's parole or pardon.

CONTEXT FOR ANALYSIS OF THE CASE

Transnational Advocacy Networks

Transnational advocacy networks, a form of international organization with voluntary, horizontal patterns of communication and exchange that "promote causes, principled ideas, and norms" and unite individuals "advocating policy changes that cannot be easily linked to a rationalist understanding of their 'interests,'" is central to international relations (Keck & Sikkink, 1998, pp. 8–9). NGOs play a crucial role in such networks by introducing issues, initiating actions, and pressuring powerful actors to take positions and recognize responsibilities. A transnational advocacy network can be successfully used in international public affairs and public relations campaigns that require carefully crafted strategies and diplomatic approaches in dealing with sensitive issues. Harotonian's arrest called for identification, creation, and utilization of an effective transnational advocacy network. This case study demonstrates how the Edelman firm and its client IREX were able to use the power of advocacy networks by successfully using public relations strategies.

Symbolic and Accountability Politics

As noted previously, networks use several types of constructivist politics in persuasion: information, symbolic, leverage, and accountability (Keck & Sikkink, 1998). Each one of these allows networks to frame a conversation about the issue in a certain way.

- Information politics points out that powerful messages must appeal to shared principles of those to whom a frame is directed. Those who construct such frames must be perceived as credible sources and present well-documented information.

- Symbolic politics provides a symbolic interpretation of the frame to create awareness of the issue. This helps to attract attention as well as to stimulate growth of the network.
- Leverage politics links the issue to material outcomes.
- Accountability politics allows networks to hold governments to their principles and to highlight the gaps between governments' discourse and practice (Keck & Sikkink, 1998).

This case study concentrates on two types of politics, symbolic and accountability, to demonstrate how they were used to effectively frame a sensitive issue in this public affairs campaign.

The Boomerang Effect

Because in-country structures do not always hold states and private actors accountable to their principles, many networks resort to a boomerang pattern (Keck & Sikkink, 1998), a process by which NGOs that are unable to pressure their own nation-states instead communicate concerns to NGOs in other countries. In turn, those foreign NGOs pressure their national governments to make policy changes. This boomerang effect is often employed in global public relations and public affairs campaigns to achieve success by attracting support of international influentials (Tsetsura, 2013). Many different actors from various nation-states can pressure other organizations, individuals, and nation-states' representatives to change policies or influence decisions. The boomerang effect normally works in a well-established network where participants see one another as equally important and credible members. The "Free Silva" campaign attracted many such influentials to create a transnational advocacy network to achieve its goal. Campaign communication strategies used symbolic and accountability politics of persuasion to create necessary frames to attract attention to the story of Harotonian and her struggles. Ultimately, the boomerang effect reached the ultimate target public, Iran's government and religious officials, to influence the outcome of Harotonian's final appeal.

GOAL AND OBJECTIVES

The goal of the campaign was "to help secure Silva's release from Evin Prison" (Edelman, 2011, p. 1). In pursuit of this goal, several objectives were established. First, the campaign had to create immediate and broad-based public awareness of Harotonian's struggle and create a "voice" for her because literally, her voice could not be heard (an informational objective). Second, a motivational objective was to

avoid making Harotonian's situation worse by minimizing communication that could be used by the Iranian government to support its allegation that Harotonian was a spy (Edelman, 2011).

KEY PUBLICS

Because of the contemporary convolutions of the Iranian government and its inherent suspicion of the United States and the media, the campaign had to focus heavily on identifying and reaching out to those specific influentials who could influence the situation without negative consequences. Messages had to be targeted and spread appropriately, with a high level of sensitivity. Research showed that the most important figure in Iran was Ayatollah Sayyid Ali Hosseini Khamenei, the supreme ruler; the second most influential figure was the president of the Islamic Republic of Iran at the time, Mahmoud Ahmadinejad. The campaign thus had to target people around the world who could influence those trusted first by the Ayatollah and then by Ahmadinejad. These people lived in many countries and included clerics and government representatives with influence on various religious leaders. The campaign also researched the relationship between Islam and Christianity in Iran to learn more about possible implications of involving clerics and religious leaders. Similarly, practitioners had to research how and to what extent various governments might influence Iranian leaders or their closest advisors.

Pre-campaign research also had shown that while influentials were a small and hard-to-reach segment of the Iranian population, these were the people who could be engaged through carefully chosen channels. The campaign managers decided to align with these individuals who could share Harotonian's story and seed the ground for negotiations and conversations, all the while maintaining a private and respectful tone in communication.

KEY MESSAGES

The campaign developed several key messages. The first was the story of Harotonian, a private, law-abiding Iranian citizen who was an aid and health worker, a dedicated caretaker, and a woman remote from politics. The campaign needed to demonstrate that Harotonian was simply an individual who became a victim of unfortunate and tragic misunderstandings (Edelman, 2011, p. 1).

Second, Harotonian's Armenian heritage had to be emphasized to gain support in the Armenian diaspora not only in the United States but also in Europe

where many countries have diplomatic relations with Iran and whose officials might help to achieve successful negotiations (e.g., the Armenian government).

Next, the campaign had to communicate that Harotonian's physical and emotional health was in danger from prolonged imprisonment.

In addition, messages had to help audiences understand the complex negotiation strategies that the Iranian government had favored in similar cases; respect and diplomatic tact were essential in all public communication on the issue.

Finally, messages had to appeal to Iranian religious leaders' compassion and reason, achievable by studying and using their writings and speeches to construct arguments.

STRATEGIES

Leveraging the credibility of Harotonian and building on her position as a health care worker and caretaker were fundamental campaign strategies. Because Harotonian could not speak for herself, the campaign created opportunities for telling her story with the help of her family, her employer IREX, and her former cellmate at Evin Prison. The campaign had to consider the complicated nature of Iranian and U.S. relations and the charged emotional reactions of Harotonian's family members.

Respect of diplomatic needs of IREX and the U.S. Department of State as well as personal desires of Harotonian's family dictated limited public engagement in the beginning of the campaign. The family wanted to follow a strategy of quiet negotiations, which is the first choice for all negotiations in cases with Iranian prisoners, according to the International Campaign for Human Rights in Iran (Sanamyan, 2009a). Therefore, another critical strategy was aligning the campaign's efforts with U.S. diplomatic activity (Edelman, 2011).

After initial reports by human rights activists, in which the names of several detainees in this case were shared (including names of Harotonian and the Alaei brothers), IREX and Harotonian's family decided to go public with the campaign and engage the targeted media (Sanamyan, 2009a). A member of Harotonian's family later discussed this decision:

> While we wanted to scream to get Silva noticed, declare her innocence, we held our breath; we pursued quiet approaches, diplomatic channels, launched a website freesilva.org to gain global support and respectfully requested mercy. But still, one year later, even after so much work, she remains in prison. We are finally speaking out; with your help we are getting louder and louder. We are writing to Iranian officials, reaching out to NGOs, and talking to the media. (Freesilva, 2009, June 30)

TACTICS

Based on these strategies, multiple tactics were implemented. Perhaps the most substantial tactic and a core platform for gathering support was the issue-specific website FreeSilva.org. This kind of website is often created to support a certain cause or an issue; it usually has a limited lifespan (Tsetsura, 2007). The FreeSilva website was specifically developed to give Harotonian "voice" and to help family and IREX generate and track international support for her release. Regularly updated online content included family personal appeals, interviews, event updates, videos about Harotonian's plight, and an interactive online petition that global visitors to the website could sign and submit to support her release. Social media accounts, including @Silva_Harotonian, also were created to attract attention to the website. A Facebook group also was created to support the campaign and to encourage followers to sign the petition to free Harotonian.

A second key tactic was to attract media attention to Harotonian's Armenian heritage. Messages about Harotonian as a private citizen who is deeply connected with her Armenian roots were targeted toward the Armenian diaspora media around the world, including the Armenian U.S.-based *Armenian Reporter* multimedia news source and Armenian radio Azatutjun. The campaign also worked for support from targeted international media—the outlets that could support Harotonian's case but at the same time maintain a respectful tone toward Iran and downplay the U.S. connections (Edelman, 2011).

The next set of tactics included assisting public and private diplomatic efforts to make personal appeals for Harotonian's release. In particular, representatives of the European Union as well as diplomats from Swiss and Japanese embassies in Iran were among those approached with appeals to help gain support for Harotonian. These tactics were discrete and were not part of the publicity campaign. With help from selected influentials and NGOs, private diplomatic channels raised awareness about the case among representatives of various governments and communicated regularly about Harotonian's situation. As a result, U.S., French, and Armenian officials sent appeals for her release to President Ahmadinejad.

In addition, the campaign engaged and mobilized several internationally known and well-respected human rights organizations, among them the International Campaign for Human Rights in Iran, Human Rights Watch, Amnesty International–USA, and the Overseas Press Club. Many influential people and organizations helped to support the "Free Silva" campaign.

Roxana Saberi was identified as one of the most influential public spokespersons for the campaign. Saberi, who had made headlines after her successful release from Iranian prison and return to the United States, voiced her support

for Harotonian (Vogel, 2009). An American journalist of Iranian and Japanese descent, she had been accused of spying for the United States while she was in Iran. Saberi spent several months in Evin Prison where she briefly shared a prison cell with Harotonian (Saberi, 2010). On May 11, 2009, Saberi was released from prison and returned to the United States after a public campaign to secure her freedom. In her public speeches in support of the "Free Silva" campaign, Saberi emphasized the importance of understanding the harsh conditions that prisoners such as Harotonian face in Evin Prison and highlighted Harotonian's strong spirit in pursuit of her religious beliefs and her dedication to her birth country, Iran (Goupil, 2009). Saberi stated that prisoners were "likely under severe psychological and, in some cases, physical pressures; many may be forced to make false confessions, and they have no access to lawyers" (Freesilva, 2009, July 8).

Klara Moradkhan, development director of Children Uniting Nations and Harotonian's cousin, also was instrumental in appealing to the Iranian government as well as other governments (i.e., Armenia and the United States) that could help to free Harotonian. Moradkhan was a spokesperson on several of the campaign's public service announcements (PSAs) both in English and Armenian (Freesilva, 2009, May 18) and voiced concerns through global media channels about Harotonian's deteriorating condition in prison (Moradkhan, 2009). In line with the campaign's key messages, all public communication, including PSAs and personal appeals, was constructed around the symbolic politics of telling a personal story of Harotonian, a gentle, dedicated health worker not involved in politics. "Sweet, shy, enthusiastic, gentle, sometimes naïve, but always kind-hearted, the caregiver, listener, humanitarian," these are the words that Moradkhan used during the news conference on June 30, 2009, to describe Harotonian (Freesilva, 2009, June 30). In the same video statement, she reprised Harotonian as a person who "never cared for politics or news." Harotonian's employer was quoted in the media as saying that "She [Harotonian] is a loyal, patriotic Iranian citizen and has no criminal intent" (Pleming, 2009).

The messages also concentrated on Harotonian's passion for her Armenian heritage to symbolically connect Harotonian with the Armenian diaspora around the world. Moradkhan continued, "Silva is proud to be Iranian, but fascinated by her Armenian roots. A faithful Armenian Christian, Silva worked at the Armenian Church in Tehran and volunteered her time teaching Armenian literature to Armenian children" (Freesilva, 2009, June 30). In another communication, Moradkhan again emphasized the same key messages about Harotonian as a compassionate, dedicated person of Armenian descent: "Silva, an Iranian citizen of Armenian descent and Christian faith, is a kind-hearted young

woman who loves poetry and helping others—hardly signs of a revolutionary or spy" (Moradkhan, 2009, p. 1).

Moradkhan communicated these messages during a New York City news conference organized by the International Campaign for Human Rights in Iran, Human Rights Watch, Amnesty International–USA, and the Overseas Press Club to support all detainees and prisoners in Iran. Hadi Ghaemi, an internationally recognized Iran analyst and executive director of the International Campaign for Human Rights in Iran; Sarah Leah Whitson of Human Rights Watch; and Saberi were among the speakers at the news conference (Freesilva, 2009, June 30). The news conference demonstrated how the campaign successfully used symbolic and accountability constructivist politics of persuasion. For instance, Ghaemi's speech contained symbolic politics as he emphasized the importance of attracting attention to Harotonian's case because it "caught everyone by surprise, and no one really knew about the case for many months 'til we learned about her; her name is Silva Harotonian" (Freesilva, 2009, June 30). Moradkhan's speech, on the other hand, was based solely on accountability politics and referred to Iran's recognition of the country's historic Armenian community and its Christian faith, evident from multiple previous statements of various Iranian religious leaders. Moradkhan said:

> For decades, the Islamic Republic of Iran has ensured the safety, religious freedom, and prosperity of its Armenian community. Releasing Silva after a year in Evin Prison would be further proof of Iranians' generosity of spirit towards this loyal and historical Christian minority. I believe there could be no greater gesture, no greater treatment to the central importance of mercy in Islamic and Christian faiths than for Iran's leaders to demonstrate their compassion by releasing my cousin. (Freesilva, 2009, June 30)

This speech, although forceful, still demonstrated a very diplomatic, humble, and cautious rhetoric, essential in direct appeals during negotiations with the Iranian government. In her speech to commemorate Saberi's release from Evin Prison, Moradkhan had relied on accountability politics to hold the Iranian government to its promises and principles; she used pathos and an emotional appeal to tell Harotonian's personal story:

> Iranian officials pledged to offer Ms. Saberi speedy and fair consideration of her appeal. Our entire family—in Los Angeles, in Armenia, in Iran—hopes they will do the same for Silva. Silva's 75-year-old mother will be waiting at the gates of Evin Prison for the day they are reunited. (Moradkhan, 2009, p. 1)

The targeted media effectively picked up the campaign's key messages, which had utilized symbolic and accountability politics. Coverage of Harotonian's case included framing her as a passionate, sensitive aid worker proud of her Armenian

roots (Sanamyan, 2009b; Vogel, 2009). Harotonian's status as an international NGO worker who had been helping Iranian health care professionals and the fact that her employer had worked in Iran with agreement from the Iranian government also were covered (Asbarez, 2010; Goupil, 2009; Kingsbury, 2009; Sanamyan, 2009a). Another media outlet directly quoted Moradkhan to illustrate Harotonian's indifference to political news: "She never even read the news or followed politics. She just wanted to do something good for her country" (Kingsbury, 2009, p. 1).

In May 2009, as Harotonian's family members were awaiting the ruling on the final appeal, supporters continued to campaign for leniency (Kingsbury, 2009). IREX president Pearson stated, "A kind-hearted 34-year-old woman, Silva has been a loyal citizen of Iran and took her position with IREX to support her family and help improve her home country. IREX asks the Iranian government for mercy by granting Silva her freedom" (Pearson, 2009). Abdolfattah Soltani, a human rights lawyer in Tehran who represented Harotonian, said, "I am hopeful Silva Harotonian's three-year jail term will be reversed in a trial with educated and experienced judges" (Memarian, 2009).

These many initiatives on behalf of Harotonian finally came to fruition several months later. Harotonian was paroled in November 2009 and on March 10, 2010, she was allowed to leave Iran (Edelman, 2011). Harotonian now lives in the United States.

TIMELINE

This campaign ran for 15 months, from January 2009 to March 10, 2010. Most of the campaign's public efforts took place during the first several months after Edelman initiated the campaign. Many messages had to be transmitted during key Iranian and Armenian holidays and significant historical dates to time communication strategies in a way that they would gain maximum leverage and to potentially succeed in reaching out to religious officials in Iran (Edelman, 2011).

The release of Saberi, Harotonian's cellmate, also created multiple opportunities for the campaign to attract attention to Harotonian's case, with media outreach through news conferences, PSAs, and other publicity efforts concentrated around the time of her release. For instance, on June 30, 2009, a news conference in support of Harotonian and other prisoners was organized in New York City shortly after Saberi's return to the United States (Freesilva, 2009, June 30). Saberi and Moradkhan directly appealed to Iranian officials, using carefully identified and selected campaign key messages (Goupil, 2009; Moradkhan, 2009).

Finally, some additional tactics, such as a news conference and a symbolic event organized at the Human Rights Esplanade in Paris, France, on June 25, 2009, commemorated the one-year anniversary of Harotonian's detention and were used to attract public and media attention to her case once again (Edelman, 2011).

BUDGET

The budget for this campaign was US$750,000 for the tactics used plus undisclosed professional fees paid to Edelman.

EVALUATION AND MEASUREMENT OF RESULTS

The success of any campaign should be measured in terms of whether the campaign's goals and objectives have been met. This extensive international campaign, implemented from multiple Edelman offices, both within and outside the United States, delivered the results that ultimately helped to free Harotonian from Evin Prison.

Analysis of this campaign's efforts to reach transnational organizations and influentials helps explain why outputs and outcomes of this campaign delivered successful results.

All aforementioned indirect communication tactics as well as direct communication efforts to appeal to the mercy of Iran's government contributed to a boomerang effect to attract attention to Harotonian's case. The campaign saw its first results from this boomerang effect in a short period of just four months (the campaign Free Silva went public in February 2009) when on July 1, 2009, Iran's ambassador in Armenia expressed hope that Harotonian would soon be granted clemency (ArmeniaDiaspora.com, 2010). The campaign's team members were careful to respect Iran and downplayed the U.S. connections. At the same time, they were able to find a "golden middle" for a successful use of boomerang effects beyond simply involving transnational NGOs to influence the target government's decision. The campaign utilized the boomerang effect by reaching out to a variety of public organizations and individuals from the European Union, Armenia, the United States, and other countries to influence decisions of Iran's officials without embarrassing or directly attacking the government of Iran.

No doubt one of the most successful tactics of the campaign was the well-publicized popular advocacy website FreeSilva.org, which was created

specifically to share Harotonian's story with the world, to gain international support for her release from prison, and to coordinate efforts to increase awareness about her situation and condition in prison. In fact, the website became so popular that one of the conditions of Harotonian's release was its elimination (Edelman, 2011). The website had housed interviews and videos of family members and a petition. Tracking tools helped to demonstrate global support without which Edelman said there could have been "a large and potentially embarrassing media campaign against Iran" (*PRWeek*, 2011, p. 1).

As a result of other successful tactics of this campaign, multiple personal letters appealing for Harotonian's release were sent to President Ahmadinejad from U.S., French, and Armenian officials. Engaging influential governments and gaining support from government officials helped to reach the desired result of the campaign. The public support by Saberi as well as by members of Human Rights Watch and the International Campaign for Human Rights in Iran helped to receive international media coverage in top media outlets such as the Associated Press, Reuters, AFP, UPI, *Le Monde*, *International Herald Tribune*, *Chicago-Sun Times*, *U.S. News and World Report*, *USA Today*, the *Washington Times*, Huffington Post, BBC, CNN, Fox News, and National Public Radio (NPR). The campaign also generated extensive coverage in the Armenian media and in Armenian language media outlets in the United States as well as in many other countries with strong Armenian diasporas (Edelman, 2011). After Harotonian was released from prison, IREX president Pearson thanked the Armenian government for help in the case. Several media, including the independent Armenian news magazine *Ianyan*, also picked up his statement: "Pearson also thanked the government of Armenia for 'their engagement in securing Silva's release'" (Aghajanian, 2010, p. 1).

CONCLUSION

With the help of this program, as well as through efforts of IREX, Harotonian's family and lawyers gained the leverage they needed to ultimately negotiate her release after almost a yearlong imprisonment (Edelman, 2011). The campaign helped to generate international awareness about Harotonian's case, to build leverage that could be used as part of diplomatic efforts and negotiations, to develop relationships with key influencers, and to minimize attention to anything that might link her to the United States. The client was very satisfied with the campaign. IREX has commended the Edelman agency for its work, and an IREX representative and a primary client contact, Paige Alexander, praised the campaign:

> For an international development organization that focuses on grassroots work, we were not prepared to know how to wage a full-on public relations campaign to tell the world about this young woman's tragic situation and build international support for her cause. . . . I have no doubt that the traction we got was due to the personal support that I felt each person brought to the table for this cause. (Edelman, 2011, p. 1)

Finally, this campaign received a 2012 Public Relations Society of America Silver Anvil Award for the Best Public Affairs Campaign of the Year and has become an example of a well-planned and well-executed global public affairs campaign. One PRSA Silver Anvil Awards judge said the campaign illustrated "superb use of research and targeting of allies. Thoughtfully planned and amazingly executed" (*PR Week*, 2011, p. 1).

NOTE

1. Other sources indicate that at least one Alaei brother and Silva Harotonian were arrested on the same date (International Campaign for Human Rights in Iran, 2009, May 28).

REFERENCES

Aghajanian, L. (2010, March 16). Free at last: Silva Harotonian released from Iranian prison. *IanyanMag*. Retrieved from http://www.ianyanmag.com/2010/03/16/free-at-last-silva-harotonian-released-from-iranian-prison/

ArmeniaDiaspora.com (2010, March 14). Iran frees Silva Harotonian. *ArmenianDiaspora.com*. Retrieved from http://www.armeniadiaspora.com/news/article-hits/1216-iran-frees-silva-harotonian.html

Asbarez (2010, March 15). Iran frees Silva Harotonian. *Asbarez Post*. Retrieved from http://asbarez.com/78283/iran-frees-silva-harotonian/

Barsoumian, N. (2010, March 29). Silva Harotonian released from Iranian prison. *The Armenian Weekly*. Retrieved from http://www.armenianweekly.com/2010/03/29/silva-harotonian-released-from-iranian-prison/

Edelman. (2011). Free Silva: Politics, prison, and the power of PR. *PRSA Silver Anvil Award Case Study: Public Affairs*. Retrieved from http://www.prsa.org/awards/search?pg=1&sa-Year=All&sakeyword=Silva&saCategory=&saIndustry=&saOutcome= - .UiEd_3_fI4k

Freesilva (2009, May 18). A message from Silva Harotonian's family. [Video file]. Retrieved from http://www.youtube.com/watch?v=OLayZZOe3HE

Freesilva (2009, June 30). Statement from Klara Moradkhan, cousin of Silva Harotonian. [Video file]. Retrieved from http://www.youtube.com/watch?v=tSA-QpQgQkM

Freesilva (2009, July 8). Statement from Roxana Saberi, journalist and Silva's former cellmate. [Video file]. Retrieved from http://www.youtube.com/watch?v=2rw_bwuzrpA

Goupil, H. (2009, June 24). Saberi to Iran: Free my cellmate Silva Horotonian. *Huffington Post*. Retrieved from http://www.huffingtonpost.com/2009/06/24/saberi-to-iran-free-my-ce_n_220365.html

Grondahl, P. (2011, August 29). UAlbany doctor's kin let out of Iran prison. *Times Union*. Retrieved from http://www.timesunion.com/default/article/UAlbany-doctor-s-kin-let-out-of-Iran-prison-2145627.php

Grondahl, P. (2012, July 19). UAlbany AIDS researchers recognized. *Times Union*. Retrieved from http://www.timesunion.com/default/article/UAlbany-AIDS-researchers-recognized-3721240.php

International Campaign for Human Rights in Iran. (2009, May 28). Court documents show obsession with alleged US intelligence actions led to unfair convictions. [Web post]. Retrieved from http://unmumbled14.veritise.com/browser.php?indx=8449679&item=1

Keck, M., & Sikkink, K. (1998). *Activists beyond borders*. Ithaca, NY: Cornell University Press.

Kingsbury, A. (2009, May 29). Iran holds aid worker Silva Harotonian on espionage charges. *US News*. Retrieved from http://www.usnews.com/news/world/articles/2009/05/29/iran-holds-aid-worker-silva-harotonian-on-espionage-charges

Memarian, O. (2009, June 26). Iran "US spy" cases remain after Saberi release. *Huffington Post*. Retrieved from http://www.huffingtonpost.com/2009/05/26/iran-us-spy-cases-remain_n_207758.html

Moradkhan, K. (2009, May 23). Please, Iran, release my cousin now, too. Media Watch. *Turkish News*. Retrieved from http://www.turkishnews.com/en/content/2009/05/23/please-iran-release-my-cousin-now-too-by-klara-moradkhan/

PanArmenian.net. (2010, March 15). Silva Harotonian released from Iranian prison. *PanArmenian English News*. Retrieved from http://www.panarmenian.net/eng/news/45539/

Pearson, W. R. (2009, May 11). Comments on the release of Roxana Saberi. *IREX website: Newsroom*. [News release]. Retrieved from http://www.irex.am/eng/newsroom/silva.html

Pleming, S. (2009, June 4). U.S. NGO urges Iran to free Armenian employee. *Armenian Radio Azatitjun*. Retrieved from http://www.armenialiberty.org/content/article/1746176.html

PRWeek (2011, May 10). PRSA Silver Anvil Awards past winners: Free Silva: Politics, prison and the power of PR. [Web post]. Retrieved from http://awards.prweekus.com/free-silva-politics-prison-and-power-pr

Rostampour, M., & Amirizadeh, M. (2013). *Captive in Iran: A remarkable true story of hope, and triumph amid the horror of Tehran's brutal Evin Prison*. Carol Stream, IL: Tyndale Momentum.

Saberi, R. (2010). *Between two worlds: My life and captivity in Iran*. New York: HarperCollins.

Sanamyan, E. (2009a, February 27). An Armenian is imprisoned in Iranian crackdown: Silva Harotonian's family blames "tragic misunderstanding." *Armenian Reporter*. Retrieved from http://www.reporter.am/index.cfm?furl=/go/article/2009-02-27-an-armenian-is-imprisoned-in-iranian-crackdown&pg=1

Sanamyan. E. (2009, June 25). Fresh appeal launched for Silva Harotonian's freedom. *Yandunts*. [Blog post]. Retrieved from http://yandunts.blogspot.com/2009/08/fresh-appeal-launched-for-silva.html

Tsetsura, K. (2007). Strategic public relations in the era of technology. In J. Olędzki (Ed.), *Public relations across borders (Public Relations Spoleczne Wyzwania): Research annual* (pp. 215–240). Warsaw, Poland: ASPRA-JR.

Tsetsura, K. (2013). Challenges in framing women's rights as human rights at the domestic level: A case study of NGOs in the post-Soviet countries. *Public Relations Review, 39,* 406–416.

Vogel, A. (2009, June 24). Freed American journalist voices support for her ex-cellmate in Iran. *FoxNews.com.* Retrieved from http://www.foxnews.com/story/2009/06/24/freed-ameri can-journalist-voices-support-for-ex-cellmate-in-iran/

Creating a National Brand for Finland: "Consider It Solved!"

VILMA LUOMA-AHO
University of Jyväskylä

LAURA KOLBE
University of Helsinki

EDITORS' NOTE

Branding of an organization is a challenging pursuit. Raised to the level of branding a nation, it requires a coordinating central authority as well as citizens' involvement and support. This case study illustrates how Finland marshaled these forces to forge a national brand with sufficient differentiation to generate new recognition and approval internationally.

Finland is one of the Nordic countries, located in Northern Europe between Sweden, Norway, and Russia. With a population of 5.4 million, Finland is Europe's eighth largest country and is part of the European Union. Since World War II, Finland has been best known for its clean environment, rapid technological development, Nobel Peace Prize winner Martti Ahtisaari, being an extensive Nordic-style welfare state, and having the best educational system in Europe.

Despite its strengths, Finland was ranked only 18th on the Anholt-GfK Roper Nation Brands Index (2008). Also, the 2008 report on Building Finland's Country Brand (Moilanen & Rainisto, 2008) found that Finland's image abroad was

unclear and weak, clearly worse than the image of neighboring Sweden. Finland was considered a cold and sparsely populated country in the north inhabited by a quiet people; a coherent image of Finland, let alone a strong brand, did not exist. The problems were obvious: The country's values were unclear, and its external messages were not coordinated because there was no single body responsible for the Finland image. Messages were random without focusing on specific markets or themes. To meet this need for brand unification, a Country Brand Delegation was established and, together with British country branding expert Simon Anholt, it branded Finland as the "Fix-it" country. Finland's country brand ranking improved; the country gained high visibility and even received the *Newsweek* (2010) nomination for "The Best Country in the World."

BACKGROUND

Previous Branding Attempts

Although the concept of branding was not yet used, a first modern-era country branding process was initiated in Finland in 1988 by the KANTINE committee (advisory board on international communications) working under the press and information department of the Ministry of Foreign Affairs. Its goal was to improve the country's brand for trade and commerce (The KANTINE Report, 1990). The KANTINE Report (1990) noted that the Cold War had cast a black shadow on the perception of Finland because it was a neighbor of the Soviet Union, and that the image of Finland would improve if its fundamental values could be projected. Values chosen were excellent education, sustainable environmental development, and creativity; the aim was for Finland to be seen as a country "with high industrial, technological, and cultural knowledge, based on a strong and well-adjusted economy, freedom of trade and competitive commerce, and care for nature" (The KANTINE Report, 2008).

Exhibitions

In world fairs from Paris in 1862 to Shanghai in 2011, Finland has been represented through its culture and quality of life. The exhibitions also have contributed to "nation-building" after the wars, and to evolving economic, political, and national development. Brand-building slogans of the exhibitions included "Creative Finland" and "The Brave New Finn," enhancing traditional values of simplicity and the well-known Finnish "sisu" (endurance). Later fairs and exhibitions abroad have highlighted Finnish design, such as that of the mobile phone giant Nokia, the

textiles innovator Marimekko, and glassware and jewelry designer Iittala. Recent themes have included Finnish CleanTech and the Rovio brand of Angry Birds.

Tourism

The Finnish Tourist Board, responsible for Finland's tourism country brand, formulated the key "promise" for that brand based on "The Four Cs": credible, contrasting, creative, and cool. "Visit Finland" was the basic message created from these four characteristics. As a whole, "Visit Finland" is seen as a challenger brand in tourism markets, and Finland is seen as an "indie" tourist country different from the mainstream.

KEY PLAYERS IN THE BRANDING PROCESS

Ministry of Foreign Affairs

The ministry responsible for Finland's foreign affairs is run by three politically elected ministers (Foreign Affairs, European Affairs & Foreign Trade, and International Development) and a permanent staff. The ministry contributed to the operating expenses of the Country Brand Delegation's meetings and provided a "face" (Minister Alexander Stubb, European Affairs & Foreign Trade) for the delegation.

MEK (Visit Finland)

MEK (Matkailun Edistämiskeskus, or the Finnish Tourist Board) works under the Ministry of Employment and the Economy and actively promotes Finnish tourism. The board works closely with ministries, travel businesses, transport companies, and other Finnish entities on research, product development, and marketing. Abroad, the agency works under the title "Visit Finland" and its key target countries include the United Kingdom, Russia, Germany, France, Spain, Italy, the Netherlands, Sweden, the United States, China, and Japan. The "Visit Finland" conceptual identity is derived from the previously identified "Four Cs." MEK also supports individual efforts to promote Finland abroad such as the Maailmalle.fi website created by young Finns living abroad.

Finland Promotion Board

The Finland Promotion Board was established in 2006 as a special body combining public and private organizations working with advocates for tourism, trade,

and innovations. The organizations included the Ministry for Foreign Affairs, the Finnish Tourist Board, the Ministry of Employment and the Economy, Finnair, Finpro, Finnfacts/TAT, the Finnish Forest Foundation, and Tekes (the Finnish Funding Agency for Technology and Innovation).[1]

The Country Brand Delegation

The Country Brand Delegation was appointed by Foreign Minister Alexander Stubb in September 2008 to create a unified team to build a strategy for Finland and to brand Finland as a great place to live, work, and visit. The delegation consisted of influential public figures such as well-known businesspeople, designers, politicians, consultants, professors, and artists. The delegation was chaired by Jorma Ollila, a leading business executive. The delegation saw nation branding as a holistic, long-term process of building awareness of the country and its reputation.

Simon Anholt and the Anholt-GfK Roper Nation Brands Index (NBI)

The Country Brand Delegation retained the British country brand expert Simon Anholt. Anholt had assisted several governments in country branding processes and, together with the research institute GfK Roper, is the publisher of The Anholt-GfK Roper Nation Brands Index (NBI) of most influential nation brands.

Demos Helsinki Think Tank

Another ally, the Demos Helsinki think tank, is a research-focused nonprofit organization that helps organizations bring about systemic change and forecasts futures. Its previous clients included companies, cities, governments, and communities.

METHODOLOGY

Combining several qualitative research methods, this case study was constructed via desk research, interviews of key players, and a review of materials published both online and offline during the branding process by the organizations involved. Nation Brand literature also was visited to understand the phenomena. As the project contained public sector funding, reliable records were available on the budget and choices made from the organizations involved. This secondary research was supplemented by primary action research-type involvement of key

players: discussion with the director general of the Finnish Tourist Board, which also commented on earlier drafts of the study, and personal reflections of one of the authors who was herself involved in the branding process (Kolbe).

SITUATION ANALYSIS

Despite its achievements in technology, welfare, and education, the image of Finland abroad was not as good as desired. A 2008 report on Building Finland's Country Brand (Moilanen & Rainisto, 2008) found Finland lacked appeal and did not stand out in country brand comparisons. Residents of its neighboring countries had a more positive image of Finland through direct experiences, but countries farther away had only vague impressions. Finland was considered a cold northern country, but beyond that a clear national brand did not exist. Moreover, the country's values were unclear, and although the overall tone of foreigners' impressions was positive, those positive impressions were not exploited in promotional efforts. A central problem was the lack of coordination of the messages because they were distributed by a variety of players. Overall, in 2008 Finland left a "satisfactory impression rather than an outstanding one" (Moilanen & Rainisto, 2008). The Country Brand Delegation started constructing a strategic brand for Finland, working with Anholt beginning in 2008.

Strengths

- Finland's commitment to basic Nordic values, such as freedom, equality, and human rights, contributed to the country's reputation as being one of the most stable and best functioning democracies. Its environmental policy, respect for human rights, and fair treatment of citizens were especially highly praised.
- The previous rankings of an independent brand index (The Anholt-GfK Roper Nation Brands Index) revealed that the general attitude toward Finland abroad was positive. People were willing to give Finland the benefit of the doubt: Many assumed something positive about Finland and the Finns, despite their lack of direct knowledge or experiences of the country or its people. Still, two-thirds of the respondents from 50 countries ranked Finland higher than the average level for their own country.
- Finland was recognized as having the best education system in the world (World Audit, 2013; OECD, 2010) so it could apply this in its brand building.

- Finland is seen as the world's third-most competitive country and the European Union's most competitive country (2013), according to the World Competitiveness Index of the World Economic Forum.
- The Finnish environment is unpolluted and clean, and the country is known for its thousands of lakes and wild forests, making it a natural attraction for environmentally aware and concerned people.
- Overall, the Finnish people are proud of their country and have a positive attitude toward making Finland stand out abroad.
- Although Finland is not famous for its cultural heritage, the number of talented, individual performers—ranging from Formula One race car drivers to architects and orchestra conductors—at the top of their chosen fields is exceptionally large in relation to the population.

Weaknesses

- Foreign understanding of Finland's specific attributes and themes was lacking, mainly because image cultivation had been random and undertaken by multiple parties.
- Finland had no distinguishable, internationally known cultural buildings or monuments to attract and impress visitors.
- Previous programs and events that had built the brand Finland were merely temporary, and no ongoing effort was established to extend the reputational gains.
- The Finland Promotion Board established in 2006 had worked to develop a country brand for Finland, but the board was a collection of actors with no single body responsible for coordinating its work, especially its messages. There had not been a comprehensive investment in the country brand nor special resources allocated for developing one (Moilanen & Rainisto, 2008).

Threats

- At first, Finnish citizens showed adverse reactions to the need for a branding process, especially its funding through the public sector budget.
- Without a central, dedicated organization responsible for the country brand, the efforts of the Country Brand Delegation could end up as another one-off attempt with no long-term positive consequences.

- The branding process would be hollow without genuine citizen input, so citizen engagement had to be integrated into the process.
- The results of a good branding process would remain worthless if the international media did not adequately cover the topic and its results.
- Brand building requires caution: Promising something that cannot be delivered, or something that could conflict with positive existing images of the nation, would reduce trust and generate backlash.

Opportunities

- There was an exceptionally good opportunity for building the Finnish brand, in that the country's recent performance and products were excellent and could stand up well in an international comparison.
- There had been an ongoing "Finland Boom" since 2003 that could resonate in a stronger brand.
- Problems with the previous branding process were linked to a poor country profile, not the product Finland itself, hence making the new branding process opportune.
- The well-established and free press in Finland could be an effective communication channel to address citizen expectations and concerns.
- The positive attitude of the citizens toward their nation could be used as a basis for greater citizen engagement in the branding process.

CORE OPPORTUNITY

"The functionality of Finnish society, our close relationship with nature, and a system of basic education that is among the best in the world are not just something to be proud of. If used properly, they can also be efficient 'tools'" (Demos Helsinki, 2010). As global challenges arose, Finland could be known as the world's problem solver. The key message regarding Finland would be "Consider it solved!"

GOALS

- Overarching goal: Capture the Finnish lifestyle and export it globally through a unified effort among officials, companies, and civic organizations.

- Global goal: By example and analogy, make Finland known as "the world's problem solver."
- National goal: Strengthen the Finnish identity by achieving understanding of the nation's strengths.
- Individual goal: Enhance an individual's experience of living, working, or visiting Finland.
- Communication goals:

 a. To engage citizens in the branding process
 b. To ensure trust in the campaign by focusing on the genuine strengths of the country
 c. To provoke and sustain interest in Finland abroad

OBJECTIVES

Six overall objectives were set for the development of the country brand:

- Increasing the appreciation of the fruits of Finnish creativity and labor, and promoting the export of Finnish products and services
- Promoting international investment in Finland
- Promoting inbound tourism to Finland
- Promoting the international status of the Finnish State
- Promoting the appeal of Finland among international professionals
- Raising the national self-esteem of Finns

Public Relations Objectives

- To make Finnish citizens into credible brand ambassadors by imbuing the Finnish people with the necessary trust in the branding campaign and a willingness to share their good experiences
- To have Finland's strengths presented with one voice through unified communication efforts by as many actors as possible
- To disseminate information about the branding process, thereby ensuring transparency, and therefore also the goodwill and collaboration of Finnish citizens

Output Objective

The branding process should consist of two-way communication (meetings, hearings, online discussions) where different institutions, organizations, experts, and individual citizens construct a realistic brand they personally can relate to. Meetings with citizens were arranged on various relevant topics and in selected areas in Finland; and the Finnish media were engaged as an avenue for news of the branding process. Because the branding campaign was publicly funded, a high priority was put on ensuring its transparency.

Outcome Objectives

- To build a stronger country brand and a good reputation abroad
- To empower the Finnish people to become brand ambassadors

KEY PUBLICS

Internal Publics

- The 5.4 million Finnish residents
- The 600,000 first- and second-generation Finns living abroad
- More than 100 "Finnish identity players" ranging from ministries and local authorities to businesses and civil society organizations
- The Finnish media

Global Publics

- Governments and potential investors globally (potential collaboration and business)
- Citizens of other countries with interest in, or potential interest in, Finland (potential tourists)
- Educators and researchers (potential research and training collaboration)
- International media (brand visibility abroad)
- International tourism associations and agencies (potential revenue)

KEY MESSAGES AS "MISSIONS"

The Country Brand Delegation established Finland's brand identity with three core themes:

1. The functionality of Finnish society
2. Finns' close relationship with nature
3. A Finnish propensity for educational excellence (Demos Helsinki, 2010)

Two traits of the Finnish brand character were further highlighted: dependability and limited hierarchy, and the intrinsic traits that make Finland not only a pleasant environment but also a useful partner for addressing global problems.

The key messages can be better understood through the "missions" the delegation gave to each of the more than 100 "identity players" (Demos Helsinki, 2010):

- For politicians and government officials: Ensure that schools receive adequate funding, as education is the font of all societal benefits.
- For school children: Involve the quietest children in the class. Engaging everyone will create a culture of belonging and increase well-being.
- For neighborhoods: Organize events to build social cohesion and celebrate successes of joint efforts.
- For the media: Focus on important issues and popularize science to generate new knowledge for your audiences.
- For employers: Promote teamwork and collaboration to foster a sense of belonging and community.
- For the tourism industry: Building and marketing holiday packets around the ideas of "silence and peace" in Finland, using the lack of noise pollution in the Finnish forests.
- For the public sector: Become "warriors" of an open information society by increasing the transparency of information on society and citizens worldwide.

Other missions included enlarging organic food production to half of the country's overall agricultural output by the year 2030; bringing lake water to drinkable purity; and establishing a peace mediation convention dedicated to the Finnish Nobel Peace Prize laureate Ahtisaari. Overall, these additional missions would continue to develop Finland's strengths while offering potential solutions to global problems such as climate change.

STRATEGIES

Branding work was seen as an effort to develop a Finland that would, ultimately, offer all Finns an even better place to live and work. The branding process aimed to be transparent and engaging for all key publics, and to be a holistic and long-term process of building awareness of the country and its reputation. The branding commitment had to support investment in developing a general and genuine country brand over the long term that would be beneficial to Finns in many respects.

The strategy was to establish and build on potential differentiating factors that distinguished Finland from similar country brands (Demos Helsinki, 2010):

- Global governance: Finland had the potential to create—and present—a more effective way for helping to solve problems in the world.
- Products: It would be natural for Finland to concentrate on developing truly efficient and sustainable products and services.
- Society and security: Make Finnish society and its sectors into a marketable "product."
- Education: Capitalize internationally on the high quality of Finnish high-level basic education.
- Wired society: Promote Finnish communication technology and its impact on social development.
- Nature: The Finns' unique relationship with nature is emotionally appealing in that it results in impressive environmental progress, much of it applicable globally.

TACTICS

The likelihood of citizen motivation increased due to counsel from an outside expert well known in the branding community (Simon Anholt). The delegation was an active player from the beginning, initiating discussion and pitching news stories to the national media. To achieve one central voice, a new kind of coordination and public support became a priority.

To give the process a human touch and to make it approachable, Foreign Minister Alexander Stubb appeared in various media as the "face" of the branding process.

Specific tactics included the following:

- Finnish corporations were invited to collaborate, which resulted in increased visibility. Sponsored outlets (such as the customer magazine of the national airline, Finnair) contributed to heightened visibility.
- The Brand Delegation was divided into four "working groups," each responsible for a share of the branding process. The entire delegation convened only eight times.
- Delegation members were encouraged to come up with their own suggestions and ideas.
- Expert sessions and hearings took place to brief the delegation on current trends, issues, and the newest research findings; approximately 200 experts from various sectors participated in the sessions and hearings.
- Government support was ensured through special meetings with members of the government and other social decision-makers (Demos Helsinki, 2010).
- The reputations of most Nordic countries were higher than that of Finland; therefore, Finland's association with being a "Nordic country" was emphasized.
- High visibility and transparency in Finland, important for the project's success and for public engagement, were emphasized throughout the campaign.
- Additional transparency was built into media relations with all members of the delegation being available for media coverage.
- Seminars and workshops engaged citizens, enabling them to participate in the branding process, increasing commitment and public support.

THE BRANDING PROCESS AND TEAM DIVISIONS

During the first stage of the work in 2009, the delegation concentrated on collecting and analyzing data and initiating communication on the topic nationally. It also analyzed opportunities for future Finnish societal successes and how to promote such progress as part of the emerging brand.

The focus in the second stage, which continued until spring 2010, was selecting and clarifying the most promising themes for a Finnish identity and Finland's brand. In the delegation's third stage, a management group examined the chosen themes in more detail and turned them into concrete proposals for action.

In practice, the Country Brand Delegation was divided into four working groups. The culture group began by formulating a Finnish identity—defining

what it meant to be Finnish. The communication group (public relations) ensured transparency and public engagement during the branding process by organizing four specific workshops around Finland on central topics for citizens' participation. The media group (media relations) was, naturally, responsible for the media relations of the branding process. The business group (business relations) analyzed Finland as a business environment and sought international benchmarks.

Culture

The task of the working group on culture was to define areas for improvement in the Finnish product and brand identity from the perspective of culture. It would identify obstacles and problems and suggest solutions. This working group examined Finnish cultural life in depth; its most tangible outcome was a May 2009 workshop that attracted more than 40 representatives from different cultural fields. It identified two important but partially conflicting aspects of the Finnish identity:

1. A fair society and reliability (equal opportunities and equality)
2. Depth and an "edge" (expertise and "creative madness")

The main obstacles to Finnish branding success also were defined: inadequate self-esteem, weak "identity marketing" competence, and questionable prioritization of investments and financing. The working group proposed these three main themes for the brand (Demos Helsinki, 2010): nature (environment) and sustainable development, education and well-being, and culture and the creative economy.

Public Relations

The task of the communications (public relations) working group was to develop the Finland brand from the perspective of transparency and outreach, and to engage all stakeholders in the process. The group was responsible for the delegation's external communication, which mainly involved organizing seminars and workshops in Finland. The group aimed to maximize citizens' participation in the work of the delegation and to build and maintain citizen support and enthusiasm for the process (Demos Helsinki, 2010). It created and managed four citizen-centered seminars, with about 350 people participating:

- The Levi Summit, in Kittle, November 2009, was a meeting for business experts to discuss Finland's brand from a commercial and financial perspective.

- Young people were invited to a public seminar in Helsinki, December 2010, on the theme of youth exclusion.
- An environmental workshop for experts arranged in Helsinki, January 2010, was a meeting to discuss proposals for "everyman's environmental obligations."
- The last seminar, in Jyvaskyla in March 2010, addressed educational themes and Finnish teaching and learning.

Public participation online was used to engage citizens. In February 2009 the website www.mitasuomion.fi was established, and it served as a channel for public debate on Finland and Finnish-ness, with more than 1,500 comments posted during the initial commenting phase of a few months. The site existed for the duration of the process, but content was later provided mostly by the organizations involved, not individual citizens.

Media Relations

The main tasks of the working group on media ranged from strategic planning of media relations to organizing interviews and trips for journalists. At the start of its term, the delegation was met with harsh citizen and media criticism, resulting in intensive debate and some disengagement. The branding process was criticized as being elitist, commercial, and "reflecting a caricature of Finnishness" (Browning, forthcoming). This challenge was met with transparency and an open invitation to engage; no counterattacks were launched.

After 2009, the media coverage became more positive, largely as a result of the delegation's openness to the public and its work that attracted positive coverage in all of Finland's leading media. Media relations were ongoing throughout the project, mostly through interviews and distribution of campaign information.

More than 200 editorials were written about the process. The summary pamphlet *Mitä Suomi on?* (*What Is Finland?*), a collection of written editorials, was produced for the delegation's online service. Its 15,000 print copies were distributed free of charge to the public via the Ministry for Foreign Affairs, the Finnish Tourist Board, and libraries, and similar material was available on the project website.

There was close collaboration with the commercial TV channel MTV3. A special program titled *Mission for Finland* featuring delegation members aired in April 2010; it inspired viewers to participate in the branding process. As a result, viewers submitted more than 200 proposals on how to promote Finland's reputation. More than 300,000 people viewed the program.[2]

Business Relations

The fourth working group examined the Finnish identity from the perspective of Finnish business life. Two characteristics emerged as being essential for the narrative: the country's creativity and its "predictability," the combination of technological skills and a culture that values stability and reliability.

For benchmark comparison, the group identified two countries in which a high level of creativity is combined with a high level of predictability, Sweden and the United States. The working group on business believed that Finland had the potential to be compared with these countries because in the Finnish identity, reliability, and creativity are connected.

The same working group also identified problems in reputation that result not from deeds, but rather from poor communication. By confronting these characteristics, Finland's overall positive image would be improved significantly.

The working group summarized Finland's problem-solving identity in a slogan used previously in the business world: "Consider It Solved!" (Demos Helsinki, 2010).

BUDGET

The Ministry of Foreign Affairs and its network of embassies carry out public diplomacy in Finland through 97 diplomatic missions. The delegation's work was viewed as a natural contribution to the Ministry's regular affairs. When compared with the annual budget of the key players, the Country Branding process budget was relatively modest.

The delegation's expenses altogether totaled approximately 520,000€ (euro) (.74 Euro = $1 USD), of which MEK (Visit Finland) paid 300,000€; the Ministry of Foreign Affairs covered the rest. The largest single expense of 150,000€ was Anholt's consultation fees.

EVALUATION AND MEASUREMENT OF RESULTS

The results of branding are often long term, and changes in visibility and awareness can best be observed over an extended period of time. However, in the case of the Finland brand, some major results were visible shortly after the process took root. The chair of the delegation concluded:

Finland's image must be based on real strengths. Only by developing our strengths in a creative way can we increase Finland's familiarity and appeal to the rest of the world. To my mind, the delegation has succeeded admirably in this creative thought process. (Country Brand Delegation Chair Jorma Ollila, 2013)

A Compendium of Specific Results

- There was strong internal support for the branding process. More than 1,000 Finns took part in the public meetings and contributed by sharing their experiences, commenting, and making specific suggestions for the delegation.
- National media coverage, despite the negative beginning, turned positive and supportive during the process and resulted in substantial public engagement.
- The delegation became the essential central voice for the campaign. And, anticipating the prospect of a fallback after the campaign, discussion began on whether Finland should establish a special institute for the country brand, similar to the Swedish Institute. As of early 2014, this had not yet been done.
- Arguably, the best "stand-alone" visibility came in the form of the overall assessment as "the best place to live" by *Newsweek* magazine. In its article "Finland—World's Best Country" (*Newsweek* Finland, 20120, the magazine gave this assessment:

Despite the long winter, Finland is a pretty great place to be—the best, actually. It ranked the highest overall and also comes in as the best small country, the best high-income country, and the best country for education. Its students scored first in science and second in both reading and math in the 2006 (the most recent one for which data are available) Program for International Student Assessment, a test of 15-year-olds' education skills by the OECD. Finland's school kids enjoy a laid-back and inclusive learning environment where shoes are optional, all teachers have master's degrees, and extra help is the norm: every year about one in three students gets individual time with a tutor.

- In the 2012 Transparency International listings, Finland improved its ranking to share first place with Denmark and New Zealand among the least corrupt countries in the world.

- Finland was ranked number 9 on the Future Brand Country Brand Index (2012).
- Finland also was ranked number one in the 2009 Legatum Institute's Prosperity Index measuring wealth, economic growth, personal well-being, and quality of life.
- Finland was ranked number one in the World Economic Forum Networked Readiness Index (Global Information Technology Report), measuring the capacity of economies to leverage Information and Communication Technology (ICT) for growth and well-being.
- Finland's education system was ranked best in the world by the global analysis called 'The Learning Curve'- an initiative from Pearson Education plc.
- The nation achieved ninth place among Forbes' "Best Countries for Business."
- Finland ranked second in the World Economic Forum's (WEF) annual Global Gender Gap report; in WEF's 2012 Global Competiveness Report, Finland was number three.
- Finland placed second for dynamic businesses to flourish, according to the Grant Thornton Global Dynamism Index.
- According to *The Economist* Intelligence Unit's annual study, the Finnish capital, Helsinki, is the world's eighth best city in which to live.
- According to the United Nations World Happiness Report, Finland is among the three "happiest" nations in the world (Finland in World Rankings, 2012).
- Despite the year of recession in 2013, Finland climbed from sixth to first in the Save the Children annual State of the World's Mothers Report.
- Finland also is now ranked among the top countries for retirement by Natixis Global Retirement Index, and sixth in the index's more comprehensive listing based on health, material well-being, finances, and quality of life.
- National air carrier Finnair ranked as the world's safest airline in the 2012 JACDEC Safety Index (Finland in World Rankings, 2012).
- Finland also is at the top of the 2013 World Press Freedom Index published by Reporters Without Borders.
- There was a 1-point increase on the Anholt-GfK Roper Nation Brands Index to place 17 (2013).

Such widespread reputational success is—as is all reputational achievement—the result of progressive policy and performance well communicated, and not all of this success can be attributed to this specific branding campaign.

Outcome and Outgrowth: One Voice

To answer the biggest challenge of the branding process that unified performance, voice, and message, the country branding process continues today under the title "Team Finland." It networks three ministries—the Ministry of Employment and the Economy, the Ministry for Foreign Affairs, and the Ministry of Education and Culture. Under this team, there also is now a Finland Promotion Board working for country promotion. The Permanent Secretaries' coordination group, the External Economic Relations Unit in the Prime Minister's Office, and the central government steer the network by establishing a set of overarching priorities for its activities, which are reviewed annually. The "Team Finland" network promotes Finland and its interests abroad, which are the country's brand, its external economic relations, the internationalization of Finnish businesses, and internal investments.

Some 70 Finnish branding teams have been set up in various countries; they bring together all Finnish authorities, publicly funded organizations, and other key parties with ties to Finland. Each team has its own work program and coordinator (Team Finland, 2012).

Future brand strengths lie in the promotion of the quality of life in Finland. Several strong indicators already exist, including gender equality, the low percentage of people living in poverty, the equality of wealth distribution, the state of the environment, and the proportion of people employed.

Finland's reputation is solid in economic dynamism, that is, the proportion of services and industrial output in GDP, innovations, the ease with which new companies can reach the market, and the scope of the stock market.

When measuring social capital, the quality of political life, democratic freedom, and the proportion of citizens involved in elections and political stability, Finland ranks high.

The remaining central challenge for "Team Finland" is to maintain the brand within the country, to reassure Finns that their country is exceptional even as it communicates that message internationally.

Evaluation in Relation to Public Relations Objectives

The challenge was to maintain national support for the brand building process and to empower Finnish citizens to become brand ambassadors. This was successful, although not to the degree that it could have been, as the approximately 1,000 active participants represent a modest fraction of Finns. On the other hand, the possibility to participate was presented to virtually all citizens, and the choice to engage was left to the individuals.

Trust building and maintenance were successful as the entire branding process remained focused on authentic strengths of the nation, and the targeted publics did not question the contents of the branding process.

Another achieved aim was to increasingly capitalize on the Finnish lifestyle and export it globally through a joint effort by officials, companies, and civic organizations.

The global goal to become known as an exemplar for solving many of the world's problems under the "Consider It Solved!" philosophy will take much more time to measure.

DISCUSSION AND CONCLUSION

Considering this process in light of current branding literature, several insights can be drawn. First, as an intangible asset, the brand and its value ultimately do not belong to the nation or organization conducting the branding, but rather to the public's assessment of it (Fombrun & van Riel, 2004; Anholt, 2007). Hence, the measures taken to brand something can never be fully controlled or successful, and the outcomes may surprise the branders. In fact, it has even been said that a nation's brand "exists with or without any conscious efforts" (Fan, 2005, p. 12) through national identity and audience perceptions.

A country's national brand is tied largely to its cultural resources and the perceivers' previous conceptions and impressions. A national brand can be defined as the "unique multi-dimensional blend of elements that provide that nation with culturally grounded differentiation and relevance for all of its target audiences" (Dinnie, 2008, p. 15). Stereotypes play a strong role in country brands, and branding something outside a country or discrediting existing cultural stereotypes may prove difficult. Nation branding should therefore build on existing impressions (Fan, 2005). This was acknowledged in the Finland nation branding process, and part of its success can be explained by the research expertly designed and conducted after public hearings held during the process. The strengths of Finland lie in verifiable areas of functionality, education, and appreciation of nature (see also Kolb, 2014).

For branding to succeed, the brand must be perceived and understood as to how it fits into peoples' experiences and life (Calder, Malthouse, & Schaedel, 2009). Keller (2009) highlights that customers and publics should be at the center of branding, and that differentiation is key. The Finnish branding process acknowledged this: Finland as a brand had to be unique. Literature suggests that the "customer relationship" with the brand progresses in stages, and branding must

develop accordingly. From audience awareness to differentiation, the aim is to achieve positive experiences and establish relationships (Keller, 2009).

The change visible on the 18th on the Anholt-GfK Roper Nation Brands Index (2013) can be understood as small. Moreover, as the Brands Index was not purchased each year but merely in 2008 and 2013, possible changes may have been overlooked. The brand equity stages can take much time. In the Finnish branding process, the first stages of awareness, differentiation, and positive experiences were established first "at home" at the national level. Reputation studies show that progress inside an organization or nation matters most for long-term improvement in overall reputation and image (Anholt, 2007; Fombrun, 1996; Fombrun & van Riel, 2004; Luoma-aho, 2007). As the *Business Insider* article (Kolb, 2014) sums up: "Finland needs to overcome its best-kept secret syndrome" and more aggressively market abroad. To begin, Kolb suggests better convincing the Finns themselves of their skills and abilities. This suggestion also resonates with this research: the main target group of the branding process remained the Finns themselves. As for being able to involve the Finns, this country brand process was quite successful.

Citizens of the branding nation and their perceptions are central to branding success. As "brand ambassadors," citizens represent the most credible source for the brand (Dinnie, 2008). Some experts even say that the citizens of a country play the largest role in nation branding (Anholt, 2007). Recent literature on brand and customer engagement defines engagement as the level and intensity of an individual's "participation in and connection with an organization's offerings and/or organizational activities" (Vivek, Beatty, & Morgan, 2012). Such engagement must be planned, not coincidental, because it occurs as a result of direct experiences (Brodie, Hollebeek, Juric, & Ilic, 2011; Brodie, Ilic, Juric, & Hollebeek, 2013; Calder et al., 2009; Vivek et al., 2012). This was one of the successes of the Finland branding campaign.

In addition, values are at the core of successful national branding (Dinnie, 2008), and the selection of key messages and values for the Finnish process was a lengthy process. Highlighting the three areas of nature (environment), education, and functionality reflected citizens' values as well as their experiences. This became apparent in the effort to change public opinion by increasing transparency in the branding process.

As the cost of national branding is ultimately borne by taxpayers, the process must be in line with public sector priorities. In Finland, this meant increasing transparency in developing the brand. The fully inclusive stakeholder model (Dinnie, 2008) mandates inclusion of a wide variety of publics and stakeholders in the values process, accomplished in Finland through the citizen meetings, seminars,

and workshops. The process managed to overcome the internal challenges and was a good example in involving national citizens.

Recent brand literature has concluded that brand engagement now takes place increasingly online (Calder & Malthouse, 2005; Calder et al., 2009). Team Finland acknowledged this; throughout the campaign, material was available online, and much of the visibility effort continues to be focused on online delivery (see, e.g., Finland.fi: "This Is Finland"). Overall, the Finnish branding process provides an excellent example of how to involve various stakeholders and publics, engage them, and listen to them. Its success was largely due to adherence to these principles.

NOTES

1. All founding organizations had worked for years to improve the country's image and provided information for foreign visitors. Finnfacts is owned by the business sector and promotes Finnish expertise around the world online and through the international media. Finpro is the national trade, internationalization, and investment development organization. Invest in Finland acquires foreign direct investment (FDI) for Finland and assists foreign companies to find business opportunities in Finland. More information can be reached through the Internet: Finnfacts, Finnpro, and Invest in Finland.

2. The expert jury led by Jorma Ollila chose three proposals from the public during the broadcast, the implementation of which the brand delegation will take forward by finding individuals and organizations to sponsor them.

REFERENCES

Anholt, S. (2002). Nation-branding: A continuing theme. *The Journal of Brand Management, 10*(1), 59–60.

Anholt, S. (2003). *Brand new justice—the upside of global branding.* Oxford, UK: Butterworth-Heinemann.

Anholt, S. (2007). *Competitive identity: The new brand management for nations, cities and regions.* New York: Palgrave.

Brodie, R. J., Hollebeek, L. D., Juric, B., & Ilic, A. (2011). Customer engagement: Conceptual domain, fundamental propositions, and implications for research. *Journal of Service Research, 14*(3), 252–271.

Brodie, R. J., Ilic, A., Juric, B., & Hollebeek, L. D. (2013). Consumer engagement in a virtual brand community: An exploratory analysis. *Journal of Business Research, 66*, 105–114.

Browning, C. S. (forthcoming). *National branding: National self-esteem and the constitution of subjectivity in late modernity.*

Calder, B. J., & Malthouse, E. C. (2005). Experiential engagement with online content web sites and the impact of cross-media usage. *Worldwide Readership Research Symposium*, Session 6.10, 201–224.

Calder, B. J., & Malthouse, E. C. (2008). Media engagement and advertising effectiveness. In B. J. Calder (Ed.), *Kellogg on media and advertising* (pp. 1–35). Hoboken, NJ: John Wiley & Sons.

Calder, B. J., Malthouse, E. C., & Schaedel, U. (2009). An experiental study of the relationship between online engagement and advertising effectiveness. *Journal of Interactive Marketing, 23*, 321–331.

Demos Helsinki. (2010). *Consider It Solved! Country Brand Report*. Retrieved from http://www.demoshelsinki.fi/wp-content/uploads/2013/02/TS_Report_EN.pdf

Dinnie, K. (2008). *Nation-branding—Concepts, Issues, Practice*. Burlington, MA: Elsevier.

Fan, Y. (2005). Branding the nation: What is being branded? *Journal of Vacation Marketing, 12*(1), pp. 5–14.

Finland in World Rankings. (2012). Retrieved from http://team.finland.fi/public/download.aspx?ID=117888&GUID={0971013C-B017-4268-8FDE-0A790C3BD118}

Fombrun, C. J. (1996). *Reputation: Realizing value from the corporate image*. Boston: Harvard Business School.

Fombrun, C. J., & van Riel, C. B. M. (2004). *Fame and fortune: How successful companies build winning reputations*. Upper Saddle River, NJ: Prentice Hall.

Keller, K. L. (2003). Brand synthesis: The multidimensionality of brand knowledge. *Journal of Consumer Research, 29*, 595–600.

Keller, K. L. (2009). Building strong brands in a modern marketing communications environment. *Journal of Marketing Communications, 15*(2–3), 139–155.

Kolb, I. (2014, February 6). Finland has a shyness problem. *Business Insider*. Retrieved from http://www.businessinsider.com/finland-has-a-shyness-problem-2014-2

Luoma-aho, V. (2007). Neutral reputation and public sector organizations, *Corporate Reputation Review, 10*(2), 124–143.

Ministry of Foreign Affairs. (1990). *The KANTINE Report*, pp. 8–9, 11–12.

Moilanen, T., & Rainisto, S. (2008). Suomen maabrandin rakentaminen. Finland Promotion Board, pp. 98–99, 111–114.

Newsweek. (2010). The best country in the world: Finland. The world's best countries. August.

OECD (2010). Tertiary education graduation rates. Education: Key Tables from OECD. Retrieved from http://www.oecd-ilibrary.org/education/tertiary-education-graduation-rates-2010_20755120-2010-table1

Vivek, S. D., Beatty, S. E., & Morgan, R. M. (2012). Customer engagement: Exploring customer relationships beyond purchase. *Journal of Marketing Theory and Practise, 20*(2), 127–145.

World Audit. (2013). "Finland: World Audit Democracy Profile." Retrieved from WorldAudit.org

Dynam Goes Public: Financial Relations Success for Pachinko Gaming

HONGMEI SHEN
San Diego State University

EDITORS' NOTE

This case study traces a successful financial relations campaign that resulted in Dynam Japan Holdings being the world's first pachinko hall operating company to make a public offering and to become the first company in Japan to be listed on the Hong Kong Stock Exchange. (Pachinko is a combination slot machine and pinball game.) The result: The company went public during the year-long campaign and substantially increased foreign investment in the company.

BACKGROUND

It was 9 a.m. on August 6, 2013, a celebratory time for Dynam Japan Holdings, Co., Ltd. (DYJH). At that exact moment, DYJH was listed on the Hong Kong Stock Exchange, the world's first pachinko hall operating company (pachinko is a combination slot machine and pinball game) to make a public offering and Japan's first company to list on the Hong Kong Stock Exchange main board.

DYJH is a Tokyo-based game hall management company, split from its parent company to be listed in Hong Kong as Dynam Holdings Co., Ltd. (referred to hereafter as the Dynam Group) in 2009. As the second-largest pachinko parlor operator in Japan, the Dynam Group, with its four group subsidiaries in pachinko hall management and other businesses, had a net worth of 15 billion Yen in 2012. The pachinko hall management subsidiary group includes Dynam Co., Ltd. (353 pachinko halls) and Cabin Plaza Co., Ltd. (nine pachinko halls). The other businesses in the group of subsidiaries consists of the Dynam Business Support Co., Ltd., and Dynam Hong Kong Co., Ltd. The latter deals with investments in Asia while the former is responsible for real estate management, brokerage services, accounting, and advertising. The Dynam Group as a whole employs 9,506 workers and manages 362 pachinko halls (Dynam, 2013).

In Japan, pachinko halls had not been able to make a public offering largely because of debates about the legality of the industry. After several failed attempts in Japan, the Dynam Group decided to try listing the company on the Hong Kong Stock Exchange. In addition to the apparent and anticipated language and cultural barriers, the Dynam Group found itself confronted with additional challenges: the Hong Kong local market's lack of knowledge of the company, the local audience's misperceptions of pachinko as a pastime, cautious Hong Kong regulators' stringent rules on publicity and promotion initiatives by Dynam, and the inconveniently scheduled listing during a weak time for the market (Public Affairs Asia, 2012). As a result, Dynam's executive team collaborated for a year with a Hong Kong–based investor relations firm to ensure its successful listing (Y. Sato, personal communication, August 20, 2013).

This case analysis evaluates the effectiveness of Dynam's financial relations campaign.

METHODOLOGY

This case study was researched and written using several qualitative research methodologies, among them a telephone interview with the chief executive officer (CEO) Y. Sato and his staff at Dynam Group and a review of a book and additional materials about the company supplied by Dynam Group. The author also reviewed materials submitted in support of a 2012 nomination for a Dow Jones Gold Standard Award for Corporate Financial Communications submitted by Strategic Public Relations Group, Hong Kong for its investor relations representation of the Dynam Group. The author also drew upon media coverage of Dynam's bid to be the first pachinko hall operator to make a public offering and be listed on

the Hong Kong Stock Exchange. This secondary research was supplemented by primary research: correspondence with Dynam's CEO Y. Sato and his staff.

SITUATION ANALYSIS

Internal Factors

The Dynam Group stated its corporate philosophy as "a centurial commitment to building trust and encouraging dreams" that emphasized building trusting relationships with employees, shareholders, financial institutions, business partners, and other stakeholders such as customers and local residents (Dynam, 2013). Further, Dynam CEO Y. Sato cited "strong financial performance" and "international personnel to understand international markets" as the company's main strengths (Y. Sato, personal communication, August 20, 2013). The company recorded a 5.2% year-on-year increase in net sales volume (897.6 million Yen) and a 12.8% year-on-year increase in net profit in fiscal 2012 (Dynam, 2012).

Going public had been a long-time goal of the Dynam Group. It joined with five other major and medium-sized pachinko hall operators in Japan—including PARK, Marian, Oath, Japan New Alpha, and HUMAX—to form a listing preparatory committee. An initial listing application was submitted in 2003 to the Tokyo Stock Exchange (JASDAQ) but was turned down in 2005 due to "pachinko's legal problems" (Sawa, 2012). Rejecting the criticism of pachinko parlors' "legal gray" operations, the Dynam Group was determined to go public—and to do so in Hong Kong (Dynam, 2012; Sawa, 2012).

Despite its strong financial performance and resolution to go public, the Dynam Group was confronted with an internal obstacle. Dynam Group is a large, complex company, and management believed a restructuring was needed to ensure a faster listing in Hong Kong because local regulations required a time-consuming review of all subsidiaries' financial records over the previous three years to comply with the International Financial Reporting Standards. A regrouping/integration of all the pachinko hall subsidiaries to be listed in the public offering also could enhance their credibility and reputation in addition to the tax cut benefits to the company (Dynam, 2012; Sawa, 2012).

External Factors

Pachinko has been popular in Japan since the 1940s. There are more than 12,500 pachinko halls in Japan, generating annually four times as much profit (30 trillion Yen) as the rest of the world's casino businesses combined (Tang, 2012). As of

2010, the industry employed 333,230 workers, bigger than the 11 major Japanese automobile manufacturers combined (Dynam, 2012). It made up more 26.8% of Japan's entertainment market (BusinessWeek, 2012).

Despite its dominance, the pachinko industry generally has been viewed as operating in a legal gray zone. The key problem is that customers' pachinko winnings could only be exchanged for prizes at pachinko parlors, not for cash. According to Japan's Penal Code, gambling is illegal except for horseracing, bicycle racing, boat racing, and motorcycle racing (Japan Cabinet Secretariat, 2013). The Act on Control and Improvement of Amusement Business further prohibits pachinko halls from providing cash as prize merchandise or buying back merchandise offered to customers. However, customers could legally exchange/sell their prizes to outside wholesalers that were not affiliated with the pachinko halls. Critics of relaxing gambling regulations for pachinko argued that in reality, many such outside wholesalers sell these prizes to pachinko parlors, violating gambling laws (Sawa, 2012). On the other hand, regulators such as the National Police Agency actually have argued in favor of legalizing the pachinko industry (Dynam, 2012; Sawa, 2012).

In addition to its legal issues, the pachinko industry in recent years had worked to expand overseas due to an increasingly lackluster business performance and stricter government regulations on the industry in Japan. According to Matsukawa (2012), rental pachinko hall volume was 34.6%, down from 2003, dropping to 1.94 trillion Yen. The number of pachinko hall guests had been on the decline as well. In addition, Japan's population growth rate had slowed to .02% in 2010, the lowest since 1920 (Saoshiro, 2011). On top of all these issues was government intervention: a 2007 regulation to prevent pachinko parlors from encouraging customers to play more and a 2011 ban on advertisements that promoted "the gambling spirit" (Stradbrooke, 2013). As a result, leading pachinko hall management companies had been eyeing neighboring Asian markets for expansion possibilities. Maruhan, the largest pachinko company in Japan, explored and invested in Cambodian banks (Honam, 2012). South Korean tourists were targeted by the pachinko industry because Korean establishments similar to pachinko halls were banned in Seoul in a government battle against gambling addictions in 2006 (Kodera, 2013). The Dynam Group targeted Hong Kong for its expansion and considered it an ideal choice because of its reputable stock market system, major financial center status, and position as a gateway to other Asian markets (Y. Sato, personal communication, August 20, 2013).

Against this controversial backdrop, the Dynam Group admitted that its main external challenge to be listed in Hong Kong was to battle stakeholders' "misperceptions about the pachinko industry" both in Japan and in international markets such as Hong Kong, according to Dynam Group's Sato (Y. Sato, personal communication, August 20, 2013). In the meantime, Hong Kong regulators also had introduced

more stringent rules on publicity and promotion initiatives by the Dynam Group in April 2012 (Public Affairs Asia, 2012). CEO Y. Sato stated that the Dynam Group further recognized the difficulty it faced in securing non-Japanese investors.

CORE PROBLEM

The Dynam Group identified this as the core problem for its initial public offering: The majority of external stakeholders in Hong Kong lacked sufficient knowledge about the company and the pachinko business, hence pachinko's low social standing. As CEO Sato acknowledged, "Pachinko is very unique in Japan. People outside do not fully understand our business. We're still educating people what it is even one year after our IPO here" (personal communication, August 20, 2013). A Dynam employee also talked about the low social standing of the pachinko industry: "We have faced discrimination in general business transactions, etc., just because we operate pachinko halls…. I hope that there will be less [*sic*] people who discriminate against us than in the past now that we have been recognized as a socially acceptable, public existence" (Dynam, 2012, p. 25).

GOALS AND OBJECTIVES

The goal of the Dynam Group was to enhance the social standing of the company and the overall pachinko industry in Japan. Employees interviewed in the company's internal publications and Sato expressed the desire to be recognized as a "socially acceptable, public existence" (Dynam, 2012).

To do so, the company's immediate objective was to go public within one year (by July 2013), inviting public attention both at home and abroad (Dynam, 2012; Y. Sato, personal communication, August 20, 2013). Dynam's objective in the period leading up to the public filing was to minimize the company's financial dependence on Japanese banks (Dynam, 2012, p. 134), specifically by raising 16 billion Yen (equivalent to the company's annual after-tax profit) through its Hong Kong listing. The money would be used to open 75 new pachinko halls in the next three years (Dynam, 2012).

KEY PUBLICS

The Dynam Group focused its investor relations campaign on Hong Kong regulators, investors, auditors, and media; and on U.S. investors (Y. Sato, personal communication, August 20, 2013). These publics were identified mainly through

informal research by the Dynam Group, including personal contacts/observations, conversations with key informants such as securities experts in Hong Kong, and secondary research by those key informants. For instance, some of the investors were introduced to CEO Sato through personal networks of the Dynam Group's global coordinators of the campaign (Y. Sato, personal communication, August 20, 2013). The company also relied on one of its key associates in Hong Kong, newly appointed independent non-executive director Thomas Yip, to learn about the Hong Kong market. The appointment of such independent non-executive directors, who provide independent opinions on the corporate governance and internal controls in the management of the listed company (usually certified public accountants), was in compliance with Hong Kong's listing regulations (Dynam, 2012).

Regulators

The regulators included members of the Hong Kong Stock Exchange's listing committee. From its 28 members, a team of 10 lawyers, accountants, and securities experts was assigned to review and assess each company's listing application. Half of these listing committee members were rotated off the committee every year (Hong Kong Stock Exchange, 2013).

Investors

The Dynam Group targeted both institutional and retail investors in Hong Kong and key cities in the United States, including New York, Los Angeles, and San Francisco (Y. Sato, personal communication, August 20, 2013).

Media

Local and regional media also were targeted (Public Affairs Asia, 2012).

Auditors

RSM Nelson Wheeler, a Hong Kong-based auditing firm, and Seiwa Audit, its Japanese partner, were hired by the Dynam Group (Dynam, 2012).

Law Firms

An American law firm, Baker & McKenzie, was hired to solicit U.S. investors, and seven other Hong Kong law firms who were versed in both Japanese and Hong Kong laws also were retained by the Dynam Group (Dynam, 2012).

KEY MESSAGES

Based on the informal research conducted and individual meetings with the identified publics, the Dynam Group decided on five key messages:

1. Dynam has a competitive business model and is the leader of the pachinko industry.
2. Dynam is financially strong and provides high dividend yields.
3. Dynam has a professional management team that has been involved in the pachinko industry for more than 40 years.
4. Dynam has very stable and excellent staff in the pachinko industry.
5. For perspective: The pachinko industry is larger than the dining industry in Japan (Public Affairs Asia, 2012; Y. Sato, personal communication, August 20, 2013).

STRATEGIES AND TACTICS

Action Strategies and Tactics

The Dynam Group used three main action strategies in this campaign. First, an internal restructuring was completed to facilitate the listing. Specifically, in September 2011, the Dynam Group grouped 11 of its pachinko hall management companies into Dynam Japan Holdings, the actual listing in Hong Kong. Then the Dynam Group reorganized all of its other businesses (eight companies) as Dynam Holdings. The two umbrella holding companies had no capital relationship (Dynam, 2012); creating that financial firewall not only sped up the listing process (reducing paperwork) but also integrated Dynam's pachinko business. Regrouping also generated other financial benefits, such as tax cuts, that a simple merger and acquisition would not have made possible (Dynam, 2012).

Dynam's second strategy, to overcome language and cultural barriers, was to appoint eight of its employees to form a special internal translation team and to hire an outside translation company, Takara Printing. The translation team worked with one of Dynam's accounting firms, RSM Nelson Wheeler, to translate and review all of the Dynam Group's past account transactions and rewrite the settlements of accounts in compliance with the International Financial Reporting Standards used by the Hong Kong Stock Exchange (Dynam, 2012).

The company's third strategy was to form partnerships with 27 domestic and international companies, including underwriters (Hong Kong sponsors), auditors, law firms, and consulting firms (Dynam, 2012). An outside Hong Kong-based investor relations firm also was hired to help manage the campaign. All of these partnering companies/firms participated in the application/listing process to ensure clear and efficient delivery of the Dynam Group's key messages.

Communication Strategies and Tactics

Due to the unique nature of the campaign (Dynam had never before made a public offering in a foreign market), the Dynam Group's communication tactics were primarily aimed at audience groupings but also involved personal contacts reaching strategic publics to credibly debunk the media portrayal of pachinko parlors as operating in a legal gray area. Both domestic and foreign media had used terms such as "legal loophole" (Honam, 2012) and "gray area" (Sawa, 2012) to characterize the pachinko industry in Japan. Tactics included obtaining the Japan National Police Agency's (pachinko parlors' regulatory agency in Japan) oral and written statements, sharing legal advice from seven reputable law firms, and arranging roadshows, face-to-face meetings, and presentations with Hong Kong and foreign investors.

The Dynam Group cited the 2003 official statement by the Japan National Police Agency in response to an inquiry from the Diet Committee on Casinos as International Tourism Industry regarding whether pachinko is gambling under Article 185 of the country's Penal Code. The agency stated, "Pachinko hall operators who conduct their businesses within the bounds set by the Entertainment Business Law (now the Act on Control and Improvement of Amusement Business) are not considered to be operating a business that runs gambling" (Dynam, 2012, p. 55). In the meantime, at the request of the Dynam Group, one of the Japan National Police Agency's section chiefs issued a statement encouraging pachinko hall operators to get listed with it in the future; this could "optimize the business activities of pachinko halls and contribute to their sound development" (Dynam, 2012, p. 57). The section chief added that the police ensure pachinko hall operators abide by the Entertainment Business Law and that violations of individual operators should not imply that the whole industry is operating in a legal gray area (Dynam, 2012).

The Dynam Group further relied on its seven law firms to detail to the Hong Kong Stock Exchange the relevant Japanese laws regulating the pachinko industry and the Japanese "three-party system" (pachinko hall parlors, customers, and outside wholesalers exchanging customer winnings). The legal experts also referred

to the aforementioned Japan National Police Agency response, explicitly stated in the Dynam Group's 530-page listing application prospectus, that "the operation of pachinko halls that hold a valid permission to conduct their businesses according to the Amusement Business Law and that offer prizes within the bounds set by such permission is not considered gambling that is prohibited by the Penal Code" (Dynam, 2012, p. 55).

In addition to these mediated communication channels, the Dynam Group used the tactic of roadshows and face-to-face meetings with Hong Kong and foreign investors. A global offering in Hong Kong normally requires that 90% of the shares be sold outside Hong Kong. The Dynam Group therefore used employees' personal networks to arrange meetings with foreign investors in Europe and the United States (Dynam, 2012; Public Affairs Asia, 2012; Y. Sato, personal communication, August 20, 2013). For two weeks, CEO Sato and his staff traveled to meet with potential investors in a series of roadshows (Dynam, 2012).

Finally, the Dynam Group held a large press conference in Hong Kong for major media outlets to address the legality of pachinko parlors and to explain the company's objectives, business model, and day-to-day operations. Many media questions centered on "misconceptions about the pachinko industry." Approximately 70 reporters attended the press conference (Public Affairs Asia, 2012; Y. Sato, personal communication, August 20, 2013).

TIMETABLE

June 1–3, 2011

Dynam Group CEO Sato first met with the Hong Kong Stock Exchange assessment personnel to discuss the possibility of listing in Hong Kong. The assessment staff concluded that the application might be accepted if a legal opinion attesting to the legality of the pachinko business accompanied the application.

June–November 2011

Sato and his staff travelled to Hong Kong every month to prepare for the listing application; during their visits they were accompanied by representatives of the 27 companies/firms Dynam had retained to participate in the process (seven law firms, 10 finance and accounting firms, and 10 securities firms and consulting companies).

January 13, 2012

The Dynam Group submitted its initial listing application, the A-1 Application.

July 6, 2012

The Hong Kong Stock Exchange completed its assessment of the Dynam application. Between January and July, rounds of inquiries and responses were exchanged between the Hong Kong Stock Exchange's listing committee and the Dynam Group with assistance from the company's contracted accountants, lawyers, and sponsor (Public Affairs Asia, 2012). All exchanges of communication between the two parties were recorded in the 530-page prospectus and disclosed to the public.

After the inquiry process, a one-day listing hearing (July 5, 2012) was held. Attendees included the listing committee and top executives of the Hong Kong Stock Exchange who had evaluated the listing committee's presentation and granted approval of the public offering.

Normally, the listing assessment takes two to four months. In the case of the Dynam Group, the negative media portrayal of the pachinko industry prolonged the assessment process.

August 6, 2013

The Dynam Group was officially listed on the Hong Kong Stock Exchange.

Figure 9.1. CEO Yoji Sato (right) of represents the Dynam Japan Holdings Co., Ltd., Group at the Hong Kong Stock Exchange with Chairman Chow Chung Kong of the Hong Kong Stock Exchange (left). Courtesy of Dynam Japan Holdings Co., Ltd.

BUDGET

Dynam Group CEO Sato estimated the total listing cost, including indirect and investor relations expenses, to be approximately 1 billion Yen (US$11 million dollars). A large portion of the funds spent was on document translations (Y. Sato, personal communication, August 20, 2013).

EVALUATION AND MEASUREMENT OF RESULTS

The Dynam Group considered the yearlong campaign a success. The company raised 1.6 billion Hong Kong dollars (US$194 million) and now is regarded as a "high-yield investment stock" by the investment community (Public Affairs Asia, 2012; Y. Sato, personal communication, August 20, 2013). Specifically, the pachinko hall operators' stock price has advanced approximately 20% since its initial listing (S. Sato, Hu, & Yamaguchi, 2013). Furthermore, the company has expanded its business in Asia, especially into the regional gaming sector (Y. Sato, personal communication, August 20, 2013), including Macao. The company's plan to run a pachinko hall at Macao's fisherman's wharf was said by financial analysts to be "the first step towards a potential Japan casino venture" in Macao (Quinta, 2013). It marked the company's conclusion of a successful financial relations campaign.

In terms of its long-term goal of enhancing the social standing of the company and the overall pachinko industry, company CEO Sato recognized that the Dynam Group still has a long way to go. The company must continue to educate the local Hong Kong community about the game of pachinko and the pachinko parlor business more than a year after its initial listing in Hong Kong (Y. Sato, personal communication, August 20, 2013). Nevertheless, the Dynam Group did establish an important precedent for Japanese companies. Other Japanese companies (not limited to the gaming industry) also were eyeing the Hong Kong and Asian markets as expansion targets (Public Affairs Asia, 2012). For example, Fast Retailing Co., Asia's largest clothing retailer, "was slated to list in Hong Kong in 2014" (S. Sato et al., 2013).

Using the inputs-outputs-outcomes pyramid model of evaluation (Broom & Sha, 2012) to assess the Dynam Group's financial relations campaign, there clearly are areas in which the campaign could have been improved. A typical public relations campaign aims to change publics' knowledge, attitudes, and/or behavior. To gauge accomplishment of these goals, the campaign's inputs, outputs, and outcomes should be evaluated (Broom & Sha, 2012). The Dynam Group's evaluation

and measurement of its campaign results were largely limited to its financial performance, an output rather than an outcome.

With respect to inputs evaluation, the company did not seek feedback from its key stakeholders about whether its message delivery and content were appropriate. Concerning outputs evaluation, the Dynam Group did preliminary media monitoring, for example, tracking local and regional media coverage of the company as proof of the company's increased profile in Asia (Public Affairs Asia, 2012). It is unclear whether the company tracked the number of people who received and understood their messages and the number of people who retained or considered the messages. Dynam Group could have conducted more formal research such as focus groups, interviews, and surveys of key stakeholders to better assess their knowledge of the company and its business as a result of exposure to media messages. Similarly, the Dynam Group could have undertaken research to examine the extent to which key stakeholders changed their attitudes and behavior (an assessment of outcomes) toward the pachinko gaming industry.

SUMMARY

This case study outlined the yearlong effort of the Dynam Group, the second largest pachinko parlor operator in Japan, to "go public" and list stock on a foreign market—the Hong Kong Stock Exchange. Overall, it was a successful campaign in terms of meeting its main objectives: going public within one year, inviting more public attention both at home and abroad, and increasing foreign investment in the company (Dynam, 2012; Y. Sato, personal communication, August 20, 2013).

Success was substantiated in the research, planning, and implementation phases of the campaign. First, the company primarily relied on informal and secondary research and personal connections/observations to identify the core problem, determine campaign goals and objectives, and target key stakeholders, but a more formal stakeholder analysis, including surveys of local investors' perceptions and sentiment, would have been more beneficial. Conducting such analysis could have helped the company better segment its individual investor audiences in Hong Kong.

Regarding campaign planning and implementation, the Dynam Group used both external assistance (a financial relations firm in Hong Kong) and internal staff to develop and roll out the campaign plan, including laudable action communication strategies and tactics. The combination of "mass" and "personal" foci of its communication strategies neatly fit the uniqueness of a little-known foreign company's financial relations campaign.

Potential areas of improvement particularly lie in the evaluation phase of the campaign. More formal research would have benefited the campaign and the company's follow-up operations in local Asian markets, given that its long-term goal was to enhance the social standing of the company and the overall pachinko industry.

REFERENCES

Broom, G., & Sha, B. (2012). *Cutlip & Center's effective public relations* (11th ed.). New York: Pearson.

BusinessWeek. (2012). Dynam bets on Hong Kong IPO. Retrieved from http://www.businessweek.com/videos/2012-08-05/dynam-bets-on-hong-kong-ipo

Dynam. (2012). *Beyond borders! Dynam challenges the international market.* Tokyo: Zaikai.

Dynam. (2013). *About the Dynam Japan holdings group.* Retrieved from http://mnt.dyjh.co.jp/english/group/message.html

Honam, K. (2012). *Pachinko operator runs responsible bank in Cambodia.* Retrieved from http://jbpress.ismedia.jp/articles/-/34308?page=4

Hong Kong Stock Exchange. (2013). *Listing requirements and procedures.* Retrieved from http://www.hkex.com.hk/eng/listing/listreq_pro/listpro/listing_process.htm

Japan Cabinet Secretariat. (2013). *Penal code.* Retrieved from http://www.cas.go.jp/jp/seisaku/hourei/data/PC.pdf

Kodera, Y. (2013). *Japanese pachinko parlors lure South Korean tourists after gambling ban.* Retrieved from http://ajw.asahi.com/article/behind_news/social_affairs/AJ201303040083

Matsukawa, M. (2011). *White paper of leisure 2012: The leisure in the post–earthquake context.* Retrieved from http://www.jpc-net.jp/eng/research/2012_06.html

Public Affairs Asia Net. (2012). *The gold standard award for corporate financial communications.* Retrieved from http://www.publicaffairsasia.net/goldstandard/financial.html

Quinta, V. (2013). *Dynam to run pachinko hall at Fisherman's Wharf.* Retrieved from http://macaubusinessdaily.com/Gaming/Dynam-run-pachinko-hall-Fisherman%E2%80%99s-Wharf

Saoshiro, S. (2011). *Japan population growth rate slows to record low.* Retrieved from http://www.reuters.com/article/2011/02/25/us-japan-population-idUSTRE71O1FK20110225

Sato, S., Hu, F., & Yamaguchi, Y. (2013). *Fast Retailing said to plan Hong Kong Exchange listing.* Retrieved from http://www.bloomberg.com/news/2013-08-26/fast-retailing-said-to-plan-hong-kong-exchange-listing-1-.html

Sawa, N. (2012). *Pachinko operator plans controversial listing in Hong Kong.* Retrieved from http://ajw.asahi.com/article/economy/business/AJ201207090067

Stradbrooke, S. (2013). *Japan casino bill in April, footie bet law revamp.* Retrieved from http://calvinayre.com/casino/japan-casino-legislation-expected-in-april

Tang, P. (2012). *The big business of Japan's pachinko parlours.* Retrieved from http://www.bbc.com/travel/feature/20120815-the-big-business-of-japans-pachinko-parlours/2

The Poznań "Fan Zone": Building Identity for a City and a Nation Through Sport

ALAN R. FREITAG
University of North Carolina at Charlotte

JACEK TRÉBECKI AND KATARZYNA KONIECKIEWICZ
Poznań University of Economics

EDITORS' NOTE

In this case, public relations professionals played a central role in managing the successful positioning and presentation of the city of Poznań—and, by extension, the nation of Poland—as welcoming the international football (soccer) community for mutual enjoyment. And, not incidentally, the well-projected event demonstrated the power of sport and entertainment to bring people of many backgrounds together in the fullest sense of the word.

BACKGROUND AND SITUATION ANALYSIS

Every four years, the European Football Championship captures the attention of football fans in Europe and fans throughout the world as well as countless people who simply enjoy athletic competition and spectacle on a grand scale. For more than 60 years, the build-up to each quadrennial championship begins many

months in advance as each nation competes for the honor and prestige of participating in the highly anticipated final rounds of pairings to determine ultimately which nation will become home for the Henri Delaunay Trophy for the next four years.

It's a distinction that earns respect, admiration, and perhaps a bit of envy. The pride felt by the victorious national team and that nation's citizens is priceless. Another way the championship conveys prestige to nations in Europe is through the selection by the Fédération Internationale de Football Association (FIFA) to host those final rounds. Normally, one country is designated host for the championship final rounds; three times, however, two countries have shared this honor. Most recently, in 2012, FIFA selected, for the first time in its history, two host countries that had been part of the former Soviet sphere: Poland and Ukraine.

With their democratic market economies barely more than 20 years old, this was a tremendous trial of the two countries' capacity to host such a complex event played out on a global stage. Each host country identified four cities that would be the sites of matches for the two weeks of the Euro Cup in summer 2012.

Preparation for the event began many months in advance with extensive promotion through multiple interpersonal, mass, and social media channels. Then, for days and even weeks before actual matches in the selected cities, fans and teams arrive and further raise visibility—and create challenges—for the hosts.

This case study focuses on Poland and specifically on one of its host cities, Poznań (selected along with Warszawa [Warsaw], Wrocław, and Gdańsk as Poland's venue cities). For Poznań and for Poland, this was not simply a major athletic event but an opportunity to showcase the final stages of its transitional evolution from a centrally controlled economy to a market-driven democracy. It was public diplomacy on a global scale.

More specifically, this case explores in depth one significant component of Poznań's comprehensive approach to its role in Euro 2012: the creation and operation of its "Fan Zone." In addition to the construction or renovation of state-of-the-art stadiums in each of the eight host cities, FIFA required each city to establish Fan Zones to extend participation in the tournament to tens of thousands of fans in each city unable for a variety of reasons to attend matches in the stadiums. In fact, although 1.4 million fans in the eight cities flocked to the stadiums themselves, another 5 million fans enjoyed watching matches on enormous outdoor screens while taking in exhibits, food and beverage stands, games, and the sheer delight of cheering on their favorite teams with hundreds of thousands of like-minded enthusiasts in the cities' Fan Zones.

Planning and operating each Fan Zone required lengthy preparation, careful consideration of its impact and consequences, and thoughtful attention to the

communication dimensions of such an undertaking. The FIFA instruction book for the design and operation of EURO Cup Fan Zones is several inches thick, covering exhaustive details such as the proper attire for volunteers who aid fans and how to ensure smooth, safe operation of the facility. In Poznań's case, its Fan Zone attracted more than 750,000 fans during its 23-day lifespan, from June 8 through July 1, 2012. The consequential match between Poland and Russia alone (played in Warsaw) drew 60,500 enthusiasts to the Poznań Fan Zone throughout the day (the maximum capacity of the Poznań Fan Zone at any given time was 30,000). An enterprise of such scope has lots of moving parts, and Poznań had only one chance to get it right.

A Poznań-based public relations firm, Prelite, earned the contract with the city to manage all communication aspects of the city's Fan Zone, including internal and external promotion and crisis communication planning. Prelite, established in 1994, was the first public relations firm in the Polish state of Wielkopolska and is still led by its two founding partners, both of whom hold doctorates in public relations (one, Jacek Trébecki, is a coauthor of this case). With a staff of just 10 public relations specialists and also with concurrent responsibility for other clients, Prelite was able to assign just five or six staff members to the consequential and extensive Fan Zone contract, and those staff members had to deal simultaneously with other client obligations.

Communication planning for the summer event began in earnest in February 2012, with actual preparations and communication activities beginning in March. In that short time, the Prelite team needed to begin by gaining local community acceptance and commitment to the idea. This was an entirely new concept for local citizens, so the public relations effort needed to address latent distrust and concern as well as potential confusion. There was fear, for example, that thousands of drunken football fans would spoil the beauty and atmosphere of this delightful city situated midway between Warsaw and Berlin. Football in Europe and elsewhere has an unfortunate reputation for "football hooliganism," the tendency for a few unruly fans to engage in disruptive, sometimes illegal, and destructive behavior. Even without incidents of that nature, the anticipated presence of 30,000 visitors to the city, primarily from Italy, Croatia, and Ireland, the three nations slated to compete in Poznań, as well as the participation of tens of thousands of Poles in stadiums and Fan Zone activities, was certain to create a considerable degree of turmoil. Business owners in the vicinity were concerned, for example, by the planned closure of a large underground public parking facility beneath the square that was to house the Fan Zone. Planned road closings would also change traffic patterns, making it difficult for customers, employees, and vendors to access businesses near the Fan Zone.

Poznań, at once both a vibrant and tranquil city of 600,000, is considered the second leading financial center of Poland and home to a significant industrial base including cutting-edge technology and manufacturing firms. It's also home to numerous and highly regarded colleges and universities such as the Poznań University of Economics, Adam Mickiewicz University, the Poznań University of Technology, and the College of Communication and Management. The city is situated on the Warta River and boasts many beautiful lakes and parks along with striking architecture from many periods, and a popular Old Market Square replete with picturesque cafés, fountains, restaurants, and shops. A popular conference and convention hub, Poznań is accustomed to accommodating visitors, but never before on the scale of Euro 2012.

Placing this historic event in the context of Poland's recent developments, particularly as those developments affect the shaping of public relations practice, aids in understanding the significance of Euro 2012 for Poland. As Ławniczak, Rydzak, and Trébecki (2003) observe, modern public relations in Poland paralleled the country's transition to a pluralistic political system beginning in the early 1990s. This fairly recent evolution, the authors point out, has introduced possibilities for broader foreign contacts and commerce along with the establishment of what they call "market instruments, mechanisms, and institutions" (p. 259) such as a stock exchange, government agencies, and foreign and domestic corporations. The authors note, too, that there is no direct Polish term for "public relations," though the term *komunikacja społeczna*, meaning "social communication," is enjoying some popularity. In practice, the concept of public relations is often considered to encompass merely publicity and media relations. In fact, the authors acknowledge that public relations in Poland is often confused with marketing and press agentry, even with propaganda. As a result, an opportunity to provide public relations support for an event of such significant scope as Poznań's Euro 2012 Fan Zone marked a significant milestone for Prelite and potentially for the development of public relations as a profession in Poland and even more widely in Central and Eastern Europe.

On a broader scale, Gannon (2004) says Polish culture is primarily characterized by the influences of three driving factors: the nation's peasant roots, its history of foreign occupation and dominance, and Catholicism. The Catholic Church has given Poles a strong sense of community and collective identity along with a spiritual link to the land. The nation's troubled and turbulent history has resulted in a strong sense of resilience, pride, and a powerful survival instinct. Perhaps as a result, Morrison and Conaway (2006) say Poles are cautious, and it can be a challenge to win them over to new ideas. However, the authors acknowledge that this

is changing as a younger generation with little or no personal experience shaped by communist rule increasingly enters the workplace.

The idea of harnessing the power of an event such as Euro 2012 for the purpose of elevating Poland's international profile would seem natural, but there were barriers to that kind of effort. Szondi (2005) writes that challenges remained for former Warsaw Pact nations even 15 years after the end of the Cold War. One problem he notes is that there was an absence of a coherent effort to recast each nation's identity. There were, it seems, multiple agencies often working at cross-purposes. Szondi says, "In Poland for example, the Ministry of Economy, Ministry of Foreign Affairs, the Ministry of Culture as well as the Polish Chamber of Commerce, the Mickiewicz Institute have all been involved in country promotion, sometimes communicating different and uncoordinated messages" (p. 210). Szondi nevertheless states that it is essential for Central and Eastern European (CEE) nations to engage actively in raising awareness of their continually emerging status as economic centers. He says the people in CEE countries are far more familiar with western nations, their cultures, and economic strengths than is the reverse case. Poland has made considerable strides, joining NATO in 1999 and the European Union in 2004, and its economy has experienced consistent growth even during the recent economic downturn. Nevertheless, EURO 2012 provided a superb opportunity to propel this nation of 35 million people further toward recognition as a major presence in the global community.

METHOD

As a case study, this project involved "viewing situations holistically" (Hocking, Stacks, & McDermott, 2003, p. 406). Two of the authors, Trébecki and Konieck-iewicz, are associated with the public relations firm carrying out the Poznań Fan Zone communication contract. The remaining author, Freitag, was serving in Poznań under a Fulbright Fellowship during the planning and operation of the Fan Zone. Consequently, all three authors functioned as participant observers with direct or indirect involvement in the project. They had extraordinary access to top officials and activities and events connected with the Fan Zone. The authors enjoyed full access to case-related artifacts such as news releases, media advisories, media coverage, media registration logs, attendance data, and other materials. From this unique vantage, the authors were able to exhaustively analyze the dynamics of the Fan Zone beginning many months before it opened its gates until long after it ceased operations.

CORE OPPORTUNITY AND GOALS

The public relations agency Prelite needed to achieve several goals and supporting objectives:

- Address citizen and business owner concerns regarding the potential disruption created by the establishment of the eight-acre venue just one block from the popular Old Market Square

 ○ Before construction activities begin, earn full support for the Fan Zone and acceptance of the interruption to normal business and personal activities in the immediate area

- Build awareness and enthusiasm among citizens of Poznań and the surrounding area so they would take advantage of this unique opportunity to participate in EURO 2012 by attending events in the city's Fan Zone

 ○ Attract at least 500,000 fans to the facility during the three weeks of its operation

- Use the Fan Zone to generate awareness of and appreciation for Poznań and for Poland

 ○ Ensure that media coverage (mass and social) is positive and extensive

Early research suggested Prelite would have a challenging task. Surveys revealed that only one in two citizens was aware the Fan Zone would be open to residents of Poznań and the surrounding state of Wielkopolska. Just one in five anticipated that the Fan Zone would offer activities for children. Asked how they planned to spend their time during the EURO 2012 period, survey respondents listed the following:

Stay home and watch matches on TV	44%
Watch matches on TV in pubs or restaurants	33%
Go to the Fan Zone	27%
Stay in Poznań, but not watch matches	16%
Watch matches on TV at friends' homes	16%
Leave the city during EURO 2012	10%

KEY PUBLICS AND MESSAGES

Prelite's leaders and its staff, in collaboration with Poznań's city public relations manager, identified the following key publics and crafted appropriate messages for each as follows:

- Business owners near Fan Zone site:
 - There will be disruption to traffic patterns and parking, but the city will work with you to explore alternatives for your customers and vendors.
 - Although there will be disruptions for two weeks, there also will be a significant influx of visitors before, during, and following that period who will be potential customers as well.
 - This is an extraordinary opportunity to showcase our city and will likely benefit Poznań's economy in the years ahead as travelers, investors, and business leaders see Poznań's potential for growth.

- Citizens in and near Poznań:
 - If you are unable to attend matches at our newly constructed stadium, you can still enjoy the stadium atmosphere in a safe, clean, family-friendly environment by viewing matches on giant screens in the Poznań Fan Zone.
 - Not only will matches held in Poznań be featured in the Fan Zone, but so will all matches played in other selected EURO 2012 cities in Poland and Ukraine.
 - The Poznań Fan Zone will have many attractions and amenities in addition to the matches shown on the giant screens, including activities for children, and the Fan Zone is easily accessible from all directions by public transportation.
 - There will be thousands of visitors to our city during EURO 2012. This is an extraordinary opportunity for us to demonstrate Poznań's welcoming and friendly culture and to confirm that our city is well deserving of the honor of hosting EURO 2012 matches.

- Visitors from outside Poznań, and especially from outside Poland, who attend events in the Poznań Fan Zone:

- ○ Our city welcomes you and encourages you to enjoy our hospitality represented by the Fan Zone.
- ○ We encourage you to enjoy the many other attractions Poznań and the surrounding area have to offer, including museums, an extensive park system, easy-to-use and inexpensive public transportation, Malta Lake, the Warta River, castles, churches and cathedrals, restaurants, shops, night clubs, shopping malls, and much more.

STRATEGIES AND TACTICS

Community Relations

The first communication efforts were aimed toward engaging Poznań's citizens, especially business owners in the vicinity of the Fan Zone. Prelite PR worked with city officials to ensure that this process was not only transparent but also that citizen input was incorporated. Several "town meetings" were conducted during which Fan Zone planners described the sequence of events that would unfold and solicited public comments. During these meetings, held once each month from June 2011 through June 2012, citizens could seek answers to questions regarding such issues as the site choice for the Fan Zone, the benefits to those living in the area, and the organization and operation of Fan Zone events and activities. Prelite PR played a limited advisory role in these meetings as they were organized and conducted by the city's neighborhood council. Prelite did develop website materials targeted toward Poznań citizens.

Media Relations

Based in large part on citizen input, Fan Zone planners made certain that the facility provided activities appealing to many more people than just football fans. To convey this message, Prelite PR managers conducted an ongoing series of news conferences and issued a steady stream of news releases to ensure that citizens were fully aware of those plans. Guidelines that shaped the media strategy included establishing and maintaining a positive relationship with journalists beginning several months before EURO 2012 and continuing through the tournament and the operation of the Fan Zone, ensuring that print, broadcast, and Internet-based media outlets were accommodated, and providing a steady flow of information through easily accessible channels of communication. Seven themed news conferences were conducted in the months preceding and during Fan Zone operation:

- March 21: A news conference conveying general information regarding the Fan Zone. The spokespersons were a representative of Poznań City Hall, the vice president of the Poznań Euro 2012 planning team, the Poznań Fan Zone chief executive, and several other people directly involved in Poznań's participation in Euro 2012. This event was held in the offices of the Euro Poznań 2012 organizing team, establishing an awareness of the central authority overseeing Poznań's participation in the tournament; 28 media representatives attended, including those from print, broadcast, and Internet outlets. This strong media turnout meant a highly successful launch of the communication effort in support of Poznań's plans for hosting the matches, including the operation of the Fan Zone.
- April 4: A news conference announcing a competition to design a portable, eco-friendly seat for guests to use in the Fan Zone. Spokespersons included David Graas, well known European designer and project consultant for the Fan Zone, as well as representatives from the Poznań EURO 2012 planning team. The venue for this event (and several subsequent news conferences) was a center called "Spot" (http://www.spot.Poznań.pl/en/spot/place). The 20 attending journalists again represented a cross-section of print, broadcast, and Internet outlets. The event successfully conveyed the potential for the sporting competition to reach into other dimensions of Poznań's identity such as its leadership in engineering, manufacturing, and art.
- April 26: A news conference to announce the results of the seat design competition. This event featured the customary spokespersons plus a representative of the Union of European Football Associations (UEFA) and the captain of the Poznań football team. Media participation dipped to 12 for this event, but broadcast coverage was particularly strong. This event also took place in the "Spot" venue.
- May 15: This news conference introduced the line-up of more than 40 performing artists who would be showcased in the Fan Zone during its operation. Spokespersons included Poznań's deputy mayor, top event planning officials, and several of the artists slated to perform during Fan Zone operation. The venue selected was Poznań's elegant Hotel Rzymski, across the street from the eight-acre square that was beginning its transformation into the Fan Zone. This significant event heralding the much-anticipated appearances of locally, nationally, and internationally renowned artists drew 36 media representatives, the highest attendance among the seven news conferences.

- May 30: A news conference to unveil the Fan Zone's integral media center. This event, held in the media center itself, introduced the 24 attending journalists to the facility that would provide them with a central base of operations from which to cover Fan Zone events and other activities in the city. Spokespersons were Fan Zone media representatives and city public relations managers.
- May 31: On the day following the introduction of the Fan Zone media center, this news conference described activities to be available in the children's "Junior Zone." One particular focus was on cooperative programs arranged through various art-related organizations in Poznań. Consequently, spokespersons, in addition to Fan Zone and city officials, included representatives of those organizations, such as the Children's Art Centre. Appropriately, the venue was Poznań's National Art Museum, conveniently located across the street from the Fan Zone. Eighteen journalists participated. This was the last news conference held prior to the Fan Zone's official opening on June 8.
- June 19: This news conference halfway through the Fan Zone's operational span provided journalists with a status overview, and it was held, naturally, in the Fan Zone media center itself. Here journalists heard from Poznań's mayor and Poznań Euro 2012 officials.

For each news conference, public relations managers prepared and distributed media kits that included news releases, additional information, and photos. Spokespersons made themselves available for interviews following each formal event.

Also central to the media strategy for the Poznań Fan Zone was a steady flow of substantive news releases distributed widely and made available on the Internet. In total, 34 news releases were prepared and distributed beginning March 5 and continuing through the final news release on July 3. Release titles included the following:

- "Fan Zone not only for football fans"
- "What will be continued after the Fan Zone operation ends?"
- "The Poznań Fan Zone is 'kid-friendly'"
- "In the Fan Zone, you do not need cash"
- "Traffic system changes around the Fan Zone from 7 June through 1 July"
- "Fan Zone a valuable experience for volunteers"
- "Fan Zone will promote Poznań"

Each release reflected a different element of communication planning for the Fan Zone. For example, a number of releases described non-football events such as

concerts and exhibitions. To make the facility popular to more citizens and visitors, planners scheduled more than 60 concerts and artistic displays on Fan Zone stages. They ranged from German singer Oceana and Polish folk group Jarzębina to rapper Mrokas and rock band Luxtorpeda. The release concerning the lack of the need for cash in the Fan Zone reflected a partnership with Polish bank PeKaO, also a national partner and official sponsor of EURO 2012 (the bank is headquartered in Warsaw but maintains operations in Poznań), to operate a booth in the Fan Zone where visitors could easily obtain a special issue debit card for use at concessions; in fact, concessions accepted only these special debit cards rather than cash, which contributed not only to convenience but also to enhanced security.

A release on May 24 provided details on the Fan Zone "blueprint" and specific facilities: accommodations for up to 30,000 fans at any given time with an expectation of an average of 18,000 fans per day; two bleacher-style seating areas for up to 1,000 fans; five secure entrances plus emergency exits; a special area for the disabled; three large viewing screens as large as 100 square meters, and seven concession stands. The release also stressed security (a concern for all European football events); this included more than 300 security personnel and an extensive camera monitoring system. The comprehensive release also addressed the eco-friendly dimensions of the Fan Zone, highlighting the 90 recycling points that would be available.

Another release soon after the "blueprint" release introduced and provided details on activities for children; this reinforced the key point regarding the family-friendly atmosphere of the Fan Zone. The release described children's art workshops to be held during Fan Zone operations, incorporating football themes. There were also screenings of films with inspiring football-themed messages for children. Other children's activities promoted pro-ecological themes. A special device to measure the speed and force of children's football kicks was available free. The release outlined additional children's competitions and activities such as performances by the World Children Folk Festival dance as well as instrumental and vocal performance groups.

One release described how Fan Zone revenue (entrance was free, but concessionaires sold food and beverages) would be used in part to help pay medical expenses for a young girl, four-and-a-half-year-old Samantha, from the city of Kornik, near Poznań. Samantha suffered from chronic myelogenous leukemia and was experiencing severe complications following a bone marrow transplant. Communication planners and city officials recognized that this gesture was the responsible thing to do and provided visitors an added incentive to participate in Fan Zone activities. In addition to designating a portion of concession proceeds to this cause, officials auctioned a football signed by UEFA President Michel Platini;

it sold for nearly USD $2,000, bringing the total raised for Samantha to roughly USD $3,000.

A release in May 2011 described the need for volunteers to help manage Fan Zone operations. The release described the responsibilities volunteers would undertake and the value of such an experience: improve your foreign language competency; observe how a large, complex sporting event is organized; meet new people; and acquire useful skills applicable to your professional career. The appeal was effective as more than 500 applicants stepped forward to participate. After screening, 136 volunteers worked the Fan Zone, providing information and assistance to guests, and another 38 volunteers served on medical teams, available to respond to emergencies.

Another release shortly before the Fan Zone opened, distributed primarily to local media outlets, reminded citizens that many outside journalists and thousands of foreign visitors would be coming to Poznań, and that this was an exceptional opportunity to showcase the best aspects of the city.

Prelite managers also used news releases to address issues that arose during the Fan Zone's operational period. An excellent example is the firm's response when Fan Zone attendance quickly began to exceed expectations. Anticipating an average of 18,000 visitors per day, with higher attendance on days of key tournament matches, Fan Zone officials were caught a bit off guard when attendance spiked well beyond those levels; the extended holiday weekend of June 8–10 saw 144,000 visitors in just those three days. Subsequently, on the day of the Poland-Greece match (played in Warsaw but viewable in real-time on Fan Zone video screens), officials had to close the gates and turn away disappointed visitors for three hours when they reached maximum capacity. Soon after, for the Ireland-Croatia match (played in Poznań), officials decided to extend opening hours to 2 a.m. to accommodate the huge crowds that included an estimated 20,000 fans from Ireland and 10,000 from Croatia. Public relations managers were transparent in explaining, through the media, the details of these developments and the adjustments being made in response; the Fan Zone media center proved to be an effective conduit in accomplishing this. Releases issued during the two-week operational period always listed remaining events such as concerts, competitions, displays, and activities for children.

Another way planners connected the Fan Zone with Poznań's citizens was through a celebration of Poznań's "Name Day." In Polish tradition, birthdays are less important than an individual's Name Day—a day designated to commemorate a saint; if you share the name of that saint, then that's your Name Day. Poznań, whose patron saints are Peter and Paul, marks its Name Day on June 30, a day that fell during Fan Zone operation. To commemorate the occasion, and to attract

more visitors to the Fan Zone, planners scheduled special concerts and various sports competitions. One of the featured concert artists was Hanna Banaszak, a popular Polish singer born in Poznań. Sports activities included competitions in football skills, skateboarding, and rollerblading. There also were classes and demonstrations of such things as yoga, zumba, and even healthy cooking. The inaugural event associated with Poznań's Name Day was a celebration of Mass in the city's main basilica; including such an event reflects the cultural and spiritual importance of the Catholic Church in Poland, where 95% of the country's citizens profess to be adherents of the Catholic faith. Advance news releases described all these activities in detail, and media were invited to cover all events.

Two of the news conferences, on April 4 and 26, concerned a competition to design an eco-friendly seat to be distributed to Fan Zone visitors. This was a particularly successful component of the communication strategy. Recycling is highly popular, and associating an event such as this with responsible use of resources is an important element of planning. For the Fan Zone, planners realized visitors who spent extended time in the venue might wish to sit and rest while enjoying a match on the big screen, a concert, or perhaps a snack. Limited space, though, precluded the provision of extensive permanent seating, and security guidelines meant visitors could not bring portable furniture into the Fan Zone. The solution? A competition to design a portable chair, made of recyclable material, that could be distributed within the Fan Zone. It was a huge success. The most common choice for entries was corrugated cardboard, and the designs were ingenious. The winning entry was about the size of a small picnic chair. It folded flat and featured a convenient carrying handle. It opened easily into its stool shape and comfortably supported an adult. Thousands of the seats were distributed and used throughout the life of the Fan Zone, and the concept proved quite popular in media coverage. The news conference announcing the contest winner featured the captain of Poznań's own professional football team and was held in a former factory, now repurposed as a popular Poznań nightclub called "Spot," another illustration of recycling that heightened the theme.

A major aspect of the media relations effort was the operation of the Fan Zone media center itself. More than 450 journalists were officially accredited just for the Poznań Fan Zone. Journalists were referred to an online accreditation form, and media representatives accredited for overall coverage of EURO 2012 were granted automatic accreditation to the Poznań Fan Zone. The Fan Zone itself was open to the public, so no special credentials for the public were required. However, formal accreditation provided access to the media center, camera platforms, and areas of the Fan Zone well suited for interviews, not open to the public.

Positioned within the Fan Zone, the enclosed media center encompassed a modern, ecologically and functionally designed space of more than 400 square meters (roughly 4,400 square feet). Dutch designer David Graas was consulted in its design. Built of eco-friendly, recyclable materials, it was aesthetically inviting and functional. It included both an enclosed space and a picturesque terrace overlooking the main stage and viewing area. Attributes included an information desk (which accommodated the accreditation process) and 60 workspaces that included desks, chairs, power outlets, WiFi, standard office equipment, and lockers for safely storing personal belongings. Additionally, a separate space permitted relaxing with comfortable sofas, chairs, and even foosball tables. Two "silent rooms" facilitated recording and editing. There were five large-screen TVs for viewing all Euro 2012 matches, and hot and cold beverages were provided along with a catering service option. Accredited journalists also were invited to roam the entire Fan Zone (with a few areas excepted for security and safety reasons).

Community Appeal

A key Fan Zone strategy was to establish mutually beneficial partnerships with organizations in Poznań and the surrounding region. As already noted, cooperation with one of Poland's major banks provided a convenient and secure process permitting fans to make purchases at concessions without cash via the Fan Zone debit card system. The cards even incorporated Fan Zone and Euro 2012 thematic art, making the cards themselves souvenirs. Fan Zone officials also partnered with the Poznań University of the Arts and the Poznań Children's Art Center to organize and conduct the art-themed activities for children visiting the Fan Zone. A major joint effort resulted from a partnership with Tourism Ireland; this resulted in the June 15 *Irish Day* that featured Celtic musical groups and dramatic presentations of "Stories from the Green Island" especially for youngsters.

One of the key messages for Poznań citizens and especially for business owners in the vicinity of the Fan Zone was that there would unavoidably be disruptions to normal traffic flow in the area. In addition to pointing out the potential for increased business from the tens of thousands of visitors, officials also sought to offset the inconvenience with incentives such as tickets for business owners in the reserved viewing bleachers in the Fan Zone.

Within the Fan Zone itself, Prelite employees and volunteers distributed 250,000 Fan Zone guides, 15,000 of the recyclable cardboard seats, and 15,000 rain ponchos.

Internet and Social Media

Strategies and tactics for Web-based activities were simple. A Facebook page targeted a young audience eager to interface with Fan Zone activities through a medium with which they were becoming increasingly familiar. It kept them apprised of upcoming activities and invited site visitors to share their comments, photos, and experiences. The Facebook site attracted nearly 16,500 "fans" (www.facebook.com/StrefaKibicaPoznań). Prelite managers established a more formal, dedicated website (http://euroPoznań2012.pl/aktualnosci/336) that chronicled the establishment of the Fan Zone and provided site visitors, especially journalists and bloggers, with a steady trove of statistics, schedules, photos, and other material. Approximately 105,000 people visited that site; public relations managers posted 215 updates to the site during Fan Zone operations. The site included continually updated photos, videos, and announcements, and it invited comments from fans.

BUDGET

Prelite worked on a retainer basis of roughly USD $2,000 per month for the six months leading up to and during Fan Zone operation; this went almost exclusively to staff salaries and expenses such as travel. The firm's leaders describe the work as modest during preparation but extremely heavy during June and July. Many additional costs were handled through normal Poznań city budgeting processes; these included printing, administration, and facility rental costs. Cost of constructing and operating the entire Fan Zone approached USD $3 million.

RESULTS

According to Prelite officials, the primary achievement of Poznań's successful hosting of the EURO 2012 final matches was to demonstrate the city's capacity to manage an event of this scope and visibility. That it did so effectively can be gauged by overwhelmingly positive media coverage that accurately and supportively conveyed that message. Documents show the Fan Zone media center accredited more than 450 journalists representing 47 countries. As many as 200 media representatives visited the center on match days. More than 20 radio and television stations broadcast reports and programming from the center, and 18 remote broadcast trucks operated from the Fan Zone media center area. Prelite

officials report that in Polish media alone, more than 2,200 print and broadcast reports appeared. The official photographer for the Fan Zone took and posted nearly 43,000 photos. With an operational goal of attracting 500,000 fans, the Fan Zone ultimately drew 750,000, 50% over expectations and more than the population of Poznań itself.

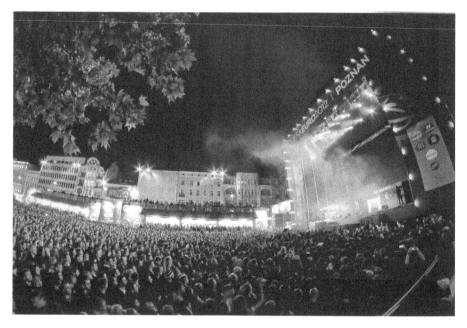

Figure 10.1. Local and international visitors enjoying the Poznań Fan Zone.

Since the EURO 2012 matches, Poznań has been able to attract significant events such as conventions and major sporting events, including the LOTTO triathlon.

Concrete measures of success include indicators of individual program success as well as overall Fan Zone activity. For example, as part of the facility's "Euro Blood Relatives" blood drive, Fan Zone visitors donated 1,273 liters of blood. More than 32,000 children visited the Junior Zone. Concession sales reflected brisk activity: 194,000 cups of beer, 28,000 soft drinks, and 23,000 baked potatoes sold.

The lessons public relations managers gained from the experience include the delicacy of working with city government officials where politics and individual interests must be blended with proven communication strategies and tactics. They also learned the importance of engendering a public commitment to such an undertaking; public relations efforts to earn the support of business leaders and ordinary citizens were critical to the Fan Zone's success. Additionally, the need to

be responsive to journalists on a 24/7 basis was clearly in evidence from the early days of preparation but especially during the operation of the Fan Zone. Prelite personnel learned quickly that they needed to be available at all times to respond to journalists' needs; mobile communication devices proved essential to this aspect of media relations. Especially enthusiastic but representative coverage appeared in Irish media, Ireland having been one of the three countries whose football teams played its matches in Poznań. Irish media reports described thousands of green-clad Irish fans filling the city's streets, parks, restaurants, cafes, and, especially, the Fan Zone. The coverage stressed the cheerful warmth of the host city as well as its beauty and charm.

One feature of the FIFA tournament is that the two host nations—Poland and Ukraine in this case—are automatic entries into the final series of matches, while all other nations must "play" themselves into this top level through earlier elimination rounds. However, although Poland was included in the final series, its young players were not expected to fare particularly well. Despite some early success, Poland was soon eliminated. Anticipating this outcome, public relations planners had designed their strategic approach to avoid building enthusiasm solely around the Polish team's participation. This turned out to be a wise decision; this can be gauged by the steady and even increasing numbers of Fan Zone visitors even after Poland was no longer in the competition for the cup.

A less tangible measure of success was the friendly and spirited atmosphere that prevailed throughout the operational period of the Fan Zone. The authors of this chapter observed that on the days of the Polish team's matches, the Fan Zone was a sea of red and white as fans sported their national team apparel. When Ireland, Croatia, and Italy played, supportive fans from those countries proudly wore their teams' colors. Opposing fans stood or sat side-by-side and reflected only a healthy and respectful rivalry. Even when language might have been a barrier, fans quickly established bonds rooted in a mutual love for football.

A significant achievement resulting from the successful operation of the Fan Zone was the demonstration of the effective use of that part of the city for other events. The Fan Zone established Plac Wolności (the official name of the square) as a suitable venue for additional cultural events. Area residents and business owners now welcome this concept. Since the Fan Zone closed, Plac Wolności has hosted Theatre Festival Malta, Movie Festival Transatlantyk, the Festival of Jewish Culture, and several other recurring events, with more such events planned.

Event officials and communication managers needed to prepare for contingencies, and a comprehensive crisis plan, including a substantial communication module, was prepared and tested. Fortunately, no significant events occurred that would have required its implementation. There were concerns, for example,

regarding the possibility, however remote, of a terrorist incident, but none materialized. There was a minor protest at one point, with a handful of people demanding "bread, not new stadiums," but it generated no interest from Poznań's citizens. At one point, too, a suspicious package was found but determined to be simply someone's forgotten parcel; the incident did, however, demonstrate the responsiveness of emergency crews in dealing with it promptly and safely, with no disruption of Fan Zone activities.

The event's success illustrated not only the city's capacity to host large-scale events but also the maturing sophistication of Poland's public relations profession. Prelite's managers and staff members demonstrated that a carefully planned, research-based, strategic communication program can contribute at many levels to an organization's highest and most ambitious goals. In this case, that organization was the city of Poznań and, in a broader sense, the nation of Poland. This gifted and dedicated staff advanced the profession in significant ways in an increasingly important global region.

REFERENCES

Gannon, M. J. (2004). *Understanding global cultures: Metaphorical journeys through 28 nations, clusters of nations, and continents* (3rd ed.). Thousand Oaks, CA: Sage.

Hocking, J. E., Stacks, D. W., & McDermott, S. T. (2003). *Communication research* (3rd ed.). Boston: Allyn & Bacon.

Ławniczak, R., Rydzak, W., & Trébecki, J. (2003). Public relations in an economy and society in transition: The case of Poland. In K. Sriramesh & D. Verčič (Eds.), *The global public relations handbook: Theory, research, and practice* (pp. 257–280). Mahwah, NJ: Erlbaum.

Morrison, T., & Conaway, W. A. (2006). *Kiss, bow, or shake hands*. Avon, MA: Adams Media.

Szondi, G. (2005). The pantheon of international public relations for nation states: Country promotion in Central and Eastern Europe. In R. Ławniczak (Ed.), *Introducing market economy institutions and instruments: The role of public relations in transition economies*. Poznań, Poland: Wydawnictwo Piar.

Part IV:
Case Studies in Measurement of Public Relations

Measurement That Matters: Systematic Assessment at Philips

ANDRÉ MANNING
Royal Philips

BETTEKE VAN RULER
University of Amsterdam

EDITORS' NOTE

Measuring the effectiveness of public relations activities is one of the most debated areas of our profession. Consensus on methodology and tools is being sought through efforts of the Coalition for Public Relations Measurement supported by the Institute for Public Relations (IPR). This case illustrates how Philips took up the challenge of implementing some of the measurement standards of the Barcelona Principles put forward by the Global Alliance for Public Relations and Communication Management by adopting a single global system for all of its earned media activities, consisting of traditional, social, and online media with a focus on the quality and outcome of the coverage and conversation.

BACKGROUND

The core question for every public relations practitioner and researcher is how exactly public relations works: what it does in, to, and for organizations, publics, or in the public arena.

The Barcelona Principles

From the earliest days of public relations as a concept and later on as a management function, measurement and evaluation have received a lot of attention, most of it lip service. Historically when many agencies pitch new business to prospective clients, the public relations priorities are usually in this order: credentials, strategy, tactics, budget, and then, only maybe, measurement of results. In the public relations new business pitch, usually, as time is running out, someone tells the measurement person that he or she will have to make that part of the pitch fast and create slides on the spot.

However, 2010 saw what leaders in the public relations industry hope is the beginning of a change. Public relations and communication managers from all over the world gathered in Barcelona and adopted seven principles for public relations measurement. While these principles do not solve every public relations measurement problem, they do specifically refute using advertising value equivalents (AVEs) and false multipliers—until now common public relations practices that equate the value of public relations with the cost of advertising—and the notion that the value of earned media is always at least twice that of paid media. Neither is true.

THE BARCELONA PRINCIPLES FOR PUBLIC RELATIONS MEASUREMENT

Principle 1: Clear goal setting and measurement are fundamental aspects of any public relations program.

Principle 2: Measuring the effect on outcomes is referred to measuring outputs and should include positive or negative outcomes.

Principle 3: The effect on business results can and should be measured where possible.

Principle 4: Media measurement requires quantity and quality.

Principle 5: Advertising Value Equivalents (AVEs) are not the value of public relations.

Principle 6: Social media can and should be measured,

Principle 7: Transparency and replicability are paramount to sound measurement.

(Source:http://amecorg.com/wp-content/uploads/2012/11/Measuring-the-True-Value-of-Public-Rela tions-based-on-the-Barcelona-Principles-11-11-12.pdf)

The Value Metrics Framework

As a follow-up, public relations leaders gathered in London to attempt to answer the following question: If we don't use AVEs, then what are the right metrics?

Much research in public relations is so-called seat-of-the-pants research. A Ph.D. study of public relations in Ireland (McCoy, 2006) confirmed what has been learned from many other studies in other countries as well: A common measurement tool for doing research in public relations practice is the "eyes and ears" method—talking to an unsystematic selection of members of the public or the media, reading some reports and drawing conclusions on the basis of these reports, or listening to solicited or unsolicited feedback from superiors or members of a public without systematically planning the research or analyzing the results. This practice needed to be eliminated.

The Barcelona Principles specifically addressed social media measurement, but how can sense be made of all the different approaches that the approximately 300 suppliers of social media measurement worldwide are pushing? In 2011, the International Association for the Measurement and Evaluation of Communications (AMEC) produced the Valid Metrics Framework, a measurement planning framework and template. The framework was designed to be flexible enough to address multiple aspects of public relations within a consistent measurement framework and approach.

The German Communication Controlling Framework

Since the turn of the century, German academic researchers, corporate communication managers, and management accountants have collaborated to answer the question of how to increase and demonstrate the value creation through communication: from input through output to outcome and outflow. Their joint efforts resulted in the establishment of a new management function called communication controlling (Zerfass, 2008). Zerfass and Storck (2012) claimed that corporate communication needs to reflect the cycle of plan-act-control and has to be evaluated in terms of public relations progress and being on target. That is why communicators need indicators showing them whether their activities are on track and to which extent the defined goals are achieved.

Based on the Balanced Scorecard principles of Kaplan and Norton (1992), the German Public Relations Association (DPRG) and the International Controller Association (ICV), among others, agreed on a common framework for assigning the effects of communication activities to specific measurement ranges and objects. The DPRG/ICV framework represents communicative inputs and effects, with the latter spread across successive stages, thus revealing the gradual impact of

communication activities on stakeholders. It enables the systematic development of value chains running from corporate strategy to communication measures and back from the effects of these measures onwards to corporate goal achievement. The framework opens up the process of value creation through communication.

The Communication Controlling Framework's Principles of Evaluation

Probably the most frequently used definition of evaluation is the systematic assessment of the worth or merit of some object, for example, a public relations campaign. The generic goal of most evaluation is indeed to provide useful feedback to certain audiences, such as sponsors, clients, staff, etc., to show what happened and what the value of the actions were. This form of evaluation is often called summative evaluation, which is to be seen as a summary of the whole. Yet, not all evaluations are necessarily summative, and summative evaluation is not the only form of evaluation that is worthwhile to public relations practice. That is why this definition falls short. Much evaluation is done to influence decisions, as an aid in decision-making, and that kind of evaluation—called formative evaluation—is becoming increasingly important in public relations. If summative evaluation can best be seen as a summary of the whole, formative evaluation can be defined as parts that combine to become the whole. Formative evaluation helps to build the summative evaluation, but they are not the same. That is why the above-mentioned definition is often seen as fitted for summative but not for formative evaluation (Zerfass, 2010).

A more generic definition might be the following: Evaluation is the systematic acquisition and assessment of information to provide useful feedback about a public relations campaign or action. The core action, then, is to acquire and assess information in a systematic way, sometimes just to show the value of the actions, but often to help decision-making itself. To illustrate this definition, this case study shows how measurement plays a pivotal role in global communications counsel and support.

METHODOLOGY AND NPS ARCHITECTURE

The Net Promoter Score (NPS) is a loyalty metric developed by Fred Reichheld, a Fellow of Bain & Co and a board member of Satmetrics, author of the book *The Ultimate Question*. He published this method for the first time in *Harvard Business Review* (2003). Many tout NPS as the most important metric for business, although it has its detractors. The Net Promoter Score tracks how customers

represent a company to their friends, associates, and others. Reichheld argues that this consumer presentation is free marketing that greatly influences business growth.

But how do you calculate NPS? Reichheld advocates asking customers the simple question, "How likely are you to recommend (our company) to a colleague or friend?" His recommendation is for a 0–10 scale where respondents are reclassified as:

0–6 = "Detractors"
7–8 = "Passives"
9–10 = "Promoters"

Reichheld's metric calculates the NPS score by subtracting the percentage of respondents who are labeled "Detractors" from the percentage of respondents who are labeled "Promoters": % of promoters − % of Detractors = NPS.

The Net Promoter Score has received significant attention and use since its introduction in the 2003 *Harvard Business Review* article, "One Number You Need to Grow," written by Reichheld. It has been used by reputable businesses such as GE, Philips, Procter & Gamble, and American Express, as well as by smaller organizations. Because NPS was used as a key business metric at Philips, the new public relations measurement system of Philips needed to follow the same methodology. And by doing so in 2010, it made the implementation of the system much easier as Philips' business partners understood the language used.

SITUATION ANALYSIS AND CORE PROBLEM

Examining Philips

This section describes the earned media measurement practices of the Philips engineering and electronics conglomerate in recent years and describes its core public relations problem: Every country and every market in which the company had a business presence had its own disparate, non-comparable media monitoring and measurement services. Acquiring all of those data was expensive and its strategic use was disputable. That is why Philips decided to implement a completely new measurement system.

The Philips Conglomerate

Koninklijke Philips N.V. (Royal Philips, commonly known as Philips) is a Dutch multinational engineering and electronics conglomerate headquartered

in Amsterdam. It was founded in Eindhoven, the Netherlands, in 1891 by Gerard Philips and his father Frederik. It is one of the largest electronics companies in the world and employs approximately 116,000 people in more than 60 countries.

Philips is organized into three main divisions: Philips Consumer Lifestyle (formerly Philips Consumer Electronics and Philips Domestic Appliances and Personal Care), Philips Healthcare (formerly Philips Medical Systems), and Philips Lighting. As of 2012 Philips was the largest manufacturer of lighting in the world measured by applicable revenues. After the divestment of its television business in 2012, the company sold the bulk of its remaining consumer electronics operations to Funai Electric Co.

Philips has a primary listing on the Euronext Amsterdam stock exchange and is a constituent of the AEX index. It has a secondary listing on the New York Stock Exchange.

GOALS AND OBJECTIVES

In March 2009, Philips appointed OneVoice, an Omnicom multi-agency team including Fleishman-Hillard and Ketchum/Pleon, to provide global communications counsel and support. From the start, unified global measurement of earned media was considered a core component, not only to deliver cost savings but also to provide effective, accurate, and consistent measures of success for Philips' diverse public relations activities.

The first goal was to focus on outcomes and outflow in the new earned media measurement system rather than quantifying mere output. The second goal was looking forward rather than backward, which means that Philips was more interested in the formative aspect of evaluation than in summative research (van Ruler, Vercic, & Vercic, 2008).

Externally, the strategic communications direction was to move Philips' perception away from consumer electronics toward health and well-being. Internationally, the measurement program's objective was to drive business processes toward measurement-driven planning and management. OneVoice needed a measurement partner with a tried and tested methodology and a track record of serving global clients with innovative and yet robust solutions. That is why Report International was appointed to build and run the OneVoice measurement system. The creation of a media impact score that would be compatible with Philips' Net Promoter Score (NPS)–based Key Performance Indicators (KPIs) was a core requirement.

Philips and OneVoice chose a strategy of using Report International to build and run an online Philips measurement system that would be compatible with a loyalty metric already used by Philips.

TACTICS

Philips implemented its single global earned media measurement system in 2010. Before, every business and location seemed to have its own metrics and vendors, which was costly, inefficient, and ineffective. Now Philips had one approach, focusing on outcome versus output and traditional as well as social media, which allowed every Philips corporate communications professional to look at the performance of any campaign, location, or business sector in the same way, and make smarter decisions about what worked. The system focused on six KPIs: volume, number of impressions, overall quality, net promoter score, message penetration, and tone of voice.

The system is accessible 24/7 for the global communications network, while reports are derived from the system monthly and quarterly with market-specific data at communication professionals' fingertips—not to control but to provide an overview of what is working and what is not working. But even more important, the system provides the Philips network with a clear indication of where to improve and, consequently, how to influence decision-making on future actions. A competitive benchmark was added to provide data on the same monthly and quarterly basis, because it was important to measure not only Philips' own progress but also that of its competitors, specifically whether they were accelerating faster than Philips, which would indicate the need for additional Philips' action.

The shift from more to less also was a critical one for aligning public relations measurement with Philips' organizational and business objectives. Public relations at Philips starts with organizational and business objectives, the vision for the conglomerate's companies during the next five years. From there Philips builds its measurement approach and system. It's no longer about seeing how many clips Philips can get and then figuring out how to measure them. It is part of an integrated measurement of its outcomes and values for the organization as well as input for future strategic decision-making.

How the System Works

The actual measurement system is a global one, covering the 17 geographical markets in which Philips operates, from one vast market such as China to more

clustered markets such as the Nordics, Benelux, or Asia Pacific. This set-up mirrors the organizational set-up of the company. Prior to each reporting year key, messaging for the company is derived from the strategic direction of the company, and KPIs are set on delivering on those messages in relevant traditional and nontraditional media. Because the key drivers for reputation are financial strength, innovation, and sustainability as well as a company's products and services, it is clear that key messages must be developed on these themes. In addition to the markets, three sector key lists of target media are defined and measured on a monthly basis. The key to Philips' successful translation from quantity, or the more traditional media measurement metrics such as volume, message penetration, and share of voice, was use of the NPS metric across the entire company. Based on an algorithm unique to Philips, the traditional quality score is converted into the NPS metric. Reporting is done centrally and provided to the company network of communications leaders on a monthly base in a transparent way.

Evaluation Framework

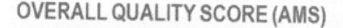

OVERALL QUALITY SCORE (AMS)

How to read an Average Media Score (AMS):

The algorithm assigned a point value from 0 to 100 to each mention, where 0 is a missed opportunity and 100 is the "perfect mention."

Scores of 45-65 are considered "good" scores. This is also the average range for media to fall into.

AMS

0 to -100 Negative/Damaging Coverage

Figure 11.1. Courtesy of Royal Philips.

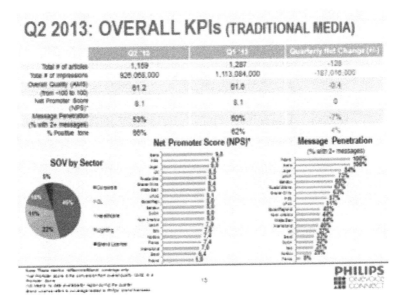

Figure 11.2. Courtesy of Royal Philips.

Evaluation of Traditional Media

Figure 11.3. Courtesy of Royal Philips.

This specific example demonstrates the evaluation and measurement of earned media that are done on a monthly basis and cover all the public relations activities in all markets in the previous month. It is an overall process without specific budget allocation apart from the initial set-up costs of the system (it turned out that the overall system is more cost effective than the multiple systems that were in place prior to introduction of the global system) as well as the annual retainer costs to keep the system running. The same methodology also is used across the company to measure the effect of specific campaigns with a defined start and end of the campaign.

Evaluation of Key Blogs

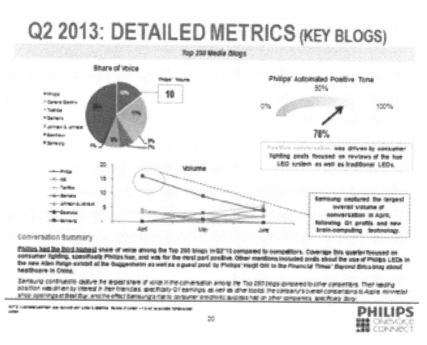

Figure 11.4. Courtesy of Royal Philips.

BUDGET

Philips' new measurement system has become a classic example of a business measurement case, the design of which started in 2009. At that time clipping services and media analysts were hired on a local base. Once new, global systems were introduced, Philips realized it could bring down the costs of measurement

and analysis dramatically. Instead of the more than EUR 2 million spent annually, Philips spent slightly less than EUR 1 million per year. This measurement budget is allocated on a central level with all sectors and corporate headquarters contributing to it; of the three sectors—Healthcare, Lighting, and Consumer Lifestyle—each was responsible for 20% and group headquarters for 40% of the total. There is no additional spending on individual markets level apart from dedicated measurement reports on specific projects if needed. In the meantime, many of these dedicated reports have been designed in close cooperation with business partners.

EVALUATION AND RESULTS

Once the public relation measurement system was introduced and embraced at Philips, a period of adjustment and improvement began, due in large part to the rapid development of social media. Today, the system is in full swing and is reviewed and discussed regularly and frequently by the highest executive level in the company. It aligns communications objectives much better with organizational objectives and forces the communications function to spend more time on research and analysis, areas in which the communications function needs to improve.

Within Philips the measurement system now serves as an important accelerator to align other marketing and business measurement tools and systems in the company into one dashboard: a significant recognition of how essential the communications function is!

When OneVoice made its business "pitch" for the Philips account, it opened with the concept of measurement introduced into the early, planning stages of a campaign instead of putting it at the end. The firm had found that by embracing measurement in this and other pitches, the communicators at client companies, including Philips, and OneVoice developed the right tools to manage how to work together and, perhaps more importantly, how to work with other partners in other parts of the Philips organization, its advertising group, and other agencies.

These suggestions weren't difficult to implement. They were relevant to the communications public relations professionals, irrespective of whether they were on the client or firm side. It was about putting a system into place that didn't cost too much and only measured what matters. At the same time, it needed to stimulate the creation of a culture of working together toward continual public

relations involvement in communications performance to drive brand marketing and corporate reputation.

The public relations practitioner who says, "We got 500 hits, which generated 250 million impressions with an AVE of $2MM!" is an artifact of the past. That same person is probably also saying that the number of "likes" can measure an organization's success on Facebook. The Barcelona Principles set the standards. The future is about smart measurement, smart budgets, adopting the language of business and consistency across the board within the organization when approaching traditional and social media.

Now, having worked together for almost four years, Philips and OneVoice have systems that will help public relations and communications management practitioners consider how to implement the Barcelona Principles.

BUDGET

Philips suggests these approaches

- Budget for measurement up front.
 - Don't budget for measurement at the back end of campaign planning. How much? Figure 5% of your total public relations spending, including fees and pass-through costs. Many think that measurement costs a fortune. It doesn't. But if you can't spend 5% of your budget to get an honest assessment of how you are doing—and to improve programs in the future—then how serious are you about trying to get results from your public relations initiatives?

- Speak the language of the business.
 - This is the way to ensure that executives believe that public relations have a business value. Many companies keep track of how they are doing with customers with a Net Promoter Score. Philips kept track of its media results in exactly the same way, converting media coverage results into an NPS-type metric. Philips even gives bonuses to staff based on how they performed against that metric. Public relations measurement has to speak the language of the business: silly terms such as *impressions*, *hits*, and *AVEs* have gone by the wayside.

- Use one approach.
 - Philips implemented a single global measurement system for earned media. Prior to that, every business and location seemed to have its own

metrics and vendors. Now Philips has one approach. Was it easy? No way. It required intense effort at the outset, and a bit of command and control, with lots of convincing thrown in and ongoing maintenance with continual improvement. Philips acknowledges it still has some kinks to work out, and it's already been two years since implementation. However, now Philips' public relations staff can look at the performance of any campaign, location, or business sector in the same way and make smarter decisions about what works.

- Adopt a new mindset.
 - Probably the hardest part of transitioning into this system was getting away from the mindset that more is always better—or that the bigger the stack of clips, the better the results. Philips measurement system measures those media, traditional and social, that are most important to its reputation and business. Philips follows the 80/20 rule, where 20% of the media is at least 80% of what is important. This is an ongoing transition and one of Philips' ongoing internal goals.

- Align your objectives.
 - The shift from more to less is also a shift to align measurement with organizational and business objectives. Start with business objectives, include the vision for the company over the next five years, and from there build a measurement approach and system. It's not about seeing how many clips Philips could get and then figuring out how to measure them.

REFERENCES

Kaplan, R. S., & Norton, D. P. (1992, January–February). The balanced scorecard—measures that drive performance. *Harvard Business Review*, pp. 71–79.

McCoy, M. (2006). Public relations evaluation. Unpublished dissertation. Belfast: University of Ulster.

Reichheld, F. F. (2003, December). One Number You Need to Grow. *Harvard Business Review*. (pp. 46–54).

van Ruler, B., Vercic, A. T., & Vercic, D. (Eds.). (2008). *Public relations metrics: Research and evaluation.* New York: Routledge, pp. 46–54.

Zerfass, A. (2008). *The corporate communications scorecard—A framework for managing and evaluating communication strategies.* In B. van Ruler, A. T. Verčič, & K. Sriramesh (Eds.), *Public relations metrics: Research and evaluation* (pp. 139–153). New York: Routledge. Wiesbaden: VS Verlag für Sozialwissenschaften.

Zerfass, A. (2010). Assuring rationality and transparency in corporate communications. Theoretical foundations and empirical findings on communication controlling and communication performance management. In M. D. Dodd & K. Yamamura (Eds.), *Ethical issues for public relations practice in a multicultural world, 13th International Public Relations Research Conference* (pp. 947–966). Gainesville, FL: Institute for Public Relations.

Zerfass, A., & Storck, C. (2012). Communication controlling: Next step in accountability. In B. van Ruler (Ed.), *Communicatie NU* [Communication NOW]. Amsterdam: Adfogroe.

Through Social Eyez: Measuring Etisalat's Social Media in the Middle East

GAELLE PICHERIT-DUTHLER
Zayed University

INKA STEVER
Zayed University

EDITORS' NOTE

This case demonstrates not only the important role social media can play in managing customer relations but also the value of gathering metrics to document the impact of social media. Etisalat, a large Middle Eastern telecommunications company, had a reputation for providing poor customer service before it became active in social media, which, inter alia, inevitably forced the company to listen to the feedback of its customers and followers.

Etisalat's Facebook page was recognized in 2012 as the "most devoted Facebook page in the UAE" (United Arab Emirates) and has become the fastest growing Facebook page in the UAE. In 2012, Etisalat's social media campaign won the Grand Prix–International Award from AMEC, the International Association for the Measurement and Evaluation of Communication.

BACKGROUND

A rapid acceleration of social media use is occurring in the United Arab Emirates (UAE), and regionally in the countries of the Gulf Cooperation Council (GCC). (The GCC is a political and economic union of countries bordering the Persian Gulf that includes Saudi Arabia, Qatar, Kuwait, Oman, Bahrain, and the UAE.) In fact, numbers show the use of social media in the Middle East is growing faster than in Europe and the United States of America (USA), with a growth rate close to 30% on average annually (Alshaer & Salem, 2013). As of 2012, there were 125 million individuals using the Internet in the region, and more than 53 million of them are active users of social platforms.

Social media's boom is largely due to the increase in use of mobile technology. According to rankings published by *Our Mobile Planet* in 2013, the UAE led the world in smartphone penetration, with 74% of mobile subscribers carrying one in their pockets. The UAE is followed closely by South Korea, Saudi Arabia, Singapore, and Norway (Our Mobile Planet, 2013). The United States is 13th on the list.

The popularity of social media is creating new opportunities for organizations, especially for a global Middle Eastern telecommunications company like Etisalat. Etisalat has been the main telecommunications company in the United Arab Emirates and the Gulf Region since 1976. It is owned by the UAE federal government (60%) and by private national investors (40%) and has established itself as a technology leader, expanding its reach to Southeast Asia and Africa in recent years. Etisalat is one of the largest corporations in the six Arab countries of the Gulf Cooperation Council (GCC), with a market value of approximately 81 billion dirhams (AED) (USD$22 billion) and annual revenues of more than 32.9 billion AED (USD$9 billion) (*Etisalat Company Profile*, 2013). It employs nearly 42,000 people through its 12 operating companies: Etisalat UAE, Thuraya, Zantel, Mobily, Etisalat Lanka, Canar, Atlantique Telecom, Pakistan Telecommunications Company Limited, Etisalat Misr, Etisalat Afghanistan, Excelcomindo, and Etisalat Nigeria.

In the global and technological environment, businesses have to develop new ways of working and interacting with their customer bases. In 2010, Etisalat UAE, which operates in its primary market of the UAE, decided to enter the realm of social media to communicate and engage with its customers. It started by engaging with customers on Twitter and Facebook, in the English language only. The main goal was to market Etisalat products and services and to communicate with customers (listening, addressing complaints, etc.). As many companies have done, Etisalat hired the services of a public relations agency to manage its social media. The agency was responsible for writing Facebook posts and tweets.

Once a company enters the world of social media, it faces two major challenges: (1) how to engage customers and (2) how to measure social media impact. It was imperative for Etisalat to measure and evaluate the quality and quantity of its social media communication. Traditionally, public relations professionals work hard at building relationships with stakeholders. Excellence in public relations is often measured by the quality of these relationships. When entering the world of social media, measurement becomes quite complex. There are many methods and tools from which to choose, but a company still needs to properly apply these to its own situation. It is not uncommon to find public relations professionals struggling to put a meaningful social media measurement program in place.

Many organizations work hard to create standards for social media measurement. In 2010, during the 2nd European Summit on Measurement in Barcelona, delegates from several trade and professional bodies agreed on the Barcelona Principles of Measurement. Commonly referred to as the "Barcelona Principles," the seven principles emphasize good measurement practices and specifically state, "Social media can and should be measured" (Barcelona Principles, 2010).

In June 2013, social media measurement standards were created as a result of the collaboration between several public relations and communication organizations, including the Chartered Institute for Public Relations (CIPR), the International Association of Business Communicators (IABC), the Council of Public Relations Firms (CPRF), the Global Alliance for Public Relations and Communication Management (GA), the Public Relations Society of America (PRSA), the Institute for Public Relations (IPR), and the Society for New Communication Research (The Conclave, 2013).

This case study illustrates how one company, Etisalat, was successful in implementing a social media measurement program.

METHODOLOGY

The research for the SocialEyez case study included primary and secondary research methods. The methodology approach for primary research was qualitative. The authors first focused on SocialEyez, the agency that submitted the case to the AMEC Communication Effectiveness Awards 2012. After obtaining a copy of the entry form, the authors supplemented the information by conducting an interview with the chief executive officer of SocialEyez. As Etisalat was the client, the researchers also studied Etisalat's website and its annual report.

SITUATIONAL ANALYSIS

Strengths

Etisalat UAE is the main telecommunications company in the United Arab Emirates. It has created a strong international network in the Middle East, Africa, and Asia and possesses high-tech infrastructures. In addition to its strong network, Etisalat is a strong brand. A recent study from Brand Finance (Mwafy, 2013, p. 27) places Etisalat as the most valuable telecom brand in the Middle East and second in overall brand value behind Emirates Airline.

Weaknesses

Despite wide use of mobile technology and social media, the UAE government tends to adopt a reserved, cautious attitude toward the Internet, and service providers as well as the UAE's Telecommunications Regulatory Authority place restrictions on social media use. In November 2012, the UAE government issued a cyber law to legislate online information (Full Text of UAE Decree, 2012). This law was designed to regulate speech on social media; specifically, it penalizes people who criticize online the country's rulers, institutions, and/or religion.

Etisalat operates in a multilingual environment: Arabic, English, Urdu, and Hindi are among the most widely used languages. Arabic is the official language of the country. However, due to the many different nationalities living in the UAE, other languages dominate. English is widely used to conduct business as well as meld the other nationalities and cultures (88.5% of the population are expatriates). Of the estimated 8.2 million people living in the UAE, Indians and Pakistani Muslims make up the majority of the country's expatriate residents, and therefore Urdu is the most spoken language in the UAE (National Statistics Bureau, 2011).

Opportunities

Mobile technology and social media have reshaped societies and economies around the world but the Middle East region has been one of the most widely influenced. And mobile technology is widely embraced by young Arabs. Two-thirds of the Middle East and North Africa (MENA) population is under the age of 30. A yearly study conducted by the public relations firm ASDA'A Burson-Marsteller (Arab Youth Survey, 2012) indicates that young Arabs are turning away from traditional media and turning to online and social media as their source for news. Similarly, a survey conducted by Booz & Co. (Sabbagh, Shehadi, Samman, Mourad, &

Kabbara, 2012) found that 83% of 15- to 35-year-olds use the Internet every day and that 40% of them use it at least five hours a day.

This increasing reliance on online technologies has attracted many global communication technology companies to the UAE including multinationals such as Apple, Google, AT&T, Facebook, LinkedIn, Microsoft, and IBM who have regional headquarters in Dubai, the UAE's largest city. In fact, Dubai has dedicated an entire area the size of a small city to tech companies, calling it "Dubai Internet City."

Threats

Du (Emirates Integrated Telecommunication Company) was established in 2005. It is the UAE's second national telecom operator. Although it lacks the international presence that Etisalat has, Du has a market share that is growing while Etisalat's is decreasing. Du now has 40% of the mobile market in the UAE.

Social unrest in the Middle East also is a major issue for most multinational companies doing business there. Historically, the Middle East has been characterized by civil unrest and violence between ethnic and religious groups. Recent events in Egypt, Bahrain, Syria, Libya, Tunisia, and Turkey have indicated that social media play an important role in coordinating and managing such protest activities. As a result, many Arab governments have taken a more conservative approach to social media by increasing their monitoring of online conversations and issuing restrictive laws on expressing ideas online.

CORE OPPORTUNITY

Etisalat was the only telecommunications company in the region until 2005. It was common knowledge that as a monopoly, Etisalat did not make customer service a priority. Stories about poor customer service appeared regularly in local newspapers (Absal, 2011; Hamilton, 2010). With the proliferation of use of the Internet, stories of poor customer service were easily shared. For example, there are websites and a Facebook page dedicated to showcasing Etisalat's poor customer service. One Facebook page states, "Please add yourself or comment on here if you have been or are currently experiencing poor, bad, terrible or horrendous levels of customer service or support from Etisalat! Maybe this is the only way we can get them to hear our issues!!" (Etisalat Worst Company, 2011).

When Etisalat began using social media such as Twitter and Facebook, customers used these venues to vent, complain, and ask questions. Overall, customers expected to be heard by Etisalat. However, like many UAE businesses, Etisalat did not have a social media strategic plan in place. They hired a public relations agency to post comments on Facebook and to tweet but had no strategic plans in terms of customer engagement and/or social media monitoring. In fact, the public relations agency only tweeted or posted in English, thus ignoring more than half of the population. Arabic-speaking customers were not happy, sharing their unhappiness on various social media platforms. Starting in 2011, Etisalat hired a different company, SocialEyez, to manage all its social media engagement activities and monitor the discussions.

GOALS

The goals for Etisalat were to monitor discussions mentioning Etisalat that were generated on social media in the UAE and to focus its customer service on social media engagement activities. These goals are related to the company's six strategic pillars that support the company's mission statement. One of these pillars is its "Customer Experience":

> Etisalat works continuously on customer insight-based and focused propositions, and the enhancement of positive customer experience across all touch points. Knowing its customers and ensuring positive interactions with them throughout their lifecycle is a core competence to compete in EG's regions. On the technology front, Etisalat Group aims to reinforce its positioning as the most trustworthy and reliable operator through superior network and services quality. (Etisalat Strategy, 2013)

After a chaotic start in the world of social media in 2010, Etisalat took a more strategic approach to social media engagement and measurement of its customer relationships beginning in 2011. The first goal of its social media strategic plan was to reduce negative sentiments and launch Arabic engagement. The strategic plan included specific objectives and key performance indicators (KPIs) such as reducing average response time to 20 minutes and increasing its fan base on Twitter to achieve this goal. Later on, Etisalat focused more on marketing goals such as the development and promotion of products based on customer feedback. Future goals will be directed at expanding its use of other social media such as YouTube and Instagram.

OBJECTIVES

Etisalat established 15 objectives for the Etisalat's use of social media in its customer relations in the UAE. Many of these objectives include key performance indicators (KPIs) as social media measurement experts recommend (Paine, 2011; Sterne, 2010).

Public Relations and User Sentiment

1. Reduce negative discussions of Etisalat and increase positive posts by November 2012, measured by a 15% decline in ratio of negative to positive posts.
2. Reduce by 10% the number of customers expressing negative sentiment or criticism.
3. Increase positive sentiment toward Etisalat as expressed on social media, measured by a 15% increase in positive brand mentions.

Customer Response

Maintain an average customer response time of 20 minutes regarding questions, complaints, and/or requests for technical assistance.

Sales and Marketing

1. Improve efficiency of marketing efforts by identifying influencers and advocates who can help Etisalat promote its programs and products. Secure a minimum of 20 Etisalat brand advocates and a 50% increase in use of Etisalat-related hashtags.
2. Increase Etisalat brand exposure on social media by increasing followers on Twitter by 80% and the number of engaged/active followers by 30%.
3. Increase fans on Facebook by 50% and the number of engaged/active fans by 30%, and increase the volume of Etisalat mentions across social media by 50%.
4. Increase number of re-tweets for Etisalat promotional tweets or announcements by 50%.
5. Increase number of times Etisalat tweets are marked "favorite" by 30%.
6. Use social media as a source of product development and innovation suggestions from customers as measured by the number of valuable and useful ideas generated.

7. Use social media as a tool to measure customer reactions to Etisalat promotions.
8. Increase viewership of Etisalat's promotions launched through social media by 30%, measured using bit.ly statistics for shortened promotional links. (Bit.ly statistics calculate how many times people click on the shortcut link.)

Corporate and Web Traffic

1. Use social media as a tool to humanize the brand and show customers there are thousands of loyal and dedicated employees behind this brand who care about customers.
2. Increase traffic on Etisalat blog by 50%, measured using independent Web analytics software.
3. Increase referral traffic from Etisalat social media accounts to the Etisalat corporate website by 30%, measured using independent Web analytics software.
4. Reduce the number of calls to 101, the number for Etisalat customer care, by answering more customer questions through social media.

KEY PUBLICS

Etisalat's key stakeholders in its social media campaign were all UAE residents, both customers and non-customers. Etisalat was able to learn what people liked and didn't like about the company and its products. Etisalat wanted to know how it was perceived and how it could leverage this against the competition. As a result, it could target different customer groups such as students or expatriates.

KEY MESSAGES

The campaign focused on three key messages, each of which addressed one of Etisalat's core values: energy, openness, and engagement ("Our Belief," 2013). These messages were:

1. Etisalat is a customer-centric company.
2. Etisalat is an environmentally friendly company.
3. Etisalat is a UAE company.

These key messages were supported with the following proof points:

- Etisalat is a customer-centric company.
 - We care about what our customers want.
 - We want to listen to our customers and adapt our services according to their demands and needs.
 - We want to meet our customers' needs.

- Etisalat is an environmentally friendly company.
 - Etisalat moved from mailing printed bills to its customers to an e-billing system.
 - Various internal programs were introduced to make operations at Etisalat more energy efficient and raise employees' environmental consciousness.

- Etisalat is a UAE company.
 - Etisalat is a national company based in the UAE.
 - Etisalat is an Emirati company run by Emiratis.
 - Etisalat's story is a UAE success story.
 - Etisalat has successfully positioned itself as a global player operating in various countries of the Gulf Region.

To not confuse its audience, one key message was chosen per quarter for better message penetration and to create greater brand recognition among Etisalat's key publics.

STRATEGIES AND TACTICS

To evaluate the reaction of customers to the campaign, all mentions of the brand across all social media platforms were monitored. While the monitoring also included YouTube and blogs, it did not consider mentions on external websites. The data were manually analyzed by a team of Arabic-speaking analysts to obtain insight on user perception of Etisalat. The analyses were compiled into actionable reports that could be used by Etisalat's various departments.

In a second step, Etisalat established a dialogue with its customers by responding directly to them on all social media platforms. To better tailor the answers to customer needs, Etisalat established two separate Twitter accounts, one directed to individual customers and the other a corporate account for internal communications purposes. Appropriate and knowledgeable Etisalat employees resolved customer inquiries on both accounts.

Etisalat, through SocialEyez, the social media firm it had hired, took multiple strategic approaches to measuring the impact of its use of social media on customers and customer relations.

- Create Natural Language Processing (NLP) research and update the structure that converted product and service terminology in a manner that captured multiple Arabic dialects (for example, there are 10 ways of saying "mobile" in colloquial Arabic).
- Train the researchers to understand Etisalat products and services so they were able to analyze and categorize the social media data captured. This allowed for easy data dissemination across various internal Etisalat departments.
- Conduct real-time searches to monitor and report on an hourly basis on what issues or themes were being discussed.
- Collect data on a daily basis to:
 o Analyze what was the most discussed subject on that day
 o Provide Etisalat with daily alerts including negative reactions posted on that day
 o Provide basic analysis of which product/service or campaign received the most negative coverage

- Compile a database of most active users to identify those who are influential on social media and to learn more about their perception of Etisalat. The database categorized users to facilitate engagement and escalation. This database was shared with the engagement team to enable them to weigh the impact of influencer tweets and to respond to them in a timely manner to avoid escalation of negative opinions or reactions.
- Create structured weekly analysis reports that provide in-depth analysis catering to the requirements of the various departments across Etisalat including public relations, marketing, engineering, and customer care. Creating these reports was a particularly important part of Etisalat's overall strategy.
- Create structured bi-monthly measurement reports that measured performance vs. KPIs and regularly assessed gaps between a target and what was achieved.

A team of 10 analysts and researchers put the strategy into action. To ensure that neither the English nor the Arabic customer segment was neglected, the analysts on the team were bilingual even though English was their native language. Nevertheless, Arabic posed a problem due to the wide variety of Arabic dialects spoken by the many Arabs of other nationalities who resided in the UAE.

Etisalat's international presence posed a problem in filtering the relevant data. The company has subsidiaries in 17 countries across Asia, the Middle East, and North Africa. The data captured had to be filtered to ensure they were particularly relevant to Etisalat UAE and not to any of the other Etisalat operations. Using Natural Language Processing (NLP) software that translates human speech into digital data and data mining technologies was a key to the success of the project, but the critical success factor was the interaction between analysts and customer service representatives. The latter enabled the analysts to derive the actual meaning of the customer comments.

While most data were summarized in weekly reports, critical actionable data were distributed as daily alerts. For example, a severely negative customer service–related complaint by an influencer would be flagged on a real-time basis. Customer representatives were able to react immediately to the satisfaction of this complaining influential client.

The key elements in the various reports included the following:

- Buzz volume: Total volume of data captured during a week. This also included a comparison of the competitor volume as well as trending to show whether the volume was increasing or decreasing. Volume analyzed was broken down by Etisalat-generated volume vs. user-generated volume mentioning Etisalat.
- Share of Voice (SOV) Comparing the SOV of Etisalat and Du, its competitor, once again comparing trends from previous weeks as well as user-generated vs. company-generated volume.
- Most discussed subjects or themes: The team of analysts manually analyzed customer comments to first identify what issues customers talked about the most. The coverage data were then broken down by subject or service area. Multiple levels of categorization were used, starting with mobile vs. Internet vs. BlackBerry, and later with technical, billing, network coverage issues, and other categories.
- Sentiment analysis: The analysts measured the level of tonality (along the continuum of positive/negative or favorable/unfavorable) in relation to the brand and its products, services, and management. The competitor Du also was measured for tonality.
- Most active users: Measurements included what they were saying, the impact of their messages, where they posted, and whether users on other social media platforms shared these discussions.
- Influencer analysis: Analysts identified who the influencers were and what they were saying. Influencer levels were determined not only by using quantitative metrics such as number of followers, but also by qualitative

metrics such as whether emotions expressed by influencers resulted in an increase in expression of those emotions among other users.

- Twitter engagement analysis: Measurements included language analysis (sentiment analysis in both English and Arabic) and average response time of Etisalat online customer care agents versus its competitor's response time.
- Twitter follower analysis: The team of analysts measured follower increase/decrease, engagement activity to assess how active followers were, and target audience analysis to assess whether followers were relevant to the brand, level of reach, and other follower measures.
- Facebook engagement analysis: A variety of tools—post analysis, content analysis, increase/decrease in number of fans and analysis of fan engagement—were used to identify passive vs. active fans.
- Media content analysis: Analysts evaluated the impact and sentiment toward Etisalat's key messages and coverage on social media.

On average, 12,500 results per week mentioning Etisalat were coded. They were then analyzed to extract only those relevant to Etisalat UAE, an average of 3,500 per week.

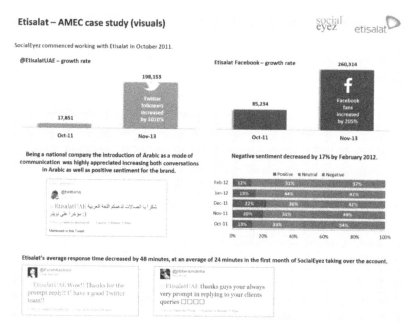

Figure 12.1. Infographic submitted as one component of Etisalat's submission in the 2012 International Association for the Measurement and Evaluation of Communication (AMEC) awards competition.

CAMPAIGN TIMETABLE

The measurement program ran from October 2011 to November 2012.

BUDGET

The monthly budget for the program was in the range of USD$5,000 to $10,000 for analytical work and between USD$10,000 and $20,000 a month for engaging with the public.

EVALUATION AND MEASUREMENT OF RESULTS

The social media measurement program and the resulting reports to the appropriate Etisalat departments proved highly successful in meeting the campaign's objectives. It allowed Etisalat to identify and target customers' complaints, demands, and needs. Parallel to running the measurement program, Etisalat's customer service representatives were thoroughly briefed on the new social media policy and on procedures to ensure their prompt and positive response to customers. The CEO's strong commitment to social media engagement was an added motivational factor in ensuring the success of the campaign.

Results

The measurement program was able to:

1. Decrease negative coverage in Arabic (9% in a period of 15 days)
2. Increase positive brand mentions of Etisalat in Arabic by 11%. A translated example: "Thank you for this positive change and thank you for supporting our Arabic identity. Etisalat UAE is tweeting in Arabic."
3. Increase Etisalat UAE's Twitter followers by 43%.
4. Decrease the average response time on Twitter by 67%; before the campaign, the average Twitter response time was 32 minutes, and by the end of the campaign the current average response time was 19 minutes.
5. Increase the total positive sentiment by 9%.
6. Increase the volume of Etisalat mentions by 26%.
7. Identify and recruit two brand advocates who now frequently post positive comments about their experiences with Etisalat services.

8. Act upon user suggestions and requests, such as during the launching of the iPhone 4S. This topic was detected as one of the most discussed subjects on six separate days. Etisalat responded by ensuring the phone would be launched prior to Christmas and New Year's and made the announcement on social media before it alerted other traditional media, allowing online users to be the first to pre-book the phone.

9. Increase marketing exposure by a 12% increase in clicks on promotional links by customizing the offerings and planning more effective timing of promotions using social media analysis findings.

10. Gain public recognition of Etisalat's effective Twitter engagement. For example, the UAE's foreign minister had a problem with his phone and decided to tweet about it. When the problem was promptly resolved, he publicly thanked Etisalat's Twitter team.

Success in Action: A Crisis Averted

The social media measurement program also proved its effectiveness in a crisis management situation. During the time the campaign was being conducted, another one of Etisalat's operating companies advertised a new offering. The text of the offering contained an unintended offensive religious message. Shortly after the release of the offer, social media picked up on it and users voiced their criticism. People were criticizing not only the Etisalat subsidiary company but also Etisalat as a whole, including Etisalat UAE. Within 30 minutes of the first criticism, social media monitoring picked it up and alerted Ahmad Abdulkarim Julfar, the chief executive officer (CEO) of Etisalat. He immediately called the CEO of the Etisalat subsidiary and the new offering was canceled. What could have developed into a major reputational crisis was averted before the traditional media knew about it.

Changes Etisalat Implemented as a Result of Social Media Monitoring

The monitoring program revealed the need and the opportunities for Etisalat to improve its customer service and with that, the company's reputation. As a result of the study, Etisalat engaged in a wide-scale change process in its customer care segment. This included:

- The launch of Arabic engagement. Previously communication with customers was mainly in the English language. Feedback from customers showed that many wanted communication in Arabic, which Etisalat started offering.

- Internal restructuring allowed faster and better access to key decision makers from all divisions. Before, communication was centralized and bottlenecked with a communication staff of only two or three people. With the new reporting structure in place, the SocialEyez firm now has access to all departments, from engineering to public relations across all seven Emirates that make up the UAE. This allows SocialEyez to quickly obtain crucial information to respond to customers. It also facilitated solving problems in a short amount of time.
- Making it possible to respond quickly to customers' suggestions for new services and changes in existing programs. Etisalat implemented changes built on recommendations from customers. One example was a recent campaign called "Build your plan" which allowed customers to customize their mobile plans. Customers could suggest new services or products and see their suggestions put into action.
- A corporate social media policy that hadn't existed before the monitoring program was created.

REFERENCES

Absal, R. (2011, 26 May). Customers accuse Etisalat of forced Internet upgrades. Gulf News. Retrieved from http://gulfnews.com/news/gulf/uae/general/customers-accuse-eti salat-of-forced-internet-upgrades-1.812850

Alshaer, S., & Salem, F. (2013). *The Arab world online: Trends in Internet usage in the Arab region.* Retrieved from http://www.dsg.ae/

Arab Youth Survey. (2012). After the Spring: Arab Youth Survey. Retrieved from www.araby outhsurvey.com

Barcelona Principles. (2010). Retrieved from http://amecorg.com/wp-content/uploads/2012/06/Barcelona_Principles.pdf

The Conclave. (2013). *Complete social media measurement standards.* Retrieved from http://www.smmstandards.com/category/welcome-to-smmstandards/

Etisalat Company Profile. (2013). Retrieved from http://www.etisalat.ae/en/aboutus/etisalatco rporation/corporation/profile/company-profile.jsp

Etisalat Strategy. (2013). Retrieved from http://www.etisalat.com/en/ir/corporateinfo/eti salat-strategy.jsp

Etisalat Worst Company. (2011). Retrieved from https://www.facebook.com/pages/Are-Etisalat-truly-the-worst-Company-in-the-UAE-for-Customer-Service/185976344787947?sk=info

Full Text of UAE Decree on Combating Cyber Crimes. (2012, November 12). Retrieved from http://gulfnews.com/news/gulf/uae/government/full-text-of-uae-decree-on-combating-cyber-crimes-1.1104040

Hamilton, C. (2010, January 27). Etisalat customers find themselves held in a queue. *The National*. Retrieved from http://www.thenational.ae/news/uae-news/etisalat-customers-find-themselves-held-in-a-queue

Mwafy, H. (2013, May 13). Top 50 MENA Brands 2013. *Gulf Marketing Review*, 26–31. Retrieved from http://brandfinance.com/images/upload/gmr_article_final.pdf

National Statistics Bureau. (2011). *Population estimate*. Retrieved from http://www.uaestatistics.gov.ae/EnglishHome/tabid/96/Default.aspx

Our Belief. (2013) Etisalat corporate values in house document.

Our Mobile Planet. (2013). Retrieved from http://www.thinkwithgoogle.com/mobileplanet/en/

Paine, K. D. (2011). *Measure what matters: Online tools for understanding customers, social media, engagement, and key relationships*. Hoboken, NJ: Wiley.

Sabbagh, K., Shehadi, R., Samman, H., Mourad, M., & Kabbara, W. (2012). *Understanding the Arab digital generation*. Retrieved from http://www.booz.com/media/file/BoozCo_Understanding-the-Arab-Digital-Generation.pdf

Sterne, J. (2010). *Social media metrics: How to measure and optimize your marketing investment*. Hoboken, NJ: Wiley.

Part V:
Case Studies in Crisis
Communication

Kiwis and a National Economy in Crisis: The New Zealand Kiwifruit Industry Responds

MELANIE PALMER
Zespri International Limited

MARGALIT TOLEDANO
University of Waikato

EDITORS' NOTE

This case is a prime example of the public relations sub-category crisis management in which public relations professionals integrate their skills with other professionals to turn back—or at least to hold back the tide of—a substantial, or even existential, threat to an industry. The strategies and tactics employed by the New Zealand kiwifruit industry may well be adaptable to many other crises that threaten the reputation—and, in extreme cases, the viability—of a company, civil society organization, industry, or, indeed, a national economy.

Zespri is the world's leading kiwifruit marketer owned by current or past New Zealand kiwifruit growers. Zespri International is a major export company, delivering more than NZ$1 billion in revenue to the New Zealand economy every year.

In November 2010, for the first time in New Zealand's history, a devastating bacterial vine disease called Psa (*Pseudomonas syringae actinidiae*) was identified in

two Zespri kiwifruit orchards. Although Psa only affects vines, not the fruit they bear, it eventually kills the vine, so Psa threatened the livelihood of thousands of New Zealanders involved in the industry.

The spread of Psa immediately became an issue of national concern and a lead story in New Zealand media. Kiwifruit growers looked to Zespri, New Zealand's predominant kiwifruit export marketer, to take the lead and clarify the facts around the crisis.

BACKGROUND

MAF Biosecurity New Zealand (MAFBNZ)

Psa was first detected in New Zealand on November 5, 2010, by MAF Biosecurity New Zealand (MAFBNZ), part of the government's Ministry of Agriculture and Forestry (now called the Ministry for Primary Industries). This ministry's responsibilities include protecting the health of New Zealand's environment, agriculture, and biodiversity. This is done mainly by controlling the borders and preventing any contaminating organism from entering the country. As the export of agriculture products makes a massive contribution to the New Zealand economy, any threat from entering contaminants to these exports is a challenge to the nation's economic welfare.

Zespri International Limited (Zespri)

In June 1988, New Zealand kiwifruit growers voted to establish a single desk exporter under grower control, which was supported by the New Zealand government and initially called the New Zealand Kiwifruit Marketing Board. This unique structure was instigated by growers who recognized that to overcome the challenges of distance-to-market, high land and labor costs, exchange rates, scale constraints, and a small domestic market, kiwifruit industry members must work collaboratively.

In 1997, Zespri International Limited (Zespri) was formed as the global marketing organization, providing a single point for the export of New Zealand–grown kiwifruit. The Zespri Kiwifruit brand was born at the same time with a commitment to grow and sell the best kiwifruit in the world.

In 1999, the New Zealand government created new legislation that established a statutory framework for the governance and regulatory oversight of Zespri's operations to ensure the New Zealand kiwifruit industry continues to lead the world in kiwifruit innovation, production, and supply. The Kiwifruit Export Regulations (1999) require that export of kiwifruit to any country (oth-

er than Australia) has to be managed by Zespri or made in collaboration with Zespri.

In 2000, Zespri Group Limited became a public company in which eligible kiwifruit producers were issued shares, with Zespri International Limited as its subsidiary. Zespri Group Limited is currently owned by 2,600 current or past growers of New Zealand kiwifruit, and the company delivers more than NZ$1 billion in revenue to the New Zealand economy every year. The united industry structure enables delivery and recognition of consistent quality through the Zespri brand and ensures the industry is able to operate on a scale to be successful in the competitive global market (http://www.zespri.com/about-zespri/history.html).

New Zealand kiwifruit is sold in 55 countries around the world with the top five markets being Japan, Spain, China, Germany, and Taiwan. Zespri's headquarters are located in the Bay of Plenty, the heart of New Zealand's kiwifruit industry. Zespri has 250 employees based in New Zealand and around the world, and the entire international team champions the Zespri brand, building mutually beneficial relationships with growers, post-harvest (packhouse/coolstore/shipping) suppliers, and customers.

New Zealand Kiwifruit Growers Inc. (NZKGI)

This grower-led organization has lobbied and communicated on behalf of its kiwifruit grower members since 1993. It is independent of Zespri and its role is to work with Zespri, government, and post-harvest suppliers to represent, enhance, and protect growers' commercial and political interests. NZKGI is funded by a member levy.

Kiwifruit Post-Harvest Operators (PHOs)

The New Zealand kiwifruit industry consists of approximately 60 post-harvest operators (PHOs), organized into 12 entities supplying kiwifruit to Zespri. The PHOs compete with each other for their share of the kiwifruit crop and are responsible for sorting, packing, cool storing, and delivering to Zespri the 100 million trays of kiwifruit harvested each year. The PHOs have strong relationships with their growers; some PHOs also own and/or lease orchards, and so are growers in their own right.

Plant and Food Research

This is a New Zealand government entity conducting professional scientific research to aid agriculture in the country. It was formed in 2008 following a merger of

government departments that were in charge of conducting such research. (http://www.plantandfood.co.nz/page/about-us). Plant and Food Research (P&FR) and Zespri work closely on kiwifruit breeding and technical solutions to assist in the growing of high-quality kiwifruit. Prior to Psa being identified in New Zealand, Zespri had been working with Plant and Food Research in Italy to help solve Italy's Psa outbreak. Due to their existing scientific knowledge of Psa, it was critical for the two organizations to work closely on the response to the Psa outbreak in New Zealand.

METHODOLOGY

This case study is based on several qualitative research methods and builds on an application submitted by Melanie Palmer, global marketing manager for Zespri International, to the Public Relations Institute of New Zealand (PRINZ) for the institute's 2011 award competition. At the time of the crisis, she was communications manager of Zespri International with responsibility for corporate communications, media and issue management, events, and tours. The information included in the award-winning case submission was supported by further interviewing of individuals involved in managing the crisis and by fact-finding from secondary sources such as company documents and publications. The analysis and conclusions draw from the public relations literature on crisis management.

SITUATION ANALYSIS

The identification of Psa on November 5, 2010, shifted the industry into crisis mode. The existing high level of grower support for Zespri and New Zealand Kiwifruit Growers Inc. (NZKGI) and structure of the industry were critical for a coordinated, swift, and effective response.

Strengths

- Since its founding in 1997, Zespri has established a positive reputation as a trustworthy company and has built positive relationships with its stakeholders: growers, NZKGI, P&FR, PHOs, MAFBNZ, retail customers, and the media.

- Zespri is an innovative and fast-growing primary-industry exporter, which, from sales of more than $1.5 billion per annum, delivers more than $1 billion in revenue to the New Zealand economy.
- An independent survey conducted by research agency Colmar Brunton in February 2010, nine months before the crisis, indicated strong support for Zespri from growers (93%), New Zealand Kiwifruit Growers Inc. (NZKGI) (87%), and the industry structure (90%).
- An October 2010 grower survey, conducted by research agency Colmar Brunton, showed that growers were also optimistic about the future (72% vs. 46% in 2007).
- Three new varieties of kiwifruit were introduced in June 2010 with strong industry interest.
- There was a high level of industry engagement with high attendance at industry meetings.
- Psa does not present any health risk to human beings. It is an airborne bacterial disease that only affects kiwifruit vines, not their fruit. It has the potential to enter the vascular system of the vine resulting in vine death; however, the fruit is safe to eat.
- The industry had some knowledge from previous Italian, Japanese, and Korean experiences with Psa, so it wasn't starting completely from "scratch."
- Zespri had a team of 250 dedicated and experienced employees around the world.
- New Zealand Kiwifruit Growers Inc. (NZKGI) cooperated with and supported the Zespri response to the crisis.
- The New Zealand government had a strong interest in solving the problem and offered support to growers.
- The Zespri communication team was comprised of three well-educated practitioners and its communications manager was a member of the company's global executive team, which reflected the strong senior management and board support for the communications function. Of particular relevance for this case, the team had pre-crisis knowledge and training in crisis management due to a number of crises faced by the organization in prior years (e.g., a tsunami evacuation, a staff member with tuberculosis, a kiwifruit picker diagnosed with typhoid, and a major hailstorm that wiped out a significant portion of the kiwifruit crop).
- Zespri had previously assigned senior staff to the roles of crisis manager and crisis coordinator. Because of their previous crisis team experience, all team members knew their roles, and the team moved swiftly into action with an immediate crisis team meeting. This meant the team could focus

on dealing with the response rather than wasting valuable time working out who should be involved and how they should work together.

- The communications team had the relative luxury of some planning time, having been first notified of the potential issue on a Friday, before it was confirmed and made public on Monday morning.

- Zespri already had established successful communication channels with the kiwifruit industry with the most popular being monthly newsletters, a bi-monthly technical journal, regular grower meetings, and a grower-only website.

- Zespri's CEO, Lain Jager, had held former roles in the company and was an excellent communicator who recognized the value of open and clear stakeholder communications. He made himself available as spokesperson as required and was well respected by industry members.

- Zespri established a crisis operations room in the early stage of the crisis. The core crisis team (crisis manager, crisis coordinator, and communications manager) was based there permanently and wider team meetings were held daily or more frequently as required. A small team of administrators ensured that basic necessities were provided (such as food, water, and office equipment).

- While approval of senior executives was required for expenditures, their decisions were not constrained by a pre-established, rigid budget.

- This was not a crisis dealing with lives lost; rather, the industry was dealing with saving livelihoods.

Weaknesses

- Devastated growers suffered depression over the loss of income and declining orchard value; the ripping out of vines they had personally nurtured; and the stressful impact on family life and future plans for a potentially weakened industry.

- Many organizations (Zespri, NZKGI, MAFBNZ, PHOs), media, and occasionally individual growers were disseminating information about Psa, so it created a challenge for Zespri to minimize mixed messaging or confusion to growers and to position itself as the major source of credible information.

- Little was known about the situation. The organizations were dealing with an invisible airborne bacterium and could not know where it was or how big the issue was. Therefore it was difficult to forecast potential impacts.

- Psa was a technical issue and the organizations involved were learning about the disease as they were trying to deal with it.

- Speculation was rife as to how long Psa had been in New Zealand and how it had arrived in the country, with suspicion that a New Zealand company had imported pollen from China and that MAFBNZ had failed in its biosecurity obligations and erroneously cleared an import. This distracted from the immediate crisis response, and three years later, in 2013, following multiple investigations, it was still not possible to say definitively when, or how, Psa arrived in New Zealand.
- The Zespri communications department was short one senior staff member. (This concern was immediately addressed by employing an additional senior communications contractor with Zespri experience to assist in responding to the intense media interest.)

Threats

- Psa threatened the livelihood of kiwifruit growers as well as the supporting industries and local communities. Low morale in the face of the adversities associated with the Psa outbreak threatened to weaken resilience in those industries and the communities supporting them.
- When the outbreak was confirmed, Zespri had 1.4 million trays of kiwifruit (1.5% of the crop) on board ships destined for key markets that would require urgent re-routing if markets closed their borders.
- If left uninformed, journalists could misreport the issue as one of food safety (e.g., poisoned fruit), which might have led to markets shutting their borders to New Zealand kiwifruit. Rumors and misinformation could have caused severe damage to the industry and New Zealand's reputation as a supplier of safe, high-quality food products.
- Stakeholders' trust in Zespri was at risk.
- There was a risk of communication team burnout under the 24/7 pressures of media and industry demand for immediate and continuous release of information.

Opportunities

- The strong existing relationships with key stakeholders would enable immediate cooperative partnerships (e.g., the government ministry agency MAFBNZ, NZKGI, and PHOs).

- Effective industry and media communication channels were already in place prior to the crisis.
- The fact that the industry was vertically and horizontally integrated could be used to mobilize resources and expeditiously gain agreement on a recovery pathway.
- Some knowledge of potential solutions already existed. Zespri knew it could work swiftly with P&FR to identify an orchard management plan for growers.
- The relevant experience from Italy, Japan, and Korea provided hope that growers might be able to continue to grow kiwifruit even in a Psa environment.
- Leveraging its international relationships, Zespri applied support and counsel from experts around the world at the outbreak of the crisis.
- Zespri had just commercialized a new gold variety of kiwifruit that was more resistant to Psa than the original gold variety.
- The intense media interest was a challenge that could be turned into an opportunity because reporters saw Zespri as a credible source of information. The Zespri team was trained and experienced in crisis management and communications.

CORE OPPORTUNITY

With well-established relationships with its various stakeholders, Zespri could respond swiftly and effectively to protect its brand nationally and internationally. Zespri was prepared internally and its crisis team worked in collaboration with other partners.

GOALS

Zespri established goals for the company and for its communication.

Organizational goal: To control the spread of Psa and maintain stakeholder trust in Zespri as the market leader in kiwifruit.

Communication goals:

- To communicate with Zespri stakeholders in a timely way and with correct information.
- To build trust in Zespri's ability to lead the management of the crisis situation.
- To utilize grower and PHO feedback to properly assess the severity of the crisis.

- To collaborate with Zespri partners and prevent misleading publicity about the Psa crisis.

OBJECTIVES

Organizational Objectives

- To identify the geographical area of Psa infection and contain the immediate risk of spread from the infected area to minimize the number of affected orchards.
- To protect the Zespri brand nationally and internationally ensuring that trading partner countries did not ban New Zealand kiwifruit.
- To determine whether eradication was feasible and viable.

Public Relations Objectives

Output Objective

The output objective was to conduct two-way communication with Zespri growers via direct channels such as the grower-only website, newsletters, and emails; through face-to-face meetings once or twice a week; and through media to inform all stakeholders of the evolving situation.

Outcome Objectives

- To empower growers to take the appropriate action in their orchards to minimize Psa spread; to provide information, advice, and financial support for those affected, and to increase the affected communities' resilience to Psa-related adversity.
- To disseminate trustworthy and useful information to all stakeholders resulting in at least 80% feeling well informed in a timely fashion, and to be recognized by media as the major authority and most trustworthy source of information on the crisis, thus preventing the spread of misinformation and speculation in misleading reports by media and others.

KEY PUBLICS

Internal

- One hundred fifty Zespri employees in New Zealand: Explain the situation and keep them updated.
- One hundred Zespri employees elsewhere: Align messages internationally. The Zespri executive team and board of directors kept employees informed and, when necessary, involved.

National

- Kiwifruit growers and the industries that support them.
 - PHOs
 - Industry suppliers: Port of Tauranga, packaging and labeling companies, and orchard equipment and service providers

- National government and decision makers: the New Zealand Ministry of Foreign Affairs (for liaison with key trading partners); New Zealand Trade and Enterprise; MAFBNZ, ExportNZ; business development agencies that could assist with financial advice and support for growers; and Plant and Food Research
- Local governments in the affected and potentially affected regions (councilors, mayors, and local MPs)

International

- Consumers of Zespri kiwifruit
- Retail, wholesale, and distribution partners of Zespri
- International media

KEY MESSAGES

Zespri crafted several different messages, each targeted to particular publics.

Messages for the growers were intended to reduce panic and irrational fear while dealing with traumatic responses to the crisis; provide messages with useful instructions about recommended orchard actions, orchard hygiene, and tactics to

prevent the spread of the disease; and where to go for further information and support.

Messages for the media emphasized the details of the outbreak and Zespri's response to it, and made it clear that Zespri wanted to prevent misinformation and would immediately correct erroneous information.

Messages for consumers and in-market business partners emphasized the safety of kiwifruit: that Psa affects vines, not the fruit they bear.

There also were more general messages to reassure all audiences that the right people were working on the right tasks for the best outcome for the industry and the community.

The underlying tone of the communication was to be one of urgency, demonstrating concern about and control of the situation.

STRATEGIES

Zespri adopted several strategies:

- To carefully manage the rapid release of accurate information to the industry first, using well established as well as new channels to educate, gain cooperation, minimize misunderstandings, and reduce the potential escalation of irrational fear.
- To cooperate, educate, and gain support from the industry while conducting an open, candid, accurate, and timely media relations program.
- To protect the Zespri brand by using multiple channels of communication to deliver honest and reassuring messages clarifying the situation at each stage of the crisis.
- To avoid speculating on who was to blame for the crisis, focusing instead on developing a solution and supporting affected people.
- To implement a flexible, adaptive media program that was neither proactive nor reactive. Zespri's communication team had to prepare materials and the organization's representatives for media inquiries within the weekend after the first Psa notification.

TACTICS

Because of the urgent nature of the issue and the global communications effort required, the crisis response was 24/7 from the first evening of notification and for the following two and one-half weeks until a new major New Zealand crisis

(the Pike River mining tragedy) diverted the attention of mainstream media and the New Zealand public.

Media Relations

Media were important in terms of accurately reporting the facts to the wider public and helping to share important messages within the kiwifruit industry. Zespri's adaptive media strategy meant that the communication team produced the materials and prepared the organization's representatives for media inquiries, and then responded when the first media inquiry came.

The media demands to identify the affected orchards and growers within the first 48 hours, and Zespri's wish to protect this information out of respect to individual grower privacy, were especially challenging. The Zespri team worked with affected growers to help them understand the media's information needs and to seek out willing and suitable interviewees. With support from the Zespri communications staff, one grower then volunteered to speak to media within the first few days to take the pressure off his fellow growers. Zespri also provided alternative story angles, and spokespeople and locations were identified as options for journalists. There were two major occurrences of inaccurate reporting. One was an article in a regional newspaper that wrongly identified the first orchard affected. The wrongly identified orchard owner was contacted immediately to let him know of this error and what his options were. The Zespri team also contacted the editor of the regional newspaper to point out the error and call for a retraction, which was published the following day. The second case of inaccurate reporting was in Taiwan, where television media reported the issue as one of "poisoned kiwifruit." The Zespri team worked quickly to support Zespri's Taiwan-based staff in organizing a correction and dealing with any customer concerns. Fortunately, none was raised.

Another key challenge was the need to ensure accuracy when dealing with rapidly changing and sometimes complex information involving multiple stakeholders and multiple information release points within the Zespri organization. This was managed through the early establishment of a clear process for signoff and distribution of information with a single point of approval and release—Zespri's communications manager—and the quick development of clear templates for statistical tables, media updates, media distribution lists, and other frequently used sources of information.

Growers and other industry members were all getting information from multiple sources so it was important to ensure that Zespri's information was easy to access, direct, short, timely, relevant, repeated, and, most important of all, accurate.

The priority of Zespri's communication manager, on learning of the suspected infection, was to immediately develop initial key messages, an initial Q & A for internal publics, and a media release. The second step was to liaise with communications managers at MAFBNZ and Plant and Fruit Research to develop a focused and coordinated approach to communications. A crisis operations room was organized for meetings and for data collection and sharing.

The following activities were organized for ongoing communication with different publics:

- Circulating media releases and holding frequent media conferences for key updates

Fig 13.1. Grower communication materials delivering background, news, and progress.

- Working closely with journalists to organize interviews, answer questions, and suggest angles
- Ensuring that a core group of experienced and senior spokespeople was available for interviews
- Inviting journalists to participate with Zespri in grower meetings
- Setting up daily media email updates of key information
- Keeping a timeline of key activities so journalists new to the topic were easily kept up to date with progress

- Developing a sub-site on Zespri's corporate website (www.zespri.com) to house key information for all interested parties
- Using Zespri's YouTube site for recordings of CEO updates, grower meetings, and educational videos
- Keeping a photographic record of the crisis unfolding to assist media
- Monitoring media: reviewing media coverage and grower/industry feedback regularly
- Adjusting positioning to further emphasize key messages as required

Relationships and Communication with Zespri Partners

- Keeping key government ministers and officials fully briefed by email and phone
- Supporting local visits by the Minister of Agriculture and Biosecurity and other government officials, and coordinating key messages for media/grower presentations
- Holding daily briefings with relevant communication managers and senior officials from the various agencies to coordinate messages and deal with issues
- Setting up daily email updates of key information

Relationships and Communication with Growers and Industry

- Using Zespri's grower website (www.zespricanopy.com) as the portal for all industry information
- Establishing a monitoring and reporting system on orchard hygiene protocols and making it available via Zespri's grower website
- Using the existing monthly grower newsletter
- Using Zespri's YouTube site for recording and posting of CEO updates, information about grower meetings, and educational videos
- Holding regular industry meetings, filming them for YouTube where appropriate, and making the presentations available online; supporting the meetings with PowerPoint presentations and handouts
- Sending daily email updates to growers
- Keeping PHOs updated via regular email updates
- Working closely with NZKGI on messages and timing of information releases

- Supporting and attending local hui (meetings) with Maori growers
- Holding regular industry contractor meetings (e.g., with beekeepers and spray contractors) and sending updates via email
- Sending letters from Zespri's CEO to all growers at key milestones in the crisis response

Relationships and Communication with Zespri Employees and Internal Publics

- Ensuring that employees and internal publics heard new information before or at the same time as it was released publicly
- Sending internal notifications and key messages by email to senior staff and directors, followed by a combination of meetings and email updates for all other staff
- Keeping Zespri's Intranet up to date with key information (including directing staff to relevant websites and YouTube to access up-to-date information)
- Preparing the in-house Grower Contact Center (team of staff available for grower phone calls) for incoming queries by providing scripts, Q&A, and key messages
- Providing Zespri's offshore staff with regular updates of key messages and drafting customer letters and media releases for local distribution as required

The Zespri Crisis Management Team

- Being a key contributor to daily team meetings to share new information and reach consensus on daily tactics
- Managing rotation of crisis team employees to avoid burnout
- Ensuring that positive feedback about the response was circulated to the crisis team to help keep spirits high
- Arranging for the manager of MAFBNZ and the NZKGI Grower President to join a BBQ to thank staff for their efforts as the initial crisis response wound down

TIMETABLE OF ACTIVITIES DURING THE FIRST WEEK OF CRISIS RESPONSE

While Zespri continued to deal with the Psa outbreak for weeks, the company clearly was in "crisis mode" the first week following the discovery of Psa in two orchards.

Table 13.1. The First Week of Response.

Friday, 5 November	Psa symptoms reported on one orchard—notified to MAFBNZ and Zespri. Crisis team established, priority work underway. Key messages, Q&A, and media release established.
Saturday, 6 November	Symptoms reported on neighboring orchard. Communications Plan finalized with MAFBNZ and P&FR.
Sunday, 7 November	Industry Advisory Council meeting (grower, Zespri, and PHO representatives). First media interview conducted.
Monday, 8 November	Growers advised online and first CEO letter distributed. Psa confirmed on first orchard. Other industry groups meet. Zespri and orchard visit by MAFBNZ officials. Government cabinet informed. Passive surveillance begins on orchard. First reports to media.
Tuesday, 9 November	Ministerial announcement. Second CEO letter sent to growers. MAFBNZ minister visits orchards and Zespri. First "open to all" grower meetings commence. Reporting mechanisms commence (number of orchards clear, number with symptoms, number confirmed as Psa, etc.).
Wednesday, 10 November	Psa confirmed on second orchard.
Thursday, 11 November	First media conference.
Friday, 12 November	Second media conference.
	Ongoing staff, customer, industry, and media communications.

BUDGET

The communications budget existed within the broader crisis response budget. Because the response focused on utilizing cost-effective channels, including

media, to help communicate key messages to industry members, the Psa crisis response budget fell within the overall crisis response budgetary expectations. A significant portion of the crisis response cost, including distribution of information via existing Zespri channels, was absorbed in Zespri's existing communications budget.

In the early stages of the disease outbreak, the New Zealand government contributed $25 million, matched dollar for dollar by industry, for the management of the Psa crisis and support to affected growers.

EVALUATION AND MEASUREMENT OF RESULTS

Evaluation in Relation to Organizational Objectives

- The New Zealand kiwifruit industry's eventual adoption of orchard management techniques to minimize the spread of Psa is a significant outcome of Zespri's effective communication management. Areas of infection were identified immediately through well-established communication channels with the growers, and orchard hygiene protocols were introduced to minimize the spread. The industry, led by Zespri, demonstrated resilience to a potentially devastating situation and found a way to overcome the challenge.
- Another significant objective was achieved in the international market: There was no restriction of the product by any offshore market. Zespri's brand remained strong and trustworthy.

Evaluation in Relation to Public Relations Messages

- Output: Weekly communication and face-to-face meetings were achieved via diverse communication channels. Fifteen hundred growers (58% of the industry) participated in Zespri grower meetings in the first two weeks, and the messages reached most, if not all, New Zealand kiwifruit growers. Zespri's grower-only website went from 739 users accessing the site in the week before the Psa crisis to 1,613 users during the week following the Psa identification, a 118% increase.
- Outcome: Growers took the recommended actions and soon knew where to go for information and support. Growers immediately started providing feedback on the Psa status of their orchards; this enabled Zespri to assess the spread of the infected areas. Growers did not raise significant concerns regarding information access or lack of information.

It would have been inappropriate to conduct a grower survey during the response given the urgency of the situation and the pressure on the industry. Nevertheless, anecdotal feedback indicated that there was overwhelmingly positive feedback from growers during and following the initial response. An internal communications survey of Zespri staff conducted in March 2011 found that 88% of staff respondents felt well informed during the Psa response.

According to an independent analysis of media coverage conducted by Media Monitors, 90% of media articles included at least one key message that Zespri provided. Almost all (91%) media coverage focused on the outbreak and the response, with 9% of that coverage focusing on potential impacts.

Each of the partner organizations (P&FR, MAFBNZ, PHOs) directed media to Zespri so that Zespri became the recognized centralized point of contact. Media quickly signed up to receive regular email updates, and media conferences were well attended. Two cases of inaccurate reporting were quickly addressed.

Zespri received a significant amount of overwhelmingly positive feedback from growers during and following the initial response. These comments from some growers summarize the feedback:

"Thanks to the management team at Zespri for their leadership in the Psa issue. The meeting yesterday was informative, intelligent, well resourced, and dealt with the rumors, pulling the industry together. Well done." (Toni Stringfield—New Zealand kiwifruit grower)

"As growers we are very privileged and much appreciate the selfless dedication and absolute professionalism that currently exudes from Zespri. Crisis is a great litmus test and Zespri is well on the road from being a good company to a great and exceptional world leading company." (David Kelly—New Zealand kiwifruit grower)

It is difficult to estimate what might have been the outcome if Zespri's professional communications team had not dealt with this crisis. Also difficult to assess is how much more harm was prevented by the information and empowerment the communications team provided to all of those affected by Psa.

Englehart (2012) describes the significant challenge of crisis management as follows:

Crisis puts a company's reputation on the line in full view of its stakeholders. It tests principles, positions and values. It magnifies every misstep, compounds every error, fuels every emotion and highlights every agenda while everyone watches—and judges—from a front row seat. (p. 401)

Even under the acid test of that kind of scrutiny, this retrospective review of the Psa crisis suggests that the Zespri communications team's handling of the 2010

Psa crisis helped avoid major reputational damage nationally and internationally. It also indicates that the team's professionalism contributed to further development of the organization's crisis planning and further enhanced trust among the Zespri workforce, industry stakeholders, the kiwifruit community, and the New Zealand government and its citizens.

DISCUSSION AND CONCLUSION

It is useful to consider this case in the context of crisis communication studies.

"As organizational crises go, it did not seem to amount to much. No one died; no one was injured; the environment wasn't threatened; there wasn't even a scandal" (Berg & Robb, 1992, p. 93). This statement did not refer to the Psa outbreak in the New Zealand kiwifruit industry in 2010 but rather to a marketing contest campaign conducted in 1989 by Kraft in the United States aiming to increase sales of cheese slices. The Kraft crisis was caused by a printing error as part of a cheese promotion that raised customers' expectations for prizes that Kraft did not mean to provide. Even though it was not a major event, it led to lawsuits that if successful, according to Berg and Robb (1992), might have cost the company $170 million NZ$. While Kraft's failed cheese promotion is not of the same severity as the Psa crisis in New Zealand in terms of its negative long-term impact on an industry, neither case is comparable to such well-documented and devastating crises in public relations history as the deadly gas leak in a Union Carbide factory in Bhopal, India, in 1984 that killed between 3,000 and 10,000 people (Coombs & Holladay, 2012, pp. 2–3) or the British Petroleum (BP) oil spill into the Gulf of Mexico in 2010, the worst spill in U.S. history (Englehart, 2012, pp. 408–409). Every crisis situation deals with different challenges, and it is hard to compare management strategies because "the variables in any particular crisis situation are so numerous that no historic case is likely to be comparable to the point of providing an optimal response" (Berg & Robb, 2012, p. 108). It is hard to follow a "by the book" guide to crisis management that would fit all situations.

However, some generalizations based on successful and failed experiences from crisis cases enable the categorization of crisis situations and provide appropriate recommended responses in each category. Coombs and Holladay (2012), for example, categorize crises according to different variables. They use situational crisis communication theory (SCCT) and attribution theory to analyze different types of crisis. They suggest a typology of SCCT crisis types, based on attribution of crisis responsibility, which distinguishes between victim crisis: minimal crisis responsibility (natural disasters, rumors, workplace violence,

product tampering); accident crisis: low crisis responsibility (challenges, technical error accidents, technical error product harm); and preventable crisis: strong crisis responsibility (human error accidents, human error product harm, organizational misdeed) (p. 249).

According to Coombs and Holladay's (2012) analyses, it is possible to relate to the Psa contamination of New Zealand kiwifruit as a victim crisis (minimal crisis responsibility) because Zespri was not responsible for the contamination. The government authority responsible for New Zealand biosecurity, MAFBNZ, was responsible for preventing harmful organisms from entering New Zealand. However, blame could not be put on MAFBNZ because it was not reasonable to expect country borders to be hermetically sealed, and the cause of the bacterial incursion has never been confirmed. Thus, the Psa case can be better classified as a "natural disaster" to the New Zealand kiwifruit industry, with the industry being the victim and Zespri being its representative.

Coombs and Holladay's (2012) recommendation for a response to "crisis with minimal attributions of crisis responsibility and no intensifying factors" (p. 250) is for "instructing information and care response" (p. 250). This is unlike crisis cases with strong attribution where response recommendations include compensation and an apology strategy. Noting the recommended strategy of providing accurate, useful, and up-to-date information can defend the low attribution of the Psa case.

Coombs and Holladay's (2012) victim crisis category also explains why Zespri could use an adaptive media strategy rather than being more proactive: This was not a life-threatening situation, and there was no risk of environmental pollution that could be avoided by prior announcement. The company could commence its direct-to-industry communications, while taking time to prepare its messages and strategy before breaking the news to the public on media channels.

The crisis management in the Psa case demonstrates multiple approaches to a challenging and complicated situation that involved many stakeholders. The crisis management responses went beyond the provision of instructional information to simultaneously mobilizing and upgrading relationships of trust with internal and external stakeholders.

It also demonstrates the complexity of public relations work in the service of global organizations where practitioners need to operate outside the familiar comfort zone of their own culture and "must resist ethnocentric tendencies as they cope with stakeholders in different cultures, unfamiliar media systems and online usage patterns, and different legal concerns" (Coombs, 2012, p. 190).

The harm to the kiwifruit industry caused by the 2010 Psa outbreak is irreversible. However, the communications effort of Zespri's crisis team succeeded

in shoring up the industry and community resilience in a way that enabled effective adaptation to the new realities as they were happening. This case can serve as a model for the value added by public relations professionals when they are well trained, well integrated into the management team, and well prepared to respond immediately and professionally to a crisis.

REFERENCES

Berg, D. M., & Robb, S. (1992). Crisis management and the "Paradigm Case." In E. L. Toth & R. L. Heath (Eds.), *Rhetorical and critical approaches to public relations* (pp. 93–109). Mahwah, NJ: Erlbaum.

Coombs, W. T. (2012). *Ongoing crisis communication: Planning, managing, and responding* (3rd ed.). Thousand Oaks, CA: Sage.

Coombs, W. T., & Holladay, S. J. (2012). *Managing corporate social responsibility: A communication approach.* Malden, MA: Wiley-Blackwell.

Englehart, H. (2012). Crisis communication: Brand new channels, same old static. In C. L. Caywood (Ed.), *The handbook of strategic public relations and integrated marketing communications* (2nd ed., pp. 401–413). New York: McGraw-Hill.

Yamato Employees Lead Response to Earthquake Relief Efforts

KOICHI YAMAMURA
Media Gain Co., Ltd.

EDITORS' NOTE

What company or organization doesn't experience a crisis at some point? The magnitude 9.0 earthquake crisis experienced by the people of Japan and Yamato Holdings, the market leader in door-to-door parcel delivery in Japan, was unpredictable and unprecedented in its impact on the Japanese and on Yamato's business. This case study provides details of how Yamato focused on its local drivers to implement a Y10 (about 12 cents in U.S. currency) per-delivery donation, approved by shareholders, that totaled Y10 billion ($14.4 billion USD) for earthquake relief and rebuilding efforts, approximately 40% of the company's annual net income.

BACKGROUND

Yamato Transport began its business in 1919 as a trucking company with four trucks. Soon the company signed a contract with Mitsukoshi, the most prestigious department store in Tokyo in those days, to undertake home delivery of purchased goods. By 1935, the company was one of the largest trucking companies in the

country. After World War II, the company diversified its operation to include rail cargo forwarding and long-distance route trucking in addition to regional deliveries.

In the early 1970s, the decline of rail cargo and the increased cost associated with the rapid expansion of department store goods delivery were starting to hurt the company's bottom line. After the "1973 Oil Shock," Yamato's department store client intensified its demand for delivery cost reduction and imposed on Yamato various costs associated with a distribution center.

During a trip to the United States in 1973 to study its trucking industry, Masao Ogura, the son of the founder and the president of Yamato at the time, observed United Parcel Service (UPS) trucks making deliveries in New York City (Ogura, 1999).

Urged by the declining profit and inspired by the UPS courier service, Yamato launched in 1976 the first courier service in Japan. The number of packages shipped on January 20, 1976, the first day of home delivery service operation, was only 11 but the service quickly grew. In the fiscal year ending March 1979, the company delivered more than 10 million packages. In December 1981, the company delivered 10 million packages in one month. Along its growth path, Yamato decided in 1978 to terminate the service contract with Mitsukoshi Department Store, the largest client of the company at the time, to focus on the courier service and concentrate management resources on the new venture (Ogura, 1999).

The company maintained its position as the largest courier service company in Japan. In 2006, the company was reorganized to transform the corporate culture and ensure further growth. A holding company, Yamato Holdings, was established. Yamato Transport and all the former subsidiaries of Yamato Transport became subsidiaries of Yamato Holdings. The purpose of the reorganization was to help non-delivery businesses grow. In its long-term business plan announced in 2011, the company aimed to increase the non-delivery businesses' operating profit share from 20% to 50% by 2019 (Yamato Holdings, 2011, January 28).

In the fiscal year ending March 31, 2011, the company had 171,642 employees with annual sales of Y1.236 trillion (US$14.86 billion based on the exchange rate of $1=Y83.15; this rate was used for all of the currency conversions in this case except in the advertisement published by Yamato). The company's main businesses were home delivery (courier) and business logistics. In March 2011, the company's home delivery division was estimated to have 3,900 service branches nationwide, 260,000 service agencies, and about 54,000 drivers who the company calls "sales drivers (SD)," covering the entire country (Yamato Holdings, 2011, September 22).

At 2:46 p.m. on March 11, 2011, a magnitude 9.0 earthquake hit Japan's eastern coast in the Tohoku area in the northern part of Japan, followed by a tsunami as high as 21.1 meters (69 feet). The earthquake left more than 18,000 people dead or missing. Of six prefectures in Tohoku, Miyagi was the hardest hit with more than 10,000 people killed or missing, followed by Iwate with more than 5,000 people and Fukushima with more than 1,800 people. In the hardest hit regions, more than 400,000 people were evacuated into emergency shelters. Five Yamato employees in these regions lost their lives in the tsunami (A. Katagiri, personal communication, June 28, 2013).

On March 13, two days after the earthquake, Yamato sales drivers in the affected regions began asking local government officials how they could help. Home deliveries to and from the affected regions were temporarily halted. Yamato headquarters had sent internal rescue supplies to its branches in the affected regions. When local managers voluntarily brought some of these supplies to evacuation centers, they learned that there was a shortage of supplies. They also learned that warehousing and distribution of the rescue supplies weren't working well (A. Soejima, personal communication, May 21, 2013).

On March 21, Yamato resumed its operation in the affected regions but without home delivery. The delivery was to and from Yamato branches and service agencies rather than to home addresses because many people were still missing or in evacuation centers. On March 23, Yamato announced that the company would voluntarily assign a maximum of 200 trucks and 400 to 500 employees from its home delivery operations for at least two weeks to handle the logistics of storing and distributing the rescue supplies and that the assignment would continue "as long as necessary" until the logistics of supplies to support evacuees become stable (Yamato Holdings, 2012).

On April 7, Yamato announced that the company would donate Y10 (about 12 cents US) per package the company carried during the fiscal year ending March 2012 to the recovery efforts in the affected regions, The total donation was expected to be Y13 billion (about $156 million) (Yamato Holdings, 2012).

METHODOLOGY

This case study was researched and written using several research methodologies. The research began with a review of Yamato's internal publication on the earthquake relief efforts, followed by personal interviews with Yamato managers who were involved with the earthquake relief efforts: one with former Miyagi branch manager A. Soejima and another with public relations manager A. Katagiri. The

findings were supplemented by the review of investor relations materials and a book on Yamato management philosophy written by former Yamato Holdings Chair M. Ogura.

SITUATION ANALYSIS

Yamato was the market leader in the door-to-door parcel delivery service in Japan when the earthquake occurred with a market share of 42.2% (Yamato Holdings, 2011, September 22). The company was known for innovative product and service development such as delivery of skis and golf bags, time-specified delivery service, purchase, payment, collection-upon-delivery service, and refrigerated home delivery service. Because it was the market leader, the company often was the focus of media attention, whether the news was positive or negative.

The unprecedented scale of the earthquake and the resulting telephone network shutdown made it difficult for Yamato management to immediately grasp the magnitude of the damage to its service and service areas caused by the earthquake. The company dispatched investigating teams from Tokyo to its branches in the affected regions to find out the situation there. However, for local sales drivers who were in daily contact with their clients, the situations in the affected regions were too grueling for them to simply observe and do nothing.

As of the end of March 2011, more than 31% of Yamato stock was held by overseas institutional shareholders who were more vocal than Japanese shareholders about shareholder value. In terms of the number of shareholders, more than 96% of the shareholders were domestic Japanese individuals who were part of the company's customer base (Yamato Holdings, 2011, April 28). Their responses were vital to the company's reputation in the capital market and also could affect the company's main businesses. Yamato's logistical support began as local employees' voluntary acts using the company's trucks and supplies; it was important that this would not be seen by suppliers as an indication of the company's lack of control nor would the donation the company made to the recovery efforts be regarded as draining profit. Investors, whether institutional or individual, needed to be provided with adequate information on the relief efforts so they could make a fair assessment of Yamato's actions. There was a risk that such acts of selfless devotion could be perceived by the general public as ill-motivated acts designed to publicize the company's goodwill, not as actions genuinely driven by altruistic spirit.

With about 3,900 home delivery service branches, Yamato was in an excellent position to serve the needs of the affected regions. Sagawa Express, the second largest home delivery service company with 36.2% market share (2010), only had

364 home delivery service branches as of April 2011 (Sagawa Express, 2011). This was a stark difference from Yamato, which had a 40.6% market share and 3,900 branches as of March 2011 (Yamato Holdings, 2011, September 22).

PROBLEM

It bears repeating: Yamato intended to contribute Y10 (about 12 cents US) per parcel to the earthquake relief efforts, a total of Y13 billion (about US$156 million), almost 40% of the company's net earnings. It was an amount large enough to have an impact on the recovery of the affected regions but could also be large enough to make investors worry about the losses they might thus bear. At the end of March 2011, more than 30% of Yamato shares were held by non-Japanese entities that generally were more vocal than Japanese shareholders.

Another problem Yamato faced was a tax issue. If the emergency relief donation was made through organizations such as Red Cross or government, there would not be any concern that the money it donated to the cause would be subject to corporate income tax. However, Yamato was afraid that the money would not be spent effectively in a timely manner through such organizations. On the other hand, under Japanese tax regulations, if Yamato controlled the use of the money and donated to local groups in the affected regions, a large portion of the donation would be treated as taxable income. Such taxation needed to be avoided, as it certainly would not make any sense from a shareholder perspective.

GOALS AND OBJECTIVES

Since the reorganization of the corporate structure in 2006, the goals of Yamato's public relations activities were to keep employees motivated and to ensure that businesses of the non-delivery group companies were recognized by society. In response to the earthquake, there were no specific public relations goals or objectives for Yamato's earthquake relief assistance.

The goal of its earthquake relief effort was to assist in rescue and recovery efforts. The objective was to donate Y10 (12 cents US) per item delivered for use in those rescue and recovery efforts.

However, people in Yamato's public relations department did have a specific communication goal in mind: to communicate about the company's relief activities, particularly the donation initiatives, effectively but not overtly in a self-congratulatory way. Taking advantage of the situation to promote its business was

contrary to the company philosophy. In other words, the motive behind the donation should not be misconceived as marketing driven. But at the same time, the stakeholders of the company needed to be properly informed of what the company was doing.

None of the objectives was expressed in quantitatively measurable terms.

KEY PUBLICS

For Yamato's public relations department in the immediate post-quake period, the most important public was the company's shareholders because making a donation this large would mean reducing a substantial portion of Yamato's net income, assets that technically belonged to the shareholders. The customers and local communities also needed to be properly informed of the support activities in which Yamato was engaging. Finally, Yamato needed to keep its employees motivated, and it was important to keep them well and properly informed of the support activities.

KEY MESSAGES

Yamato's public relations department did not draft specific key messages for post-quake communications because it did not want its relief efforts to sound like an initiative driven by marketing.

For Yamato, the post-quake initiatives were the repayment to the customers of the affected regions for their years of support of Yamato businesses. The company's actions were its message: delivering urgently needed relief supplies to residents of the region affected by the earthquake.

STRATEGIES

Yamato knew that in Japanese society, donations for the sake of marketing would be regarded as self-serving and would be harmful to the company's reputation. In the western context, it may be that, whatever the motive, a good deed is a good thing. In Japan, motives often become the focus. If a commercial motive becomes apparent, no matter how humane a campaign may be, the reputation of the organization driving the campaign may not necessarily improve. In this case in particular, if Yamato was viewed as commercially motivated, people of the affected region might have felt that Yamato was taking advantage of them, and this view might have been shared by others around the country.

Yamato's public relations department decided not to aggressively pursue media exposure. What it needed to do was to communicate directly and sensitively with stakeholders so that the information was properly but not excessively conveyed.

As to the tax issue, the company decided to consult government agencies and work out a way to avoid taxation while keeping control of the way the money it donated was to be spent.

TACTICS

Yamato's public relations staff was in close contact with Yamato's senior executives. Immediately after the earthquake, the public relations staff began attending daily meetings with top executives and in-house union leaders.

Yamato negotiated with government agencies as to how the company could make its donation without paying corporate income tax. Understanding Yamato's motive and the impact the donation could make on the recovery efforts, the government agency personnel cooperated by devising ways to eliminate additional taxes. Yamato came up with a solution: Masao Ogura, the founder's son, had donated his personal wealth in 1993 to establish the Yamato Welfare Foundation that aimed to help handicapped Japanese lead independent lives. The Ministry of Finance designated the Yamato Welfare Foundation as a tax-free emergency relief charitable organization on the condition that Yamato Holdings was not the only source of funding. So the foundation set up a quake emergency relief fund for public donations.

On April 11, four days after Yamato's board of directors officially agreed to make the donation of Y10 (about 12 cents) per package the company earned in the fiscal year ending March 2012, the company posted a newspaper advertisement in 48 newspapers, including five national papers and key regional papers. The half-page all-text advertisement is included in the box below.

EVERY PACKAGE WE DELIVER WILL ALSO CARRY HOPE

March 11th 2011

For those of us who work closely with our local communities, the devastation caused by the earthquake and tsunami that struck that day is almost beyond comprehension. We are profoundly saddened by the knowledge that many thousands of lives were lost as an entire city perished.

For our employees who work in the affected area, the devastation was personal, and it is felt in ways far beyond the statistics and stories reported by the media. For them, these are the faces and voices of people they know, people who lived alongside them in the same community, who traveled the same familiar roads, and with whom they shared the simple moments of everyday life.

Our employees, many of whom are also affected by the disaster and lost a great deal, are responding in ways that come from knowing the community and the people so well. Through their actions, they are showing the rest of the 170,000 Yamato Group employees throughout Japan what it is we should be doing now.

Fishing and agriculture, two industries that nurtured and helped our parcel delivery business grow, suffered catastrophic damage. This presents a major challenge that affects the dietary habits of people throughout Japan. Therefore, while continuing our overall support activities of sorting relief supplies and transporting goods to strategic relief centers where they are urgently needed, we will also begin moving to help restore local infrastructure and support the recovery of fishing and agriculture in the affected areas.

For those industries, the road to recovery will be long and hard and will require tremendous financial resources. And we want to do our best to help.

Yamato handles about 1.3 billion parcel deliveries annually. By donating Y10 (about 12 cents) for every parcel we deliver, about Y13 billion (about $USD156 million) can be collected in a year to help fund restoration efforts. Our charge will not change. But the fund we collect will be generated through our business and with the assistance of our customers throughout the country.

Each month, we will update our website with the amount of money that has been collected and utilized for restoration. We are determined to adhere to this program no matter how difficult it may become, to show our gratitude and repay the people who have supported us over the years.

It's been a month since the earthquake. The eyes and interest of the world will gradually shift away from the events that occurred in Japan. Yet, there will be many who remain crushed by the weight of reality and enveloped in sadness.

But we will never forget. We will always try to imagine the pain only those personally affected can know and make this the starting point for our actions toward recovery.

We will begin. We will carry on with our business as always, now knowing that with every package we carry we also carry the hope for a better day.

(Yamato Holdings, 2011, April 11)

An interim report on the impact of the donation was posted as a one-third page advertisement on October 12, 2011, in the 48 newspapers that included five national papers and major regional papers, the same media as in March.

The advertisement is included in the box below.

EVERY PACKAGE WE DELIVER CARRIES HOPE

Seven months have passed since the earthquake. Our yearlong program to help rebuild the fishing and agriculture industries and restore infrastructure in the affected areas by donating ten yen for every parcel we deliver is continuing. Since April, we have handled 683,155,742 parcels (106,563,477 in September alone), which brings the total amount donated to Y6,831,557,420 (US$89 million) as of September 30. Once again, we would like to take this opportunity to thank each and every customer who has used our delivery service. Previously, it had been determined that all the funds donated through the program would be administrated by the Yamato Welfare Foundation. In the wake of the earthquake, the East Japan Great Earthquake Life, Industry Infrastructure Recovery, and Rebuilding Relief Fund was launched for the purpose of supporting the recovery and rebuilding the industries and infrastructure of the affected areas. On June 24, Japan's Ministry of Finance recognized the Fund as an incorporated public interest fund. This designation allowed donations to the fund to be treated as tax-exempt and used in full to support the affected areas for the purposes stated earlier. It was for that reason that Yamato decided to donate the funds raised through its package delivery to this organization. On July 1, Yamato Welfare Foundation began accepting applications for funds to support recovery projects that were qualified to receive relief assistance. At the same time, to ensure the integrity and impartiality of the Fund's operation, a special review committee was organized consisting of third-party specialists. The organization received applications and heard from local government and public sector authorities representing the affected areas, and provided support to recovery and rebuilding projects on a continuing basis. At the first selection and review meeting held August 24 to determine the first group of fund recipients, nine projects were awarded a total of Y4.1 billion (US$53.4 million). Altogether, five application rounds were held during the 2012 fiscal year. The members of the selection committee shared a common goal to provide visible, rapid, and highly effective support. They also shared a goal that this support effort, as evidenced through the projects themselves, would become a model for effective restoration that others might find useful. We are also gratified to report that

the projects described in this report are exactly the type we envisioned and hoped would come to pass when we began this program.

(Yamato Holdings, 2012)

On January 8, 2013, Yamato posted a full-page advertisement with a photo of children playing in the playground in front of a newly built children's daycare center. It was published in *Nihon Keizai Shimbun*, a national business daily newspaper with a daily circulation of about three million, to provide an update on the donations and how the money was being spent.

The advertisement's wording appears in the box below.

NODAMURA DAYCARE, IWATE PREFECTURE

As you climb the gentle slope, you hear the children. These are the children of Nodamura Daycare in Iwate Prefecture. On the day of the Great East Japan Earthquake, the children, led by their teachers, walked 2 km and climbed a slope to reach the higher ground that enabled them to survive the tsunami that followed. Thanks to a monthly evacuation drill, the children and daycare staff were safe that day. But the daycare facility was washed away.

For the sake of the children—and for their parents, who need a safe place to leave their children while they work toward the recovery of their community—rebuilding the daycare facility became an urgent need. With relief funds from the Yamato Welfare Foundation, a new daycare facility was completed at the end of October last year. According to the teachers, the facility stands on high ground where it is safe from tsunami and the spacious grounds provide an ideal environment for children. This is a significant part of the life that the people of Nodamura (Noda Village) have worked together to reclaim. It will soon be one year and ten months since March 11, 2011. Time has passed in different ways for those who were affected that day and in the days since. At Yamato Group, we conducted a yearlong program that began the month following the earthquake. Ten yen was collected for each parcel we delivered and was donated to help restore the infrastructure, and marine and agricultural industries in the affected areas. This was done in gratitude to the people of the Tohoku area who helped our delivery service grow. Funds collected from all parts of Japan reached Y14,236,081,360 million (US$171.95 million based on an exchange rate of US$1.00 = Y82.79 as of March 30, 2012). Together with donations sent directly to the Foundation, the grand total amounted to Y14,284,480,751 million. We are sincerely grateful to each and every customer who used our delivery service as well as to all those

who supported the program. The Yamato Welfare Foundation administers relief funds directed to the affected areas, and various projects are steadily taking shape. Included are 11 projects in Iwate Prefecture, eight in Miyagi Prefecture and 12 in Fukushima Prefecture. The rebuilding of Nodamura Daycare was one of those projects. The decision to initiate this program was inspired by our employees. After the tsunami, they immediately began to work in ways that could only be accomplished by those who shared the same painful experience and who knew the areas and people well. Their example continues to inspire nearly 180,000 Yamato Group employees throughout the country and shows what can be accomplished when employees are closely connected to the places they work. The damage caused by the great earthquake was extensive. It will be a long and difficult road to recovery. Employees throughout the country will continue to focus on the communities in which they work and seek out ways to help as they carry out their daily jobs. Details about the 31 projects and their progress can be viewed in the monthly report posted on the Yamato Holdings website.

(Yamato Holdings, 2013, January 8)

To communicate with its employees, Yamato set up, in June 2011, a restoration support portal on its intranet. On the first anniversary of the earthquake—March 11, 2012—Yamato published a 61-page brochure titled *Higashi Nihon Dai Shinsai no Kiroku (Records of the Great East Japan Earthquake)* that contained records and memoirs of how the company dealt with the earthquake and the post-quake restoration support. The brochure was distributed to approximately 180,000 Yamato employees and 50,000 contract workers.

It also was important to disclose how the money was spent. Yamato released a monthly report on its website and disclosed how many parcels were carried and how much money was donated to the Yamato Welfare Foundation. Detailed information including the list of projects and the amount of money allocated to each project was made public through the foundation's website.

TIMETABLE

March 11, 2011

- At 2:46 p.m., a magnitude 9.0 earthquake hits off the coast of East Japan.
- At Yamato headquarters, the earthquake emergency response headquarters was established immediately after the quake.

- Communication between the company headquarters and branches in the affected regions was terminated.
- At 7 p.m., shipments of parcels to and from the affected regions were suspended.
- Procurement of vital relief materials began. This included bottled water, food, and other life-sustaining goods. The Yamato head office in Tokyo as well as its branches other than those in the affected regions procured these materials and prepared them for shipping to Yamato branches in the affected regions.

March 12, 2011

- Starting this day, earthquake emergency response meetings were held every day at 7:30 a.m. until March 25. The key participants were top and senior executives and labor union leaders. The public relations managers also participated in the meetings.
- Regional head managers of heavily affected regions—Iwate, Miyagi, and Fukushima prefectures—visited local branches under their control, except those washed away by the tsunami and those in the immediate vicinity of the Fukushima Daiichi Nuclear Power Plant.
- Shipment of internal rescue materials to branches in Miyagi began.
- The Ministry of Land, Transport, and Infrastructure asked Yamato to engage in the transportation of rescue materials to depots in the affected regions.
- Fukushima Daiichi Nuclear Power Plant exploded.

March 13, 2011

- Branch managers began asking local governments how they could help. Upon request from local governments, some Yamato local branches began delivering rescue materials from prefectural government depots to emergency shelters.
- Shipment of internal rescue materials to branches in Fukushima began.
- Internal rescue materials began arriving at Yamato branches in Miyagi. Leaving the minimum necessary amount aside, many branch managers brought rescue materials to nearby emergency shelters because there were shortages of materials due to logistical problems.

March 14, 2011

- The Miyagi regional head manager officially offered the Miyagi prefectural government its support for transportation of rescue materials.

March 15, 2011

- The Iwate regional head manager officially offered the Iwate prefectural government its support for transportation of rescue materials.

March 17, 2011

- The Fukushima regional head manager officially offered the Fukushima prefectural government its support for transportation of rescue materials.

March 21, 2011

- Yamato resumed its courier operation to and from local branches in Iwate, Miyagi, and Fukushima prefectures. Home delivery was not yet offered because many people were still in emergency evacuation shelters.

March 23, 2011

- Yamato announced that the company had set up the Rescue Supply Logistical Support Squad in Iwate, Miyagi, and Fukushima prefectures to engage in sorting and transportation of rescue supplies free of charge in each of the three prefectures. The company would assign up to 200 delivery trucks and 400 to 500 employees as drivers and warehousing workers. The duration was scheduled to be about two weeks but would continue until the logistics in the region were stable.

April 7, 2011

- Yamato's board of directors resolved to donate Y10 (about 12 cents) for every parcel the company would deliver from April 2011 until March 2012.

The decision was announced in a press release and also was posted on the company website.

April 9, 2011

- With the gradual recovery of local transportation companies, Yamato began charging fees for the Rescue Supply Logistical Support operation in Miyagi prefecture in order not to squeeze out local operators from providing the service for fees.

April 11, 2011

- Yamato began charging fees for the Rescue Supply Logistical Support operation in Iwate prefecture.
- A half-page newspaper advertisement announcing the donation the company planned to make and the thought behind it was published in 48 newspapers including five national papers and major regional papers.

April 16, 2011

- With the recovery of local transportation companies, the Rescue Supply Logistical Support operation in Fukushima prefecture was terminated.

June 24, 2011

- The Ministry of Finance recognized Yamato Welfare Foundation's donation vehicle, the East Japan Great Earthquake Life, Industry Infrastructure Recovery, and Rebuilding Relief Fund, as an incorporated public interest fund, paving the way for donations to be tax-exempt.

August 24, 2011

- The first round fund recipients were determined. Nine projects were awarded a total of Y4.1 billion (about $49.3 million USD).

August 31, 2011

- The Rescue Supply Logistical Support operation in Iwate prefecture was terminated.

October 11, 2011

- The second round fund recipients were determined. Six projects were awarded a total of Y2.2 billion (about $26.5 million USD).

October 12, 2011

- An advertisement reporting the status of Yamato's donation was published in 48 newspapers including five national papers and major regional papers.

December 12, 2011

- The third round fund recipients were determined. Five projects were awarded a total of Y2.2 billion (about $26.5 million USD).

December 22, 2011

- The fourth round fund recipients were determined. Five projects were awarded a total of Y2.1 billion (about $25.3 million USD).

January 15, 2012

- The Rescue Supply Logistical Support operation in Miyagi prefecture was terminated.

March 31, 2012

- As the fiscal year ended, Yamato's program to donate Y10 (about 12 cents) for every parcel delivered came to an end.

April 5, 2012

- Yamato announced that the number of packages Yamato handled during the fiscal year ending March 2012 totaled 1,423,608,136. The amount of the donation Yamato made totaled Y14, 236,081,360 billion (about US$171.2 million).
- The total support devoted to the project was 4,286 person-days and 4,187 truck-days.

April 17, 2012

- The fifth round fund recipients were determined. Seven projects were awarded a total of Y3.7 billion (about $44.5 million).

April 27, 2012

- The company posted Y1,686 million (about $20.28 million USD) in March 2011 as an extraordinary loss resulting from the earthquake.

July 20, 2012

- Yamato Welfare Foundation announced that the total amount of the donation made by Yamato, combined with the money directly sent by individuals and organizations to the fund, reached Y14, 236,838,872 (about US$171.2 million USD).

BUDGET

Similar to other Japanese companies involved in humanitarian activities in communities where they do business, Yamato did not publicly disclose the cost associated with its campaign. However, the estimated cost of the three advertisements in newspapers and 230,000 copies of a 61-page color brochure was about Y200 million (US$2.4 million). The company did not hire an outside public relations firm, and there was no additional cost other than salaries and the associated cost of the internal public relations personnel.

EVALUATION AND MEASUREMENT OF RESULTS

With its donation, Yamato Welfare Foundation supported 31 projects in Iwate, Miyagi, and Fukushima prefectures, in the areas of fishery, agriculture, commerce, and local infrastructure. The projects are as follows:

Table 14.1. Yamato Welfare Foundation projects.

Round	Domain	Amount Yen million	Content	Completion date
1	Fishery	100	Purchase of sea bottom debris collector	03/16/2012
	Fishery	600	Purchase of ice-making machine	03/31/2012
	Fishery	500	Purchase of aquaculture equipment	01/31/2013 (partial)
	Fishery	1,600	Purchase of seafood processing equipment	03/31/2013 (partial)
	Fishery	403	Temporary securement of cold storage warehouse and transportation to and from this warehouse	12/31/2012
	Commerce	180	Refurbishment of highway-side sales facility to market local agricultural and fishery products to tourists	08/11/2012
	Commerce	80	Repairing water temperature control system of a local aquarium	01/06/2012
	Agriculture	255	Refurbishing a warehouse to consolidate six damaged warehouses into one	08/02/2012
	Fishery	347	Building temporary facilities for fish market, aquaculture, and processing facilities	10/04/2012

Continued.

Round	Domain	Amount Yen million	Content	Completion date
2	Fishery	97	Purchasing and repairing hoist and crane at fishing ports	03/31/2012
	Fishery	248	Building ice-making facilities and ice storage	10/27/2012
	Fishery	155	Purchasing crushed ice-making car and disinfected cold sea water making facility	11/22/2012
	Agriculture	1,324	Purchasing farming machineries and building facilities	10/31/2012
	Infrastructure	280	Rebuilding a nursery center on high land	10/30/2012
	Commerce	103	Building temporary cranes and container stacker at temporary ocean container port facility	01/28/2012
3	Fishery	758	Repair and purchasing of ice-making and storage facilities in 13 fish markets	06/10/2013 (partial)
	Fishery	880	Repair and purchasing of fish processing facilities of 16 fishermen and processors unions	03/31/2013 (partial)
	Agriculture	300	Building hydroponic culture facilities for farmers in Fukushima area (close to the nuclear power plant)	04/30/2013
	Infrastructure	30	Building a "mental care center" in areas affected by the nuclear power plant accident	01/12/2012
	Infrastructure	234	Rebuilding a nursery center on high land	03/31/2013

Continued.

Round	Domain	Amount Yen million	Content	Completion date
4	Fishery	966	Building water supply, sterilization, and sorting facilities and fish tanks in 13 fish markets	01/31/2013
	Fishery	570	Rebuilding fishery research and promotion center with evacuation facility on the third floor	09/10/2013
	Agriculture	300	Purchasing farming machineries for production, processing, and sales of soy bean products	09/30/2012
	Agriculture	270	Building two farming warehouses to consolidate five damaged warehouses	07/31/2013
5	Fishery	58	Purchasing debris cleaning equipment and subsidizing its maintenance	03/31/2013
	Fishery	177	Building temporary fish processing facility and purchasing necessary equipment	09/25/2012
	Fishery	130	Purchasing fishing and aquaculture equipment and facilities to supply high-quality products	03/31/2013
	Infrastructure	2,000	Rebuilding a damaged building of a general hospital	11/30/2014
	Infrastructure	1,000	Building an elder care facility attached to a hospital	11/30/2013
	Infrastructure	191	Building a temporary school building for use during reconstruction for two years	03/31/2015
	Infrastructure	130	Nurturing plants to be planted in a disaster-prevention forest	03/10/2017

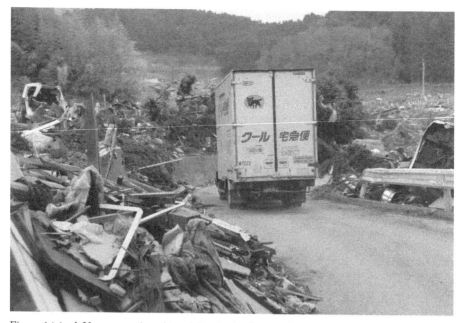

Figure 14.1. A Yamato truck making deliveries in the area destroyed by the earthquake and tsunami.

Yamato did not measure the impact of its public relations activity to assist victims of the earthquake and tsunami. With its fundamental mission of keeping employee motivation high and increasing exposure of its non-delivery businesses, the company's public relations division did what it thought it should do to the best of its capacity. There were many media inquiries and much media exposure, but Yamato did not keep a record of the number: with a small public relations staff, measurement was low in priority. Yamato had so many branch offices interacting with the outside world on a daily basis that even trying to grasp the number of interviews locally conducted was overwhelming, and the public relations department was not sure if it would be worth the effort needed.

Yamato Holdings had four staff members in its public relations division. Yamato Transport, the largest subsidiary engaging in the delivery business, had seven public relations staff. All other subsidiaries had someone in charge of public relations as a secondary responsibility. Without retaining any outside public relations help, it was a very small public relations team for a company with about 3,900 branch offices and 180,000 employees.

The company recognized that its more than 54,000 "sales drivers" who see customers face to face every day were the best spokespersons for the company. The main focus of its public relations activities was to communicate with these employees to keep their motivation high.

This approach was partly because Yamato's top executives understood the importance of public relations. For example, President Makoto Kigawa was willing to give his time if a planned interview seemed to benefit the company. In the absence of pressure from senior management to show public relations performance in measurable terms, counting interviews and media exposures was not necessary. Whether public relations staff members were successful in keeping employee motivations high was something that Yamato's senior managers were capable of sensing on their own and translating to the evaluation of its public relations activities. This may be one of the factors that made its public relations activities successful despite lack of solid planning and measurement. Despite their success with this campaign, Yamato's public relations manager acknowledged that Yamato needed to think about what and how they may measure in the future (A. Katagiri, personal communication, June 28, 2013).

As to the evaluation of the earthquake relief efforts, the only metrics available were the prior estimation of the number of packages to be delivered during the campaign and the number of packages actually delivered. When the Y10 (about 12 cents US) donation program was first announced on April 11, 2011, the company was expecting to carry about 1.3 billion packages in that fiscal year, down 4% from the previous year because of the negative impact of the earthquake. When the program ended on March 31, 2012, the number of packages delivered in the year was actually 1.42 billion, up 9% from the forecast a year earlier.

Yamato was concerned about the reaction of its shareholders because the donated amount was expected to be almost 40% of the company's annual net income. Shareholders might demand an increase in dividends instead of funding donations. When Yamato President Kigawa made an investor relations tour in the United States in the summer of 2011, he was ready to be blamed by some of the shareholders for spending that much money on donations to earthquake relief. As it turned out, no one blamed him for making the donation. The CEO of a global giant corporation that is a Yamato shareholder said to him in the meeting, "Mr. Kigawa, you are crazy," and approached him to shake his hand.

Employees seemed content, too. Although no research had been conducted, the public relations department felt, through their interaction with various sections of the company, that employees' motivation was higher because of the program. President Kigawa also told the public relations staff that he felt the same way. The company received many letters from family members of its employees, stating that upon learning of the donation program, they were happy to be the family members of ones who worked for a company that contributes to the society in such a way.

REFERENCES

Ogura, M. (1999). *Ogura Masao: Keieigaku* [Masao Ogura: Management]. Tokyo: Nikkei BP.

Sagawa Express. (2011, April 19). *Sagawa Kyubin eigyo ten shinsetsu no oshirase: Abiko ten Chiba ken* [Sagawa Express announcement of a new branch: Abiko branch in Chiba prefecture]. Retrieved from http://www2.sagawa-exp.co.jp/newsrelease/detail/2011/0419_615.html

Yamato Holdings. (2012), *Higashi nihon daishinsai no kiroku* [Records of the Great East Japan Earthquake]. Tokyo: Author.

Yamato Holdings. (2011, January 28). *Yamato group choki keiei keikaku "DAN-TOTSU 2019" oyobi chuki keiei keikaku "DAN-TOTSU 3 ka nen keikaku HOP" nit suite* [On Yamato Group long-term management plan "DAN-TOTSU 2019" and mid-term management plan "DAN-TOTSU 3 years plan HOP"]. Retrieved from http://www.yamato-hd.co.jp/news/h22/h22_48_01news.html

Yamato Holdings. (2011, April 11). *Every package we deliver will also carry hope*. Retrieved from http://www.yamato-hd.co.jp/english/information/info/contribution_1104_03_en.html

Yamato Holdings. (2011, April 28). *Yuka shoken hokoku sho 146 ki* [Annual securities report 146th term]. Retrieved from http://www.yamato-hd.co.jp/investors/library/securities/pdf/y146_04.pdf

Yamato Holdings. (2011, September 22). *Annual report 2011*. Retrieved from http://www.yamato-hd.co.jp/investors/library/annualreport/pdf/2011/j_ar2011_00.pdf

Yamato Holdings. (2013, January 8). *English translation of the advertisement*. Retrieved from http://www.yamato-hd.co.jp/information/info/adnp130108.pdf

AUTHOR'S NOTE

The program won several awards, including the Corporate Public Relations Award Grand Prize from the Japan Institute for Social and Economic Affairs, the Nikkei Advertising Award Highest Award from Nihon Keizai Shimbun, the Corporate Philanthropy Award Grand Prize from the Japan Philanthropic Association, and CANPAN CSR Award Grand Prix from the Japan Foundation.

Part VI:
Case Studies in Addressing
National Issues and Opportunities

Addressing Ethnic Tensions: Registering Stateless Malaysian Indians

KIRANJIT KAUR
Universiti Teknologi MARA

EDITORS' NOTE

Societies and communities around the world managing ethnic tensions within their populations can find valuable insights in this case study of how public relations principles were applied in registering stateless Malaysian Indians. Although such situations vary greatly, government-civil society partnerships and willingness to employ "on-the-ground" direct communication strategies are potential elements of success in many cases.

BACKGROUND

Malaysian Indians: History and Problems

Indian migration to Malaya in the late nineteenth century was an important feature of the expanding world economy, British imperialism in Asia, and the global demand for commodities for the Industrial Revolution. Britain's economic policies in India impoverished Indians, and their subsequent landlessness and poverty, especially in the agricultural areas in the Madras Presidency, facilitated

Indian migration to Malaya. The British also established a migration machinery to facilitate and finance poor Indians' migration, and this corresponded with the development of indentured and contract labor schemes for Indians' employment in Malaya (Kaur, 2012). The Indians were regarded as sojourners and repatriated when the price of rubber fell (Kaur, 2000).

After achieving independence in 1957, the Malaysian national government's new immigration legislation, development policies, and affirmative action agenda further discriminated against low-skilled Indian workers employed on rubber plantations or in public services. Those who lacked legal documentation were expelled from the country despite having worked and lived in Malaysia for generations. The government's 1969 New Economic Policy as well as land development and infrastructure schemes after the 1970s also displaced former plantation workers who became one of the most marginalized communities in Malaysia. Thus the Indian poor had few avenues for redress (Kaur, 2004).

Displacement of Indian plantation and working-class groups, the rising number of stateless Indians, state-sponsored demolition of Hindu temples, and the denial of educational and employment opportunities subsequently led to the emergence of Hindraf (Hindu Rights Action Force), a coalition of several Indian NGOs in 2007. Hindraf filed a class action lawsuit against the United Kingdom (seeking reparations for the Indians brought to Malaya during the colonial period) that met with what was widely viewed as excessive force by the state and suppression of mass rallies. The Hindraf demonstrations of late 2007 and the subsequent detention of much of its leadership, coupled with the reduced majority of the ruling party in the Malaysian election of March 8, 2008, had focused both Malaysian and international attention on the role and sociopolitical profile of the Indian community in Malaysia (Kaur, 2009). An important outcome was the government's effort to deal with statelessness by registering stateless Indians in an attempt to regain the confidence of the 1,907,827 Malaysian Indians (2010 census) in Malaysia.

Special Implementation Taskforce on the Indian Community (SITF)

A Special Implementation Taskforce on the Indian Community (SITF) under the Cabinet Committee on the Indian Community in the Malaysian Prime Minister's Department was established in June 2010 to monitor and strengthen delivery and implementation of public sector services and programs for the often-destitute Indians. Its primary task was to resolve the problem of lack of identification documentations and the resulting dissatisfaction among those in the Indian community who felt they were being denied their basic human rights. Protests by

Indian activists, including Hindraf, had highlighted several issues affecting the plight of undocumented Malaysian Indians through alternative and social media, and pushed for the government to intervene and to use a more concerted proactive approach to resolve this documentation problem.

The prime minister appointed Datuk Seri Dr. S. Subramaniam, Human Resources Minister and deputy president of the Malaysian Indian Congress (MIC), as chair of the taskforce, and Tan Sri Gnanalingam, a prominent Indian businessman, as co-chair. In addition, the government appointed a consultant, Datuk N. Sivasubramaniam,[1] as SITF chief coordinator to work closely with the Prime Minister's office, MIC leadership, Indian nongovernmental organizations (NGOs), and other relevant government agencies to resolve these issues.

The MyDaftar Campaign

This case examines how the Malaysian government, through the dedicated taskforce SITF, strategized to resolve the problem of statelessness of members of the Malaysian Indian community. To do so, SITF organized a comprehensive eight-day *MyDaftar* (My Registration) campaign in nine Malaysian states February 19–26, 2011. The campaign was conducted in partnership with the National Registration Department in the Ministry of Home Affairs. SITF was assisted by volunteers primarily from the MIC and Indian NGOs, including Hindu temples, the Indian Women Caucus (a loose coalition of Indian women's groups), and Hindu Sangam (a religious Hindu NGO). It generated responses from 14,385 Malaysian-born Indians; 9,529 of those Indians were eligible to register, and 6,590 of them completed applications within that year (2011). Others were unable to lodge any application due to a lack of supporting documents (Sivasubramaniam, 2012).

Essentially, the *MyDaftar* campaign involved a series of "meet-the-people" sessions led by SITF and officers from relevant agencies as well as a door-to-door drive by several Indian NGOs. In addition, the taskforce launched an aggressive media campaign through print media, radio, television, and the Internet, and simultaneously sought the support of the government Information Department, which has officers located in all districts throughout Malaysia.

Prior to the campaign launch, SITF had organized a special pilot session on December 11, 2010, at the National Registration Department's offices at Seberang Prai (North), Butterworth, and at Seberang Prai (South), Jawi. At these meetings, the Indian community was invited to submit applications on the spot. SITF officials were present with their teams to assist the applicants.

SITF found this approach of establishing a link between the community and relevant public sector agencies the most effective way to solve the statelessness problem. The pilot sessions illustrated the following:

- The lack of documented evidence was a major problem.
- There was a lack of confidence in the affected community that their applications would be successful.
- There was a fear among Indians of approaching authorities about their undocumented status, especially officials linked with the Ministry of Home Affairs (which controlled citizenship through its National Registration Department).

During the pilot exercise, 42 applications were received, 24 of which sought to secure a birth certificate; eight applications pertained to identification cards (*MyKad*), and 10 were citizenship applications. All were eventually approved.

METHODOLOGY

This case study examines how public relations principles were applied in addressing a problem with a minority ethnic group: registering stateless Malaysian Indians. It examines various strategies used in the campaign to persuade undocumented Malaysian-born Indians, those Indians eligible for citizenship, to register with the National Registration Department. It also identifies and analyzes the preparatory work done to ensure the success of the campaign as well as the challenges faced in the campaign's implementation.

The case study was researched and written using a number of qualitative research methodologies. They included a review of government and NGO reports as well as media coverage of the campaign by both mainstream media and online news portals. The secondary research was supplemented by primary research through interviews with the campaign project manager M. Thanasegaran and opposition political activist S. Arutchelvan.

SITUATION ANALYSIS

Public/government campaigns generally have two purposes: to have an impact on individual behavior or an impact on policy. This case focuses on changing individuals' behavior by creating awareness of the need for proper citizenship

documentation. Behavioral change research incorporates social science theory into both campaign design and evaluation. Research shows that mere dissemination of information may increase knowledge or awareness about the need to change or adopt a particular behavior, but in itself, it typically does not change behavior (Coffman, 2003).

Initially, a nationwide government study called *Program Mesra Rakyat* (or "people-friendly program") identified key problems facing the Malaysian Indian community. One of the most complicated problems faced by a small section of Malaysian-born Indians was the lack of documents that certified their Malaysian citizenship. Without citizenship, the illiterate Malaysian-born Indians were trapped in poverty with no documents, largely because of their ignorance of the necessity and process to acquire them.

Several factors contributed to the problem of lack of Malaysian Indians' documentation:

- Lack of a birth certificate: While the colonial British had a system to record all births on their estates, this procedure was generally not adhered to as rigorously on the estates after the British departure from Malaysia.
- The historical displacement of Malaysian Indians from plantations led to their inability to trace the original documents or identify members of the older generation who could act as witnesses, especially in cases of home births. Because the plantations were defunct, it was difficult for the affected individuals to acquire and provide the required documents.
- Marriages were not registered under civil law (the Indians had only had temple ceremonies without legal registration), and this affected the legal status of their children.
- Births of children to unmarried mothers were kept secret and the children were thus not registered.
- Children were adopted or put in foster care without legal documents and had no access to their biological parents; some had no access to records of their dead parents.

Several factors affected the ability of Malaysian Indians to register for the mandatory *MyKad* Identification Card.

- Many of the Malaysian Indians did not have a birth certificate.
- Some could not prove the authenticity of their birth certificates as they only had a copy of their birth certificate and not the original.

- Penalties that had been imposed for late registration of births and/or the *MyKad* created problems because some Indians could not afford the fines or provide the necessary additional evidence required in such cases.
- Indians feared they would be arrested if they approached authorities. They also were unable to communicate due to lack of language proficiency, and many lacked the reading and writing skills to complete the application forms.

Problems with citizenship also had an impact.

- Individuals born in Malaysia before 1957 (Malaysia's Independence) as-sumed they would become citizens automatically and did not apply for citizenship by registration under Article 16 of the Federal Constitution. Children born after 1957 to these individuals were therefore also affected and not registered as citizens.
- Foreign spouses from India married to locals who possessed only red iden-tity cards (given to noncitizen residents who were not eligible for several privileges) had yet to be given citizenship. In some cases, these parents also failed to register their children as citizens.
- Illiteracy and lack of language proficiency deterred some from completing the citizenship application process through written and oral interviews.
- Some failed to clear vetting by the police because of past criminal records.

Additional factors:

- Indians, generally poor and uneducated, saw the expense, time, and bureau-cracy involved in acquiring the required documentary evidence as insur-mountable hurdles and thus did not pursue correcting their stateless con-dition.
- Others did not follow up their applications with required additional sup-porting documentation.
- A number did not have permanent addresses at which they could receive any correspondence from the National Registration Department after they had made their applications.
- Some government officials were apathetic and did not undertake measures to assist the individuals to obtain the necessary evidence or documents such as birth registration records, which are kept in NRD computer sys-tems (SITF 2011 report, various news clippings, and personal communi-cation with SITF *MyDaftar* program manager M. Thanasegaran, 2013). During the earlier nationwide state program *Mesra Rakyat*, a total of 658

applications were received within the Indian community. Of these, 40% were citizenship requests, 27% dealt with late birth registration concerns, and 22.6% were to resolve problems in securing identification cards. The remaining 10.2% had other issues including those pertaining to marriage registration. The authorities only managed to solve 7.6% or 50 cases as of November 17, 2010.

Why did documentation matter? An undocumented Malaysian, one without a birth certificate and/or citizenship, has little or no access to schools or health care and is marginalized by government enforcement agencies and corporate institutions. Possession of an identification card indicating citizenship provides access to education, employment, political rights, and full membership in Malaysian society. The lack of proper documentation thus becomes an obstacle to upward social mobility as well as being an affront to human dignity.

Activists also have suggested a link between statelessness, poverty, and an increased crime rate in this sector of the Indian community being denied or having only restricted access to inclusion in the mainstream society.

CORE PROBLEM

Due to rapid development, former large plantation holdings declined in number with the result that plantation workers were displaced and forced to become urban or semi-urban squatters. (Fifty-four percent of Malaysian Indians have worked as plantation or urban underpaid laborers [Asiaweek, 2002, cited in http://malaysianindiantoday.wordpress.com/malaysian-indians-plight-a-fact-file].) Their squatter colonies were in turn often demolished to make way for development with little or no alternative housing, leading to further conditions of poverty for the poor and illiterate Malaysian-born Indians.

These conditions led to rising dissatisfaction in the Indian community, especially among activists. Hindraf leader Uthayakumar accused the Malaysian Indian Congress (MIC), the Indian party in the National Coalition and the ruling government, of not fulfilling their 2008 election promises made to the Indian community.

A major problem was the lack of awareness among the poorer sections of the Indian community of the importance of securing the necessary citizenship documents that would allow them to exercise their citizenship rights and responsibilities.

A second problem was their inability to fill out the forms correctly with complete, documented evidence. Thus, a majority of Indians seeking citizenship left the department without making a submission and did not return with the supporting documents.

Without a birth certificate, individuals could neither apply for the *MyKad* document at age 12 as required by law, nor could they register marriages officially or claim children as Malaysian citizens. As a result, the children could not attend public schools or get formal employment when they reached adulthood. Nor were they eligible for subsidized health care, thus creating a vicious cycle of poverty.

GOAL

SITF had two broad goals. The first goal was to examine the relevant policies and ensure adequate access, opportunities, and resources for the registration campaign. The second was to identify problems and implement programs at the grassroots level with the relevant public agencies to assist Malaysian-born Indians eligible for citizenship to submit applications. More specifically, SITF was tasked to identify and assist in resolving the lack of citizenship documentation as well as assisting with other programs.

The goal of the *MyDaftar* campaign was consistent with the federal government's goal of resolving this old grievance among a sizable section of the Indian community. The campaign sought to find a permanent solution for all stateless Malaysian-born Indians who had been unable to secure the required identification documents and thus remained ineligible for citizenship.

OBJECTIVE

The objective of the *MyDaftar* campaign was to assist with documenting as many Indians as possible from an estimated 100,000 Malaysian Indians who did not possess the relevant documents pertaining to their birth, identification, and citizenship.

SITF and its partners used a hands-on approach to assist these individuals to complete the relevant forms and secure the supporting information and details on their origin and birth. Sometimes the officials had to personally drive or accompany individuals to another town to gather information from their place of birth. Alternatively, officials sought assistance from their colleagues who had to

physically go to a clinic or hospital to search for the records (MyDaftar Campaign Begins Today, 2012).

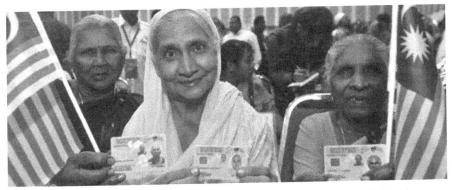

Figure 15.1. Indian registrants express enthusiasm in celebrating their official Malaysian certification.

KEY PUBLICS

The *MyDaftar* campaign sought to identify and assist:

- Individuals who possessed a birth certificate but had not applied for a *MyKad*
- Individuals who did not possess a birth certificate and therefore were unable to secure a *MyKad*
- Children who did not possess a birth certificate and were therefore unable to go to school
- Children and young people in residential homes run by the Social Welfare Department and voluntary organizations who did not possess sufficient documentation
- Individuals above 55 years of age who were born in then-Malaya and who still possessed only a red identification card
- Individuals who had applied for citizenship and were still waiting for a decision

The campaign involved several stakeholders in achieving desired outcomes. These included:

- The Ministry of Home Affairs
- The National Registration Department (NRD) state directors and officials
- Police
- Information department officials

- The Malaysian Indian Congress or MIC, including its local Indian community leaders and members.
- Indian political leaders and members of all other political parties
- Community leaders from religious, civil, and social voluntary organizations, including Hindu Sangam, the Tamil Language Foundation, and temples
- Community volunteers, especially Tamil speaking individuals
- The media, especially the Tamil press: Tamil language newspapers *Malaysia Nanban*, *Tamil Nesan*, and *Makkal Osai*; Tamil radio stations *TH R*and *Minnal;* and Radio-Television Malaysia (RTM), the Malaysian government media organization
- "Stateless" Malaysian Indian residents and their families

STRATEGIES

SITF, entrusted to resolve the problem of the undocumented Indians, developed a three-pronged focus:

- Consolidate policy formulation and advocacy
- Achieve community intervention and delivery
- Generate stakeholder partnerships and engagement

SITF developed several specific strategies to resolve the Malaysian Indian problem.

Strategy 1: Identify Affected Individuals and Disseminate Information on the *MyDaftar* Campaign

SITF began by identifying Malaysian Indian individuals and families who were stateless or undocumented. Political and civil society leaders and volunteers, such as the Malaysian Indian Congress and Indian NGOs, were mobilized to reach out to the dispersed rural and/or marginalized Indian community in the selected nine states to identify those with documentation problems and arrange for them to travel to the registration centers.

In addition, the special task force leveraged the support of the Malaysian government's Information Department, which has information officials placed in every district in the country, to disseminate information about the registration exercise to the Indian communities in their respective districts.

The SITF team also ran an aggressive media campaign through print media, radio, television, and the Internet in English, Malay, and Tamil languages to create

general awareness of the registration exercise and to provide details on where, when, and how to register.

The Tamil press ran stories of successful applicants, which in turn boosted the confidence of hesitant applicants to seek assistance with their registration process. For example, *Tamil Nesan* ran the story on "2,000 Indians to Get Malaysian Citizenship" (2012).

SITF placed two advertisements per week for four weeks in each of three popular Tamil newspapers in the two weeks leading up to the campaign and the two weeks of the campaign. The media partners also provided additional publicity through announcements and interviews with SITF campaign coordinators in Tamil, Malay, and English newspapers and on radio and television, especially during Tamil-language programs.

Strategy 2: Provide Assistance in Completing Forms

SITF worked with volunteers to train them to personally assist the applicants to complete the forms and to help them secure the basic supporting documentation. As part of the *MyDaftar* campaign the SITF officers held a series of "meet-the-people" sessions in addition to their door-to-door drive. They were aided by local Indian political leaders, party members, and Indian NGOs.

SITF also invited the NRD officers to train, explain, and provide hands-on assistance to affected individuals and volunteers on how to complete the forms. Sessions were initially held in six districts. The community leaders in turn hosted a series of briefing and planning meetings in 30 venues at the state and district levels to prepare the volunteers to go to the NRD counters during the campaign with the completed forms and supporting documentation.

Strategy 3: Setting Up Dedicated Counters by the National Registration Department

During the campaign, February 19–26, 2011, the National Registration Department office (NRD) set up dedicated counters in 80 offices in 30 towns in the nine states of Kedah, Penang, Perak, Selangor, Kuala Lumpur Federal Territory, Pahang, Negeri Sembilan, Melaka, and Johor to process applicants from the Indian community. NRD documented the applications of all individuals who came forward, even those who did not have the necessary supporting documents to ascertain the extent of the problem. Each case was provided with a reference number to enable the department to monitor the process and provide periodic updates to

the national campaign coordinating committee at Putrajaya[2] chaired by the Home Affairs Deputy Secretary General.

NRD also provided a public status report on the cases received during the campaign period within two weeks after the campaign ended. In addition, officials agreed to process all applications within nine months with periodic reviews every three months. They provided a first progress report in May 2011, a subsequent report in August 2011, and a final report in November 2011.

SITF also set up *MyDaftar* centers in the nine campaign states to liaise between the applicants and NRD, and to resolve any problems in the application process. They provided continuous services to the affected communities.

Strategy 4: Prevent Abuse and Exploitation During the Campaign

The Ministry of Home Affairs issued stern warnings that no money was to be collected by anyone assisting applicants in the process of securing documentation. Home Affairs warned it would investigate complaints and take necessary action against individuals who abused the free service provided by the federal government (*Documentation of Indian Malaysians*, 2011. This action was necessary because there were individuals purporting to be agents who made false promises to deliver for a fee but were in fact exploiting the vulnerability of the applicants.

Strategy 5: Specified Follow-Up Measures

The taskforce set a six-month timeframe to ensure that follow-up strategies were effectively resolved. A number of the cases were especially complicated because the applicants were unable to secure the required supporting documents. SITF worked with its partners to assist the applicants in securing those required documents. For example, it sought proof of the status of the applicant from schools attended even if in a different state, from a village leader or from the midwife who had performed the home delivery (Arutchelvan, personal communication, July 19, 2013). SITF officials also occasionally meet the Bukit Aman police department (police headquarters) to expedite the criminal record vetting process for the *MyDaftar* citizenship applicants.

TACTICS

The *MyDaftar* campaign achieved many of its objectives because of the on-the-ground tactics used to support the strategies. These included the following:

Grassroots Door-to-Door Visits

SITF used local runners[3] from among its volunteers and local community leaders to visit the home of every applicant to offer advice about the evidence required with each submission.

Training to Fill in the Forms

Some of the partners even facilitated a special training program at the Registration Department on the campaign date to ease the submission process. For example, an MIC local leader attended a training session on how to fill out the form at the NRD office in Petaling Jaya city. He met the officer-in-charge to gather all the necessary forms. He also sought the assistance of volunteers to fill out the forms. In addition, he organized a gathering at the community hall and invited an NRD officer to attend and review the applications being prepared for submission. This process saved time and ensured that submissions were complete or near completion. Major complications or difficulties were avoided; where necessary, assistance such as verification of the residency status of the applicant was provided by a local leader (Local community response to MyDaftar campaign, 2011).

Transport Arrangements to the NRD Counters

A number of the applicants did not have the means to pay for the transportation to and/or knowledge of how to get to an NRD office. So MIC and the other volunteer organizations arranged transportation (cars or buses) for the applicants to reach the NRD counters. In addition, a commissioner of oaths[4] was recruited in some areas to certify documents of applicants to ease submissions.

Arrangement for an Integrated Setup at the Registration Site

Photostat machines were specially rented and photography services were hired in some NRD offices for the benefit of the applicants. The NRD officials arranged for a photographer, a commissioner of oaths, and their counselors to be at registration sites. Registration was carried out at both mobile temporary offices and at the regular NRD offices with designated counters for the Indian cases. During the campaign, the NRD officers worked over the weekends as necessary (Undocumented Malaysian Indians, 2010).

Inclusion of All Parties: Ruling Political Parties, Opposition Political Parties, and NGOs

Although this was a state-run program in partnership with Indian NGOs, leaders from opposing Indian political parties such as Keadilan assisted in communicating with the affected Indian communities as well by helping them with their applications (Arutchelvan, personal communication, July 19, 2013).

CALENDAR

The campaign sequence was as follows:

Date	Event
June 2010	SITF was established
October 18, 2010	Roundtable discussion with policymakers and NRD
December 2010	*Program Mesra Rakyat* or People friendly Program
June 2010–January 2011	Identify problem cases
February 19–26, 2011	*MyDaftar* campaign
February 28–March 4, 2011	Campaign period is extended
Post *MyDaftar* campaign, until end 2011	Periodic review of applications every three months
2013	*MyDaftar* national campaign for all individuals of all races (including the indigenous groups such as the Orang Asli)

BUDGET

The *MyDaftar* campaign was run on an allocated budget of less than 200,000 Ringgit Malaysia (RM) or US$63,000 (1USD = 3.3RM). Although this was a seemingly small budget, the campaign also received substantial voluntary assistance and pro bono financial support from temples, Indian NGOs, and Indian political parties at both the state and local levels. Expenses incurred by the NRD, the Federal Information Department, and other government agencies and authorities were borne by those entities.

The Tamil and national press also supported SITF by providing details about the campaign including the venues, dates, and times of registration opportunities. This was in addition to the paid advertisements placed in two Tamil newspapers

during the two-week campaign period, which cost about 40,000 Ringgit Malaysia (US$12,122) (Thanasegaran, personal communication, September 11, 2013).

EVALUATION AND MEASUREMENT OF RESULTS

On the first day of the *MyDaftar* campaign, 3,418 people filed their cases or made related enquiries. National Registration Department officers in 80 centers across the nine states were involved during the campaign, including over weekends. A large number of volunteers from a variety of organizations also participated in the campaign (Mass Movement of Indians, 2011).

A total of 14,882 applications were received during the eight-day *MyDaftar* registration campaign in the nine states from February 19–26, 2011. This included 3,546 applications for birth certificates, 2,569 for identification cards, 7,486 for citizenship, and 1,281 other citizenship-related applications. There was a successful resolution of 6,590 cases from the 9,529 valid applications within the year, with 4,023 of them being for citizenship (Sivasubramaniam, 2012).

The successful applicants included those with red identity cards, including foreigners who had married Malaysian citizens or those who resided in Malaysia and who had submitted their applications during the campaign (*2,000 Indians to Get Malaysian Citizenship*, 2012).

Due to the overwhelming response, SITF in consultation with the Ministry of Home Affairs and the National Registration Department extended the *MyDaftar* campaign period for an additional week, from February 28 to March 4, 2011. The SITF *MyDaftar* special unit set a six-month timeframe to continue to monitor and assist in the follow-up after the campaign dates to ensure successful resolution of the pending cases (Initial Findings, 2011).

This approach was viewed as a good outreach model for the affected segment of a population: a campaign in which government agencies worked with local community leaders, NGOs, and volunteers for an outcome aimed at resolving a long-standing grievance. It was especially helpful in overcoming language and cultural differences of the Indian community with the primarily Malay staff of the NRD.

Deputy Secretary General of the Home Ministry Dato' Raja Azahar Raja Abdul Manap admitted that while the *MyDaftar* campaign brought to public notice the complexity of the documentation problem, there was still more work to be done to ensure that applicants fulfilled all the basic requirements and that they secured and filed supporting documents. He pledged that the government would review such applications on a case-by-case basis (*Special Implementation Taskforce on Indian Community, PM Department*, 2010).

Generally, there was a positive change in the attitude of the Malaysian Indian community as it evolved from apathy to engagement in achieving citizenship.

CONCLUSION

MyDaftar was a successful program carried out by the Malaysian government in partnership with the National Registration Department in mitigating the problem of stateless Indians in Malaysia. As a result of the success of the campaign, a second phase of the *MyDaftar* campaign was conducted nationwide from February 19 to March 4, 2013. This campaign was expanded to register residents of all Malaysian communities without proper citizenship documentation.

The SITF consultant coordinator Sivasubramaniam was invited to present a paper on the *MyDaftar* campaign and its success at a workshop on civil and birth registration organized by the United Nations High Commissioner for Refugees (UNHCR) and ASEAN Intergovernmental Commission on Human Rights (AICHR) in Bangkok on December 10, 2012. In addition, the *MyDaftar* campaign received special recognition from the United Nations in early 2013 as a government effort providing proper citizenship documentation to undocumented Malaysian Indians (Sivasubramaniam, 2012).

NOTES

1. MIC) is the largest Indian political party and is a component party of the ruling National Front (Barisan Nasional) in Malaysia.
2. Putrajaya is the administrative capital of Malaysia situated just outside Kuala Lumpur, which is the business capital of the country.
3. "Runners" in this context refer to agents who assisted the campaign organizers in reaching out to the affected individuals or homes voluntarily and without a fee.
4. A commissioner of oaths is an individual licensed to administer oaths and attest to signatures to minimize fraud in legal documents.

REFERENCES

Campaign to resolve Indians' MyKad woes. (2010, December 30). Bernama Online.

Coffman, J. (2003, June). *Lessons in evaluating communications campaigns: Five case studies.* Cambridge, MA: Harvard Family Research Project.

Documentation of Indian Malaysians: The way forward. (2011). Report on the findings of the Special Implementation Task Force on the Indian Community, Prime Minister's Department. SITF, Prime Minister's Department: Unpublished document. Retrieved from http://taskforceindiancommunity.blogspot.com

Initial Findings of MyDaftar campaign. (2011, March 1). Retrieved from http://taskforceindiancommunity.blogspot.com/search?updated-min=2011-01-01T00:00:00-08:00&updated-max=2012-01-01T00:00:00-08:00&max-results=41

Kaur, A. (2000). Sojourners and settlers: South Indians and communal identity in Malaysia. In C. Bates (Ed.), *Community, empire and migration: South Asians in diaspora* (pp. 185–205). Basingstoke: Macmillan.

Kaur A. (2004). *Wage labour in Southeast Asia since 1840: Globalisation, the international division of labour and labour transformations.* Basingstoke: Palgrave Macmillan.

Kaur, A. (2009). Labour crossings in Southeast Asia: Linking historical and contemporary labour migration. *New Zealand Journal of Asian Studies, 11*(1), 276–303.

Kaur, A. (2012). Labour brokers in migration: Understanding historical and contemporary transnational migration regimes in Malaya/Malaysia. *International Review of Social History, 57,* 225–252.

Local community response to MyDaftar campaign. (2011, February 22). Retrieved from http://taskforceindiancommunity.blogspot.com/2011_02_01_archive.html.

Long wait but finally successful. (2011, December 11). Retrieved from wait-but-finally-successful.html

Mass movement of Indians—not for protest but problem solving. (2011, February 19). Retrieved from http://taskforceindiancommunity.blogspot.com/2011_02_01_archive.html

MyDaftar campaign begins today Feb 19 (Sat) till Feb 26 (Sat). (2011, February 18). Retrieved from http://taskforceindiancommunity.blogspot.com/2011_02_01_archive.html

Sivasubramaniam D. N. (2012). *The efforts made by SITF to address the problem among Indian community.* SITF, Prime Minister's Department: Unpublished document.

Special Implementation Taskforce on Indian Community, PM Department. (2010, December 29). Unpublished document.

2,000 Indians to get Malaysian citizenship. (2012, August 14, 2012). Retrieved from http://www.thestar.com.my/story.aspx?file=percent2f2012percent2f8percent2f14percent2fnation percent2f11850921

Undocumented Malaysian Indians. (2010, November 1). Retrieved from taskforceindiancommunity.blogspot.com/.../undocumented-malaysian-indians

United Nations recognises MyDaftar campaign. (2013, February 14). Retrieved from http://www.kualalumpurpost.net/united-nations-recognises-mydaftar-campaign

Working visit by YM Dato' Raja Azahar, Deputy Secretary General Ministry of Home Affairs to PJ JPN Office. (2011, February 24). Retrieved from taskforceindiancommunity.blogspot.com/.../working-visit-by-ym-dato-raja

Let's Clean Slovenia in 'One Day'!

DEJAN VERČIČ

University of Ljubljana

EDITORS' NOTE

The power of a mobilized community is clearly demonstrated in this case study when a well-executed public relations campaign takes shape. This case also speaks to the careful attention that was placed on research and analysis by conceptualizing a campaign designed to hit the right "sensible chords" of Slovenians. This case also demonstrates that building bridges and listening to the needs of a community can be a powerful strategy provided that implementation translates to concrete actions. We also were impressed with the simplicity of the main message and the clear call to action. Public relations at its best!

Let's Clean Slovenia in One Day! is a civic initiative that on April 17, 2010, motivated 270,000 volunteers (13% of the Slovenian population) to join in and remove 60.000 m³, or 12,000 tons, of waste from 7,000 landfills. Together, activists and communicators developed and executed a large multidimensional communication campaign that engaged practically the whole country, from government ministers and military personnel to academics, municipalities, and ordinary people. At the end of the campaign, 99% of the national population knew about the project, and 97% declared they were prepared to do it again. And they did it again in 2012.

In July 2009, Slovene environmental activist Nara Petrovič attended a conference in Finland where he learned about a project called *Let's Do It!* which in 2008 mobilized 4% of Estonians to participate in a national cleanup of their country. Returning home, he sent a link to video on YouTube to several colleagues with a challenge, asking them if they dared to do something similar in Slovenia. One of the recipients was Aleš Prevc, publisher of a website magazine who decided to invite some friends and his readers to a meeting. This took place in early September 2009 and was attended by 16 people. Two of them were young geography graduates interested in waste management who in spring 2009 initiated the Ecologists Without Borders Association. Participants in the first meeting decided to accept the challenge and several days later there was another meeting with 26 participants. By using social tools for self-organization such as Open Space and World Café, organizers soon established five workgroups: name and graphic design, mapping of illegal dumpsites, communication, organization, and finances. In six months they staged the biggest ever civic campaign in Slovenia that attracted 270,000 volunteers or 13% of the national population to engage and participate in the *Let's Clean Slovenia in One Day!* campaign.

BACKGROUND

Slovenia is a small country in Central Europe, between Austria, Croatia, Hungary, and Italy. It is at the intersection of three climates (Alpine, Mediterranean, and Pannonian) and three major cultural and linguistic groupings (Germanic, Latin, and Slavic). Its two million people (about the same population as the Seattle metropolitan area) living on 7,827 square miles (a bit larger than the state of New Jersey) were part of many different political or state formations prior to independence: the Roman Empire (later the Holy Roman Empire), the Habsburg (Austro-Hungarian) Empire, the Kingdom of Yugoslavia, and socialist Yugoslavia aligned with the former Soviet empire. In June 1991, Slovenia gained its independence as part of a larger movement that followed the fall of the Soviet regime. In April 2004, Slovenia joined NATO; in May 2004, the country joined the European Union; in January 2007 it joined the Eurozone, and in May 2010 Slovenia was recognized as part of the OECD (a global association of developed countries). A number of activities typically associated with public relations can be found throughout the history of Slovenia, and since the 1990s, Slovenian public relations has matured as a profession and became one of the most documented practices in the world (see Grunig, Grunig, & Verčič 2004; Podnar & Verčič, 2011; Verčič, 1999; Verčič, 2002;

Verčič, 2004; Verčič, 2009; Verčič, 2011; Verčič, Grunig, & Grunig, 1996; Zavrl & Verčič, 1995).

METHODOLOGY

This case study was researched and written using several qualitative research methodologies, among them participatory action research (the author of this case was personally involved in crafting the communication strategy of the campaign), a review of materials submitted in support of the 2010 Golden *Effie* Slovenia Award and the 2010 *Prizma* Award for communication excellence by the Public Relations Society of Slovenia, and the final report of the campaign written by the organizers (Petrovič, 2011). The author also drew on media coverage of the campaign provided by Kliping d.o.o. company. This participatory and secondary research was supplemented by primary research: correspondence with Alja Gogala, who at the time of the campaign managed the project at Pristop d.o.o.

SITUATION ANALYSIS

Illegal dumpsites are common, yet not every municipality in Slovenia will publicly admit they exist. There are reportedly 50,000–60,000 dumpsites in Slovenia, "hosting" more than two million tons of illegally dumped waste. There has been national legislation demanding that municipalities document these sites and take responsibility for cleaning and remedial action. However, by 2009 only one municipality had completed the first task of establishing a register of sites. As government was clearly not doing its job, citizens engaged directly.

In 2008, a group of environmental activists in Estonia organized an environmental cleanup action, *Let's Do It! 2008*. Fifty thousand Estonians participated voluntarily. This success was noted by a small Slovene environmental organization, Ecologists Without Borders, which decided to follow the Estonian example. The first meeting to discuss a Slovene campaign to be executed in 2010 was held September 21, 2009, and was attended by 16 people. Within three weeks, solely through word-of-mouth communication, the group preparing the action grew to 350 activists. Half a year later, at the height of the campaign, there were 1,000 activists managing the campaign in which 270,000 volunteers participated (13% of the Slovenian population).

CORE OPPORTUNITY

Slovenia has a long tradition of volunteering that goes back to the eighteenth century. Some have estimated that there are between 280,000 and 350,000 volunteers in Slovenia; the top end of this estimate would mean that 17.5% of the national population is involved in voluntary activities. There are many voluntary organizations in the country: 19,069 societies, 149 foundations, 449 private institutions, 645 church organizations, and 22 nonprofit cooperatives are registered in Slovenia (GHK, n.d.).

It is a well-known characteristic of Slovenia that the population is attached emotionally to the land, the country's mountains, and the sea. Slovenians engage in many outdoor activities that keep them in touch with nature: cycling, jogging, mountain walking, skiing, and swimming. Every year they engage in local cleanup actions trying to preserve their environment and make shared spaces more pleasant in which to live. If one could connect all these energies and produce synergy among cleanup activities, results of the landfill cleanup could be enormous and rewarding.

GOALS

From the experience of the Estonian project *Let's Do It!* and local knowledge, the initiators of the *Let's Clean Slovenia in One Day!* formulated four goals:

- To gather at least 200,000 volunteers on April 17, 2010, for what would be the largest environmental project in Slovenia to date
- To create the first registry and national map showing locations of as many illegal dumpsites as possible
- To remove from the natural environment at least 20,000 tons of illegally dumped waste
- To increase awareness and educate the public, hence improving the attitude toward disposal of waste

OBJECTIVES

The *Let's Clean Slovenia in One Day!* campaign had a formal planning process that resulted in the following program and communication objectives. Program

objectives were deduced from an analysis of the original *Let's Do It! 2008* Estonian campaign.

Program objectives:

- Project objective #1: to make a map of illegal dump sites in Slovenia by registering at least 6,000 of them.
- Project objective #2: from December 2009 to April 2010, to build the first digital map of illegal dump sites in Slovenia by mobilizing at least 1,000 volunteers for Web cartography
- Project objective #3: in one day (April 17, 2010) cleanup action at the estimated 6,000 illegal dumpsites, to remove at least 10,000 tons of waste
- Project objective #4: for the action day, April 17, 2010, to mobilize at least 200,000 volunteers
- Project objective #5: to provide financial and material infrastructure for the campaign with a total value of 700,000 euros

In December 2009, Pristop, the largest communication/public relations company in Slovenia, entered the project as a pro bono provider of communication services, and one of the first services to be activated was work on a communication strategy. This strategy set the following communication objectives to support the campaign objectives:

- Communication objective #1: to make at least 80% of the total national population aware of the campaign
- Communication objective #2: publicity: to obtain more than 200 media placements in the 10 weeks from February to April 2010. This target was calculated on the basis of average planned publicity campaigns and their average successes (To put this in perspective: there were 563 media reports on the Slovene national basketball team at the time of the world basketball championship in 2010.)
- Communication objective #3: to position *Let's Clean Slovenia in One Day!* as the largest volunteer event in Slovenia. Until then, the largest voluntary project in Slovenia was a 2010 cultural event *Škofja Loka Passion Play* (http://en.wikipedia.org/wiki/%C5%A0kofja_Loka_Passion_Play) that engaged 800 amateur/voluntary actors and attracted 24,000 viewers/participants.
- Communication objective #4: to nurture a benevolent climate for the campaign with at least 90% of media reports neutral or positive, mobilizing volunteers and attracting honorary sponsors

KEY PUBLICS

Pristop's communication strategy targeted six key publics:

- Internal publics (organizers and volunteers)
- The wider Slovenian population (potential volunteers)
- Potential partners
- Potential honorary patrons and ambassadors
- Potential sponsors
- Media

KEY MESSAGES

There was a hierarchy of key messages. The primary communication message was *Let's Clean Slovenia in One Day!* Supporting communication messages were:

- The *Let's Clean Slovenia in One Day!* project is an opportunity for Slovenia to clean 20,000 tons of household waste in one day.
- There are 50,000–60,000 illegal dumpsites in Slovenia, containing 400,000 tons of illegal waste (200 kg per each Slovenian citizen).
- Illegal dumpsites have negative influence on the environment and the quality of life (climate change, drinking water, local natural environment, and animals).
- The project will unite 200,000 volunteers.
- The largest mapping of illegal dumpsites in Slovenia will support the project.
- Many celebrities and dignitaries will support the project.

Messages had both a functional (rational) component (We need to clean up our local environment if we want to preserve a liveable and aesthetically pleasant natural environment.) and communitarian (emotional) component (Join your friends, colleagues, and neighbors to do something valuable together.).

STRATEGIES

The Slovenian *Let's Clean Slovenia in One Day!* campaign introduced an important innovation compared to the original Estonian *Let's Do It!* campaign: By recognizing that cleaning up illegal dumpsites may be too difficult for many people, the

Slovenian campaign offered and organized other valuable alternatives: cleaning litter from streets, walking tracks in schools, and residential areas; and cleaning up waste in mountains and on the banks of rivers, lakes, and the sea. Divers dragged piles of waste from the bottom of rivers and lakes, while cavers cleaned many of the Karst caves.

Another important strategy of the cleanup effort was the development and evolution of the illegal dumpsites registry. It started with the existing data that were then enriched with citizen reports. The Slovenian Forestry Service joined in by contributing its reports. This was complemented by a search for potential dumpsites on the Internet map Geopedia. The next step consisted of actual visits to the dumpsites and verification of their existence.

Building networks and partnerships was another strategy. The entire organizational structure was built on volunteers, and it grew through personal meetings and the use of Internet-based technologies. Simultaneously, relations with all kind of associations and organizations, including the government ministries and their agencies, grew into an impressive superstructure in which many associations and organizations participated. It is impossible to list all of them here, but among the most significant were the Tourist Association of Slovenia (initiating many local cleanup events and inviting its local associations to participate), the National Fishing Union (inviting all its member associations to engage), the Mountaineering Association of Slovenia, the Slovenian Hunters' Association, the Slovenian Catholic Girl Guides and Boy Scouts Association, the National Scout Association, the Slovenian Firemen Association, the Olympic Committee of Slovenia, the Kayak and Canoe Federation of Slovenia, the Slovenian Diving Federation, the Slovenian Bird Watching Association, the Slovenian Forestry Service, the Institute of the Republic of Slovenia for Natural Conversation, General Police Directorate, the Association of Municipalities of Slovenia, the Ministry of Education and Sports, the Ministry of Defense, the Slovenian Roads Agency, the Red Cross Slovenia, and the Photographic Association of Slovenia. They provided the campaign with its greatest leverage in the community.

By the end of 2009, the campaign gained momentum and another strategy was implemented: to generate public support from influentials. Celebrities and dignitaries publicly supported it. The president of the Republic of Slovenia, Dr. Danilo Türk; the prime minister of Slovenia, Borut Pahor; and the chair of the Slovenian parliament, Dr. Pavel Gantar, became honorary sponsors. The European Commissioner from Slovenia, Dr. Janez Potočnik, stepped in. And on April 17, 2010, the cleanup day, all of them showed up and worked with other volunteers.

A crisis communication plan to deal with negative media coverage and criticism of the project also was prepared in the strategy development process. If

needed, it could have been activated immediately. All media were pro bono monitored and analyzed in real time (including social media) by Kliping, a sister company of Pristop. No responsive crisis actions were needed. The only real criticism came from a group that called itself *I won't participate in Let's clean Slovenia in one day!* and created a Facebook page on which members criticized the organizers of the *Let's Clean Slovenia in One Day!* as being too populist, having a political agenda, and seeking self-promotion and financial benefits. Cleanup organizers ignored the group and it didn't cause any harm to the campaign.

TACTICS

By March 2010, all 210 Slovenian municipalities had organized local volunteers. The campaign had its own corporate identity: its logo was a stylized image of a tree with an open hand as a trunk and branches.

Web

It all began with a video on YouTube showing the original Estonian campaign, *Let's Do It!* Other Web tactics included the following:

- Development of a campaign website (www.ocistimo.si). The website was created in January 2011, and in the final week leading up to the cleanup day it attracted more than 50,000 unique visitors.
- Creation of Facebook and Twitter profiles and video materials on YouTube. A Facebook profile was opened in December 2010 and grew to more than 10,000 members in the first week of its existence.
- Creation of Web banners.

Mobile

SMS messaging was another tactic.

Events

Events held in connection with the cleanup included the following:

- Road shows with lectures, roundtables, and workshops. The eco-tours visited Slovenia's largest 14 towns spread over all of the country's regions,

entertaining and simultaneously educating children with games and cartoons. At the roundtables, there were serious debates on waste management involving stakeholders from local government and the private sector.

- A fashion show. This was a creative way of demonstrating how useful values regarding waste could be used to develop viable products.
- A preliminary cleaning campaign done by the Slovenian Army
- Smaller, local, and pioneer cleaning actions
- A photo exhibition
- Three large rock concerts at the end of the campaign to celebrate its success
- The cleanup day itself, recorded by 15 volunteer video crews

Publicity

Publicity tactics included the following:

- The first news conference was staged on January 12, 2011.
- There was extensive use of honorary patrons and celebrities to generate publicity.
- Background materials were prepared and experts offered to the media to provide them with enough input for story development.
- There was another news conference a day prior to the cleanup day.
- On the cleanup day, April 17, 2011, it was at a news conference at 5 p.m. that organizers announced that the cleanup campaign was a success.

Advertising

Advertising tactics included the following:

- Billboards
- Print ads
- Television and radio spots
- Branded cars
- Projections on bus displays
- Promotional materials such as leaflets

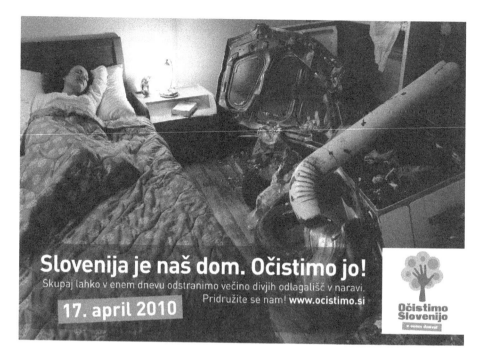

Figure 16. 1. Print advertisement for the campaign.

All of the "formal" tools of the campaign were only part of all communication tools employed by volunteers and partner associations. There was a real multi-step communication process going on during which the formal campaign communication only triggered a broader social conversation regarding the status of human nature, waste management, and communitarian values that brought people together in this endeavor.

CALENDAR/TIMETABLE

The project began in September 2009 and climaxed in the all-Slovenia volunteer action day on April 17, 2010.

The *Let's Clean Slovenia in One Day!* campaign went through seven stages. It all started with an admiration of the original Estonian campaign, *Let's Do It!* Its simplicity, mobilization (4% of the national population took part), and the use of hi-tech "gizmos" enchanted Slovene activists. Intensive debates in a small circle of environmental activists provided for the incubation of the idea to try what Estonia had done.

July 2009: Environmental activist Nara Petrovič attended a conference in Keuruu, Finland, where he first saw information on the Estonian project on cleaning up their country in a day.

August 2009: Aleš Pevc published news on the Estonian cleanup and an invitation to an organizational meeting on his website.

September 2009: The first activist meeting was held on September 2, 2009, attended by 16 people. Conscious work on both internal and external communication was initiated at the very beginning.

October 2009: Communication agencies were asked to join in and help. Pristop was selected as the primary agency. Potential partnering associations and organizations were identified, a PowerPoint presentation was prepared, a leaflet was drafted, and website development started.

November 2009: The budget was calculated and the Slovenian Forestry Service joined as a partner. Municipality level organizers met for the first time, and the first test of mapping was executed.

December 2009: Pristop developed the graphic design and the logotype, and extensive work on communication materials was initiated. A Facebook profile was opened. The first report on the project was broadcast on a national radio station, followed by all reports on/in national and local electronic and print media.

January 2010: The first news conference was organized. The organizers met with representatives of the Ministry of Environment. The president of the Republic of Slovenia, Dr. Danilo Türk; the prime minister of Slovenia, Borut Pahor; and the chair of the Slovenian parliament, Dr. Pavel Gantar, became honorary patrons. The Slovenian Roads Agency joined in as partners, offering trucks. The Ministry of Education also joined, which made communication with schools and kindergartens easier. The Slovenian Army joined as a partner, and ministries of defense and of police confirmed their cooperation.

March 2010: A drawing contest was organized in schools and an open invitation for a photo contest was published. Eco tours around Slovenia started, as well as the advertising campaign. A fashion show was staged and SMS services were used to enable micro donations.

April 2010: The cleanup day was April 17, 2010. The day's events were steered by a group of 15 core organizers and 15 volunteers helping them at the base camp.

May 2010: On May 17, 2010, the final event was held to celebrate the campaign's success, and all partners and members of workgroups were invited to celebrate.

June 2010: On June 15, 2010, the registry of illegal dumpsites in Slovenia was symbolically handed to the Ministry of Environment.

Budget

The initial budget was based on an extrapolation from the Estonia cleanup and the costs of the original campaign there. The original assessment was that 700,000 euros would be needed to succeed with the project. In total, 1,097,043 euros were received in donations and sponsorships. Organizers estimated that if activists' and volunteers' time were added, the total budget of the campaign would climb to an estimated 10,470,580 euros.

Many of the campaign's needs were met by pro bono or in-kind contributions. For instance, all of the advertising was donated by the media that carried the ads, as shown in Table 16.1.

Table 16.1. Media-Buying Budget and Timetable.

Medium	Estimated value of advertising	When ads ran/were broadcast
Television	102.685 EUR	16. 3. – 16. 4. 2010
Print	269.000 EUR	8. 3. – 16. 4. 2010
Outdoor	46.000 EUR	1. 3. – 16. 4. 2010
Internet	15.500 EUR	1. 4. – 16. 4. 2010
Radio	45.000 EUR	29. 3. – 16. 4. 2010

Evaluation

The campaign was carefully planned, monitored, and evaluated. Program and communication objectives were measured separately.

Targeted Program Objectives

- Targeted project objective #1: Make a map of illegal dump sites in Slovenia between December 2009 and April 2010 by registering at least 6,000 of them.
 - Result for project objective #1: The first map of illegal dumpsites in Slovenia was completed by April 17, 2010, and added 11,394 illegal dumpsites.
- Targeted project objective #2: Build the first digital map of illegal dumpsites in Slovenia by mobilizing at least 1,000 volunteers for Web cartography.
 - Result for project objective #2: The first interactive register of illegal dumpsites in Slovenia was created on the Geopedia portal by 2,832 users/volunteers.

- Targeted project objective #3: In a one-day (April 17, 2010) cleanup at the estimated 6,000 illegal dump sites, remove at least 10,000 tons of waste.
 - Result for project objective #3: The cleaning action on April 17, 2010, removed approximately 15,000 tons of waste from more than 7,000 illegal dump sites.

- Targeted project objective #4: For the action day, April 17, 2010, mobilize at least 200,000 volunteers.
 - Result for project objective #4: On April 17, 2010, more than 270,000 volunteers participated: 13% of the whole national population. (In the original Estonian campaign, only 4% of the total national population participated.) Participation was amplified by active participation of all municipalities, 27 partnering organizations, 273 kindergartens, 527 schools, 63 waste collection and separation companies, 5 sponsors, 94 donors, and 11 media sponsors.

- Targeted project objective #5: Provide financial and material infrastructure for the campaign in the total value of 700,000 euros, of which at least 100,000 would be paid in cash.
 - Result for project objective #5: By April 17, 2010, 1,720,000 euros were collected: 148,503 euros in money and the rest in donated services and materials such as the 750,000 euros worth of advertising space and time donated by media.

Targeted Communication Objectives

- Targeted communication objective #1: Make at least 80% of the total national population aware of the campaign.
 - Result for communication objective #1: A national representative survey documented that 99% of respondents knew about the campaign.

- Targeted communication objective #2: publicity: Earn more than 200 media placements in 10 weeks from February to April 2010.
 - Result for communication objective #2: The campaign earned 2,076 media appearances, of which 1,433 were in April 2010. On the day of the campaign, April 17, 2010, *Let's Clean Slovenia in One Day!* was the headline news on all national media. In total, there were 969 appearances in print, 140 on television, 261 on radio, and 790 on the Internet media.

- Targeted communication objective #3: Position *Let's Clean Slovenia in One Day!* as the largest volunteer event in Slovenia.

○ Results for communication objective #3: Even before April 17, 2010, *Let's Clean Slovenia in One Day!* attracted wide attention from volunteers and organizations, thus enabling it to become the largest volunteer action in Slovenia by mobilizing more than 270,000 volunteers. For this, the president of the Republic of Slovenia, Dr. Danilo Türk, awarded the Order for Merit to the campaign.

• Targeted communication objective #4: Nurture a benevolent climate for the campaign with at least 90% of media reports neutral or positive, motivating volunteers to participate and attracting honorary sponsors.
 ○ Results for communication objective #4: There was not a single negative media report on the campaign. Volunteer numbers envisioned by program organizers were surpassed. The campaign was publicly endorsed by celebrities and politicians, including the country's government leaders. The Facebook page of the project had more than 42,000 friends. Measured with Google Analytics, the project website had more than 245,000 visits, of which 141,000 were unique. In the final week, there were 86,000 visits, of which 62,000 were unique.

The Project Is Over but the Story Goes on

Activists and volunteers did great work and passed it on to government on all levels to do its job in cleaning the illegal dumpsites and instituting sensible waste management practices. Volunteering should not cover up for ineffective government waste control and management. The vision of Ecologists Without Borders activists was to eradicate all illegal dumpsites in Slovenia by 2020, and to make Slovenia a zero waste country by 2030.

In 2012, as part of the World Clean-up 2012 initiative, the Ecologists Without Borders Association organized another cleanup campaign in Slovenia in which 250,000 volunteers joined forces. Cleanup campaigns also were organized in more than 80 countries.

Supporting Video and Web Materials

http://www.youtube.com/watch?v=A5GryIDl0qY
http://www.youtube.com/watch?v=CVUhSt6wFEY

REFERENCES

GHK. (n.d.). *Study of volunteering in the European Union: Country report—Slovenia.* Brussels: European Commission. Retrieved from http://ec.europa.eu/citizenship/pdf/national_report_si_en.pdf

Grunig, J. E., Grunig, L. A., & Verčič, D. (2004). Public relations in Slovenia: Transition, change, and excellence. In D. J. Tilson & E. C. Alozie (Eds.), *Toward the common good: Perspectives in international public relations* (pp. 133–162). Boston, MA: Pearson.

Petrovič, N. (2011). *Očistimo Slovenijo v enem dnevu! Final report.* Ljubljana: Ecologists Without Borders Association. Retrieved from http://www.ekologibrezmeja.si/r/OSVED-zakljucno.en.pdf

Podnar, K., & Verčič, D. (2011). Corporate reputation and the news media in Slovenia. In C. E. Carroll (Ed.), *Corporate reputation and the news media: Agenda setting within business news coverage in developed, emerging, and frontier markets* (pp. 399–407). New York: Routledge.

Verčič, D. (1999). Public communication campaign for the World Bank air pollution abatement program in Slovenia. In J. VanSlyke Turk & L. H. Scanlan (Eds.), *The evolution of public relations: Case studies from countries in transition* (pp. 8–17). Gainesville, FL: Institute for Public Relations.

Verčič, D. (2002). Public relations research and education in Slovenia. In S. Averbeck & S. Wehmeier (Eds.), *Kommunikationswissenschaft und Public Relations in Osteuropa* (pp. 157–173). Leipzig: Leipziger Universitätsverlag.

Verčič, D. (2004). Slovenia. In B. van Ruler & D. Verčič (Eds.), *Public relations and communication management in Europe: A nation-by-nation introduction to public relations theory and practice* (pp. 375–386). Berlin: Mouton de Gruyter.

Verčič, D. (2009). Public relations in a corporativist country: The case of Slovenia. In K. Sriramesh & D. Verčič (Eds.), *The global public relations handbook: Theory, research, and practice* (Exp. and rev. ed., pp. 527–546). New York: Routledge.

Verčič, D. (2011). Public relations: Contributions from Ljubljana. *Teorija in praksa, 48*(6), 1598–1610.

Verčič, D., Grunig, L. A., & Grunig, J. E. (1996). Global and specific principles of public relations. In M. Culbertson & N. Chen (Eds.), *International public relations: A comparative analysis* (pp. 31–65). Mahwah, NJ: Erlbaum.

Zavrl, F., & Verčič, D. (1995). Performing public relations in Central and Eastern Europe. *International public relations review, 18*(2), 21–23.

The Vote for Table Mountain: A 'New 7th' Wonder of Nature Site

CHRIS SKINNER
Durban University of Technology
East and Southern African Management Institute

EDITORS' NOTE

This case illustrates the power of mobilizing a community toward a common goal through communication and public relations efforts. It is a campaign aimed at generating a single call to action by the population to influence a world body. The main challenge was to position the iconic Table Mountain as a national rather than regional symbol. It also introduced or stimulated the use of Internet and mobile telecommunications technology in rural parts of South Africa. Not surprisingly, the project accomplished its mission in quantitative and qualitative terms. The icon made the list and citizens contributed to the extension of civic pride right across the country. The case received an award from the Public Relations Institute of Southern Africa (PRISA) in 2012.

Table Mountain is a global icon. It was declared a UNESCO World Heritage Site in 2004 and a New 7th Wonder of the Nature in 2012 and forms part of the Table Mountain National Park that also includes the Cape of Good Hope, the most southwestern extremity of Africa.

Table Mountain also is part of the Cape Floristic Region, the smallest and richest of the earth's six floral kingdoms, boasting 8,200 rare and endangered plants, some of which are found nowhere else in the world.

Table Mountain is located within walking distance of the city of Cape Town. The Table Mountain Cableway, which has been operating within the Table Mountain National Park since 1929, provides easy access to the summit.

During the days of apartheid in South Africa, Table Mountain was regarded as a symbol of hope for freedom fighters who were jailed with Nelson Mandela on Robben Island, the penal settlement at the foot of Table Mountain to which political prisoners were sent by boat from Cape Town.

BACKGROUND

Origins of the 7 New Wonders Campaigns

In 2000, as a millennium project, entrepreneur Bernard Weber, a Swiss-born Canadian, created the New 7 Wonders Foundation (N7W Foundation) in Zurich, Switzerland.

Using the Internet and telephony, he organized the first-ever global voting campaign and secured more than 100 million votes from people in more than 200 countries to elect the New 7 Man Made Wonders of the World in 2007.

Those selected in this competition were:

- Christ the Redeemer: Rio de Janeiro, Brazil
- The Great Wall of China
- Machu Picchu: Peru
- Petra: Jordan
- The Pyramid at Chichen Itza: Yucatan Peninsula, Mexico
- The Colosseum: Rome, Italy
- The Taj Mahal: Agra, India

The Official New 7 Wonders of Nature Campaign

Weber repeated this feat with a further campaign to elect the Official New 7 Wonders of Nature. This campaign received more than 440 nominations representing more than 220 countries.

Global voting to narrow the field of nominees for this new competition took place from December 2007 until July 7, 2009. From these national qualifiers, the top 77 became eligible for finalist short listing.

Selection of finalists was based on the following criteria:

- Unique beauty of the nominated site
- Diversity and distribution
- Ecological significance (in terms of either stand-alone eco-systems and/or their significance for human beings)
- Historical legacy (relation that human beings and or indigenous population have or have had with the site)
- Geo-location (even distribution of the 28 Official Finalists between all continents)

Only sites with an official supporters committee were considered.

The New 7 Wonders panel of expert judges consisted of thought leaders across a range of environmental fields: Dr. John Francis (American environmentalist), Simon King (British broadcaster and photographer), Ana Paula Tavares (executive vice president of the Rainforest Alliance), Rex Weyler (American/Canadian author, journalist, and ecologist), and Dr. Jan Zima (professor and member of the Council of the Academy of Sciences, Czech Republic). Dr. Federico Mayor Zaragoza, former director-general of UNESCO, chaired the judging panel. It announced 28 Official Finalist Candidates on July 21, 2009:

- The Amazon: South America
- Angel Falls: Venezuela
- Bay of Fundy: Canada
- Black Forest: Germany
- Bu Tinah Island: United Arab Emirates
- Cliffs of Moher: Ireland
- Dead Sea: Israel, Jordan, Palestine
- El Yunque: Puerto Rico
- Galapagos: Ecuador
- Grand Canyon: USA
- Great Barrier Reef: Australia, Papua New Guinea
- Ha Long Bay: Vietnam
- Iguazu Falls: Argentina/Brazil
- Islands of the Maldives: Maldives
- Jeita Grotto: Lebanon
- Jeju Island: South Korea
- Kilimanjaro: Tanzania
- Komodo: Indonesia
- Masurian Lake District: Poland

- Matterhorn/Cervino: Italy/Switzerland
- Milford Sound: New Zealand
- Mud volcanoes: Azerbaijan
- Puerto Princesa Underground River: Philippines
- Sunderbans: Bangladesh and India
- Uluru: Australia
- Vesuvius: Italy
- Yushan: Chinese Taipei

Results of the New 7 Wonders Competition

Voting for the New 7 Wonders took place over a three-year period. According to the organizers, total voting set a new record in the N7W Foundation's competitions; hundreds of millions of votes were cast, which represented a significant increase over the number of votes recorded in the first campaign held in 2007. Once again, everyone around the globe was eligible to vote. People could vote once online for their top seven attractions and could vote as often as they liked via mobile phone technology.

The winners were:

- The Amazon: South America
- Ha Long Bay: Vietnam
- Iguazu Falls: Argentina/Brazil
- Jeju Island: South Korea
- Komodo: Indonesia
- Puerto Princesa Underground River: Philippines
- Table Mountain: Cape Town, South Africa

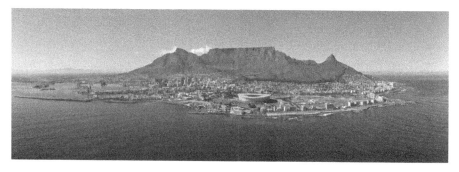

Figure 17.1. Lofty and magnificent Table Mountain rises 1086 metres above sea level, the city of Cape Town nestles beneath.

METHODOLOGY

This case study was researched and written using qualitative research methodologies, among them a review of materials submitted in support of an entry in the 2012 Public Relations Institute of Southern Africa (PRISA) PRISM competition. This case study was awarded the top gold PRISM award. It was subsequently entered as the South African entry in the competition for the International Association of Business Communicators (IABC) Silver Quill awards for that year. The author also drew on interviews of and primary resource material provided by Kerry Seymour, managing director of Splash Public Relations and Media Consultancy as well as secondary source material obtained from various tourism websites relevant to the study.

SITUATION ANALYSIS

Members of the public from around the world would choose the New 7 Wonders sites in the first worldwide democratic election of its kind. So the success of any campaign of this nature depended largely on how successful organizers were in encouraging as many people as possible to vote for a particular national natural wonder site.

The main strength of the South African bid was that Table Mountain had an extremely proactive organizing committee set up and led by the Table Mountain Cableway Company, which carried more than 700,000 visitors to its summit annually.

Also, Table Mountain had already been declared a UNESCO World Heritage site so it had been exposed to the growing world tourism market over many years. And the mountain's location within the city of Cape Town gave it an advantage over other global competitor sites that were difficult to access.

Cape Town also had gained global recognition as the best city to visit in Africa as well as being one of the top international tourist attractions according to recent international tourist statistics. As Cape Town's popularity grew, so did interest in Table Mountain.

Despite this advantage, South African campaign organizers—Table Mountain Cableway Company set up, led, and funded the Table Mountain Official Supporters Committee (OSC)—retained the Cape Town public relations firm, Splash PR, to assist them in generating voter turnout.

Research conducted by the N7W Foundation, the OSC, and Splash PR found that 98% of voters in Phase 1 of the initial competition were in fact international

voters. This showed that it was local South Africans who needed to be motivated, not just international voters. Furthermore, additional research conducted with the help of key local stakeholders (including Cape Town Tourism, the City of Cape Town itself, and Table Mountain National Park) revealed the national population of South Africans needed to learn why they should get involved in the voting process.

This apathy was reflected in Table Mountain being viewed as a Cape rather than a South African icon, so media outside of the Cape area generally struggled to find any significance in the campaign and therefore did not provide much editorial coverage about the competition until the very last stage.

Other weaknesses that emerged from the research were slow Internet bandwidth speeds that meant many South Africans found the Swiss-based N7W Foundation website frustrating to navigate when trying to vote.

Another significant weakness was the lack of a substantial budget from either private or government sources to support any of the local initiatives proposed to attract South African voters. At the same time, many of the other 27 world iconic sites vying against South Africa for one of the top seven spots had the advantage of being in areas with larger populations and, above all, bigger promotional budgets than Table Mountain.

CORE OPPORTUNITY

The SWOT (strengths, weaknesses, opportunities, and threats) analysis Splash PR conducted revealed that there was little or no initial local interest in the competition or its relevance and value as a public relations/marketing tool for the Cape and South Africa. This had to change if Table Mountain had any chance of being chosen.

To their credit, the Table Mountain Official Supporters Committee (OSC) and Splash PR got directly involved in the competition, and the campaign was underway.

GOALS

The goals of the campaign were to raise awareness for Table Mountain as a natural wonder and to market the Cape and South Africa as key tourist destinations, and by so doing create a long-term historical and economic legacy for the country.

OBJECTIVES

The campaign's objectives were to:

- Highlight Table Mountain's attributes and the benefits of winning to the South African public at large
- Maintain a constant flow of information to the media
- Get fans to vote weekly on the NW7 website using mobile voting platforms
- Use the N7W Foundation website to promote Table Mountain globally
- Ultimately draw more than 30 million votes to clinch acceptance and success for Table Mountain's entry

To measure its success, Splash PR planned to conduct a detailed review and analysis of all media clippings. The OSC created South African "SMS" and social media voting platforms from which reliable analytics could be drawn, and Splash PR posted every local news release on the N7W Foundation website, measurable by analyzing site visits.

TARGET PUBLICS

The campaign clearly was geared to get everyone in South Africa behind the Table Mountain bid. But because the voting was done electronically, for all practical purposes it meant that voting by South Africans was restricted to those who had Internet access and/or who also had cell phones. School children were identified as a particularly important target market because a high proportion have cell phones and are frequently sending and receiving messages. Linked to this market was a special corporate social investment (CSI) initiative that focused on township residents on the Cape flats who had limited access to the Internet but who were willing to learn more about the Internet and were keen to vote.

A move that had a significant impact and was seen as the key to Table Mountain's success was when organizers managed to get Mxit, Africa's biggest social network and free mobile instant messenger, on board as a voting platform. At the time Mxit had approximately 40 million registered accounts. The Internet provider agreed to charge its subscribers a lower rate for messages sent in support of the campaign. In the final stage of voting, with only days to go, Mxit permitted anyone in Africa and South Africa to use the Mxit app to vote for a significantly reduced rate of 20 cents (2 US cents).

KEY MESSAGES

Clearly the key message was to vote for Table Mountain as one of the 7 New Wonders of the World, thereby joining the growing band of celebrities, sports stars, and politicians who had endorsed the campaign. The message was simple: "You too can make a difference." The campaign stressed that Table Mountain was the only South African site that had been nominated and that winning this competition would bring enormous prestige and with it substantial tourism revenue to South Africa. This could not be achieved unless South Africans voted—and as often as they could. The campaign stressed that voting was easy: South Africans could vote for free online, via SMS for as little as R2 (20 US cents), and/or via Mxit in the final stages for a significantly reduced rate of 20 cents (2 US cents).

STRATEGIES

The key to success here was to develop a successful stakeholder engagement strategy. As the body charged with the responsibility of coordinating the public relations campaign in the final stages of the competition, Splash PR sat in on OSC's regular monthly meetings during which it provided expert knowledge and assistance on public relations opportunities that the competition presented at various levels.

In addition, Splash PR also met regularly with the communication managers from Table Mountain Cableway, Cape Town Tourism, the City of Cape Town, and South African National Parks to see how they could leverage their individual networks for mutual advantage. Weekly reports also were sent to the N7W Foundation in Switzerland with a request that they be posted on the Foundation's website.

Splash PR gave careful thought to the communication channels that might be used to disseminate any news, opinions, and endorsements that might help in the success of the campaign. For this purpose, national, regional, and local newspapers were targeted as well as environmental, travel, tourism, in-flight, and lifestyle magazines. Radio and television channels were approached for interviews and special features.

Online sites with large visitor footprints also were used and stories were fed regularly to digital press release sources and wire services.

A website funded by Table Mountain Cableway was created at www.votefortablemountain.com for posting updates and keeping the public aware of the latest developments.

Splash PR worked closely with Flow Communications, a social media agency that built a strong fan base for the competition on social media platforms Facebook, Twitter, and Flickr.

TACTICS

Together with the OSC, Splash PR developed a series of innovative tactics to keep the campaign current, relevant, and exciting. These included the following:

- Table Mountain ambassador activities
- Vote for Table Mountain Thursdays
- Promoting Mxit voting
- An economic impact report prepared by international assurance, tax, and advisory consultant firm Grant Thornton
- Community outreach programs
- Developing a public relations toolkit for the campaign website www.votefortablemountain.com

Identifying Special Ambassadors for the Campaign

Local celebrities, media personalities, sports stars, politicians, and musicians were invited to become ambassadors for Table Mountain. For example, the national rugby team, the Springboks, came on board and during the build up to the 2011 Rugby World Cup made a series of videos that featured the Springboks calling for votes.

Other ambassadors included the South African cricket team, pop stars Freshly Ground, and Nobel Peace Prize winners F.W. de Klerk and Archbishop Emeritus Desmond Tutu. With Archbishop Emeritus Tutu on board, the organizers were able to attract global attention, and an emotive video was created to bring others on board. It proved a hit on YouTube and on national television.

With three months to go, Cape Town's mayor, Patricia de Lille, also took up the cause. She voted for Table Mountain during a press conference covered by the media. Her office also organized numerous public relations activities to draw attention to the campaign.

The local government's Minister for Finance, Economic Development and Tourism Alan Winde descended by rope down the mountain to draw attention to the campaign. Ambassador briefings with media, bloggers, twitterati, and celebrities were hosted regularly to motivate more people to become campaigners.

On one occasion ambassadors and celebrities were invited to a Table Mountain election day in the café on top of the mountain, where South African comedian Marc Lottering played master of ceremonies. Voting stations were set up and media were invited to cover the event.

Every new personality who came on board created an opportunity for a media release, event, or photo call to maintain the momentum for the campaign.

Vote Thursdays

Repeated mobile voting was South Africa's only hope of competing against other countries with greater populations, so a Vote for Table Mountain Thursdays program was created. This grew through public relations and social media, and thanks to DJs, TV presenters, and those with an audience on Twitter and Facebook, the campaign gathered momentum.

Mxit

Mxit came on board as a voting platform, charging its subscribers a low rate to vote, in the final stages charging just 20 cents (2 US cents) per vote. The video of Archbishop Emeritus Tutu on the mountain and a series of media releases were particularly important in encouraging Mxit voting. At the time Mxit had approximately 40 million registered accounts.

Last Minute Voting

The OSC expected many people to vote at the last minute. When Table Mountain was missing from the Top 10 list issued by the N7W Foundation on November 6, 2011, with just five days to go, Splash PR issued a final massive media call that received widespread news coverage.

Economic Impact

To secure their votes, it was important, too, to get South Africans to recognize the campaign's positive marketing and overall economic impact. The OSC employed the consultancy firm Grant Thornton to assess the impact of Table Mountain being named a N7W site.

The impact report predicted an R1.4 billion ($140 million) annual tourism bonanza for South Africa if Table Mountain was named one of the New 7 Wonders of Nature. Grant Thornton found that tourism to Table Mountain, and thus

Cape Town, would increase by about 20% annually. Approximately 7% of these visitors were expected to be international tourists.

Grant Thornton's research, based on international and domestic travel trends, took into account a tourist's average length of stay and average spending, and forecast that the increased tourism would generate an additional R1.4 billion (US $140 million) annually or about R116 (US $1.16) million a month, which would support approximately 11,000 employment opportunities in South Africa.

Grant Thornton based its projections on the initial New 7 Wonders campaign in which 100 million votes were cast worldwide to vote for the New 7 Man Made Wonders in 2007. Positive measurable results were seen at the seven sites that made the final list in this campaign. For example, visitors to Petra in Jordan increased by 61% and to Christ the Redeemer in Brazil by 30%.

A media release focusing on the Grant Thornton survey results generated multiple editorials across all major news channels with 100% message penetration.

Community Outreach

To reach informal settlement dwellers in and around the city and suburbs of Cape Town who had an appetite for voting but did not have the means to do so, the OSC teamed up with Reconstructed Living Labs, a nonprofit organization that provided laptops and Internet access to disadvantaged learners. In particular, the townships of Khayelitsha, Gugulethuu, and Langa were serviced. Learners were shown how to vote online so that they, too, could be part of the global election. Splash PR spread this news via the South African media and the N7W Foundation, which posted it on its website.

The township campaign was coupled with a broader school campaign. Vote for Table Mountain activist and media personality Kia Johnson visited more than 30 schools in the Western Cape. As a result many schools hosted Vote for Table Mountain days and students voted en masse using their cell phones.

Digital PR Toolkit

To tackle widespread demand for content from a variety of sources in the final three months of the campaign, a digital PR toolkit was set up to provide easy and quick access to media releases, pictures, videos, and FAQs literally at the press of a button on the OSC website (www.votefortablemountain.com). This also proved to be a selling point for the campaign, and many media organizations took advantage of this free service.

Adjustments to the Plan

N7W Director Weber paid Table Mountain an official visit on November 3, 2011, to motivate people to support the N7W campaign. This proved to be a great public relations opportunity for Splash PR, which managed a press conference with the director on top of the mountain. Television and radio news crews and print and online journalists queued up for interviews with the N7W director in the hope that he would provide sound bites and footage to shed light on Table Mountain's potential to appear on the final list of 7 Wonders of Nature.

CALENDAR/TIMETABLE

The 7 Natural Wonders competition spanned a four-year period from the beginning of nominations in July 2007 to November 2011 when the seven winners were announced. However, it was only in 2011 that the campaign to seek one of the top seven places for Table Mountain really gained momentum.

Splash PR knew it was necessary to research the 27 rivals to get some insight into their individual campaigns and to assess their strengths and weaknesses. Splash PR then drew up a public relations program for a 10-month period in 2011, the focus of which was a detailed media program.

Each month, the OSC generated an event or activity to drive newsworthy stories to the media. This became a weekly occurrence in the final month leading up to the November 2011 voting deadline.

A final event was hosted by the OSC at the V&A Waterfront restaurant and bar where invited guests gathered to await the global announcement of the results by the New 7 Wonders Foundation. At the same time, a free music concert was hosted at the V&A Waterfront open-air Amphitheatre close by in Cape Town. A video showing Table Mountain's bid journey was shown as a backdrop to the music performed live in the Amphitheatre. All the VIP guests at the N7W party joined the public there to hear the mayor of Cape Town make the official announcement that Cape Town's bid had been successful.

BUDGET

Splash PR was appointed in January 2009 and worked on the campaign from the start. Splash PR managed all awareness generated for the campaign, whether international or domestic, between 2009 and 2011. This was funded by the Table

Mountain Cableway whose CEO, Sabine Lehmann, was also the driving force behind the campaign.

In 2011 a campaign manager, Fiona Furey, was appointed for approximately nine months to coordinate campaign efforts on behalf of the Official Supporters Committee (OSC). Splash PR worked alongside Furey and Cableway's social media agency, Flow Communications, until the final announcement in November 2011. Splash PR was paid R100,000 ($10,000) for their services during the final year of the campaign. The City of Cape Town spent R1.4 million ($140,000) on advertising. Table Mountain Cableway Company spent R4.9 million ($490,000) in total on the project.

EVALUATION AND MEASUREMENT OF RESULTS

From a top 28 position on February 1, 2011, the Vote for Table Mountain campaign won Table Mountain a Top 7 position on the provisional list announced November 11, 2011, beating other global icons including the Grand Canyon, the Great Barrier Reef, and Mount Kilimanjaro.

Media exposure for the final phase of the contest spanned nine months with a massive crescendo in November 2011 just prior to the voting deadline.

Editorial coverage included 1,967 stories across print (521), broadcast (897), and online (549) media channels in South Africa.

Message penetration was measured at 90% across all coverage achieved with little negative coverage.

The outreach campaign introduced an estimated 10,000 school children to email and opened their eyes to the power of the Internet.

Visitor numbers to Table Mountain Cableway reached a record high of 116,000 in December 2011, a high that was sustained in January and February 2012.

On December 1, 2012, Table Mountain was officially inaugurated as a New 7 Wonder of Nature, and members of the OSC together with representatives from the other six sites were recognized at a celebration. This generated additional media exposure for Table Mountain.

In April 2013, South African media reported that Cape Town continued to buck global trends in tourism with visitor numbers increasing despite the difficult economic climate around the globe. This growth in tourism during 2012 and 2013 was comparable only to the height of South Africa's tourism boom in 2007, prior to the economic crash.

In the financial year July 2012 to June 2013, Table Mountain Cableway recorded 855,000 visitors, the highest number in one year since the Cableway was launched. The Table Mountain Cableway Company continues to drive awareness for the accolade and planning is underway for an annual New 7 Wonders legacy celebration on December 1 each year. The other six sites also cross promote each other.

Table Mountain is the only New 7 Wonder of Nature located in a city. The six other sites are difficult to get to, whereas Table Mountain is extremely easy to access from Cape Town. This puts Table Mountain in a unique position to truly leverage its title.

The first of the special New 7 Wonder frames for viewing Table Mountain has also been installed and was launched on World Tourism Day on September 27, 2013. The frame is the first of a series of structures to be installed in Cape Town, each providing a perfect vantage point that literally frames Table Mountain so that people can take photographs of themselves—"selfies" in today's parlance—within the frame, with Table Mountain in the background. It is being called the Table Mountain legacy project and will become a tourism project in its own right.

Table Mountain is a New 7 Wonder of Nature and people around the globe are now exposed to its uniqueness and special attractions. The latest figures provided by the Table Mountain Cable Car company show that the number of annual visitors recorded could soon top one million.

The Grant Thornton tourist report also highlighted the economic benefits that could flow from increased tourism to the region. Whether this can be attributed directly to the campaign is difficult to assess but it certainly has been a major contributing factor.

Table 17.1. Achievement of Objectives.

Objectives	Results
Beat 21 sites	From 28 finalists, secured a top 7 position, beating other icons such as the Grand Canyon and Mount Kilimanjaro.
Achieve more than 30 million votes	The N7W Foundation did not release the final voting number, but Table Mountain had to feature in the top 25% to win. The campaign believes it achieved more than 30 million votes.
Convincing messages for South Africans	Key message penetration was 90%.

Continued.

Objectives	Results
Six-month media presence	Six months of editorial exposure resulted in print (449), broadcast (784), and online (416) mentions.
Voting regularly on mobiles	Vote Thursdays and Mxit's 40 million users delivered high voting traffic. "At the height of Mxit voting, the social network was carrying 2,333 votes a second," according to Allan Knott-Craig, Mxit CEO.
Use the N7W Foundation to promote Table Mountain internationally	100% of Table Mountain's media releases were posted on the N7W site.

AUTHOR'S NOTE

The author would like to thank Kerry Seymour, Managing Director of Splash Public Relations and Media Consultant, for her assistance in writing this case study. Also the following websites were consulted: New7Wonders of the world at www.world.new7wonders.com/, SA tour at www.southafrica.net, Captour at www.africa/com/captour, Cape Town at www.capetown.travel/, Table Mountain Aerial Cableway at www.tablemountain.net, and Grant Thornton at www.gt.co.za.

Contributors

EDITORS

Judy VanSlyke Turk, Ph.D., APR, Fellow PRSA, is professor emerita in the Richard T. Robertson School of Media and Culture (formerly the School of Mass Communications) at Virginia Commonwealth University (VCU). She is a Visiting Professor for the 2014-2015 school year at the School of Journalism and Mass Communication at Florida International University.

From March 2002 through June 2010, Turk was the School's director. Prior to joining VCU in March 2002, she was founding dean of the College of Communication and Media Sciences at Zayed University in the United Arab Emirates, a position she held for 2.5 years. Previously, she was dean or director of several journalism and mass communications programs in the United States.

Turk is past president of the Association of Schools of Journalism and Mass Communication (ASJMC) and of the Association for Education in Journalism and Mass Communication (AEJMC), the largest association of journalism faculty and administrators in the United States. She is immediate past president of the Arab-U.S. Association of Communication Educators.

Turk is a past chair of the College of Fellows of the Public Relations Society of America (PRSA) and is currently co-chair of the Fellows' Educational Initiatives Committee.

Turk was named Outstanding Public Relations Educator in 1992 by PRSA. In 2005, she received the Pathfinder Award from the Institute for Public Relations for her lifetime contributions of research, and in 2006, AEJMC recognized her as its "Outstanding Woman in Journalism Education."

Turk is co-author of *This Is PR: The Realities of Public Relations* (Cengage/Wadsworth Publishing), now in its 11th edition, and author of dozens of articles in scholarly and professional journals.

She has consulted and lectured on public relations and journalism/mass communications teaching and curriculum issues in Eastern Europe, the Newly Independent States, the Baltics, Russia, the Middle East, China, and Asia.

She a member of the board of directors and co-chair of the Research and Education Committee of the Global Alliance for Public Relations and Communication Management.

She can be reached at jvturk@vcu.edu.

Jean Valin, APR, Fellow CPRS, founded Valin Strategic Communications after a 30-year career as a senior communication executive. He has advised senior officials and ministers of the Government of Canada on communication matters throughout his career.

He worked on several high-profile national issues such as a gun control program, anti-terrorism and organized crime legislation, same-sex marriage legislation, the launch of Service Canada (Canada's one-stop destination for all government services), as well as transportation policy for air, road, and marine safety and for security issues.

Valin's career began in broadcasting with Radio Canada and private radio stations in the Ottawa region.

Valin is active in the professional association, the Canadian Public Relations Society (CPRS). He was awarded his accreditation (APR) in 1987 and was called to the College of Fellows in 2001, becoming the youngest member to achieve that highest level of recognition. He served as national president of CPRS in 1996–1997 and has received several national public relations awards throughout his career. He is a co-author of the official definition of public relations adopted by CPRS in 2008.

In 2000, he became a founding member of the Global Alliance for Public Relations and Communication Management, a confederation of more than 70 major public relations associations around the world representing more than 170,000 members. He was chair of the Global Alliance for 2004 and 2005 and is an inaugural member of the Global Alliance Advisory Council.

In 2008 he received the President's Medal from the Chartered Institute of Public Relations in the United Kingdom, and he received the Award of Attain-

ment from the Canadian Public Relations Society in both 2010 and 2013—the latter for his leadership in developing the Melbourne Mandate advocacy platform for public relations. He is the 2013 recipient of the David Ferguson Award presented by the Public Relations Society of America (PRSA) to a practitioner who has made an especially significant contribution to the advancement of public relations education.

He can be reached at jvalin@videotron.ca.

John L. Paluszek, APR, Fellow PRSA, is senior counsel at Ketchum specializing in reputation management and corporate social responsibility. He is liaison to the United Nations for the Global Alliance for Public Relations and Communication Management and the Public Relations Society of America (PRSA), and he is a past chair of the Global Alliance.

In 2012, he established "Business in Society," video programming delivering news and analysis on corporate social responsibility.

The PRSA 1989 national president, Paluszek has received numerous professional awards, most recently PRSA's 2010 Atlas Award for lifetime achievement in international public relations. That work began in 1988, shortly before the fall of the Berlin Wall, when he represented PRSA in the first United States–Soviet Bilateral Information Talks in Moscow and in the first East-West Public Relations Summit in Vienna. Paluszek has lectured on corporate responsibility and public relations at U.S. colleges and at business conferences on five continents. He is a member of the Committee of the Accrediting Council for Education in Journalism and Mass Communication and a member and former co-chair of the Commission on Public Relations Education.

A former journalist, Paluszek has written many commentaries for business and academic journals such as *Journalism Studies*, the Foreign Policy Association's "Viewpoints," and the CNBC Blog. He is the author of seminal books on corporate social responsibility, *Organizing for Corporate Social Responsibility* (Amacom, 1973) and *Will the Corporation Survive?* (Prentice-Hall, 1977). A graduate of Manhattan College (B.A., management), he was a trustee of the college for 15 years and was awarded a Manhattan College honorary degree, Doctor of Humane Letters.

He can be reached at john.paluszek@ketchum.com.

CASE STUDY AUTHORS

Shannon A. Bowen, Ph.D., is associate professor at the University of South Carolina's School of Journalism and Mass Communications. Bowen is a member of the Board of Trustees of the Arthur W. Page Society, and the Board of Directors of the

International Public Relations Research Conference (IPRRC). She is co-editor of *Ethical Space: The International Journal of Communication Ethics* and serves on several editorial boards, including the *Encyclopedia of Public Relations* (Sage). Bowen, a former chair of the Media Ethics Division of the Association for Education in Journalism and Mass Communications (AEJMC), researches public relations ethics and has won the Jackson, Jackson and Wagner Behavioral Science Research Prize and the Robert Heath Outstanding Dissertation Award. She is a 2014 Page Legacy Scholar. She can be reached at sbowen@mailbox.sc.edu.

Barb DeSanto, Ed.D., APR, Fellow PRSA, teaches and writes in the A.Q. Miller School of Journalism and Mass Communications at Kansas State University. DeSanto's research areas include public relations management, public relations management roles, international tourism, and public relations curriculum development. After 10 years of professional practice in Florida tourism and public affairs, DeSanto earned her doctorate from Oklahoma State University in 1995. During her 18 years of teaching, she has created and taught 15 different public relations courses, including developing and teaching study abroad classes in the United Kingdom, Germany, and Australia. She has authored three books, six book chapters, and numerous journal articles. Her latest book is *Public Relations: A Managerial Perspective* with co-author Dr. Danny Moss, University of Chester, United Kingdom. She advises the Kansas State PowerCat Public Relations Student Society of America (PRSSA) chapter. She can be reached at barbdesanto@gmail.com.

Finn Frandsen, Mag. Art, is a professor of corporate communication and director of the Center for Corporate Communication (CCC) in the School of Business and Social Sciences, Aarhus University (Denmark). He can be reached at ff@asb.dk.

Alan Freitag, Ph.D., is a Fulbright Scholar and a professor in the Communication Studies Department at the University of North Carolina at Charlotte. He retired from the U.S. Air Force in 1995. He is lead author of *Global Public Relations: Spanning Borders, Spanning Cultures* (Routledge, 2009). He is accredited in public relations through the Public Relations Society of America (PRSA) and is a member of the society's College of Fellows. He can be reached at arfreita@uncc.edu.

Chun-ju Flora Hung-Baesecke, Ph.D., is a faculty member at Hong Kong Baptist University. She is a member of the Academic Committee in the China International Public Relations Association. She was voted one of the Top 100 People in Public Relations in China in 2009. Her research interests are relationship management, strategic management, corporate social responsibility, reputation management, and crisis communication. Dr. Hung-Baesecke has published her

research in academic journals including *Journal of Public Relations Research, Journal of Communication Management, Public Relations Review,* and *International Journal of Strategic Communication.* She also has published her research in edited book chapters. She can be reached at chingrulu@yahoo.com.

Winni Johansen, Ph.D., is a professor of corporate communication and director of the Executive Master's Program in Corporate Communication in the School of Business and Social Sciences, Aarhus University (Denmark). She can be reached at wj@asb.dk.

Kiranjit Kaur, Ph.D., is an associate professor of public relations at Universiti Teknologi MARA Malaysia. She graduated from the University of Maryland with a PhD in Mass Communication in 1998. She is a Fellow and accredited member of the Institute of Public Relations Malaysia (IPRM) and chair of the IPRM education committee. Kaur also serves on the Malaysian Communication and Multimedia Content Forum Council and chairs the Media Commission of the National Council of Women's Organizations, Malaysia. Her main areas of research are in public relations, media and ethics, and women and media. She can be reached at kkludher@gmail.com.

Laura Kolbe is a professor of European History at the University of Helsinki, Finland, a position she has held since 2001. Kolbe also is a research leader in a group of historians studying the postwar urban history of the Helsinki metropolitan area. In addition, she is the former president of the International Planning History Society (IPHS), the founder and former president of the Finnish Urban Research Society, and chief editor for *Tiedepolitiikka* (Science & Politics) in 2003–2006. While she was its chief editor, *Tiedepolitiikka* published the four-volume *Suomen Kulttuurihistoria I-IV* (Cultural History of Finland I-IV, 2002–2005), which looked at the national cultural history contextualized within European development. The relationship between "national" and "European" has been the central idea in all her recent research, teaching, and writing. Kolbe's present research project deals with the development of capitol cities and their role in Europe, in different times and areas. Her research also has covered urban governance and finances, municipal policies, urban infrastructure, city building processes, architecture and planning, and welfare systems. She was a member of the Country Brand Delegation that led the Finnish branding effort presented in this volume. She can be reached at laura.kolbe@helsinki.fi.

Katarzyna Konieckiewicz is a graduate student in the Public Relations and Economic Journalism Department, Poznań School of Economics, Poland. She is completing her master's degree in economics. She is the TED Poznan team's director

of mass and social media relations activities. (TED is a nonprofit, entrepreneurial organization devoted to "Ideas Worth Spreading.") She also is on the staff of the PRELITE public relations firm. She can be reached at k.konieckiewicz@gmail.com.

Alessandro Lovari, Ph.D., is an assistant professor of cultural and communicative processes at the University of Sassari's Department of Political Sciences, Science of Communication, and Information Engineering, where he teaches corporate communication and social media for public administrations. He has been a visiting scholar at the Department of Communication at Purdue University (USA). His main research interests are public communication, public relations, and the relationships between institutions, media, and citizens. He also studies the characteristics of Web 2.0 and social media and their impact on companies' and citizens' behaviors. He can be reached at alelovari@gmail.com.

Vilma Luoma-aho is a professor of organizational communication and public relations at the University of Jyvaskyla, Finland. She has been a visiting scholar at the Annenberg School for Communication, University of Southern California, and at the Media Research Center at Stanford University, California. She is known for her innovative concepts and has coined the "Faith-holder" and "Hateholder" concepts in stakeholder theory. She also has introduced the idea of neutral reputation (related to public sector organizations) and is a co-creator of the issue-arena theory. She is an active member of ProCom, the Finnish Union of Communication Professionals, and has won prizes and mentions for her applicable research ideas. She is the author of several book chapters on intangible assets and has published in academic journals including *Public Relations Review, Journal of Communication Management, Corporate Communication: An International Journal, Business History, Business Ethics: A European Review, The International Journal of Public Sector Management, Ethical Space, Management Research Review,* and *Journal of Media Business Studies.* Luoma-aho's research focuses on hybrid forms of public relations, the value of intangible assets, and stakeholder relations. Currently, she leads a research group studying engagement and the transparency of new forms of media advertising online. She can be reached at vilma.luoma-aho@jyu.fi.

Andre Manning, group head of public relations and public affairs at Booking.com, and previously vice president of corporate communications, Royal Philips, is an experienced and results oriented communications leader who has held various international communications leadership positions within Philips in the Netherlands, Central and Eastern Europe, and the United States. He was included in the 2011 and 2012 Holmes Report top 100 list of the World's Most Influential Communicators. As a result of his focus on measurement and accountability of

communications, he was named public relations measurement expert of the year by *PR News* in 2012. He can be reached at andre.manning@philips.com.

Valentina Martino, Ph.D., is an assistant professor in the Department of Communication and Social Research at Sapienza University of Rome, where she teaches business communication and coordinates a seminar on scientific writing. Her main research interests are public relations, university communication, and analysis of cultural consumption. Her last book is *La comunicazione culturale d'impresa. Strategie, strumenti, esperienze* (Guerini, Milan 2010). She can be reached at valentina.martino@uniroma1.it.

Melanie Palmer, Global Marketing Manager for Zespri International, won the Public Relations Institute of New Zealand (PRINZ) 2011 top award for her management of the kiwifruit crisis. At the time of the crisis, she was communications manager of Zespri International with responsibility for corporate communications, media and issue management, events, and tours. As a public relations and communications graduate of Auckland University of Technology (AUT), Palmer also has held senior communications roles in the financial services and hospitality sectors. She can be reached at melanie.palmer@zespri.com.

Gaelle Picherit-Duthler, Ph.D., is an associate professor and director of graduate programs in the College of Communication and Media Sciences at Zayed University in Abu Dhabi. She has consulted with several national and international organizations. She is the founder and organizer of the Middle East Public Relations Conference. She can be reached at Gaelle.Duthler@zu.ac.ae.

Bill Proud lectures in integrated marketing communications, marketing, and related marketing subjects at Queensland University of Technology (QUT) Brisbane. Proud's career in marketing spans 40 years and stretches from senior marketing positions in fast-moving consumer goods companies, such as Fosters, Danone, and Campbell's Soups, to running his own marketing consultancy and advertising agency for 20 years. Proud has served as a consultant to local, national, and international companies on marketing and advertising issues and directed campaigns in both the public and private sectors. He is a Certified Practicing Marketer (CPM) and is a member of the Marketing Research Society, a national board member of the Australian Marketing Institute, Fellow of the Australian Institute of Management, and a founding member of the Academy of Advertising in both Australia and New Zealand. He can be reached at w.proud@qut.edu.au.

Hongmei Shen, Ph.D., APR, is an associate professor in the School of Journalism and Media Studies at San Diego State University. She has authored 16 refereed journal articles in various top-tier academic journals, has had two papers published

in conference proceedings, and has presented 37 refereed conference research papers (with five top paper awards) at international and national conferences in public relations and mass communication. Her research focuses on relationship management, international public relations, work-life conflict, and crisis communication. Shen has been the chair of the Public Relations Society of America's (PRSA) National Committee on Work, Life & Gender since 2012. She also serves on the Commission on Public Relations Education, the authoritative body for public relations curricula. She advises the Public Relations Student Society of America (PRSSA) at San Diego State University. Her professional background is in media relations, marketing, and journalism, both in the United States and in China. She can be reached at hshen@mail.sdsu.edu.

Chris Skinner, APR and Fellow, Public Relations Institute of Southern Africa (PRISA), is a research associate at the Durban University of Technology. He also is a senior consultant with the East and Southern African Management Institute (ESAMI). He is the co-author of *The Handbook of Public Relations*, which recently celebrated its 10th edition after 30 years and is regarded as one of the leading texts of its kind in Africa. He can be reached at Chris.skinner@telkomsa.net.

Don W. Stacks, Ph.D., is professor of public relations in the Department of Strategic Communication in the School of Communication at the University of Miami, Coral Gables, Florida. Stacks has written more than 200 scholarly articles, chapters, and papers. His awards include the Pathfinder Award and the University of Miami's Provost's Award for Outstanding Research and Theory. The Public Relations Society of America named him Outstanding Educator and awarded him the Jackson, Jackson & Wagner Behavioral Science Prize. He also has been named an Outstanding Professor by University of Miami students. Stacks has authored or coauthored eight books on communication topics, including the award-winning *Primer of Public Relations Research,* and was awarded the Measurement Standard's "measurement tool" for 2003. He was inducted into the *PRNews* Measurement Hall of Fame in 2012. Stacks is the editor of *Communication Research Reports* and serves on the boards of the Institute for Public Relations and the International Public Relations Association. He can be reached at don.stacks@miami.edu.

Inka Stever is an assistant professor at the College of Communication and Media Sciences at Zayed University in Abu Dhabi. She comes to higher education with more than 15 years of work experience in public relations, working in the Global Corporate Communications Department of DaimlerChrysler Financial Services in Berlin, Germany. She can be reached at Inka.Stever@zu.ac.ae.

Margalit Toledano, Ph.D., APR, Fellow PRSA, is a senior lecturer in the Management Communication Department of the Waikato Management School in New Zealand. She was inducted into College of Fellows of the Public Relations Society of America (PRSA) in 2007 and of the Public Relations Institute of New Zealand in 2012. She served as president of the Israeli Public Relations Association in 1993–1996. She is a member of the editorial boards of *Public Relations Inquiry* and *Public Relations Review* in which she also has published a number of articles. A book she co-authored with Professor David McKie (Routledge, 2013) is titled *Public Relations and Nation Building: Influencing Israel.* She can be reached at toledano@waikato.ac.nz.

Jacek Trebecki, Ph.D., is a professor in the Public Relations and Economic Journalism Department at Poznań University of Economics, Poland. He also is co-owner and vice president of PRELITE, a Polish public relations firm, and a member of the Polish Society of Public Relations (PSPR) and the European Public Relations Education and Research Association (EUPRERA). He can be reached at jacek@prelite.pl.

Katerina Tsetsura, Ph.D., is a Gaylord Professor of strategic communications and public relations in the Gaylord College of Journalism and Mass Communication at the University of Oklahoma (USA). She has published peer-reviewed research in the areas of international and global media and strategic communication, global journalism, public relations ethics, and public affairs in countries in the process of change within new digital media environments. She can be reached at tsetsura@ou.edu.

Betteke van Ruler, Ph.D., is professor emerita in corporate communication and communication management at the University of Amsterdam, the Netherlands. She earned her Ph.D. at the University in Nijmegen and has published in numerous journals and books. She is past chair of the Public Relations Division of the International Communication Association and past president of the European Public Relations Education and Research Association (EUPRERA). Her research is on the relationship between organizations and society and on the practice of communication management and its professionalization. She can be reached at ruler@telfort.nl.

Dejan Verčič, Ph.D. (LSE), FCIPR, is a professor at the University of Ljubljana, Slovenia. He has published 14 books and more than 300 articles, book chapters, and conference papers. Prof. Verčič has served, inter alia, as the president of EUPRERA. Since 1994, he has organized an annual International Public

Relations Research Symposium—BledCom. He can be reached at Dejan. Verčič@fdv.uni-lj.si.

Donald K. Wright, Ph.D., is the Harold Burson Professor and Chair in Public Relations at Boston University's College of Communication. He is one of the world's most published public relations scholars with the bulk of his work focusing on public relations ethics and the impact of emerging media and other new technologies have on public relations practice. He is the founding editor of *Public Relations Journal* published online by the Public Relations Society of America (PRSA), has served 24 years on the Board of Trustees of the Arthur W. Page Society, is a past president of the International Public Relations Association (IPRA) and a long-time trustee of the Institute for Public Relations (IPR). He can be reached at donaldkwright@aol.com.

Robina Xavier is a professor and executive dean of the Queensland University of Technology (QUT) Business School. She has more than 20 years of experience in the academic sector both as an academic and executive. Prior to joining QUT, Xavier worked as a consultant to both the private and public sectors, specializing in corporate and financial relations. Xavier is a former national president of the leading industry body, the Public Relations Institute of Australia (PRIA), and is a former chair of the industry's National Education Committee that oversees accreditation of Australian university programs. Xavier is a Fellow of PRIA, a Senior Fellow of the Financial Services Institute of Australasia, and is co-editor of the book *Public Relations Campaigns* published by the Oxford University Press. She can be reached at r.xavier@qut.edu.au.

Koichi Yamamura, Ph.D., is an executive vice president of Media Gain in Tokyo, Japan. For more than 13 years, he has been engaged in communication advising for clients on cases including crisis management, battles for corporate control, hostile takeover defense, reputation management, and marketing development. His clients include global and domestic companies and investment funds in industries such as banking, food, liquor, paper, real estate, textiles, aviation, publishing, and pharmaceuticals. He also managed a $7 million project for Japan's Ministry of Economy, Trade, and Industry. His article on the historic evolution of public relations in Japan was published in *Public Relations Review*, and an article on hostile takeover defense in the paper mills industry was published online on the Institute for Public Relations website. Several of his articles, in Japanese, also have been published in *Corporate Communication Studies* and other Japanese-language periodicals. Yamamura received a Bachelor of Liberal Arts from International Christian University in Tokyo, a Master of Science in Public Relations from Boston University, and a Doctor of Philosophy in Communication from the University of Miami. He can be reached at koichi.yamamura.55@gmail.com.

Index